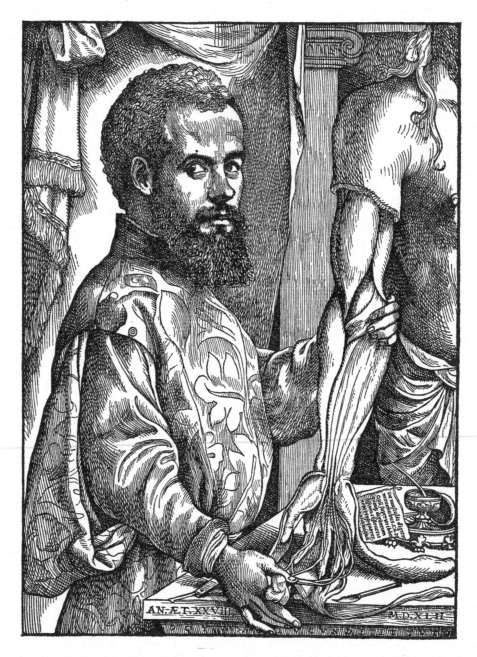

PLATE 1. WOODCUT PORTRAIT OF ANDREAS VESALIUS

THE ILLUSTRATIONS
FROM THE WORKS OF
Andreas Vesalius
OF BRUSSELS

WITH ANNOTATIONS AND TRANSLATIONS,
A DISCUSSION OF THE PLATES AND THEIR
BACKGROUND, AUTHORSHIP AND INFLUENCE,
AND A BIOGRAPHICAL SKETCH OF VESALIUS

BY

J. B. deC. M. Saunders
UNIVERSITY OF CALIFORNIA

AND

Charles D. O'Malley
STANFORD UNIVERSITY

DOVER PUBLICATIONS
Garden City, New York

This Dover edition, first published in 1973, is an unabridged and unaltered republication of the work originally published in 1950 by The World Publishing Company, 2231 West 110th Street, Cleveland, Ohio. The text is reprinted here by special arrangement with the original publisher.

This book was designed by Abe Lerner.

DOVER *Pictorial Archive* SERIES

This book belongs to the Dover Pictorial Archive Series. You may use the designs and illustrations for graphics and crafts applications, free and without special permission, provided that you include no more than ten in the same publication or project. For permission for additional use, please email the Permissions Department at: rights@doverpublications.com or write to: Dover Publications, 1325 Franklin Ave, Suite 250, Garden City, NY 11530.

However, resale, licensing, republication, reproduction or distribution of any illustration by any other graphic service, whether it be in a book or in any other design resource, is strictly prohibited.

Library of Congress Catalog Card Number: 72-94756

International Standard Book Number

ISBN-13: 978-0-486-20968-5
ISBN-10: 0-486-20968-7

Manufactured in the United States of America
20968721 2021
www.doverpublications.com

Contents

List of Plates

[7]

Introduction

THE WORK OF ANDREAS VESALIUS OF BRUSSELS constitutes one of the greatest treasures of Western civilization and culture. His masterpiece, the *De Humani Corporis Fabrica* and its companion volume the *Epitome*, issued at Basel in 1543, established with startling suddenness the beginning of modern observational science and research. Their author has come to be ranked with Hippocrates, Galen, Harvey and Lister among the great physicians and discoverers in the history of medicine. However, his book is not only one of the most remarkable known to science, it is one of the most noble and magnificent volumes in the history of printing. In it, illustration, text and typography blend to achieve an unsurpassed work of creative art; the embodiment of the spirit of the Renaissance directed toward the future with new meaning.

The purpose of the present work is to make available to the general reader, the student of art, of science and of medicine, the illustrations from the works of Andreas Vesalius through the medium of which they may gain some insight into this achievement of science and art. In the dynamic and dramatic postures of the figures which emanated from the workshop of the master painter Titian, one may trace with something of the original freshness and enthusiasm man's discovery of his own bodily structure. In them, the student of the graphic arts will perceive the movement which freed art from conventional forms to re-approach nature, whence it could once more depart to explore other fields. Here, too, he will find the sixteenth-century woodcut at its finest, and here he will feel the power of the illustration employed for the advancement of knowledge.

To facilitate this purpose each of the illustrations has been briefly annotated. First there appears in italics Vesalius' own legend to the drawing followed by an explanatory note which in many instances, owing to the nature of the material, is perforce somewhat technical and therefore will be of greater interest to the physician or biologist than to the general reader or to the artist. However, it is hoped that despite the necessity of such information, the general reader will find enough in these notes to give him some understanding of the meaning of the drawing. Vesalius provided each of the illustrations with an elaborate index to the letters denoting the various structures exposed. Since the terminology employed is so archaic as to require, except for the expert in sixteenth-century medicine, interpretation of almost every term, which would greatly increase the bulk of this volume, it was thought wiser to omit the translation of the indices. However, this should present no difficulty to anyone with a knowledge of human anatomy since he will be able to identify easily the many structures, and attention has been drawn to those which might prove confusing. At this juncture the reader should perhaps be warned of the danger of judging Vesalius' knowledge or lack of knowledge by the illustrations alone. This has been

responsible for innumerable erroneous conclusions in the Vesalian literature. While the drawings were being prepared, Vesalius himself was undergoing a rapid evolution and making new discoveries from day to day which required him to correct in the text earlier but erroneous opinions portrayed in the illustrations.

The illustrations reproduced in this volume are derived from the magnificent edition of the plates entitled the *Icones Anatomicae* of Andreas Vesalius and, for the most part, struck directly from the original wood blocks and published jointly by the New York Academy of Medicine and the Library of the University of Munich in 1934 under the editorship of Doctors Wiegand, Lambert and Archibald Malloch. The story of the re-discovery of the wood blocks of the *Fabrica* and *Epitome* is as extraordinary as any in the long history of bookmaking. Engraved in Venice, their peregrinations began with the long journey across the Alps to Basel, as recounted in Vesalius' letter to the printer Oporinus. Thereafter, they were used once again in the preparation of the second edition of 1555, slightly modified by cutting away the wood around some of the guide letters where they tended to be obscured by the shadows. It would seem that after Oporinus' death they passed into the hands of Jerome Froben's son and remained with this family until the third generation went out of the printing business in 1603. It is presumed that the blocks passed to Ludwig König, successor to the Frobens, and eventually they were purchased by Andreas Maschenbauer, a printer of Augsburg, who published, as the work of Titian, a selection of the plates for the use of artists and sculptors in 1706 and again in 1723. Once more they disappeared to be re-discovered, this time by the physician von Woltter. He, after having sent them in 1777 to the publisher Crusius of Leipzig, who decided that the expense of a new edition would be too great for him to undertake, entrusted them to the Bavarian anatomist and surgeon H. P. Leveling of Ingolstadt, who printed editions of the plates, financed by subscription, at Ingolstadt in 1781 and again in 1783. The blocks, now two hundred and fifty years old, were stored in Ingolstadt until that city was captured by the French in 1800 when they were evacuated to Landshut in Bavaria, to rest there for twenty-six years before continuing their journeyings. From Landshut they passed to the Library of the University of Munich where they gathered dust in a disused cupboard until they were recognized in the course of an inventory in 1893. In the meantime, the wood block of the re-engraved title page of the 1555 edition passed by some devious route into the hands of a collector in Antwerp and was subsequently presented to the Library of Louvain. Once more, in 1932, the wood blocks were unexpectedly found, stored in the Munich Library. Of the estimated 277 original blocks only fifty were missing, among which unfortunately was the portrait, and these, together with the plates of the *Tabulae Sex* and the single diagram from the *Venesection Letter*, were reproduced in facsimile to complete the *Icones Anatomicae* of the New York Academy of Medicine. But to this long odyssey a colophon must be written. The precious wood blocks were destroyed in the bombing of Munich during World War II.

The great achievement of Vesalius has led to strenuous efforts by historians to uncover and understand the forces responsible for the sudden emergence of the modern observational method of science in the midst of the renaissance cult of antiquity. For this reason every aspect of his life and personality has been examined with the utmost care. Despite all these efforts, many important questions go unanswered. Much of his life is an enigma, and the enigma extends to his works, notably to the illustrations. Around few other figures in the history of science has such an immense literature gathered. In order to orient the reader in the Vesalian problem a brief examination of his life and work must be made which has been based as far as possible on primary sources, but, since it is beyond the intention of this volume, the documentation has been omitted.

ANDREAS VESALIUS OF BRUSSELS (1514-64)
BIRTH AND FAMILY ORIGINS

Andreas Vesalius, like so many who have

achieved renown in the field of medicine, owed much to his heritage. The earliest existing records of the family show a long devotion to the cult of Aesculapius. Peter, his great-great-grandfather, was a physician of reputation who gathered a large and costly collection of medical treatises and wrote a commentary on the fourth *Fen* of Avicenna. Several of these valuable manuscripts descended to the young Vesalius and were the great joy of his student days. John, Peter's son, enrolled in the University of Louvain in 1429, that is, soon after the opening of that renowned institution, and eventually taught there until about the year 1446. He, too, was a physician who concentrated on "mathematics," i.e., astrology, and would seem to have been well in advance of his times since he addressed a letter to the pope, Eugenius IV (1431-1437), advocating reforms in the calendar which were not to be achieved until late in the following century. Later John was chosen physician to the city of Brussels, and evidence suggests that he was appointed adviser to the Duke of Burgundy. Everard, John's son and grandfather to our Vesalius, maintained this connection, being physician to Mary of Burgundy and, on her marriage to the Archduke and later Emperor Maximilian I, began a long tradition of Vesalian service to the Hapsburgs. Everard was the author of a commentary on the *Ad Almansorem* of Rhazes, which inspired young Andreas Vesalius' graduation thesis, and wrote, in addition, on the first four sections of the *Aphorisms* of Hippocrates. He was rewarded with the rank of *chevalier* but died comparatively young, around his forty-sixth year, sometime prior to 1485. Finally we come to Andreas, father of the great anatomist, who was the natural son of Everard and Marguerite Swinters. Long after his birth he received as a reward for faithful services papers of legitimacy dated October 1531. He had entered the service first of Margaret of Austria as an apothecary and then of her nephew the Emperor Charles V. It was to this Andreas Vesalius and his wife, Isabella Crabbe, that the celebrated anatomist, distinguished as Andreas Vesalius of Brussels, was born. According to a horoscope cast by Jerome Cardan, the Milanese physician, mathematician and epis-

tolary friend of Vesalius, the birth occurred at a quarter to six on the morning of 31 December 1514, reckoned according to the Julian Calendar. The place was Brussels, the chief city of Brabant, where his father owned a house on the Rue de Manège — then the Rue d'Enfer, although the family had not always lived in Brussels. The name Wesel, or variations of that form, was of pure Brabantine origin and designates several localities, notably around Campine; but early records indicate that the family had been long domiciled at Nimwegen in the Duchy of Cleves where, as the result of marriage alliance, the family was also known as Witings or Wytincx. Certainly Vesalius himself regarded Nimwegen as his ancestral home.

EARLY EDUCATION

Vesalius passed his earliest years in the city of his birth, in the home which was to be rebuilt in 1525 at the same time as that of his neighbor and relative John Martin, also an apothecary. Of this period of his life very little is known except that he was encouraged to pursue the family tradition by his mother, to whom he was devoted, and greatly stimulated by his father on those occasions of family reunion when the latter's presence was not required at court or on the ceaseless imperial journeys or campaigns. With such a heritage the family library was extensive, and Vesalius early acquired the habit of reading. Falloppius tells us that Vesalius was always to be found in the library studying the ancient authors. How powerful was this tradition is seen in the case of his younger brother Franciscus who, although destined for the study of law, turned to medicine in his pride for the achievements of his elder brother.

LOUVAIN 1528-1533

In 1528 after a preliminary education, unknown as to time or place, Andreas Vesalius entered the University of Louvain, pursuing his studies in the *Pedagogium Castre* where he received a thorough grounding in Latin, with possibly a smattering of Greek, and continued his acquaintance with the medieval writers on science which he had begun at home. He had already

displayed an interest in anatomy and in later writings refers to dissections which he had performed at this time on small animals of all sorts, including "our weasels," a conceit pointing to the origin of his name and the animals adopted as the family arms in the form of three weasels *courant*.

Three years later in 1531, when Vesalius was about seventeen, he transferred to the more progressive *Collegium Trilingue* at Louvain, founded in 1517 under the influence of the new humanism by Jerome Busleiden (1470-1517). In accordance with humanistic conceptions, the purpose of this school was to ground young men in what were considered the three all-important keys to education and learning, Latin, Greek and Hebrew. With such keys the doors to universal knowledge would be opened, and learning would be reborn by the restoration of the dead past to new life. That Vesalius did not become a scholar in the sixteenth-century understanding of the term was due to his medical ambitions and a bent of mind early directed along the pathway of science. Latin he learned thoroughly in the best Ciceronian tradition, but his Greek was of a very lame variety, the result of his restlessness and desire to get on with his medical education. Of Hebrew he knew practically nothing. Yet the spirit of the school was permanently imbedded in Vesalius. All his writings indicate an intense interest in philology, Latin, Greek, Hebrew and Arabic. Some years later, apparently recognizing his linguistic deficiencies, he undertook the study of Arabic with a Jewish tutor, Lazarus of Frigae, although his accomplishment appears to have been slight. The same influence is evident in his attitude towards his own accomplishments in the field of anatomy. He looked upon himself as a restorer so that "anatomy will soon be cultivated in our Academies as it was of old in Alexandria" and so was kin to Rabelais, Michelangelo, Vives, and the host in art, literature and science to whom the Renaissance was indeed a renaissance.

Although we know so little of Vesalius' education at this period, we do know through his own words that two of his fellow students were Gisbertus Carbo and Anthony Perrenot, later Bishop Granvelle and imperial chancellor. To the former,

who became a physician in Louvain, he presented the first articulated skeleton which he had obtained under great difficulties by robbing the gibbet, and to the latter he owed a certain degree of favor at the imperial court.

PARIS 1533-1536

It was probably in 1533 that Vesalius, now ready for a formal medical education, set out for Paris equipped with suggestions and possibly introductions from Nicolaus Florenas, an imperial physician and friend of his father, who had taken a great personal interest in the young man. Vesalius, in his dedication to the *Venesection Letter* of 1539, was to describe Florenas as almost a father to him, which would seem to have been more than fulsome sixteenth-century rhetoric since his own father was frequently absent in attendance upon Charles V, and Florenas may have acted as director of his studies and spiritual mentor. It is even possible that it was on advice of Florenas that Vesalius decided to go to Paris.

Although the University of Paris possessed a great name and great influence in northern Europe, it was nevertheless an extremely conservative institution. This conservatism extended to the medical school and placed the study of medicine at a considerable disadvantage in relation to the great progress which was being made, notably in the universities of Italy. In 1477 the medical school of Paris had obtained its own building in the Rue de la Boucherie, but no provision had been made for the teaching of anatomy by means of dissection, and although from 1493 onward occasional anatomies were conducted in the basement of the hospital Hôtel Dieu, these were carried out in the medieval manner amounting to little more than ceremonies. However, in 1526 the Medical Faculty made a successful appeal to the Paris Parlement for a greater supply of dissection material which resulted in more frequent anatomical demonstrations. However, even then they were comparatively infrequent. It is to be doubted that Vesalius witnessed more than three or four during his stay in Paris.

Nevertheless, a candidate for the bachelor's degree was formally required to display a knowl-

edge of anatomy which he gained largely from textbooks and the study of disarticulated bones when he could obtain them. Prior to 1514 the texts were for the most part derived from the medieval Arabic tradition, that is, from the writings of Moslem physicians and their commentators or from translations of the works of classical authors necessarily corrupted by passage from Greek into Syriac, Syriac into Arabic and thence into obscure Latin. In that year a collection of Galen's works, translated directly from the Greek into Latin by Nicolò Leoniceno (1428-1524), was published in Paris and seized upon with enthusiasm. The new medical humanism had arrived in Paris, and thereafter the publication of such translations occurred in rapid succession. Physicians, seeing for the first time the works of Galen and Hippocrates stripped of their dross, believed that now they had captured the essence and spirit of the great classical authors and were at last about to enter a new Golden Age. As yet medicine had not developed a philosophy of progress but tended to look upon the present as inferior in knowledge and achievement to the past with the resultant enslavement to the literal word, and in particular to that of Galen. This is especially evident in the membership of the Medical Faculty at Paris among whom was Johann Guinther of Andernach (1487-1574), one of Vesalius' more important teachers. Guinther, who had previously taught Greek at Louvain, came to Paris in 1527 and established a considerable reputation for himself as an anatomist by translating Galen's work on anatomical procedure entitled *De Anatomicis Administrationibus* which was issued in 1531. Although nominally termed a professor of anatomy, his major qualifications were linguistic, and there is no evidence that he actually dissected. Indeed, his pupil Vesalius was to write somewhat cruelly of him later: "I would not mind having as many cuts inflicted on me as I have seen him make either on man or other brute (except at the banqueting table)." While other teachers of Vesalius at Paris were the philosophic Jean Fernel (1497-1558), Jean Vasse of Meaux (1486-1550), dean of the faculty, and one Oliverius of whom nothing is known, the most important was Jacques du Bois of Amiens, Latinized as Jacobus Sylvius (1478-1555).

Like Guinther of Andernach, Jacobus Sylvius had in earlier life devoted himself to humanistic and literary studies but did not enter medicine until late, receiving the doctorate at the age of fifty-two. He owed supreme allegiance to Galen which led him on occasion to remark that any structure found in contemporary man which differed from the Galenical description could only be due to a later decadence and degeneration in mankind. Nonetheless, his contributions were of great importance and influence. He clarified and systematized existing anatomical knowledge, and to him we are largely indebted for the foundations of a rational terminology, much of which, especially in regard to the muscles, is in employment today.

Vesalius, like any other young student of the times, naturally accepted the Galenical anatomy. He could hardly do otherwise since there was no other. Although much has been made of the Vesalian anti-Galenism, this has been grossly exaggerated and is a complete misunderstanding of Vesalius and his times. "As the gods love me," writes Vesalius, "I, who yield to none in my devotion and reverence for Galen, neither can nor should enjoy any greater pleasure than praising him." He was never to oppose himself completely to the Galenical system but rather attempted to reconcile or correct the anatomical descriptions of Galen whenever they were found not to agree with observation. "I hear that many are hostile to me because I have held in contempt the authority of Galen, the prince of physicians and preceptor of all; because I have not indiscriminately accepted all his opinions; and, in short, because I have demonstrated that some fault is actually discernible in his books. Surely, scant justice to me and to our studies, and, indeed, to our generation!" The greatness of Vesalius lies in his refusal to accept slavishly the teachings of the Greco-Roman physician and authority but rather to seek corroboration and to note discrepancies by the observational method.

While in later years Vesalius was to write

slightingly of his schooling in Paris and the instruction he received there, and bitterness was to arise between him and his master Sylvius, there is no doubt that he profited greatly. However, what he wanted most, dissection and instruction at the dissecting table, was denied him. Nevertheless, by his own initiative he acquired a considerable knowledge of anatomy, probably by dissection of animals, so much so that at the second anatomy which he attended in 1535 he was requested by his teacher and fellow students to assist in the demonstration; and, so he writes, for he was not one to hide his light under a bushel, he displayed a skill which far surpassed that of the customary dissector. In the following year he conducted the third anatomy of his Paris period almost single-handed.

The very fact that there were no teachers of practical anatomy to satisfy the demands of the ambitious and impatient young student led him to seek out information at first hand and thus possibly to benefit more by his own initiative. In order to acquire osteological specimens he became a constant frequenter of Montfaucon and the Cemetery of the Innocents. The first was a mound not far without the northern wall of old Paris where a gibbet had been erected as early as the twelfth century. One of its earliest victims, ironically enough, had been a barber-surgeon, Pierre de Brosse, chamberlain and confidant of Louis IX. In Vesalius' day, it was occupied by the finest gallows in the kingdom. This was no ordinary affair but a huge charnel house crowned by a colonnade of sixteen stone pillars thirty feet high, connected by wooden beams. To this forbidding site were brought the bodies of all malefactors executed at the numerous centers within the city to be suspended from the beams until dissolution warranted disposal of the remains in the charnel house below. This place was haunted by crows and pariah dogs but provided exceptional riches for the avid anatomist. On his way to Montfaucon, Vesalius would pass the Cemetery of the Innocents. In this ancient cemetery were buried victims of the plague. Reconstruction of the city wall in 1186 had required disinterment of many of the cemetery's occupants,

and the bones had been removed to a series of charnel houses specially constructed for the purpose. A marble figure which once decorated the wall may be seen to this day in the Louvre. Here Vesalius and his fellow students found "an abundant supply when I first studied the bones . . . and having learned by long and tiring observation, we, even blindfolded, dared at times to wager with our companions, and in the space of half-an-hour no bone could be offered us . . . which we could not identify by touch. This had to be done the more zealously by us who desired to learn inasmuch as there was a great lack of the assistance of teachers in this part of medicine."

LOUVAIN 1536-1537

After some three years in Paris, Vesalius left the medical school without graduating and returned to Louvain. The cause of his departure was the outbreak of war and the invasion of Provence by Charles V, and Vesalius, an imperial subject, needs must return to the Low Countries. Immediately he began once more to pursue his favorite discipline, and in the company of Regnier Gemma (1508-1555), later celebrated as a mathematician, astronomer and physician,

"While out walking, looking for bones in the place where on the country highways eventually, to the great convenience of students, all those who have been executed are customarily placed, I happened upon a dried cadaver. . . . The bones were entirely bare, held together by the ligaments alone, and only the origin and insertion of the muscles were preserved. . . . With the help of Gemma, I climbed the stake and pulled off the femur from the hip bone. While tugging at the specimen, the scapulae together with the arms and hands also followed, although the fingers of one hand, both patellae and one foot were missing. After I had brought the legs and arms home in secret and successive trips (leaving the head behind with the entire trunk of the body), I allowed myself to be shut out of the city in the evening in order to obtain the thorax which was firmly held by a chain. I was burning with so great a desire . . . that I was not afraid to snatch in the middle of the night what I so longed for. . . . The next day I transported the bones home piecemeal through another gate of the city . . . and constructed that skeleton which is preserved at Louvain in the home of my very dear old friend Gisbertus Carbo."

It was under such difficulties that Vesalius obtained his first articulated skeleton. For reasons of discretion he announced that he had obtained the specimen in Paris, although, as it turned out, the local government was not particularly hostile to his anatomical pursuits since "later the Burgomaster so favored the studies of the candidates of medicine that he was pleased to grant whatever body was sought from him, and he himself . . . was in regular attendance when I was administering an anatomy there."

THE "PARAPHRASE" 1537

Apparently some reputation had preceded Vesalius to Louvain, or he was more energetic and zealous in his approach to the magistrates, for with the opening of 1537 he was granted permission to conduct an anatomy before his eager fellow students, the first demonstration of human dissection which had been seen in that city for eighteen years. With unusual modesty he confessed that at this time he was relatively unskilled in the art of dissection since he had overlooked the true origin of the haemorrhoidal vessels. The year so spent at Louvain might be termed the continuation of his medical training which had been undertaken at Paris. In February 1537 his baccalaureate thesis, *Paraphrase on the Ninth Book of Rhazes*, was published at Louvain. We assume that his degree was granted by the University of Louvain, but no record of his graduation at that institution has been uncovered.

While the return of Vesalius to Louvain was generally marked by amicable relations, there was, however, one jarring note which in its results was to be of great importance to his career. As early as 1514 a dispute had arisen in Paris over the question as to what vein should be incised in bloodletting. In view of the universal employment of venesection as a therapeutic procedure the controversy became bitter and widespread. Indeed, in the whole history of medicine there is no more extensive and polemical a literature than that which revolved around this question. Stated in the simplest terms, the issue was whether one should incise a vein on the affected side of the body or on the opposite. This in turn

represented respectively the Hippocratic and the Arabic views. It is not to be wondered at that Vesalius, a budding humanist, accepted the Greek view which led him into a fiery and intemperate dispute with Jeremiah Drivère. The latter, who Latinized his name as Thriverius Brachelius (1504-1554), had taken his degree in philosophy at Louvain and had then turned to medicine. He was regarded as a very capable teacher of great erudition, possessed an influential following among the physicians of Louvain and occupied a position which had been created by the amalgamation of two of the four public chairs of medicine. In 1532 and in 1535 Drivère had written two works on bloodletting in which he supported the ridiculous Arabic practice. Vesalius, in loyalty to his teachers in Paris who had been ridiculed, sharply attacked Drivère's conclusions at a public assembly. This action, although excusable on the grounds of youth, was nonetheless exceedingly bad judgment since Drivère was himself a most intemperate man who "used to proclaim unashamedly that he had to employ words from the common dung-heap to suit such barbarians lest we, not yet Candidates, be infected by this sort of pestiferous decay." As a result, Louvain could have held no future for the aspiring young anatomist despite his promising start there; the dispute led, furthermore, to the introduction of certain caustic remarks inserted in the first plate (plate 87) of his *Tabulae Sex* which were finally developed into the *Venesection Letter* of 1539.

PADUA 1537-1542

With his baccalaureate completed, Vesalius now appears to have traveled to Basel where he had his thesis reprinted by Robert Winter, a Basel printer who became an intimate friend of Vesalius. His stay in the Swiss city was brief, and almost immediately he set out for Italy where he rightly believed there were greater opportunities for the study of anatomy and medicine, as well as the possibility of obtaining the doctorate of medicine. The great attraction was the University of Padua which at this period reigned supreme, not only in the arts, literature and philosophy but as the center of the scientific

renaissance. The university, almost from its foundation in 1222, had begun to play a role of constantly increasing importance in the intellectual life of Europe. The deep influence of Pietro d'Abano (1250-1316), which affected even Dante, was continued by Gentile da Foligno (d. 1348), Giorgio Valla (fl. 1450), Ermolao Barbaro (d. 1493) and Alessandro Benedetti (1460-1525) down to the opening of the sixteenth century to prepare the way for the rise of medical humanism, and the development of a progressive and critical spirit was to establish the medical school as the greatest glory of Padua.

Since Padua was under the rule of Venice, it was only natural that Vesalius should make frequent visits to the famous capital city which was only some twenty miles away. It was there that he first began to visit the sick under the tutelage of J. B. Montanus (della Monte, c. 1489-1551), Professor of Medicine at Padua, who re-introduced a type of clinical instruction which had been almost non-existent since the time of Hippocrates. It is not unlikely that Vesalius while on one of these visits first made the acquaintance of his fellow countryman, the artist Jan Stefan van Kalkar, who was later to be associated with some of the Vesalian publications. Kalkar was himself a new arrival in Venice where he had entered the school of Titian.

On 5 December 1537 the faculty of the University of Padua, after examining Vesalius, granted him at a solemn convocation the degree of Doctor of Medicine *cum ultima diminutione*, which represented "with highest distinction," and thus Vesalius was required to pay a fee of only seventeen and a half ducats, diminished in accordance with the excellence of the examination. On the following day after performing a dissection, he was nominated by the "Illustrious Senate of Venice" as Professor of Surgery, an appointment which at that time bore the responsibility of teaching anatomy as well. To what influences he owed such early recognition we do not know. Certainly despite his youth, for he was but twenty-three years of age, he seems to have made a profound impression on the members of the Senate and his professors. The recommenda-

tion of powerful friends in the Imperial court may also have been of assistance.

THE "TABULAE SEX" 1538

With characteristic energy the young and ambitious Professor of Surgery began his academic duties encouraged by his friend Marcantonio of Genoa, Professor of Philosophy, and with a success which exceeded all expectations. The sight of a professor descending from his academic chair to dissect and demonstrate personally on the cadaver was something entirely novel. Students, physicians and men of learning crowded his classes. Many came to dispute the statements of this brash young man only to be convinced by ocular demonstration. To clarify his discussions he introduced large charts. "Not long ago . . . I delineated the veins on a chart. . . . The delineation . . . pleased the professors . . . and all the students so much that they earnestly sought from me a like drawing of the arteries and also of the nerves. . . . I knew delineations of this sort would be not a little useful for those who might attend my dissections" wrote Vesalius in the introduction to his *Tabulae Sex* published in April 1538. It may be difficult today to understand the novelty of this venture. Few anatomical works up to this time had been illustrated, and of those that were, the illustrations were little more than symbols or decorations. Indeed, many of the leading physicians of the day were actively opposed to the illustration of the printed word on the grounds that this had not been done in classical times and would degrade scholarship. Technical incapacity and the lack of development in standards of reproduction gave support to such opposition, but it was now to become apparent that if not the professors, at least the students quickly became aware of the value and power of graphic anatomical demonstration. The printers were not behindhand and sought to copy both the procedure and the plates to supply a new and lucrative market.

To protect his interests and to prevent the students from employing inferior charts, Vesalius was led to publish his drawings. "Since many in vain have sought to copy what I have done, I have sent these drawings to the press." To his

own three sketches of the vascular system he added "three views of my skeleton which, to the gratification of the students, I caused to be set up and drawn from the three standard aspects by a distinguished artist of our day Jan Stefan [van Kalkar]." The six plates, issued in 1538 without title but now known as the *Tabulae Anatomicae Sex*, constitute his first anatomical publication. They were an instantaneous success to judge from the immediate plagiarisms which appeared almost simultaneously from Marburg, Augsburg, Cologne, Frankfurt and Paris, and by the fact that only two complete sets of the Vesalian plates have survived, the rest having been literally thumbed out of existence. Indeed, the woodcuts set a new standard in biological illustration as well as in the graphic arts. The project, as evidenced by the two variants of the original edition, would seem to have been a joint venture in which the artist received in place of a fee the rights of general publication other than copies employed by Vesalius in his classes.

THE "INSTITUTIONES" 1538

The year 1538 saw a third publication by Vesalius and one which drew together all the threads of his student and earlier academic life. This was an edition of a compendium or synopsis of the anatomico-physiological views of Galen, originally composed by Vesalius' Paris teacher, Johann Guinther of Andernach, and first published at Basel in 1536 under the title *Institutionum Anatomicarum secundum Galeni Sententiam ad Candidatos Medicinae Libri Quatuor*. Vesalius was still studying under Guinther when the first edition of the *Institutiones* was published, and in it the pupil is cited as "Andreas Wesalius . . . a young man of great promise who possesses an extraordinary knowledge of medicine, learned in both [classical] tongues and skilled in dissection." Justification for a new edition of the work is hard to find except that we regard this small manual, highly popular with students, as a makeshift companion to the recently published *Tabulae Sex*. Vesalius himself explained somewhat lamely in the preface that the new edition was necessitated by the numerous typographical errors which had

rendered the work not entirely satisfactory for students. There would seem to have been other reasons. It is possible that in the manner of young academicians he was desirous of publication for its own sake and anxious to impart to his former teachers his present activity and generally to inform his friends in Louvain of his success abroad. Finally, Vesalius in thoroughly realistic fashion was always careful to dedicate his works to persons who might be of importance to him in his career. He seems never to have thought of immediate material rewards but rather of the influence which the person might exert on his behalf in the future. Thus in the preface to his edition of the *Institutiones* the dedication is to Joannes Armenterianus who was not only Professor of Medicine but also Rector of the University of Louvain. The preface is of the type usual in the sixteenth century, offering the recipient nauseatingly fulsome flattery, but it then goes on to recount Vesalius' academic achievements almost in the manner of an application for a position. Perhaps the young anatomist was momentarily unsure of his tenure in Padua, or possibly homesick, and preparing the ground for a return to Louvain. If so, he seems to have recovered his spirits or to have been given assurances of the esteem in which the Paduan authorities held him, since the possibility of his returning to his *alma mater* is never again apparent.

THE "VENESECTION LETTER" 1539

Unlike the *Institutiones* there was ample justification for the publication in the following year, 1539, of Vesalius' next work, the *Venesection Letter*. From remote antiquity venesection had been established as a standard therapeutic procedure and acquired in classical times, at the hands of Hippocrates and his interpreter Galen, new and more precise indications for its performance in conformity with humoral doctrines of disease. Thereafter, in medieval times and under the influence of Arabic medicine the Hippocratic practice had become corrupted, but with the recovery of classical learning at the beginning of the sixteenth century it was becoming apparent how far traditional methods had deviated from

the precepts of the Father of medicine. The first to enunciate and support what was termed the true Hippocratic and Galenical technique of bloodletting was Pierre Brissot, a Paris physician, who based the correctness of his view upon the successful treatment of patients during an epidemic of "pleurisy" in 1514. He condemned the Arabic procedure of bleeding a patient from a point on the body as far away from the region of the ailment as possible and removing no more than a mere token of a few drops of blood. He contended that the true classical method required the removal of a sensible quantity of blood, and since "pleurisy" existed in a region drained by the vena cava, it did not matter whether the blood was evacuated from the right or the left side. Moreover, said Brissot, one might open a vein of the arm on the affected side and still preserve sufficient remoteness in the Hippocratic sense.

Brissot was bitterly attacked by the conservative element, and eventually two camps were formed and engaged in a violent polemic over the question which reached such proportions that in 1537-1538 the government of Spain was dragged into the controversy. The appearance of the *Venesection Letter* finds Vesalius foursquare with the champions of the purified classics, an adherent of the Hippocratic-Brissot school. Superficially the work might be judged as being no more than one more polemic on the subject to announce his stand and at the same time to attack the Arabist Jeremiah Drivère, his teacher at Louvain for whom he had acquired an intense dislike. But the Vesalian contribution was far more than this. Up to 1539 every participant in the dispute had based his arguments on either the pronouncements of ancient authorities or on empirical observations upon the outcome of illness in relationship to the procedure employed. Vesalius, on the contrary, introduced into the hitherto barren controversy an entirely new element, the findings of direct observation. Accepting the basic theory, and he could hardly do otherwise without knowledge of the circulation, he drew his conclusions from the results of his dissections and observations on the venous system, and since the disease

in question affected the pleural cavity, he took pains to describe the arrangement of the azygos system of veins (plate 86). The effect was startling. Thereafter every future participant in the controversy was compelled to appeal to the body which, in turn, led to the discovery of the venous valves and thereupon provided William Harvey with the key to unlock the secret of the circulation. Furthermore, Vesalius in devoting so much attention to the venous system was unwittingly exposing one of the weakest aspects of the Galenical anatomy. Thus, it is in this small work that we first perceive the slow and gradual loosening of traditional and authoritative bonds whence eventually emerged the principle that the validity of a hypothesis rests solely upon the facts established by observation. Here Vesalius asks a first tentative question "whether the method of an anatomy could corroborate speculation." The *Venesection Letter* of 1539 is therefore a very important document which enables us to trace the transition to the observational method which made his great masterpiece, the *Fabrica*, the first positive achievement of modern science.

THE "OPERA GALENI" 1541

Sometime in 1539 the famous Venetian publishing firm of Giunta conceived the plan of a complete edition of the works of Galen. For such an edition translations hitherto made would need revision in the light of new discoveries, both philological and medical, and a few recently discovered manuscripts would require incorporation. The general editor chosen for this stupendous undertaking was the celebrated Joannes Baptista Montanus who was to be assisted by Augustinus Gadaldinus, a first-class classicist as well as a physician. The edition would entail the collaboration of many scholar-physicians, and among those invited to participate was Vesalius who was asked to contribute three revised texts, the *Dissection of the Nerves*, the *Dissection of the Veins and Arteries* and the very important *Anatomical Administrations*. In the case of the last mentioned work he would be required to revise the translation of Guinther of Andernach and thus for a second time to pass judgment on the work of his

former Paris teacher. It was naturally a great honor for the young anatomist to be asked to participate in the undertaking along with men who had already achieved fame, but there were a number of good reasons for his inclusion. Montanus, the editor, was his teacher, colleague and friend, and fully appreciated the abilities of the young man. Vesalius himself was an indefatigable student of the works of Galen. He had already been responsible for the revision of Guinther's commentary and, as we shall see, had compiled a large book of annotations on the writings of the Greco-Roman physician. Moreover, Padua was Venetian territory, close to Venice and the Giunta press, and so Vesalius was conveniently situated for the forwarding of copy and any consultations which might be required. Moreover, it should not be overlooked that Vesalius in his own right was on the threshold of a great reputation. His name had become widely known through the popularity of the *Tabulae Sex*, and even his plagiarists had mentioned him with the highest commendation.

Many have been amazed that Vesalius should have accepted the invitation to participate in the Giunta edition of Galen since he was already engaged at this time in writing the *Fabrica*, which in sheer bulk would require all his powers. Furthermore, there has been incredulity at the seeming paradox of an avowed anti-Galenist undertaking the task. In the first case, it should be recognized that his editorial duties were to be of the lightest, merely revision of existing translations. Two of the books are brief tracts occupying scarcely a half dozen folio-sized leaves, and his emendations are very superficial. We doubt that the task occupied more than a few days. In the second case, the paradox is more apparent than real and arises from the gross exaggeration of his anti-Galenism through failure to understand the curious conflict between progressiveness and the cult of antiquity which existed during the Renaissance.

The great task of editing and printing the *Opera Galeni* was eventually completed, and the work was issued from Venice in seven massive folio volumes during the years 1541-1542, but only after the working editor, Augustinus Gadaldinus, had been brought to the verge of mental collapse by the pressure and magnitude of the undertaking. Almost simultaneously the great printing house of Froben in Basel began to reprint the Giuntine edition. It would appear that some sort of agreement must have existed between the two publishing houses, for the Froben edition was ready in 1542. The fact that both these famous publishers were fully occupied may have had considerable bearing on Vesalius' choice of a printer for his masterpiece.

THE "FABRICA" AND "EPITOME" 1543

The publication of the *De Humani Corporis Fabrica* of Andreas Vesalius in 1543 marks the beginning of modern science. It is without doubt the greatest single contribution to the medical sciences, but it is a great deal more, an exquisite piece of creative art with its perfect blend of format, typography and illustration. The first hint that Vesalius had in mind a major work is possibly the statement appearing at the end of his introduction to the *Tabulae Sex* of 1538. "If I shall find this work acceptable to you and to students, some day I hope to add something greater." This statement becomes more than suggestive when in the *Venesection Letter* of the following year he tells us of his activities. "We have now also finished the two plates on the nerves; in the first, the seven pairs of cranial nerves have been drawn, and in the other, all the small branches of the dorsal medulla expressed. I consider that these must be kept until we undertake the plates on the muscles and all the internal parts." Thereafter, writing of the difficulty of obtaining bodies for dissection and remarking on the encouragement which he had received from his colleague, the Paduan philosopher Marcantonio of Genoa, presumably to continue with his plan for the large anatomical work, Vesalius adds, "wherefore, if the opportunity of bodies offers, and Jan Stefan [van Kalkar], outstanding artist of our age, does not refuse his services, I shall by no means evade that labor."

These remarks are interpreted as indicating Vesalius' initial efforts on the *Fabrica*, and, since

the *Venesection Letter* is dated by its author 1 January 1539, we may justly assume that its composition was under way sometime in 1538. We may be certain that the *Fabrica* and its companion volume, the *Epitome*, were the accomplishment of at least four years. The remarks on the drawing of two illustrations for the plates on the nerves leave us in doubt as to their authorship. They are in type very similar to Vesalius' own sketches of the vascular tree found in the *Tabulae Sex*, but they may have been the work of Kalkar. For the moment the ambiguous statement concerning the artist must be left for later consideration. We pause but to point out that this is the only other occasion on which the name of the artist is mentioned, the first being in the introduction to the *Tabulae Sex*.

We do not know how long Vesalius had in mind the composition of a major textbook of anatomy. The idea may have existed from the beginning of his career; the ambition of every scholar to produce a great work in his field of study. On the other hand, if the decision was the result of liberation from Galenical authority, then there are some who believe that it could have been no earlier than his last work markedly Galenical in character, the 1538 revision of Guinther's *Institutiones*. However, even at this time he was deeply disturbed by discrepancies in traditional teaching, and he remarked as early as 1539, in discussing these errors of observation, "I have noted them as fearfully as I could both in the plates [*Tabulae Sex*] and in the four books of the *Institutiones Anatomicarum* of Johann Guinther which we re-issued with many emendations." Regardless of time and reason, by the end of 1538 Vesalius already had accumulated a vast store of information from which to draw. During his student days in Paris he had assiduously studied osteology, participated in several dissections and no doubt examined the structure of animals on many occasions. Thereafter, he had again dissected the human form at Louvain, articulated at least two skeletons and performed numerous anatomies in the course of his teaching duties at Padua. We have good reason to believe that Vesalius, who was himself a reasonably

competent draughtsman, made sketches from the beginning of his studies to which he added from time to time.

The method of composing the *Fabrica* appears to have been to complete the books in the order in which they are found in the finished work. The majority of the illustrations for a particular book seem to have been drawn during the time that the text was being written. Evidence exists that many of the illustrations, especially those of the entire vascular tree and the distribution of the nervous system, were developed from preliminary sketches made by Vesalius himself which were modified and added to as details were uncovered by dissection on different occasions. In other words, illustrations of this type are composite pictures. In many instances the basic arrangement would seem to have been established by the dissection of forms other than man, which accounts for the intrusion of animal anatomy into figures otherwise representing the human form. After completion of a book it was sent on to the printer for composition in type. We know that the first two books of the seven, that is, almost half the total work, were completed sometime in 1541, and the remainder passed on to the printer at intervals up to the time of writing the dedicatory preface addressed to Charles V, dated 1 August 1542.

While the composition of the text was in progress, especially of the later books, the accompanying drawings were being cut in wood. For each of the illustrations he prepared a legend, or as he called it an "Index of Characters," working sometimes from the drawings prepared for the engraver and sometimes from the finished engravings as is evident from the fact that he often forgot that the picture would be reversed when printed. From his letter to the printer Johannes Oporinus, dated 24 August 1542, we learn that the last act was the addition to the proof of the elaborate system of cross references between the printed text and the illustrations which made the *Fabrica* unique in the history and development of the printed book as a medium for the communication of a descriptive science. It was by means of this system that text and picture were woven into an integrated whole. The ex-

traordinary importance of such a system, analogous to the "feedback" or "servomechanisms" of the engineer, for the communication of ideas in a descriptive science can best be appreciated when we realize the limitations and ambiguity of language in describing the intricacies of anatomical structure in the absence of the body, especially in an age when scientific nomenclature was still in a state of fluidity. Through many hundreds of cross references Vesalius employed the illustration to eliminate ambiguity and to delimit the verbal statement. This is not the same thing as saying that "a picture is worth a thousand words." In fact, the latter attitude has been responsible for the innumerable errors, misunderstandings and superficial criticisms of Vesalius' works in modern times as facility in the Latin language becomes more rare. To Vesalius picture and text were one.

JOHANNES OPORINUS, THE PRINTER

Let us for a moment consider the printer to whom Vesalius entrusted the publication of this work which had consumed so much of his time, energy and money. Johannes Oporinus (1507-1568), the Latinized form of Herbst, was the son of an impoverished and unsuccessful artist, yet one whose work was sufficiently admired by his colleagues to attract to his studio numerous young artists seeking employment in Basel. It was in this studio that the Holbeins seem to have made their start, and from it many of the illustrations, initial letters and decorative frontispieces for the famous presses of Basel emanated. Oporinus was born in Basel where he received his initial education under his father's guidance since the family was too poor to send him to school. However, the youth showed such promise that he was later admitted to a boarding school for poor scholars at Strasburg, the city of his family origins and where his grandparents had been substantial citizens but had disowned his father. Here he spent four years in the study of the classical tongues under Hieronymus Gebwyler. Upon his return to Basel, owing to the associations of his father, he received his first initiation into printing while copying manuscripts and acting as a corrector for the

great printer Johann Froben. Aside from an unhappy marriage, the next important event in the life of Oporinus was a hectic period of medical study in the household of the eccentric genius Theophrastus Bombastus von Hohenheim, otherwise known as Paracelsus. Unable to endure the erratic conduct of his mentor, whom he regarded as an impious sot, Oporinus left Paracelsus, convinced that his career was not to be in medicine. Thereafter he entered upon a more serene academic life, first as Professor of Latin in the university and later of Greek. Changes in the university regulations with regard to qualifications which he was unwilling to meet compelled him to seek other occupation. As early as 1536 he was devoting a portion of his time to the printing business, having entered into partnership with Thomas Platter, a compositor named Lasius (Balthasar Ruch), and his brother-in-law Robert Winter under whose imprint Vesalius' thesis of 1537 had been re-issued. The firm acquired their equipment by buying out Andreas Cratander for 800 gulden, to be paid within a certain time. The partnership was an unfortunate one which was soon dissolved, as was a later venture of Oporinus and Winter, and in 1539 Oporinus established himself independently as a Basel printer, a position he was able to maintain despite constant financial difficulties into which he was led by his generous nature, until 1566 when he retired to enjoy a life of leisure. He died on 6 July 1568 and was buried in the cathedral of Basel.

There were many good and sufficient reasons why Vesalius should have selected Oporinus of Basel as the printer of his immortal work. Basel had now supplanted Venice as the chief publishing center of Europe. The development of intimate relations between such distinguished printers as Froben, Petri, Episcopius, Cratander, Curio and Bebel with the Holbeins, Urs Graf and other designers had revolutionized the illustrated book. Their editions, embellished by brilliant decorations and initials, had no equal. It was no accident that two of the most beautiful illustrated books in the history of science, the magnificent herbal, *De Historia Stirpium* of Leonhardt Fuchs

and the unrivaled *Fabrica* of Vesalius, should have emanated from this city. Furthermore, the Giunta press of Venice, as well as Froben of Basel, was fully engaged in the publication of the *Opera* of Galen, an immense undertaking. But as a printer Oporinus had special appeal for Vesalius. He had some, although slight, acquaintance with medicine. He was a trained classicist, not only in Greek and Latin, but also in Hebrew, and all three tongues are employed in the *Fabrica*. He was a meticulous printer, as one may judge today from the beauty of the printed page of the *Fabrica* and from the almost complete absence of typographical errors, apart from pagination. He was not only an artist but an innovator. He avoided the heavy roman type usual among the Basel printers and adopted a more delicate font, reminiscent of Plantin or rather of the great French school. It was Oporinus who had the temerity to print the first Latin edition of the *Koran*, a venture which landed him in jail, and no less than the efforts of Martin Luther were required to gain his release. Finally, Vesalius was beholden to the Basel printers, for Oporinus' former partner, Robert Winter, had published the second edition of his *Paraphrase* on Rhazes and the *Venesection Letter* of 1539, and they grew to be intimate friends. No doubt there was a certain spiritual kinship between Vesalius and Oporinus. The former knew that Oporinus would spare no pains on the production of his masterpiece even though it might lead to serious financial loss, and in view of the epochal text, the significance of which he may have understood slightly, and the illustrations which he fully appreciated, the artist in Oporinus could not refuse. And so the composition of the printed text began, presumably in 1540 or 1541, and the book was completed according to the colophon in June of 1543.

At the same time Oporinus undertook the printing of the *Epitome* of the larger work which was dedicated to Philip, son of Charles V and later king of Spain, on 13 August 1542. Like the *Fabrica*, it carries the publication date June 1543, for, in the words of the author, it was conceived of as a companion piece to be used as a pathway beside the highway of the major work. The title

is somewhat misleading, for in reality the *Epitome* is the descendant on a more magnificent scale of the earlier *Tabulae Sex*. It was composed as a ready guide for students, largely pictorial with the bare minimum of textual description and direction, and is in no sense an epitome. Vesalius believed that the two books would complement one another and serve as a complete course in anatomy from the elementary to the advanced stage. He was to be deeply disappointed when the public seized upon the *Epitome* to the neglect of his *Fabrica*. This was undoubtedly due to the greater cost of the larger work and its unsuitability for the general student since it was an exhaustive text calling for a considerable knowledge of anatomy on the part of the reader.

ANATOMICAL ILLUSTRATION

The Renaissance saw the emergence in the realm of art of a new dogma of aesthetic theory which stated that a work of art is a direct and faithful representation of natural phenomena. The assumption required that the artist acquaint himself with the structure and physical properties of natural phenomena in order to insure objectivity and with the rules of perspective and mathematics in order to obtain representational correctness. Art had gone scientific. By the fifteenth and sixteenth centuries the new theory was firmly established and universally accepted, and it was therefore entirely logical that in their study of nature artists such as Andrea Verrocchio, Andrea Mantegna, Luca Signorelli, Antonio Pollaiuolo, Leonardo da Vinci, Albrecht Dürer, Michelangelo and Raphael, to mention but a few, should turn with enthusiasm to the detailed study of the human body. Modern natural science owes more to the efforts of these theorizing artists than to all the learned commentaries of the physicians on the Greeks and their Arabic interpreters. Nonetheless it should not be forgotten that in the midst of this progressiveness, the artist like the physician was reactionary in his pursuit of the cult of antiquity. Artist and physician were not far apart but undergoing parallel development.

Although the publication of the *Fabrica* of

Vesalius in 1543 marked a new era in anatomical illustration, numerous instances of collaboration between physician and artist in a field of mutual interest had occurred. Leonardo da Vinci (1452-1519) doubtless began his anatomical investigations in pursuit of better pictorial representation, but his insatiable curiosity soon overcame his artistic instincts and led him into scientific investigation. The textbook which he had planned in collaboration with the anatomist Marcantonio della Torre (1481-1512) was never completed, but had it been published it would have revolutionized the sciences of anatomy and physiology. However, the sketches lay hidden, first in the Ambrosian Library in Milan and later in the Royal Library at Windsor, for centuries, finally to be uncovered as a monument to the greatest mind of the Renaissance. But the influence of Leonardo was not entirely lost. His was the intellectual climate which made the work of Vesalius possible, and from him indirectly stems the notable line of anatomists of Ferrara who were to continue the tradition of Vesalius.

To consider the true history of anatomical illustration in its continuity from medieval to modern expression, we must leave Leonardo in his relative isolation and go back some fifty years prior to the publication of the *Fabrica*. The earliest printed medical work which indicates the influence of the new art of the Renaissance is the *Fasciculus Medicinae*, Venice, 1491. This collection of medical tracts contains several figures skilfully drawn but hardly anatomical. However, the edition of 1493 contains a fine representation of an academic anatomy such as Vesalius was subjected to at Paris and, in addition, an illustration of the female organs of generation which though erroneously depicted at least indicates that the draughtsman had seen the structures and was reconstructing them from memory. The latter is the first instance in a printed book of a naturalistic representation of an internal organ of the body.

The next noteworthy source of illustration is the *Spiegel der Artzny*, 1518, of the Dutch physician and geographer, Laurentius Frisius (Phryesen), teacher of Mercator, which contains two anatomical plates bearing the date 1517. The first of these is a crude and fanciful diagram of the skeleton, typically medieval. The second presents the body down to the knees with the thoracic and abdominal cavities laid open to expose the contained viscera. Surrounding the main figure are six smaller views depicting the anatomy of the brain and one of the tongue. These smaller views despite their crudity are remarkable and without doubt were drawn from the actual dissection. Nothing like them had appeared previously, and the treatment was wholly new and exceptional. Their influence—indeed, the very illustrations—can be traced in the work of Johann Dryander, and they are even suggestive of several of the Vesalian plates. The artist was possibly Hans Baldung Grün, but others attribute the woodcuts to Johann Waechtelin, a pupil of the elder Holbein. The illustrations bear little or no relationship to the text of the work and are classed as so-called "fugitive sheets" such as the *Tabulae Sex* of Vesalius.

The first illustrated anatomical text in the modern sense is the *Commentary*, 1521, on the work of the medieval anatomist Mundinus by Jacopo Berengario da Carpi. Berengario, says Benvenuto Cellini, who was treated for his syphilis by this famous physician and surgeon, "was a great connoisseur in the arts of design"; indeed, Berengario was once the possessor of Raphael's painting of John the Baptist. His work is of first importance and clearly shows the advent of the critical spirit, but despite his hyperbolic claims to have dissected several hundred bodies and obviously greater knowledge of the body, the illustrations are transitional. While traditional, schematic representations are not lacking throughout the work, many of the illustrations show artistic ability and possess a certain naturalistic quality, although at times the woodcuts are crude and unskilled. His interest in art is shown by the inclusion of drawings of the superficial muscles of the body which appear to have been included specifically for the instruction of artists. It is therefore surprising that he did not obtain more skilled representations. Some of the plates, it is true, do show a more finished workmanship, thus

suggesting possible dissatisfaction and a plurality of illustrators.

It should be noted that Berengario was among the first to employ dramatic postures in the representation of the anatomized human body. These muscle figures are based on free and artistic drawing and possess a certain dynamic quality, and although the execution of the woodcuts is somewhat crude, they should be recognized as a pioneering step leading to the magnificent "musclemen" of Vesalius' *Fabrica*. These illustrations were perhaps the exemplar for the corresponding Vesalian plates which were likewise intended for the student of life drawing.

A surprising feature of Berengario da Carpi's *Commentary* is the omission, save one, of illustrations of the internal organs. This omission was remedied in the following year by a second publication entitled the *Isagogae Breves*, 1522. The *Isagogae* is a short anatomical compendium which was intended to replace the medieval anatomy of Mundinus. Many of the illustrations from the earlier work were retained and some improved, but the new figures still display the same diagrammatic crudities.

Johann Dryander (Eichmann) (d.1560), professor of anatomy at Marburg, was one of the first anatomists after Berengario da Carpi to have illustrations made from his own dissections. In 1536 he published at the request of the rector of the university his *Anatomia Capitis Humani* containing eleven woodcuts based upon anatomies held in that and the previous year. A second illustrated anatomy was published in the following year and another in 1541, to which were added further original figures and many more stolen from Berengario, Frisius and Vesalius. All the plates are crude, yet they do not lack a certain fidelity to nature.

The most notable contribution of the Parisian school was the work of Charles Estienne (Stephanus) (1504-1564), who came of the famous family of printers of that name. Somewhere in the neighborhood of 1530, in collaboration with the surgeon Estienne de la Rivière, he began the composition of an illustrated anatomy which was ultimately published in 1545 under the title *De*

Dissectione Partium Corporis Humani. The delay in publication was due to a legal controversy arising in 1539 at which time the book had been almost completely set up in type. Of the more than fifty plates, the earliest bear dates from 1530, and some are identified by the initials S[tephanus] R[ivière]. Others carry the mark of François Jollat, the Parisian engraver, and still others have been suggested as the work of that singular genius Geoffrey Tory. Thus, while it is true that the publication of the book is post-Vesalian, the majority of the plates antedate the *Fabrica*, and some even the *Tabulae Sex*. Proofs of several of the illustrations may have been in circulation at an early date. The plates of Estienne have the distinction of being without doubt the most hideous ever published, yet possess great merit from the standpoint of the anatomist. The majority of the plates consist of large nude figures seated, reclining or standing in all sorts of surroundings, from interiors to ruined walls. From these figures small sections of the body have been removed and clumsily replaced by insets showing the anatomy of the corresponding part. The vast amount of non-essential delineation serves no purpose but confusion. It has from time to time been suggested that some of the Vesalian illustrations, especially Kalkar's plates of the skeleton in the *Tabulae Sex*, were inspired by those of Estienne and conversely that the later illustrations of Estienne were influenced by those of the *Fabrica*. There is little to support either of these views.

A very considerable advance in anatomical illustration is to be found in the work of Giovanni Battista Canano (1515-1578), a physician and anatomist of Ferrara. This work, one of the rarest of books, is entitled *Musculorum Humani Corporis Picturata Dissectio* and was published around the year 1541. It consists of some twenty leaves only and appears from the preface to have been intended as the first fasciculus of a larger and more extensive work. The drawings, twenty-seven in number, representing in a very exact manner the muscles and bones of the upper arm, forearm and hand, were prepared by Girolamo da Carpi (c.1501-1556), a pupil of Garofalo, and engraved on copper. The work of engraving has

been attributed, it would seem erroneously, to the famous Venetian craftsman Agostino de Musi. Although printed on thin almost transparent paper, ill-adapted to receiving impressions from the plates, these illustrations are among the most skillful and artistic anatomical representations of the first half of the sixteenth century. The greater flexibility of copper-engraving no doubt contributes to their excellence. In spirit they belong to the Vesalian school, and despite a few erroneous details, they are completely naturalistic. There is no borrowing and no holdover from earlier works, yet they are inferior to the woodcuts of the *Fabrica*. It has been suggested that Vesalius, while on his way to Basel to supervise the publication of the *Fabrica*, had stopped over in Ferrara to visit his brother Franciscus who was assisting Canano. There he spread before the latter proofs of the illustrations for the *Fabrica* with the result that Canano, recognizing their superiority, decided to withdraw his own publication despite the fact that it had already gone to press. At least, no other parts of his anatomy after the first ever appeared.

Finally, something must be said concerning the forerunners of the type of illustration comprising the Vesalian *Tabulae Sex* of 1538, the so-called "fugitive sheets." These were as a rule single broadsides, sometimes two, usually printed on only one side of the sheet. They preceded the Vesalian plates by a few years, but continued to appear up to the final quarter of the century. Their purpose was to present popular information or to provide a ready reference for the student or relatively unlettered barber-surgeon. This naturally required a large illustration; indeed, those of Vesalius are among the largest woodcuts ever printed in Venice, the opening being no less than nineteen by thirteen and a half inches. Views of the skeleton, the internal organs and the female organs of generation were commonly represented, but perhaps the most popular, in view of the importance of bloodletting in that age, were representations of the venous system. The original market for such sheets was among bath attendants, barbers and surgeons, not a discriminating group; hence the illustrations were frequently crude and anatomically inexact. Locations on the body were marked in various ways, by the name printed on the part or by letter with the corresponding name inserted in the margin; and because of the unlearned audience to whom they were addressed, the language employed was often the vernacular. Of course there were exceptional cases, such as the two sheets published by Chrestien Wechel in Paris, 1536, representing a front and rear view of the skeleton which are superior to those of Berengario da Carpi or of Dryander although considerably inferior to the Vesalian plates.

Vesalius sought by his *Tabulae Sex* to serve much the same purpose as the "fugitive sheets" but on a different plane, since they were directed to the relatively well-educated student and physician and were expressing not an obsolete but his current anatomical teaching. They were, furthermore, exceptional in that the first three were not so much representational as expressive of the fundamental abstract physiology of the times. That they surpassed any previous sheets artistically was the result of his demand for accuracy which required the employment of a skilled artist and wood engraver.

A second feature adopted by Vesalius from the "fugitive sheet" was the "cut-out," a device at all times popular with our children. The arrangement was such that the pictures of the internal organs could be cut out and mounted on a larger figure in such manner that when lifted or moved aside the organs could be observed in sequence from the surface to the innermost parts. This plan was utilized by Vesalius in his *Epitome*, copies of which could be purchased with the figures already made up and colored by hand.

THE ARTISTS: TITIAN, KALKAR, CAMPAGNOLA, VESALIUS

There is no more contentious and difficult subject respecting the Vesalian problem than the question of the identity of the artist or artists responsible for the Vesalian illustrations. The puzzle has led to numerous conjectures, ingenious, improbable and absurd. Opinions have ranged all the way from the view put forth at the begin-

ning of the present century that the *Fabrica* is a flagrant and gigantic plagiarism from the drawings prepared by Leonardo da Vinci in collaboration with Marcantonio della Torre for their contemplated volume on anatomy, to a theory recently promulgated that the real instigator of the *Fabrica* was the Flemish artist Jan van Kalkar, who employed Vesalius as a literary hack to provide the text. Such extreme views arise in the incredulous minds of their authors when faced with the extraordinary achievement of this young man of twenty-eight which seems to them miraculous rather than the product of genius. Furthermore, such opinions are characteristically uninformed, and the student of Vesalius can only admire the rude facility with which the factual evidence is brushed away in favor of superficial judgments. On this whole question there is much which must go unanswered until patient research has uncovered further information.

No doubt exists as to the identity of the artists of the *Tabulae Sex*. Vesalius definitely informs us that the first three plates are his own work, drawn originally as separate charts or illustrations to be employed by him as pedagogical aids to his lectures on anatomy. They were so well received by his colleagues and students, who, however, found difficulty in copying them, that he promptly decided on publication. It was then that Jan van Kalkar drew the three views of the skeleton which were included in the printed edition. The colophon notes that the plates were published at the expense of Kalkar, a statement which has given rise to a great deal of speculation. The suggested explanation, entirely logical, is that Vesalius turned over the rights of publication to Kalkar in payment for his services. This is perhaps borne out by the existence of a variant edition in which the Kalkar statement is absent and which, if not a proof, may represent copies distributed by Vesalius to the members of his classes. Thus both parties to the agreement would be satisfied, Kalkar by the profits from the publication and Vesalius by identification with the plates which would now be accessible to his students.

But who was Jan Stefan van Kalkar? Search as one may, Kalkar proves to be a very shadowy figure of whom we know a great deal less than we do of Vesalius. He was born at Kalkar, a small town of the Rhine province, midway between Wesel and Cleves, around the year 1499. He studied art in the school of Jean de Bruges, following which he proceeded in 1536 or 1537 to Venice where he placed himself under the tutelage of Titian. After living for a few years in Venice during which time he is supposed to have acquired successfully the Italian manner, "that his works were not always perceived to be those of a Fleming," as the unsupported statement of his friend Vasari runs, he removed to Naples where he died in 1546 or, according to some authorities between 1546 and 1550. Of his paintings we know nothing. Several portraits have been attributed to him but on very unsubstantial grounds; a portrait of Cardinal Colonna, formerly thought to be by Holbein, Rome; supposed portraits of Vesalius at Amsterdam, London, Glasgow, Paris, Boston, none of which is a genuine portrait of Vesalius, all of which are attributions, and many of which are obviously copies. Apart from these, there is a series of sketches in the Hunterian Museum in Glasgow evidently made for the *Fabrica*, attributed in the eighteenth century to Kalkar, and a pen and ink sketch of the title page reproduced in the present volume (plate 95). This does not leave much to go on. The only unquestioned work of Kalkar are the figures of the skeleton in the *Tabulae Sex*, and these perforce must be the standard against which his artistic abilities are measured. We confess that by this criterion they do not place him in the first rank and leave him wanting when we come to examine the *Fabrica* itself.

The illustrations of the *Fabrica* have been attributed at different times to a number of different artists. For a long period the woodcuts were accepted as the work of Titian on the basis of their excellence. This attribution was re-enforced by the proximity of Padua to Venice and the knowledge that although the work was published in Basel, the wood-blocks, as stated in the preface, were cut in Venice. Further strength was given to this view by the fact that around the year 1670 Dominicus Bonavera published his *Notomie di*

Titiano which included the three figures of the skeleton and the fourteen muscle plates from the *Fabrica* upon which were engraved the initials T.I.D., *i.e.*, "Design and drawing by Titian." The tradition was continued by Giuseppe Montani in his book of anatomical illustrations (1679) in which he spoke of the "very famous plates of Vesalius" designed by Titian. Thereafter, in 1706, the original wood blocks came into the possession of Maschenbauer who published some of them and on the title page of the work noted that "The figures were designed by Titian," which statement he emphasized in the preface. No one at this time seems to have heard the questioning voice of Albrecht von Haller, the eminent eighteenth-century medical historian, who remarked that if Titian were truly the artist, and in view of his great reputation, why was he not mentioned in the *Fabrica*.

It was not until the nineteenth century that attention was called to certain passages in the *Lives of the Painters* by Vasari which seemed to indicate a different artist, namely Jan van Kalkar. Vasari remarked on "the eleven large plates of anatomical studies which Andreas Vesalius engraved after the designs of Jan van Kalkar"; elsewhere, "Jan van Kalkar . . . by his hand . . . were the designs for anatomical studies which the most admirable Andreas Vesalius caused to be engraved on copper and published with his works"; and finally, "the anatomical drawings for the works of Vesalius were made by Kalkar." This would seem to clear up the question of the artist's identity were it not for the fact that strangely enough these statements are not to be found in the original edition of 1550, in which no mention is made of Kalkar, but in the 1568 edition, some twenty years after Kalkar's death. In addition, it is surprising that Vasari, a connoisseur of the fine arts and an intimate of his "very dear friend van Kalkar," should have been unable to distinguish between woodcuts and copper engravings. But this and other contradictory statements have been ascribed to Vasari's defects as a writer. Further, the absence of any mention of Kalkar's name in the earlier edition of Vasari is ascribed to the fact that it was his intention to discuss only those artists not living at that time.

Nonetheless, the theory on the origin of the plates now swung from one extreme to the other. Titian was deposed, and Kalkar received the entire credit of being the author, not merely of some, but of all the illustrations of the Vesalian works. Additional support was forthcoming on the recognition that the three skeletal figures of the *Tabulae Sex* were certainly his work and discovery of Vesalius' mention of the artist in his *Venesection Letter* of 1539.

More recently opinion has begun to veer away from Kalkar and to deny him any, or but slight, credit for the illustrations of the *Fabrica* and the *Epitome*. Recognizing Kalkar to be the artist of the skeletons of the *Tabulae Sex*, at which time he was thirty-nine—an age scarcely formative for a draughtsman—it has seemed inconceivable that he could have developed a year or two later into the great creative artist of the *Fabrica*. Furthermore, careful examination of the plates of the *Fabrica* reveals stylistic differences suggestive of the participation of several artists, which is borne out by Vesalius' own statements that he had employed a number of draughtsmen and that some of the illustrations were by his own hand. Still more recent research has supported these conclusions, and we return once more through a full circle to the name of Titian.

Attention has of late been called to a work by Annibale Caro entitled the *Dicerie*, of which one portion, ascribed to a period no earlier than 1540 and written possibly in 1543, mentions "the anatomy of Vecelli [*i. e.*, Titian]." There is no doubt that the reference concerns the drawings of the *Fabrica*, which would be correct as to the time of composition. Caro was in personal touch with Titian and stayed with him during the year 1540 at which time work on the *Fabrica* was in progress, thus giving his statements considerable authority. It has been pointed out that the present attribution to Titian does not represent a later tradition based on quality and the substitution of a greater name for a lesser, since thus far Kalkar's name had not been mentioned, but a piece of contemporary information derived from personal association with the great artist and his

friends. As for the later and contradictory account of Vasari, it is suggested that he wanted to call attention to the share played in the illustrations by Kalkar with whom, incidentally, Vasari was on terms of close friendship. Indeed, were it not for the testimony of Vasari, there would have been no reason to question the authorship of Titian in view of the excellence of the drawings, especially since "the postures and the proportions of the figures, and the landscapes in which the figures are placed, are entirely in his style."

With the exception of the three skeleton plates of the *Tabulae Sex* which can definitely be assigned to Kalkar, none of his works has been preserved or can be identified with certainty. Assuming that Kalkar had artistic ability commensurate with the quality of the illustrations of the *Fabrica*, one might assume that efforts would have been made to preserve his other artistic works. Absence of them leads to the conclusion that he was not possessed of great ability. This is to some degree apparent by comparison of the three skeletons of the *Tabulae* with the far more skillfully drawn skeletons of the *Fabrica*—assuming that the latter were the work of someone else.

However, if Kalkar was not the artist, who was? It should be noted that Vesalius spared no effort to produce the *Fabrica* in a sumptuous edition. The choice of printer, the care with which he wrote directions for the printing of the wood blocks suggest not only the maximum of personal care, effort and energy on the part of the author, but a willingness as well to spend whatever money was necessary to obtain the finest results. In view of this, it seems logical that Vesalius, living at Padua, would seek out the finest artist available. Who then better than the great Venetian artist Titian? Moreover, Kalkar, a pupil of Titian, may already have given Vesalius an *entrée* into the great painter's studio. It is unlikely that Titian himself would undertake the commission, but more likely would turn it over to one or more of his assistants, possibly including Kalkar. It has been suggested that in this manner these assistants would probably employ studies made by Titian which they would copy in clearer outline and under Vesalius' instruction fill with anatomical

detail: "the artistic invention of the figures, the *idea*, in the terminology of the period, and the *mise en scène* would be Titian's while Kalkar's would be that of the 'medical designer.'" Such a hypothesis has certain merits. It explains the characteristics of Titian observable in the figures, the question of how Kalkar, seemingly a second-rate artist, could produce work of the quality to be found in the *Fabrica*, and, finally, the fact that Vesalius definitely speaks in the *China Root Letter* of a plurality of artists.

Any attempt to distinguish between the work of the various artists employed on the *Fabrica* would be based largely upon subjective criticism and certainly subject to much doubt. Yet there are indications of the work of more than one artist. Most obvious, perhaps, is the comparison of the skeleton figures of the *Fabrica* with the far less artistic ones of the *Tabulae Sex*. Since we know the latter to be the work of Kalkar, it is difficult to conceive of him as the draughtsman of the former. On this basis it is perhaps possible to distinguish between Kalkarian and non-Kalkarian illustration, that is, upon the basis of definite and objective lesser and greater skill in draughtsmanship.

In this regard another point must be considered. In some of the illustrations Vesalius wrote his text from drawings already made from previous dissection material, forgetful that when printed from the blocks, presumably yet to be made, these illustrations (9:1-2, 12:13) would be reversed. In 15:1-6 Vesalius admitted this confusion. This illustrates several things. Most obvious is the fact that the drawings in some instances had been made prior to the writing of the text, probably in accordance with the ready availability of osteological material. This is also supported by the fact that on occasion (13:4-5) the illustration indicates earlier erroneous beliefs which Vesalius, on the basis of later research, corrects in the text. Moreover, some of these earlier illustrations (9:1-2, 13:4-5, 18:11) are somewhat out of drawing, and because of lesser skill suggest the work of Kalkar.

Nevertheless this is not the complete answer. Certainly some of the drawings were the work of

Vesalius himself. John Caius who lived with Vesalius in Padua, and Fallopius, a later successor to the chair of surgery at Padua, speak quite clearly of his "writing and illustrating" the *Fabrica*. There is other support for this view. It can be established definitely that Vesalius drew not only the first three plates of the *Tabulae Sex* which demonstrate no slight artistic ability and the single diagram in the *Venesection Letter*, but also all the illustrations of the vessels in the *Fabrica*, "for without mentioning anything else, the course of the vessels which, as my friends know well, are delineated in my books solely through my own efforts." This is borne out in the captions to the illustrations of the *Fabrica* where frequently a distinction between the singular and plural verb is made which suggests the occasions upon which the illustrations were drawn by Vesalius himself. Thus in 46: 4 he writes "I have sketched the arrangement of the cava," and in 46: 5-7 "I have now represented . . . by separate diagrams."

The portrayal of the female genitalia in 60: 4 is certainly not an artistic one. Furthermore, Vesalius tells how he had obtained the body of which the organs of generation are here portrayed. It was a case of body snatching which required rapid dissection and thereafter quick disposal. Thus there is the likelihood that no artist may have been immediately available and that Vesalius was required to make his own sketch. It is true that the caption to the figure uses the plural "we," but in this instance Vesalius in recounting the incident refers to his students' help which may account for the pronoun used. To be sure, the lack of artistry suggests amateur draughtsmanship. Similarly it is possible to conjecture from their amateurish quality that he was responsible for 65: 6 and 65: 7.

Furthermore, Vesalius informs us of the manner in which some of the illustrations of the musclemen were made, it should be said not by Vesalius, but also not in Titian's studio. Presumably he refers in the following statement to some locality in Padua, either the dissection theater or possibly his own living quarters.

"Usually when administering the dissection of a man, I draw a strong chord under the lower jaw and through each jugal bone to the vertex of the head, confined as by a noose, and either more toward the forehead or the occiput according as I had it in mind to suspend the cadaver either with the head erect or depressed. I placed the longer end of the noose across a pulley fixed to a beam of the room, and by that I drew the suspended corpse now higher now lower, taking care that it might be turned in every direction according to the requirement of the task; and again when desired, I was able to rest it on a table, for the table was easily able to be accommodated to the region of the pulley. And the cadaver was suspended in this way during the delineation of all the plates of muscles, just as it is displayed in the Seventh plate [plate 30], although when that was delineated, the rope was twisted back to the occiput because of the muscles which are conspicuous in the neck."

Almost half a century ago it was pointed out that the background to the series of musclemen, if placed in contiguous sequence, formed a continuous landscape. The region has been identified and the late Harvey Cushing visited the site and left us the following description: "the region around Abano Terme, now a fashionable watering place in the Euganean hills a short distance south by west of Padua—the countryside of Petrarch, as a matter of fact. There the site of the old Roman Thermae shown in ruins . . . the Bacchiglione river with the bridge over it, and the rugged trachytic rocks can all be easily identified." Certain peculiar mannerisms in the drawing of the landscapes suggest that they were the work of Domenico Campagnola, who worked for Titian as a landscape draughtsman at this time. His mannerisms are sufficiently distinctive to differentiate his work from that of his master.

In conclusion, the cumulative evidence points with near certainty to the fact that the illustrations of the *Fabrica* and *Epitome* emanated from the *atelier* of Titian. Jan van Kalkar, Domenico Campagnola and doubtless other artists participated in the work under the supervision of the master, but some of the plates are certainly the work of Vesalius himself.

IMPERIAL PHYSICIAN 1543

The publication of the *Fabrica* and its so-called

Epitome was the culmination as well as the turning point in Vesalius' career. The wood blocks and final instructions to the printer were ready for dispatch by 24 August 1542, and the strange caravan was on its way across the Alps under the care of the Milanese merchants, the Danoni. Nothing now remained but the completion of the typography, the printing and the work of the binder. Sometime early in 1543 Vesalius journeyed to Basel to be on hand for the arduous and tiresome task of proofreading until finally, according to the colophon, the task was completed in June 1543.

Vesalius remained in the city enjoying a well-earned rest and, incidentally, on August 3 acted as godfather to a son of his old friend and former publisher, Robert Winter. But it was not social obligation which kept Vesalius in Basel since it would seem that despite the date of the colophon, his great work was not ready for distribution until August, apparently due to binding difficulties. The anatomist needs must wait for final publication and the special copies to be presented to his patron, the emperor.

On or about August 4 Vesalius set out for Speyer where at that time the Emperor Charles V was staying, and it was presumably there that the presentation was made. A magnificently bound copy of the *Epitome* printed on vellum was long one of the chief treasures of the great library of Louvain until its destruction during the invasion of Belgium in 1914. This volume was believed to have been part of the gift which undoubtedly included the greater *Fabrica*. Although the dedication and presentation of the *Fabrica* to the emperor would be natural on the general grounds of desirable patronage, it seems that in reality it was connected with the decision of Vesalius to seek a court appointment as imperial physician. The ground had long been prepared for such a move. His father, an imperial apothecary, was in a position to smooth the way for him, and favor had already been sought by the presentation of a copy of his son's *Tabulae Sex* in 1538. Moreover, it is evident from the later *China Root Letter* that a general impression existed at Padua that he would not return to his academic duties after the publication of his book.

It can be said that with the publication of the *Fabrica* and his determination to enter the imperial service, Vesalius' period of achievement was at an end. As Charles Singer, the eminent historian of science, has remarked, after the publication of this epochal work, anatomy thenceforth becomes Vesalian, while Vesalius himself passes into the background. Various suggestions have been made as to the reason for this withdrawal of Vesalius while at the height of his academic career and with every prospect of a still more brilliant future. It is possible that he needed the imperial protection as a safeguard against wrath aroused by his too thorough exploration and use of anatomical material, as suggested by some, or that the expenses of preparing the *Fabrica* required him to recoup his fortune, as put forward by others, but it is most probable that the answer is to be found in the introduction to the *Fabrica*.

In the preface to that work Vesalius shows himself in complete accord with the philosophical and aesthetic views of his time which led him to demand recognition of the essential unity of the art of medicine, of which anatomy was but the foundation stone. The Vesalian ideal was the complete physician. Only in the practice of the art could he achieve that completeness. It is true that he might have sought this practice at Padua or Pisa, but there were strong traditional ties of family with the Hapsburg court. War, so he states, offers the highest opportunities for service to the physician and a chance to perfect surgical skill. In the imperial retinue he would see much of that, and so it was, for he performed his first service for the emperor in the short campaign against the Duke of Cleves, a rebel vassal of Charles V and an ally of Francis I.

PADUA, BOLOGNA, PISA 1543-1544.
RECEPTION OF THE "FABRICA"

The latter part of the year 1543 and the first half of 1544 were relatively peaceful since it was not until the summer that the fourth Franco-Imperial war was to break out. Since his services were apparently not needed immediately, at least

in a military capacity, Vesalius was free to return to Italy to wind up his affairs at Padua. Meanwhile, his former assistant Realdus Colombus, the same Colombus who later was to dissect with Michelangelo in Rome, assuming that his master's absence was permanent and using the opportunity to advance his reputation by liberal criticisms of Vesalius, was somewhat embarrassed by the return of the latter. Vesalius held a farewell anatomy at which, needless to say, Colombus was not present.

New truths rend the old with violence. Sufficient time had now elapsed since the publication of the *Fabrica* for Vesalius to learn of the reception of his book, which seems at first to have been so unfavorable that in a rage of disappointment he burned the manuscripts of his notes and works under preparation, including, so he writes, his annotations on Galen which he had planned to publish at some future time. Much speculation has centered around this incident, and Vesalius is often pictured as a kind of embattled martyr consumed in the fire of his scientific heresies. Old men with a reputation to maintain are not tolerant of dictation from their erstwhile pupils. Jacobus Sylvius of Paris, Vesalius' former teacher and recognized as the foremost anatomist in Europe, was especially indignant and attempted to undermine his position at Court. He demanded that his pupil recant or forfeit his friendship.

Despite such attacks Vesalius was not without friends. In fact, as we have it on the authority of Fallopius, the great majority of the physicians in Italy supported Vesalius in his new teachings. On leaving Padua he proceeded on what almost amounted to a royal progress. Traveling in company with Petrus Tronus, professor of surgery at Pavia, to Bologna, he stayed there with Professor Andreas Albius, who escorted him to the medical school in which a dissection was then being performed. In the name of the large gathering of spectators, one Buccaferreus requested Vesalius to oblige the students by dissecting and lecturing on some topic. Vesalius acceding, chose to discuss the venous system, a fitting subject in view of his contributions to the theory of bloodletting. Two bodies were available on which he exposed the vena cava and its tributaries before the large group of spectators attracted by the fame of the anatomist. However, the discussion turned into a wordy and acrimonious debate between the philosophers and the physicians on the origin of the blood, and the meeting extended far into the night and was only ended by the intense cold. These fruitless discussions frequently lasted for days, and Vesalius, so Jerome Cardan, the mathematician, tells us, had no time for argumentative disputes. Furthermore, he had an appointment at Pisa for which he set out at dawn. As the dissection was to have continued the next day, and many had come from neighboring towns to hear the distinguished speaker, his precipitate departure was received with great disappointment and no little criticism.

The purpose of the journey was to conduct a course on anatomy at the newly established University of Pisa on the invitation of Cosimo de' Medici, Duke of Tuscany. Vesalius arrived 22 January 1544. Dissection material was floated down the Arno to Pisa, and a temporary theater was erected for the occasion. The proceedings were enlivened by the collapse of the scaffolding, so great was the press to view the demonstrations. The course continued until brought to a close by the onset of the Lenten season. Vesalius long treasured the unusual recognition of having been invited to lecture at no less than three academies, Padua, Bologna and Pisa, within the space of scarcely a single year, and he regarded the acclaim of the Italians, always very sympathetic towards him, as some compensation for the reception which his work had received at Paris and Louvain.

Duke Cosimo fully appreciated Vesalius' abilities and attempted to gain his services on a permanent basis despite imperial competition, but Vesalius, committed to the emperor, had to depart for Florence and thence northwards to join the imperial military forces.

MILITARY SURGEON

War with the French once more broke out in the summer of 1544, and it is during this campaign that we obtain the first clear picture of Vesalius as the imperial physician. Before the

walls of Saint-Dizier he was called upon to attend René of Nassau, Prince of Orange-Châlon, the Lord of Halvin and many others who were mortally wounded by the "fiery bombs." On them he carried out autopsy examinations to determine the cause of death which at this time was universally believed to be due to the poisonous effects of gunpowder. In addition, the duty of embalming the dead devolved upon him, for the bodies of the nobility must be transported home for sepulcher. Curiously enough, within the walls of Saint-Dizier, attached to the opposing forces of France, was Ambroise Paré (1510-1590), the most famous surgeon of the Renaissance. It was Paré who popularized the *Fabrica* and the Vesalian teachings among surgeons by writing an epitome of it in the vernacular which he attached to his works. In the following year Paré was to publish, out of his experience in warfare, his greatest contribution to surgery by disproving that gunshot wounds were poisonous and therewith discarding the barbaric dressing of boiling oil which Vesalius, still a tyro in the surgical art, employed at this time. Likewise, it was Paré who had first introduced (1536) disarticulation at the elbow, an operation which Vesalius attempted with a prentice hand on a Captain Solis not far from Saint-Dizier.

The campaign came to an end with the Peace of Crespy in September of 1544. In the meantime, during the winter of 1543-44, Vesalius' father, the imperial apothecary, had died leaving his son a considerable inheritance which included the family residence in Brussels. On his return, no doubt relying upon his new status as head of the family and an assured position at court, Vesalius entered into marriage with Anne, daughter of Jerome van Hamme, a counselor and master of accounts. A year or so later Vesalius' only child was born, a daughter Anne.

"CHINA ROOT LETTER" 1546

Vesalius was growing in professional stature. The emperor had arrived in Brussels in January 1545 disabled from his eleventh attack of so-called "gout," and Vesalius was employed for the first time in the treatment of his imperial master.

Charles V was a difficult patient. He seldom followed the advice of his regular physicians but was always ready to lend a willing ear to any quack who had some nostrum to sell or who promised him relief from his chronic ailment. He refused to restrict his exotic and bizarre appetite which demanded a capon and cold beer at three or four in the morning. Impressed by the high praises in irregular circles for a remedy called the China root, a variety of sarsaparilla which had been introduced to Europe some ten years previously and had already fallen into disrepute, he demanded its administration. Not only had he high expectations of its efficacy, but, although he would not admit it, the approved method of administration did not require such strict control of his dietary regimen. His first physician, Cornelius van Baersdorp, and Vesalius, despite their doubts of its value, duly carried out their orders and, according to court fashion, were promptly called upon to administer the decoction to all and sundry with ample opportunity to confirm its uselessness.

Nevertheless, the China root had now received the stamp of imperial approval, and promptly the royal physicians were importuned on all sides by the medical advisers to the petty princes and nobility for the method of administration of this new remedy since their charges, like the emperor, were anxious to undergo treatment for their syphilis, or the French disease as they called it, by a regimen which was less rigorous than the standard cure by guaiac. Among those who had written Vesalius to ask his opinion of the remedy was his friend Joachim Roelants (1496-1558), city physician of Mechlin. Vesalius' reply constitutes the curiously entitled *China Root Letter* which was published at the instance of his brother Franciscus, by Oporinus of Basel in 1546.

The *China Root Letter* is in fact not one but two letters. The first portion, making up a very small part of the volume, is his reply to Roelants, and its contents is of little significance except insofar as it shows Vesalius to belong with the more progressive members of his profession in matters of materia medica. The second and larger section is the substance of his reply to a letter which he

had received from his old teacher at Paris, Jacobus Sylvius, discussing certain offensive passages in the *Fabrica* and informing Vesalius that these must be withdrawn if he were to retain Sylvius' friendship. The reply is a brilliant and systematic defense of the Vesalian criticism of the anatomy of Galen and reveals his extraordinary knowledge of both human and comparative anatomy. He takes the opportunity to emend certain of his statements in the *Fabrica* and gives an account of his new discoveries which were eventually incorporated in the second edition of his masterpiece. Here, too, he demonstrates his intense interest in pathology, and in this regard his observations and descriptions of post mortem findings are the first of any importance after the work of the pioneer Antonio Benivieni (d. 1502) of Florence. Furthermore, the *China Root Letter* is our most important source for details of Vesalius' personal life. Written with the warmth of personal friendship, it offers us a glimpse, slight and shadowy though it may be, of his personality.

PERSONALITY

Many attempts have been made to reconstruct the character and personality of Vesalius. He is often portrayed as a fiery, hot-tempered, disputatious extrovert of tremendous energy and ambition, "the man of wrath." On the other hand, a recent writer would see in him a shut-in, schizoid, melancholic individual who rapidly passed into depression upon achieving the pinnacle of his success and accomplishment. Such diversity of opinion is no more than a measure of our ignorance of the man and his character, and the extraordinary facility with which writers will lose all sense of objectivity to spin elaborate webs of romantic fantasy from the thinnest of factual threads. Rather, let us confess that the materials with which to reconstruct his personality are of the scantiest and that we are not in a position to view the man except dimly.

Vesalius was essentially the student possessed of an intense enthusiasm for his profession. No one, say his contemporaries, spent more time in the library reading, exploring and digesting the technical literature. Truly a child of the Renaissance and deeply influenced by humanistic teachings, he sought not refuge in his books but the restoration of the golden age which had been destroyed. This was the same impulse which motivated the artists of the period in their pursuit of nature. Impetuous he most certainly was, but seldom did he allow his ardor to outrun his sense of decency. In fact, unlike his contemporaries, he seldom descended to personalities in his criticisms, which are usually overt without mention of names. He was not quarrelsome nor did he like argument for argument's sake, says his friend Jerome Cardan, who holds up Vesalius as an example to a disputatious age which had bred such vicious battles as those between Fuchs and Cornarius, Fuchs and Ryff, Argentarius and Fernel, Matthiolus and Amatus Lusitanus, to mention but a few. Like every ambitious and successful man Vesalius made enemies, but he had many friends to whom he appears to have been deeply attached. He was fully aware of the significance of his work and jealously defended it. Possessed of an artistic temperament, he was perhaps unduly sensitive and deeply resentful and hurt by the attitude of his former teachers at Paris to whom he had given his affection. He has been accused of being avaricious, but we suspect that the charge was the outcome of envious regard for the considerable fortune which he acquired in practice. We doubt that he, fully conscious of his intellectual superiority, was able to tolerate his less progressive colleagues who, in their pursuit of imperial favor, sought every opportunity to undermine his authority. His mind was intensely visual, and he retained his great powers of observation to the end of his days as may be gathered from the last pathological report which he wrote. His approach to problems was exceedingly direct, and he was not much concerned with philosophical speculations. He was strangely the epitome of a modern scientist in outlook but with this difference that specialization was entirely foreign to his conception of the province of a physician. He saw medicine as a whole, and as he had done for anatomy so it was his ambition to restore the art of surgery which through ecclesiastical prohibition and other influences had been relegated to

menials. In this laudable endeavor he was almost completely frustrated and unable to overcome tradition. Indeed, had he received his doctorate from the University of Paris he would have been required to take an oath not to demean himself with the work of barbers. His attitude was misunderstood by his fellow physicians and threatened the vested interests of the surgeons' guild. This frustration would seem to have robbed him of much of the satisfaction to be derived from practice and appears to have been one of the factors which eventually made his life as court physician intolerable to him. He was not one who found it easy to conceal his feelings, which only served to increase his difficulties among jealous and servile men overly anxious for court favor and ever ready to seek personal advantage through criticism. That he should have reacted by remaining aloof and responding with cynicism is not surprising, but his friends recognized in his behavior only the earnestness and desire for the advancement of his profession.

COURT SERVICE

The opportunity for writing the *China Root Letter* occurred at Nimwegen, the city of his ancestral origins. The emperor on his return from a meeting of the Order of the Golden Fleece at Utrecht had passed through Nimwegen on his way to Guelders and arrived at Maestricht in February 1546. Here he received information that the conference being held at Ratisbon (Regensburg) as the outcome of the Diet of Worms of the previous year, was in danger of breaking up. He immediately dispatched a message to the commissioners to prolong the meeting until he might arrive and hurriedly pushed on towards Speyer on the Rhine. Meantime, it was reported that the Venetian ambassador, Bernardino Navagero, had fallen seriously ill and had remained at Nimwegen, and Vesalius was promptly ordered to attend the distinguished patient. The ambassador's illness proved stubborn and his recovery slow, which made it necessary for Vesalius to remain with his charge for nearly a month, during which time he occupied the period of enforced leisure by visiting the tombs of his ancestors and

composing his long letter to Joachim Roelants.

This year of 1546 in which the *China Root Letter* was written is doubly interesting. Andrea Navagero, brother of Vesalius' patient, had been the intimate friend of Hieronymus Fracastorius (1478-1553), who in 1530 had published his poem *Syphilis*, a great literary success of the age, and who was now about to issue his famous treatise *De Contagione*, the first scientific statement on the true nature of contagion and the modes of transmission of diseases. It is possible that Vesalius met the great epidemiologist in this or the following year. Furthermore, soon after Bernardino was well enough to travel and patient and physician had completed their journey to Ratisbon, Vesalius was called into consultation with the famous anatomist of Ferrara, Giovanni Battista Canano, over the illness of Francesco d'Este, scion of that famous and noble house. At the bedside while discussing the problems of venesection, the question of the existence of venous valves was brought up by Canano, and it was at this time that the mystery of the valves originated, to be solved later by William Harvey with the discovery and demonstration of the circulation of the blood.

The position of Vesalius at court continued to improve. The emperor had complete confidence in his protomedicus, Cornelius van Baersdorp, but was desirous of having the young physician in constant attendance for a secondary opinion. The position of chief physician to the King of Denmark had, meanwhile, been offered to him but refused. In March 1547 Vesalius took a brief trip to Basel the purpose of which journey is uncertain, although it may have been in connection with a projected second edition and revision of the text of the *Fabrica*. However, he had no sooner set out on his return than he was overtaken by an imperial courier who urged him to hasten to the side of the emperor now lying at Nuremberg. In Charles' mind Vesalius was now essential to his health.

Despite the criticism and censure of his colleagues, Vesalius seized whatever opportunities offered to improve his surgical skill. Already in 1545 he had operated upon a Flemish knight

named Busquen for an osteomyelitis of the lower end of the femur, the first deliberate operation for this condition of which we know. Two years later he made what was his greatest contribution to the surgical art by the re-introduction of the classical, Hippocratic operation for drainage of the chest in empyema. With the passage of the years he obtained an extensive experience with the procedure, and his contribution was widely proclaimed by his contemporaries though few dared to follow his example. A brilliant description of the operation and his clinical success was written in 1562 and has survived in a publication of Gian Filippo Ingrassia (1510-1580), distinguished physician of Naples and later of Palermo.

While in attendance on the emperor at Brussels during the winter of 1548, Vesalius made a dramatic prophecy of the imminent death of Maximilian of Egmont, Count of Buren, which was fulfilled with startling precision almost to the very hour on December 23. The count had just returned from a mission to England, suffering from a severe quinsy of the throat. After his examination, Vesalius advised him to put his affairs in order since he had but a few hours to live. Brantôme tells us that the nobleman ordered a splendid banquet graced with his finest plate to which he invited all his friends and, sitting at table, he distributed handsome presents among them and then took his leave with the utmost calmness. Thence he was carried to his bed and expired at the very hour foretold by his physician. The event caused a tremendous sensation throughout Europe and inspired writers and poets for over a generation. But Vesalius drily reported, following autopsy, that death was due to an extensive abscess involving the mediastinum of the chest. However, there were those who later became skeptical of Vesalius' powers and motives in such predictions. The Chancellor Granvelle wrote to the president of the privy council in 1558, saying, "M. de Lalaing is well and does not much fear the opinion of Vesalius on his patients, because he always declares them mortally ill so that if they die, he is excused, and if they live, he has performed a miracle."

Vesalius' abilities now were receiving more than the approval of the emperor and popular acclaim. He was honored at Basel in August 1549 by members of his profession through the dedication to him of a new edition of the works of Alexander Benedictus (1460-1525), a predecessor in the chair at Padua and the first since medieval times to write a comprehensive text entirely devoted to anatomy. Further recognition in a material sense was afforded him by an increase in salary and the opportunity of looking after the Cardinal Granvelle, the most powerful figure at the court. The cardinal died in 1550 only to be succeeded by his son, Antony Perrenot, Bishop of Arras and later, like his father, Cardinal Granvelle. Perrenot had been an old classmate of Vesalius at Louvain and was responsible for his receiving the increase in salary.

THE ABDICATION OF CHARLES V

In February 1553 the emperor was severely ill and prepared himself for possible death. Despite the efforts of Vesalius and the favorite physician Baersdorp, his attacks of so-called "gout" had become more frequent and more severe. Burdened by his illness and affairs of state, the emperor decided to abdicate, but it was not until 1555 that he was able to take the first step in the fulfillment of his intentions. In the afternoon of October 25, supported by the Prince of Orange, he entered the great hall of Brussels where at the same hour, on the eve of the Epiphany forty years previously, his grandfather, the Emperor Maximilian, had released him from his minority at the age of fifteen. Surrounded by the members of the Golden Fleece, the nobles, the deputies of all the provinces and his personal attendants, Charles V presented his famous speech amidst the open and unashamed sobbing of the assembly. Vesalius had lost a courteous and warm-hearted master and acquired a new one, the cold and stiff-necked Philip II of Spain. However, it was not until 16 January 1556 that Charles resigned his Spanish kingdoms and that of Sicily to free himself of all responsibility and retire to the Jeromite convent of Yuste high in the Estremadura. In parting he gave Vesalius a life pension and permission to enter the service of the new ruler.

THE SECOND EDITION OF THE "FABRICA"
1555

Almost, as it were, a colophon to the emperor's reign, the second folio edition of the *Fabrica*, carrying the same dedication to Charles V, was issued in August 1555. The volume was far more sumptuous than that published in 1543. The paper was heavier and the type larger. The initial letters had to be re-cut and a new block prepared for the title-page in which, however, much of the beauty of the original was lost. Vesalius made many definite improvements in the text, which was shortened by getting rid of the many redundancies and the omission of comments on his personal life and that of his friends. He added further observations and corrected others, but perhaps the most valuable addition was the extension of the chapter on his physiological experiments which now included his report on the effects of nerve section, on laryngeal paralysis following section of the recurrent nerve, on collapse of the lung after opening the pleural cavity, on artificial respiration by intratracheal intubation and the continuance of life after removal of the spleen. Indeed, the second edition of his work is often praised more highly than the first on the grounds of its augmented and corrected text, but it is as a supreme example of the typographer's art of the sixteenth century that this edition deserves first consideration. The illustrations are superbly reproduced and show to better advantage on the heavier paper. Nowhere, and this includes the modern *Icones* of 1934, are the illustrations better seen. It is difficult to understand how the printer Oporinus could have hoped to receive any return on such a costly venture. The plates had by this time been plagiarized all over Europe, and in consequence the opportunities for sale of the book must have been greatly reduced. Even though we recognize that Oporinus was an exceedingly poor businessman, we doubt he could have found much to encourage him in the undertaking. Oporinus' catalogue indicates that the edition had been in preparation since May 1552 when five of the seven books were offered for sale, and a letter from the printer to

Conrad Hubert of Strasburg reveals that part of the delay was due to difficulties in obtaining the molds for the larger type. We suspect that another reason was lack of funds. However, Vesalius was now a wealthy man. He had recently completed the building of a palatial residence in Brussels not far from the home of his father, and with this expense over he may have now been in a position to offer a subsidy for the completion of the work.

DEATH OF HENRY II OF FRANCE 1559

Not long after assuming his responsibilities under the new monarch, Philip II, Vesalius was called upon in the tragic case of Henry II of France. Under the terms of the treaty of Cateau-Cambrésis which terminated Franco-Spanish hostilities, the double marriage of Henry's daughter to Philip II and the French king's sister to the Duke of Savoy had been arranged to take place in June and July of 1559. To celebrate the affair a brilliant series of entertainments had been provided which in a curious resurgence of medieval chivalry included tournaments and jousts. Philip remained in Brussels and on June 22 was duly married by proxy, being represented by the Duke of Alva. The betrothal ceremonies of the second marriage were no sooner over than the passage of arms commenced. On Friday, June 30, the French king participated in the jousts, and in running a second course against the Comte de Mongonmery, contrary to the rules of the tourney, he was wounded above the right eye by the broken lance of his opponent. The wound proved fatal, and the king died ten days later from an associated injury to the brain.

Immediately after the accident the most celebrated physicians of the realm were sent for. The protomedicus, Jean Chapelain, and the famous surgeon Ambroise Paré were early at his bedside. Since the king's condition showed no improvement, experiments were conducted with the stump of Mongonmery's lance on the heads of four executed criminals in an attempt to discover the secret of the wound, but the grisly procedure revealed little. In the meantime a messenger had been dispatched to Philip at Brussels

to inform him of the accident and request the services of Vesalius.

Vesalius arrived in Paris on July 5 and as soon as he entered the king's chamber dramatically applied a clinical test from the result of which he declared a fatal outcome. His position in Europe was now supreme, for upon his arrival he was put in charge of the case. In view of the momentous issues at stake, the responsibilities no doubt carried with them considerable nervous strain, and he was doubly burdened by the requests of importunate courtiers, especially of the house of Montmorency since the death of Henry might well result in their ruin. There was little that Vesalius could do, for the French king was beyond aid as the post mortem findings later indicated. Death was due to cerebral compression from a *contre-coup* injury of the brain and subdural haemorrhage. From both Ambroise Paré and Vesalius we have reports on the findings which established once again the truth of ancient Hippocratic observation that the brain could be injured without frank fracture of the skull, a matter of considerable dispute during the sixteenth century.

THE ILLNESS OF THE INFANTE DON CARLOS

In the autumn of 1559 Philip II transferred his court from Brussels to Madrid and thereafter spent the rest of his life away from the Netherlands. Vesalius and his wife, breaking family ties with their native land, traveled in the king's retinue. However, in Madrid Vesalius continued to serve representatives from Flanders at the court and, on occasion, members of the English diplomatic staff. Despite his seniority in the imperial service and the confidence with which he had been regarded by Charles V, Vesalius does not appear to have received the position of chief physician to the new monarch but to have remained as physician in ordinary. Unlike his father, Philip was more Spaniard than Netherlander and was more kindly disposed towards the Iberians when granting favors.

In 1562 Vesalius participated in his last important case, the illness of the Infante Don Carlos, whose tragic and pitiful life forms the subject of romances by Schiller, Otway and many another. Philip had sent his son, recently recovered from a quartan fever, to Alcalá where, in the company of Don John of Austria and the Prince Alexander Farnese, he was to complete his education under the tutelage of the archbishop. This ancient town, the birthplace of Catherine of Aragon and the home of Cervantes, was then a flourishing university center which rivaled the better known Salamanca. The wayward and unbalanced youth of seventeen had scarcely been in residence two months when, so it is reputed, pursuing a serving maid to whom he had made amorous advances, he fell down a flight of stairs and was thrown against a door at its foot.

The Infante was rendered unconscious by the fall, and his personal physicians, Doctors Olivares, Vega and Daza Chacon, who gave him immediate attention, found a small contused wound on the back of his head which apparently penetrated to the bone. Upon notification of the accident, Philip promptly dispatched his protomedicus, Juan Gutierrez, the royal surgeon, Pedro de Torres, and a certain Portuguese physician. The accident had occurred on Sunday, April 19, but despite the multitude of physicians, who were undecided as to the nature of the wound, the prince got progressively worse, and, upon fears of erysipelas, a messenger was dispatched on Wednesday, April 29, to inform the king that his son was in a perilous condition. Philip, accompanied by Vesalius, rode through the night from Madrid and arrived on the morning of May 1. The wound was explored and dressed in the presence of the new arrivals.

It was obvious from the start that the native physicians regarded Vesalius as an alien interloper, and they paid little attention to his advice until more desperate remedies were required. Vesalius contended that the lesion extended more deeply and that it was necessary to examine the bone and even to trephine, but he received no support. The unhappy prince made no progress, and three days later a fatal issue was expected. The king rode away to the monastery of St. Jeronimo to seek solace in prayer.

Now there occurred a series of incidents char-

acteristic of the superstitions of the times. Relics and charms were applied to the wound, and a procession of flagellants filed past the quarters of the ailing prince. Meanwhile, the populace began to assume a threatening attitude towards the assembled physicians, and public opinion forced the attendants to apply the nostrum of a Moorish quack named Pinterete from the kingdom of Valencia, whose ointments burned the wound and rendered the patient worse. Finally, a procession of townsfolk came to the palace bearing the corpse of a friar, who had died a century before, celebrated during life for his miracles and later canonized as St. Diego of Alcalá. The corpse was placed in bed all of one night with the delirious prince. The Duke of Alva acted as a sick-nurse and sat fully clothed throughout the nights beside the boy while the regular physicians engaged in ceremonious consultations some of which lasted for hours.

All hope had long since departed, but the physicians remained steadfast to their duty. On May 16, at the insistence of Vesalius, the left orbit was incised and a considerable collection of pus evacuated. In the evening the same procedure was carried out on the right. Promptly the prince began to improve and the fever dropped, disappearing by May 22. It was now apparent that the patient was out of danger, and on Trinity Sunday, the 24th, the king attended a solemn procession of thanksgiving. In June the prince shed a sequestrum from the diseased bone, and by July was well enough to attend a bull fight held in his honor.

The case had been a tedious one. The rank of the patient, the responsibilities, and the threatening attitude of the populace had made it a nerve-racking experience for the physicians. For Vesalius the charge was rendered doubly unpleasant by the jealousy and provincialism of the Spanish physicians, and no doubt this was but one of several such instances of professional discord which had made his position at the Spanish court almost unbearable. He had now a considerable fortune, and a return to the calm of his earlier academic life must have seemed most desirable provided he could find some way of obtaining a

release from court service.

THE "EXAMEN" OF FALLOPIUS' "OBSERVATIONES ANATOMICAE" 1564

The desire to retire and to return to Padua seems to have been awakened in Vesalius by the receipt, a few months previous to the Don Carlos case, of the gentle criticisms of the *Fabrica* contained in a book by Gabriel Fallopius. In 1561 Gilles Hertog, a physician of Vesalius' native Brabant and a former pupil of Fallopius, had arrived in Madrid carrying a presentation copy to Vesalius of his master's work, the *Observationes Anatomicae*, which had just been published in Venice. Here was an unusual contribution of original and distinguished investigation. The author wished to be regarded as a spiritual pupil of "the divine Vesalius" whom he had never met, and Vesalius immediately recognized a kindred spirit, a seeker after truth not controversy, and was quick to reply. By the end of the year 1561 he had completed a lengthy letter analyzing the Fallopian criticisms, although he confessed that there was much which he was unable to confirm owing to the impossibility of obtaining anatomical specimens in Spain; however, there were many observations with which he was able to agree from experiences gained since the last edition of his book. Furthermore, he expressed amazement and chagrin at the high praise given by Fallopius to the Spanish anatomist, Juan Valverde di Hamusco, whose book had been published five years previously, and there was much justification for Vesalius' irritation since Valverde's illustrations were for the most part deliberately plagiarized from the *Fabrica*.

The letter was consigned for delivery to Paolo Tiepolo, the Venetian ambassador to the court of Philip II. Unfortunately the ambassador was delayed in Spain for many months and when he finally arrived in Venice, sometime after October 1562, Fallopius was dead, and the letter remained undelivered. It was not until some two years later that Vesalius learned of the death of the anatomist, while passing through Venice on his way to the Holy Land. It is evident that he had no intention of publishing the reply as he

considered it a purely personal communication. However, it chanced that on entering a bookshop in Venice he encountered Augustinus Gadaldinus, the managing editor of the *Opera* of Galen to which Vesalius had contributed, and several other prominent physicians who inquired of the work and expressed a desire to see it in print. Paolo Tiepolo, the ambassador, was sought out, since Vesalius had not kept a copy of the letter, and the original was handed over to the publisher. This, the last work of Vesalius, appeared 24 May 1564, under the title *Andreae Vesalii Anatomicarum Gabrielis Fallopii Observationum Examen*, but its author was never to see the work in print.

PILGRIMAGE AND DEATH 1564

In the spring of 1564 Vesalius departed from Venice on the pilgrimage from which he was never to return. What had caused him to give up court service still remains one of the unsolved mysteries of his life. Ambroise Paré, the great French surgeon, relates the story of an anatomist performing in Spain a dissection upon a noblewoman suffering from "strangulation of the uterus" and presumed dead. On the second incision of the knife she suddenly came to life "which thing struck such an admiration and horror into the hearts of all her friends that were present, that they accounted the Physician, being before of good fame and report, as infamous, odious and detestable . . . wherefore he thought there was no better way for him, if he would live safe, than to forsake the country." Edward Jorden, an English physician, repeats the same story but mentions the name of Vesalius and suggests that he undertook a pilgrimage as an excuse for leaving Spain. In a third account by Hubert Languet, the victim of the dissection is transformed into a man, and Languet states that Vesalius became liable to the Inquisition which he escaped only through the protection of Philip II to whom Vesalius made promise of a pilgrimage.

However, other contemporary opinion entirely ignores any such dramatic reason for Vesalius' departure to the Holy Land. Several accounts suggest that he was weary of court service and the hostility of the Spanish physicians and sought only an excuse for withdrawal. There are many factors which support this view.

Vesalius was an alien in Spain and, as is evident from the Don Carlos case, was regarded with envy and jealousy by his colleagues who attempted to obstruct his every move. Gachard, the Belgian historian, informs us that they even attempted to prevent his coming to Alcalá and that his efforts were later belittled and all credit for the prince's recovery was ascribed by them to the miraculous intervention of the body of the exhumed Fra Diego. Political reasons, for the Netherlands were by now seething with disaffection, had made it impossible for him to assume the position of protomedicus despite the fact that Philip, like his father, had come to rely on Vesalius in all dire emergencies. Clusius, the botanist, who reached Madrid the same day that Vesalius departed, states that the physician had not been well and was granted permission to withdraw and undertake a pilgrimage for the sake of his health. Be this as it may, conditions of service had become extremely unpleasant and irksome which may have led to illness, or perhaps a feigned illness, providing a convenient excuse to retire from an intolerable position.

Finally, a desire to return to scientific research seems to have been awakened in Vesalius by the receipt of Fallopius' *Observationes*. It was quite impossible for him to carry out such pursuits in bigoted and heresy-hunting Spain, and in his letter to Fallopius he makes it apparent to us how deep was his longing for academic life. "I sincerely hope that you may long maintain this purpose in that sweet leisure of letters which is yours, and in that throng of learned men whose studies are dear to their hearts and with whom you can daily compare the concepts of your mind. For I feel that the ornaments of our art originate in that arena from which as a young man I was diverted to the mechanical practice of medicine, to numerous wars, and to continuous travels . . . therefore continue to embellish with the fruits of your talents and industry our common school, whose memory is most dear to me."

The death of Fallopius had left the famous

chair of anatomy at Padua once more vacant. We do not know whether Vesalius openly sought his old position from the Venetian government or whether it was offered to him, but it was understood that he would once more resume his professorship on his return from Palestine. And so, with an assured position upon his return, Vesalius set sail from Venice in April of 1564. The first leg of his journey took him to Cyprus, during which time he had the company of Giacomo Malatesta di Rimini, general of the Venetian army.

At one time the following inscription was to be read on a lonely grave on the small island of Zante, not far from the western seaboard of Peloponnesus. "The tomb of Andreas Vesalius of Brussels, who died October 15 of the year 1564 at the age of 50 years, on his return from Jerusalem." The details of the circumstances surrounding his death are very contradictory and confusing. The most authentic account suggests that he was shipwrecked on his return and that his body was washed ashore where it was recognized by a goldsmith who had known Vesalius during life and who arranged for burial. Others contend that he took ill on shipboard, and that the sailors, fearing the plague, were about to throw him into the sea but were prevailed upon to land him on the island where he later died. A certain Johann Metel in a letter to George Cassander states that he had undertaken the voyage upon promise of a large sum of money. On his return in the company of one George Boucher of Nuremberg, the ship was driven for forty days before a storm and such was the parsimonious nature of Vesalius that he had provided inadequate provisions, from which cause he became ill. Many were dying and were thrown into the sea, but Vesalius begged the sailors not to dispose of his body in this way if he should die. Eventually the island of Zante was reached and, after disembarking, Vesalius made his way to the city only to die at its very gates. As has been mentioned, the majority of these accounts are highly suspect, written long after the event and derived from secondary sources.

To many it has seemed strange that Vesalius should have abdicated his pre-eminent position as a scientist to bury himself in the relative obscurity of the Spanish court. But this is to think of Vesalius as a specialist in the modern sense; whereas the conception of specialization was entirely foreign to the sixteenth century. Medical men dabbled in theology, philosophy, mathematics, astrology, geography or any other intellectual pursuit, science or pseudo-science, for which they had the inclination. On the other hand, the laity just as frequently attempted to practice medicine. Although Vesalius defends this attitude, nonetheless he himself followed his profession with unusual singleness of purpose. He was fully conditioned by his age, and, therefore, to him the ultimate aim of the physician was the perfection of the medical art as a whole, and its practice as a natural corollary. Tradition and his aims dictated service at the imperial court. Likewise tradition restrained his development as a surgeon, and he recognized his disappointment after scarcely three years of service. By that time he was dependent upon royal permission to retire to more fruitful fields, but when the opportunity came, fate decreed otherwise.

Had Vesalius been allowed to resume his researches at Padua, it is quite possible that the whole field of medicine would in his remaining years have been advanced by a half century. His past researches had led him to the very threshold of the secret of the circulation of the blood, and the possibility is considerable that he would have taken the final step which fate was to reserve for Harvey. While such a discovery would have been the most fitting climax to the Vesalian anatomy, yet so vast were his contributions that this single factor can in no way decrease his greatness. To Andreas Vesalius of Brussels, the first man of modern science, no more fitting words could be dedicated than the epitaph engraved on the tomb of the mourning skeletal figure of the *Fabrica*, "Genius lives on, all else is mortal."

J. B. deC. M. Saunders
Charles D. O'Malley

Plate 1 FRONTISPIECE

THE WOODCUT PORTRAIT OF ANDREAS VESALIUS OF BRUSSELS FROM THE
FIRST EDITION OF THE "DE HUMANI CORPORIS FABRICA," 1543

The only authentic portrait of Andreas Vesalius of Brussels is this famous woodcut from his great treatise *De Humani Corporis Fabrica*, first issued at Basel in 1543. Its authority is unquestioned. The same wood block was used in both Latin and German editions of his *Epitome*, also published in 1543, in the *China Root Letter* of 1546 and in the second editions of the *Fabrica* and *Epitome* of 1555, as well as in several posthumous publications of his works. It has been re-engraved on numerous occasions and is the prototype of innumerable portraits in oils painted in later times as honest memorial pieces or to entrap the unwary. On the front edge of the table we find the inscription, AN. AET. XXVIII. M.D.XLII, which provides us with the date of the portrait as well as the age of Vesalius at the time the portrait was drawn. Beneath the first inscription may be read indistinctly OCYUS, IUNCUNDE ET TUTO—swiftly, pleasantly and safely—a motto apparently derived from an aphorism of the ancient physician Aesclepiades and quoted from a medieval version of the works of Aulus Cornelius Celsus (c. 25 B.C.—50 A.D.) which reads: "Aesclepiades says that it is the duty of the physician to cure his patient safely, swiftly and pleasantly."

The portrait of Vesalius has been universally admired and has attracted a great deal of attention. It is obviously successful in its expression of a vital, dynamic and vigorous young man, full of energy, radiating self-confidence and self-assurance. In atmosphere, "coloring" and illumination it is brilliant due to the admirable skill of the woodcutter, so much so as to rank as one of the finest book illustrations of the period. Despite this high praise, the woodcut presents many puzzling features. The head of Vesalius is disproportionately large and dwarfs the rest of the body. Hand, wrist, forearm and arm are badly out of drawing. Still more obvious and flagrant is the lack of proportion between the dimensions of Vesalius and those of the dissected specimen. The errors of perspective are numerous. Some would excuse such gross disproportions as being due to the aesthetic conscience of the artist seeking to avoid the commonplace, others find in the faulty draughtsmanship evidence that this is no work of a competent artist and certainly of no pupil of Titian. This naturally raises the question of the author of the portrait.

Many competent experts and critics assert that the portrait is the work of Jan Stefan van Kalkar (1499-1546/50), the Flemish artist trained in the school of Jean de Bruges and later a pupil of Titian. This view has come to be accepted almost universally. However, it should not be forgotten that the attribution depends solely upon the very general statements of Vasari which have been discussed in the introduction and is no more than an attribution. Charles Singer has recently re-examined the question and argues with much cogency that no pupil of Titian could have so botched his anatomy and therefore concludes that it is obviously not the work of a trained artist. He believes that Kalkar, or another, drew or painted a head of Vesalius to which a craftsman added a composition of his own, Vesalius supplying the anatomical details. But even Singer's view is not entirely satisfactory for reasons too lengthy to enumerate here. If we may be excused for complicating the problem, the suggestion that this is a self-portrait might be entertained. Vesalius was by no means unskilled as a draughtsman. The pose is characteristic of a drawing made from a mirror image, and the treatment of the specimen recalls plate 61:1 which is possibly the work of Vesalius himself. However, it is safer to say artist unknown.

Another peculiar feature is the legend engraved on the scroll resting against the inkpot. It purports to be the opening lines of Chapter 30 on the muscles moving the fingers, presumably from the *Fabrica*. On consulting the *Fabrica* it will be found that chapter XLIII, not 30 of book II, deals with these muscles. The opening words are almost identical with those inscribed on the scroll but differ somewhat in arrangement. If the inscription refers to the *Fabrica*, then doubt is cast upon the accuracy of the dating of the portrait since by this time the early chapters would long since have been in the hands of the printer and already set up in type. The difficulty stems from the assumption that the legend relates to the *Fabrica*. On the other hand, we know that Vesalius was already engaged on another work to be entitled *Annotations on the works of Galen*. This work he later destroyed in anger over the onslaughts of his enemies. The legend may perhaps refer to chapter 30 of the *Annotations*, especially since in one of the very first dissections he had ever undertaken on man he discovered discrepancies in the account of Galen on the musculature of the forearm, discrepancies which he now symbolically displays on the specimen shown in the illustration. A further note of perhaps minor nature is the fact that the chapters of the *Fabrica* are numbered in Roman numerals while the legend of the portrait carries Arabic.

Plate 2

The striking and turbulent scene represented in the title page of the *Fabrica*, and also of the *Epitome*, has been the subject of endless comment regarding its significance, its artistic merits and its author. There can be no question that the woodcut ranks among the finest achievements of the art of the engraver in the sixteenth century. The line is clear and precise, the depth and perspective remarkable, the difficult cross-hatching in the shadows accomplished almost without blemish, and the whole executed with a skill and craftsmanship of the highest order. Many competent critics have expressed their admiration of the conception and arrangement of the composition, although a few find the scene too blatant a piece of self-advertising to be wholly satisfying, but it must be remembered that this was a brassily strident age.

The scene represents a public anatomy conducted by the young Vesalius and is as crowded with symbols reflecting his ideas as there are figures in the surrounding throng. The demonstration is in the open air before some ornate building in the Palladian renaissance style, possibly imaginary, and not, as often erroneously believed, within a theater. The out-of-doors is emphasized by the plant life seen clinging to the masonry of the arch on the left. In this scene, as was the custom in public anatomies, a temporary wooden structure has been erected to accommodate the spectators. Wooden theaters of this kind, to be dismantled at the end of the course, were introduced at Padua by the anatomist Alessandro Benedetti and continued to be used until the academic year 1583-1584 when the theater was moved indoors to one of the classrooms. A permanent anatomical theater, which still stands, was constructed in 1594.

In the center of the scene stands Vesalius surrounded not only by his students and fellow physicians but also by the Rectors of the city and university, councillors and representatives of the nobility and the church. The professor dissects and demonstrates from the body itself. He signalizes the break with authority by descending from the *chair*, dispensing with the ostensors or demonstrators, and relegates the menials who formerly did the dissection to a position beneath the table where they are seen quarreling amongst themselves. In the foreground stand three figures robed in the vestments of classical antiquity representing the golden age. They now occupy a position on a level with the new age, for, as Vesalius said, "There is ground for hope that anatomy will ere long be cultivated in all of our academies as it was of old in Alexandria." Galen's dependence upon animal anatomy is indicated by the dog and the chained monkey, the latter being in itself an age-old symbol of medicine.

The very center of the middle distance is dominated by a skeleton articulated in the manner fully described by Vesalius, who was convinced that the study of anatomy begins with the bones, to which constant reference must be made during the process of dissection, and, in addition, the bones of animals must always be present for purposes of comparison. The nude figure clinging to the column on the left indicates the importance of surface anatomy as shown in the *Epitome* (plates 80, 81) and draws attention to the functional aspects which Vesalius is to teach. In the decoration of the entablature above the Corinthian columns appear the lion of the Venetian state and the ox of the Paduan school. Two *putti* support an armorial shield carrying three weasels *courant* on a sable field, the crest of Vesalius and a play on the vernacular version of his name, Wessels. On the left, beside the doorway or window leading to the balcony, are the initials I and O, interlaced like the Greek letter *phi*, constituting the monogram of Johannes Oporinus, professor of Greek and the publisher and printer of both the *Fabrica* and the *Epitome*.

Many have sought the portraits of Vesalius' contemporaries in the surrounding figures. Vesalius is recognizable mainly by his occupation and his costume which is similar to that of the portrait, but the likeness is not particularly good. There is good reason to suppose that the figure clothed in classical garments, standing in the right foreground and admonishing the custodian of the dog, is Realdus Colombus (1516?-1559), assistant to Vesalius and one of the first to describe the pulmonary circulation. Likewise, the elderly bearded man seen looking over the balcony on the right is reputed to be the publisher, Johannes Oporinus. These attributions possess some force since the resemblances to existing portraits are close.

It would be of the greatest importance were it possible to identify the artist's self-portrait among the crowd. The late Harvey Cushing, distinguished student of Vesalius, presumed that the young man in the second row to the left of the center and holding an open book is the artist Jan Stefan van Kalkar. Cushing would read the initials S. C. on the cover of the volume, which he holds to be a sketchbook since he believed that he could discern in the right hand of the figure a pencil, the upper end of which projects beyond the upper edge of the book. It would, however, require a considerable stretch of the imagination to accept such an identification. At this time Kalkar was no youth. Closer inspection of the woodcut reveals the supposed initials (which have also been read C. G., *i.e.*, Claudius Galen) to be no more than oval, decorative medallions which is also borne out by the re-cut made

(continued on page 44)

[42]

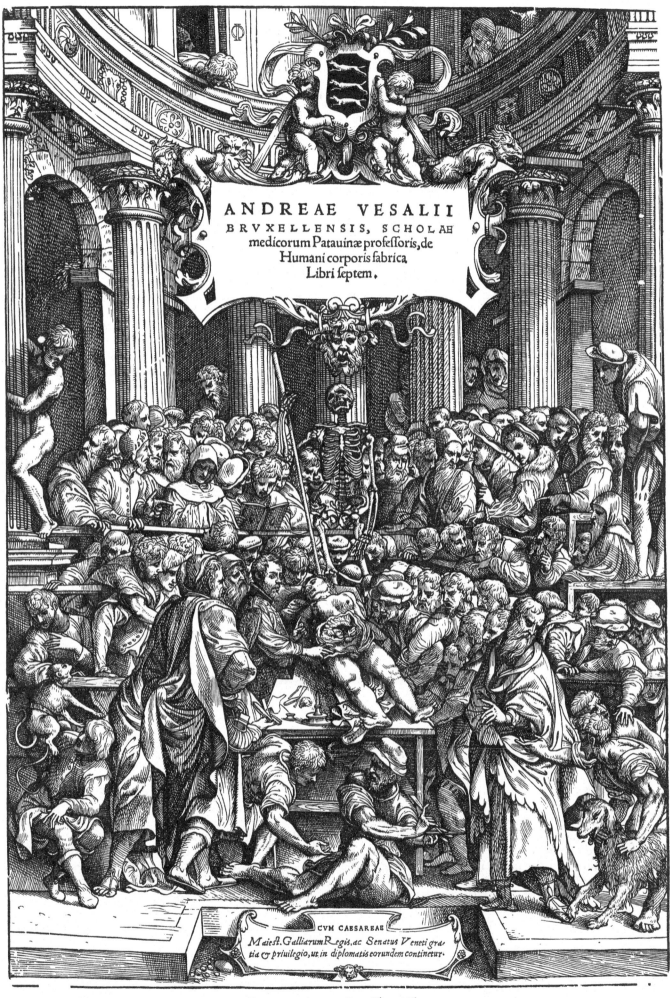

ANDREAE VESALII

BRVXELLENSIS, SCHOLAE
medicorum Patauinæ professoris, de
Humani corporis fabrica
Libri septem.

CVM CAESAREAE
Maiest. Galliarum Regis, ac Senatus Veneti gra-
tia & priuilegio, ut in diplomatis eorundem continetur.

BASILEAE.

Plate 3

For reasons quite unknown the title page of the second edition of the *Fabrica* is a re-engraved copy of the original in which numerous minor modifications were made. The craftsmanship is totally different, and although perhaps more advanced in technique, it has given to the whole a sense of stiffness with considerable loss in fluidity, especially in the rendering of the draperies.

The alterations have in many instances destroyed the symbolic significance of the figures. Of the many changes, the most important is the representation of Vesalius. The head has been greatly enlarged and is obviously derived from the portrait. As H. M. Spielmann, the eminent iconographer, points out, this is the only portrait to reproduce the birthmark or wart above Vesalius' right eyebrow. The skeleton has been provided with a scythe—a decorative *motif* which Vesalius himself recommends while describing the method of articulating the specimen. The cartouche carrying the title of the work has been altered and enlarged and

now indicates that Vesalius has assumed the position of physician to the Emperor Charles V. The animals in Vesalius' coat-of-arms more closely resemble weasels rather than coursing greyhounds. The monogram of Oporinus has been removed and his name introduced at the foot. A goat has been introduced in the foreground, and the lower cartouche, carrying the privilege, now represents the animal board described by Vesalius in his vivisection experiments and as illustrated on plate 42:6. Unaccountable are such changes as the clothing of the nude on the left and the alterations in the footgear of the figures in classical garments. These modifications and many others detract from the character and significance of the illustration. Furthermore, losses in the general illumination, atmosphere and perspective of the drawing have destroyed much of the quality which has caused the original version to be so greatly admired as a work of art.

for the second edition. Furthermore, the right hand of the figure may be observed fully engaged in grasping the volume, and the pencil is surely but a fold in the garment. Although the title page is generally attributed to the Flemish artist Jan Stefan van Kalkar, pupil of

Titian, there still remains much uncertainty. For the extraordinary story of the development of the title page and a more detailed analysis of the question of the artist, the reader should consult the introduction and plates 93-96.

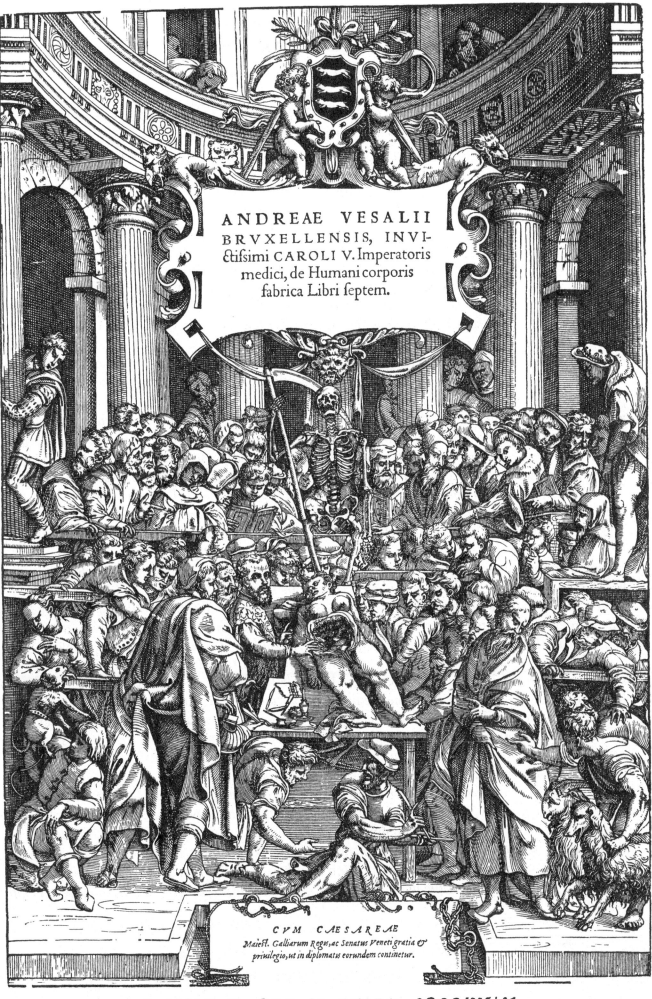

To Johannes Oporinus

PROFESSOR OF GREEK AT BASEL AND VERY DEAR FRIEND

GREETINGS. Through the agency of the Milanese merchants, the Danoni, you will shortly receive, with this letter, the plates engraved for my books DE HUMANI CORPORIS FABRICA and its EPITOME. I trust that they will reach Basel intact and safely since, lest they be defaced in any way or suffer any other damage during their cartage, I carefully packed them with the help of the engraver and Nicolaus Stopius, trustworthy manager here for the firm of Bomberg, a youth well versed in the humanities. Between the series of plates we have placed separately their proofs as well as the letter-press for the individual figures, on each of which I have written where it is to go so that their arrangement and disposition might present no difficulty to you and your workmen and hence prevent the plates being printed out of order. You will readily observe from the proof where the type of characters must be changed, since by means of lines I have separated that part of the letter-press which comprises the account of the organs, divided in the continuous descriptive text into separate chapters, from that which aids in the explanation of the characters found engraved on the plates. For this reason the latter is called the Index of the figures and their characters. In the continuous course of the text, nowhere interrupted by references to figures, you will employ the small type which printers call "superlinear" to indicate those annotations which I have added to the inner margin, not so much through industry as through labor and tedium, in order that they might serve as a commentary for the reader and indicate in whatever plate the part under discussion may be seen; on the other hand, the annotations seen on the outer margin present to some extent a summary of the discussion. To avoid prolixity, wherever an indicated figure is attached to the chapter containing the annotation I have observed the practice of providing no chapter number in the inner margin, although I have included it if the figure is placed in another chapter. Again, if the figure is found in the "book" where the annotation occurs, I do not subjoin the number of the "book" to the figure. You will find clearly explained in the titles of the "books" and in the indices of the characters why I have decided that the plates ought to be gathered in this or that place. For signs with which to designate the parts in any delineation, we have carved on the plates characters of the sort constantly employed in printing shops; first we used upper-case Latin letters and then, lower-case; thereafter, lower-case Greek and then some upper-case which are not identical with the Latin ones; but since all of these did not suffice, we used numerals even though other indicative signs occur in ordinary types. In the description of these indices it should be observed that an indicating character having only a single reference is placed in the margin of the book. But if it does not have a single indication and is described as well by another character, I have added a period to it in the margin so that it, as well as the others in the series, would be clear to the reader. Elsewhere I wrote to you at length of this procedure and why I believed that the index of characters should not be confused with the account of the parts. But now I urge and exhort you most earnestly to execute everything as handsomely and swiftly as possible so as to satisfy in my undertaking the expectations which all conceive of your printing shop, now for the first time, under the happy auspices of the Muses, completely devoted to the greater convenience of students. Special care should be employed on the impression of the plates which are not to be printed like ordinary textbooks with simple line engravings; nowhere should the import of the picture be neglected, unless perhaps where the delineation is [verbally] complemented. And although here your judgment is such that I have promised myself nothing other than your industry and care, I desire above all that in the printing you copy as closely as possible

the proof struck off by the engraver as a specimen, which you will find enclosed in its place together with the wood blocks; for thus no character, although concealed in the shading, will lie hidden from the careful and observant reader. Likewise take care of what I consider most artistic and so pleasing in these pictures, that the thickness of the lines which produce gradation in the shadows is tastefully rendered. But this is not the reason that I write to you since everything depends on the smoothness and solidity of the paper, and above all, on the carefulness of your efforts. And may each plate issued from your printing shop be of the same quality as the several copies of the proofs which we now send. I shall strive to journey to you soon, and I shall remain in Basel, if not for the whole period of printing, at least for some time. I shall bring with me a copy of the decree of the Venetian Senate warning everyone not to print the plates without my consent. My mother will send you from Brussels an imperial license inasmuch as you generally have one in all the books which you print for the first time. It was obtained for me some time ago, and thus far we have not been able to get it renewed and validated for a longer period of years. The Bishop of Montpellier, ambassador to Venice, will obtain for me the license of the French king. I have no concern on this score so long as I am not compelled to fill a page with copies of official decrees. For what the decrees of Princes are worth among booksellers and publishers, now very thickly sown in every corner, is well known from the fate of my ANATOMICAL TABLES first printed three years ago in Venice and thereafter, although decorated with pompous titles, issued miserably depraved throughout. For in an edition from Augsburg my letter to Narcissus Vertunus, first physician to the Emperor and to the King of Naples, and a rare example of the physicians of our age, was replaced by a preface written by some German babbler who, unworthily decrying Avicenna and the rest of the Arabic writers, enumerates me among the concise Galenists, and (to deceive the purchaser) falsely asserts that I have compressed into six tables what Galen diffusely expressed in more than thirty books. Then adding that he has trans-

lated the Latin into German, he affirms that he employed the Greek and Arabic words, although actually not only has he entirely suppressed them, but he omitted all which he was unable to translate and whatever gave value to the TABLES in the first place; furthermore, the Venetian plates were wretchedly reproduced. But he of Cologne who put his hand to the same plates is by far more crude and unskilled than the Augsburg engraver; and although some one in Cologne wrote in praise of the printer, that not only was he able to observe the construction of man better from my plates than from the dissection of the human fabric, but also that they had made from my most elegant figures much more pleasing ones, although, as it happens, they corrupted the pictures and added a delineation of the nerves imitated with little success from a rough sketch which I had drawn, with an index added, for one or two friends who sought it from me during the progress of the work. At Paris they have printed the first three very elegantly, but the others, I imagine because of engraving difficulties, they have omitted, although if they were considered for the sake of students, the first [three] might best have been dispensed with. Moreover, that one of Strasburg whom Fuchs reviled with so great an outcry because of certain forgeries, and whom I am able to name on other grounds as a plagiarist, deserves the very worst from students, because the plates, which could never be large enough for students, he contracted so abominably, colored so shamefully, surrounded them beyond all reason with the Augsburg text and published as his own. Still another seems envious of the latter's glory, and having compiled from all sides without discrimination, from the books and pictures of others, is preparing to publish books of the sort issued at Marburg and Frankfurt. I gladly tolerate, indeed, greatly admire the divine and most felicitous talents of the Italians, in contradistinction to my judgment of German physicians, because the latter seek the services of certain sordid printers who, for the sake of any mean profit which can be squeezed out, dare to issue any type of writing which the physicians abridge, alter or simply copy and publish as apparently new and in their own

name, while the decrees of Princes remain silent. I write these things that you may understand how little I believe that you will do that sort of printing, but rather I feel compelled to state that gladly I will transmit the plates to any diligent printer whomsoever, and in whatever way I can, offer the use of my literary efforts. Likewise, I shall attempt in every way in my power to hinder any inept person from reproducing the plates, made with so much labor for the general use of students, so that regardless of whatever turgid title is prefixed to them, they may not come into human hands as if they had been issued carelessly by me. And in particular, this is the reason why I have prepared the plates at my own expense, and now once again I shall urge you to preserve them faultlessly and elegantly by your efforts.

Farewell. Venice, September 5th. Your Andreas Vesalius.

THE PLATES

FROM

THE FIRST BOOK

OF THE

DE HUMANI CORPORIS FABRICA

NOTE: *The illustrations on the plates are described from left to right and thence downward row by row. This is indicated in the enumeration with each descriptive text. The first figure indicates the plate and the second the position of the individual figure on the plate. The numbers in brackets refer to the book and chapter in the* FABRICA *where the proper context may be found.*

All text in italics is translated directly from the Latin of Vesalius. All text not in italics is by the translators.

Plate 4

4:1 [I:iii]. *The attached figure delineates several of the bones for the sole purpose of representing, at least in some of them, the bony parts and regions, the names of which I shall consider in this Chapter.*

In the chapter illustrated by these figures, Vesalius discusses the various technical terms employed in osteology such as an epiphysis, apophysis, process, spine, head, neck, shaft, articular surface, etc. The skeleton selected as a model for the earlier plates of the *Tabulae Sex* (q.v.) was that of a young man, aged eighteen, who obviously suffered from rickets; but for the *Fabrica* the bones from a more perfect subject, of approximately the same age, were obtained; hence the epiphyses or lines of epiphyseal fusion are frequently observed as in this plate. The ossification of the acromion process, as here indicated, was somewhat anomalous since it is stated that there were several distinct centers. Other points of interest are that the term "tarsus" designated the three cuneiforms and the cuboid only, and that the metatarsus, like the metacarpus, consisted of four elements since, following Galen, the first was regarded as a phalanx.

Preliminary sketches in red chalk of some of the figures of this illustration are to be found in the Glasgow Codex and have been attributed to van Kalkar. These have been reproduced by Ludwig Choulant in his *History and Bibliography of Anatomic Illustration* (Chicago, 1920).

4:2 [I:iv]. The four small figures here shown were inset in the chapter to point analogies in the discussion of the cranial sutures. They demonstrate successively a serrate joint, a joint *ad unguem* or by interdigitation, dovetailing and hemstitching by means of "florettes."

4:3 [I:i]. *As the different bones represented by figures attached to each chapter in which the individual bones are described, are shown intact, so that the remaining matters considered in the present chapter are not demonstrated, we have depicted here a portion of the humerus dissected longitudinally. . . .*

Below the humerus, sectioned longitudinally, Vesalius has placed the navicular bone of the foot and the first phalanx of the great toe, both divided in half. His purpose was to demonstrate cancellous bone, the medullary canal and the compact cortex. In addition, Vesalius included the smaller bones in order to confute Galen's opinion that these were solid.

4:4 [I:iv; xv, 1st ed.]. *Here the letter A indicates the metal or hinge implanted in the wall; B, the metal joined to the door or window.*

A small figure inset in the chapter to illustrate comparisons which may be drawn between a hinge and a ginglymus joint.

4:5 [I:iv, 2nd ed.]. *The upper figure represents a hinge, as described in the text, by which two boards are joined; A indicates one metal element and B the other, while C is the key which makes firm the mutual ingression of the former. The lower figure delineates another type of hinge in which D denotes the metal fixed to the wall and E the metal by which the key is attached to a door or window.*

An elaboration for the second edition of the *Fabrica* of the previous figure and again employed to illustrate the description in the text of the nature of a ginglymus joint.

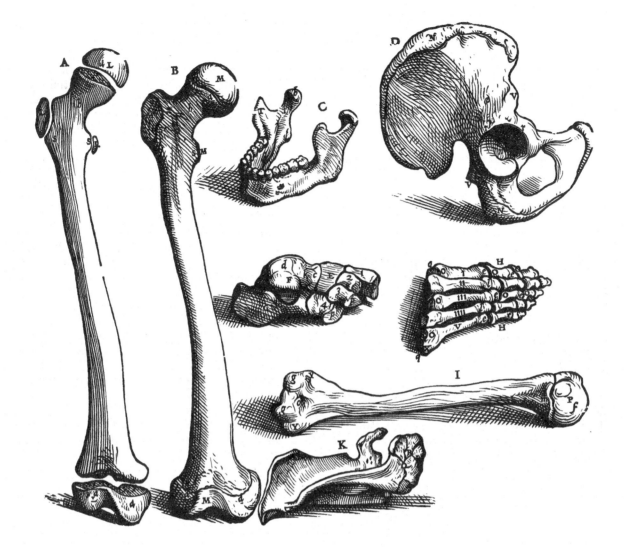

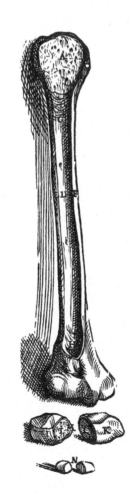

Plate 5

5:1 [I:v]. *In the first figure is delineated the natural head or skull shape which resembles an oblong sphere slightly depressed on either side and protruding anteriorly and posteriorly.*

5:2 [I:v]. *The second figure demonstrates the first type of non-natural [abnormal] head shape in which the anterior eminence is lost.*

5:3 [I:v]. *The third shows the second type of non-natural head shape in which the anterior [error for "posterior"] eminence disappears.*

5:4 [I:v]. *In the fourth is indicated the third type of non-natural head shape in which both tubers, that is, anterior and posterior, are lost.*

5:5 [I:v]. *In the fifth we represent the fourth type of non-natural head shape in which both the eminences of the natural shape face, not to the front and rear, but to either side.*

These are the first meager beginnings in physical anthropology. Although conscious of racial differences, Vesalius attempted to establish a norm for skull shape of which the four abnormal types were variants. He further believed that the pattern of suturation was related to the prominence or lack of prominence of the cranial eminences; hence in his abnormal type I the coronal suture is absent, and the sagittal continues as the metopic to the nasal region, and the reverse in type II, an inter-occipital suture being represented. He was, however, aware that suturation varied with age. These beginnings had their inspiration from the works of Hippocrates, and such criticism of the Vesalian classification as developed was at first based upon opinions as to whether he had correctly interpreted the classical authors.

5:6 [I:vi]. *The first figure of the sixth Chapter which shows the two portions of the bones of the vertex [parietals] somewhat separated so that the very skillful construction of the suture may be seen more conveniently.*

5:7 [I:vi]. *The second figure of the sixth Chapter displays a portion of the bone of the vertex [parietal] divided by a saw from the rest of the bone so that the substance of the skull in the forehead, vertex and occiput is exposed, which is formed by two dense and solid squames or laminae, commonly called the tables and the diploe. . . .*

5:8 [I:vi]. *The third figure of the sixth Chapter exhibiting the whole skull without the lower jaw, depicted on the left side.*

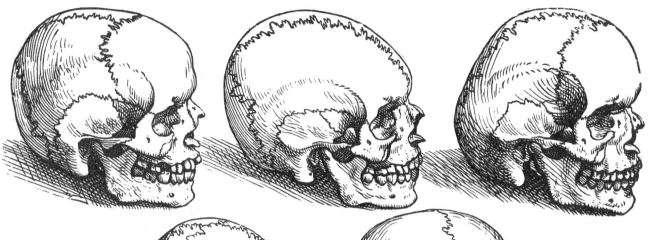

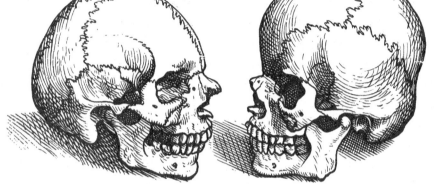

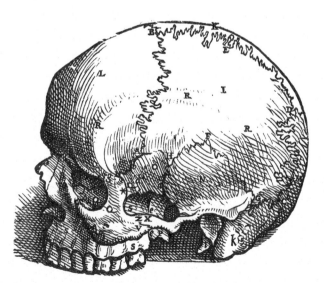

Plate 6

6:1 [I:vi]. *The fourth figure of the sixth Chapter represents the skull lying further on the left side so that the base of the skull comes somewhat into view. In this figure we have removed the jugal [zygomatic] bone with a saw to expose several of the sutures. . . .*

6:2 [I:vi]. A schematic diagram inserted in the index to the figure on the base of the skull seen below. It represents the sutural boundaries of the occipital bone and of the greater wings of the sphenoid. The denticulate portion from D to C is the parieto-occipital suture, followed by the occipito-temporal suture at m and the junction of the basi-occiput with the basi-sphenoid at n. Thereafter the boundaries of the greater wing of the sphenoid and its articulation with the temporal, parietal, frontal, zygomatic, maxillary and palatine bones are indicated at appropriate intervals by letters.

6:3 [I:vi, ix]. The base of the skull is shown; anteromedial to the foramen spinosum in the scaphoid fossa between the pterygoid laminae on the right side of the illustration may be seen the inconstant "foramen of Vesalius," one of the few structures which is eponymously named for this great anatomist.

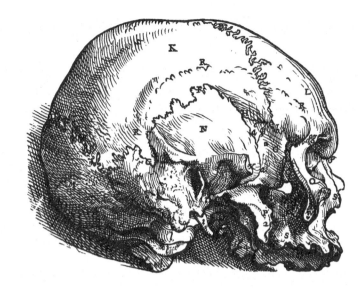

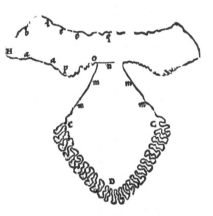

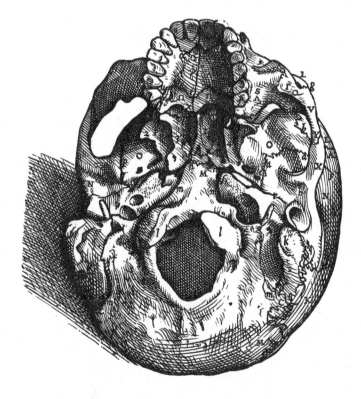

Plate 7

7:1 [I:vi, xii]. *The sixth figure of the sixth Chapter exposing to view the internal aspect of the base of the skull. We have here delineated the skull from which the superior part, represented in a subsequent figure, has been removed in the manner in which we customarily divide the head with a saw when we are going to show the structure of the brain.*

The foramen of Vesalius is now seen on the left of the illustration, just lateral to the anterior clinoid process and anterior to the foramen spinosum marked by the letter Q (cf. Fig. 6:3). Such correspondences would indicate that the same skull was used in the majority of the illustrations.

7:2 [I:vi]. *As I do not wish in the least to annoy the reader with numerous plates, I am, for that reason, purposely not representing in the above the individual bones of the head by separate figures. However, because the boundaries of the wedge-like bone [sphenoid] and of the eighth bone of the head [cribriform plate of ethmoid] are not so readily understood as the rest, in the present figure these bones freed from all others are represented from that aspect which faces the internal surface of the skull. We have displayed the cuneiform [sphenoid] so that the hollows frequently occurring in it might be shown. . . .*

By tilting the sphenoid somewhat its sinuses and the foramina passing forward to the orbit are revealed for the first time in the series. The ethmoid of Vesalius is the cribriform plate and processes only, since difficulties in the preparation of such a delicate bone led him to believe that the ethmoid labyrinth was a separate bone which he called the "spongiform." Gabriel Fallopius later corrected the error by employing the skulls of infants and children to obtain the bone intact.

7:3 [I:vi, xii]. *The seventh figure of the sixth Chapter showing the remaining portion of the internal aspect of the skull, not represented in the sixth figure.*

The calvaria from the skull in the previous illustration is now exposed to exhibit not only the markings of the meningeal vessels but also the internal appearances of the suture lines and such details as the fossae for the arachnoidal granulations associated with the name of Antoine Pacchioni (1665-1726), an anatomist and physician of Rome and Tivoli.

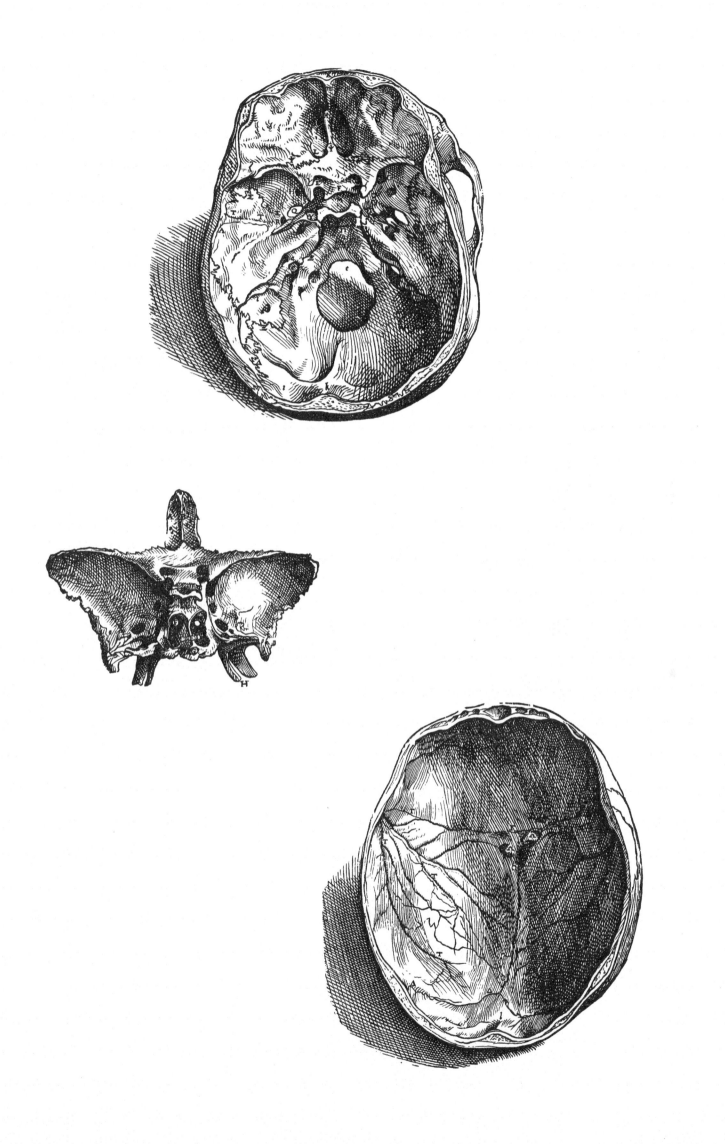

Plate 8

8:1 [I:ix, xii]. *This figure represents the anterior aspect of the skull in which the bones of the upper jaw are shown as accurately as possible. We have placed the skull of a dog beneath that of man so that anyone may understand Galen's description of the bones of the upper jaw without the slightest difficulty. In addition, it was necessary to rest the human skull on its occiput and to set its anterior portion on the dog's so that the orbits with the sutures and bones appearing in them may be more clearly seen. . . .*

This arresting illustration was of extraordinary symbolic significance to Vesalius, who employed it twice as a chapter heading. Apart from its obvious value for the demonstration of the boundaries of the facial bones, the primary purpose of the illustration was to reveal that Galen had described the premaxillary bone and suture of the dog as though present in man and thus could not have been familiar with human anatomy. Vesalius thus opened a great controversy of singular importance in comparative morphology which was to rage with bitter polemics for nearly four centuries and to be settled only in recent times. Literally hundreds of articles have been written on the subject. His discovery, from which he made the correct deduction, was one of the major factors leading to the overthrow of Galenical anatomy. Although Vesalius is commonly accused of being unjust and unfair in his criticism of Galen, making allowances for the temper of his age when all was black or white, he is in fact always cognizant of his debt to Galen and respectful of Galen's opinions where he feels the facts justify acceptance.

Another feature to be observed in the above illustration is that the ethmoidal labyrinth, the orbital plate of which is labeled ⊕, was regarded as a separate bone by Vesalius until Fallopius a few years later showed that this was not the case.

8:2 [I:viii]. *This figure exhibits the ossicles of the auditory organ. The principal drawing in the figure shows a portion of the right temporal bone which has been cut out and divided in half, thus bringing into view the two membranes and ossicles which lie in the bony cavity.*

The petrous temporal has been divided in approximately horizontal section to reveal the tympanic membrane, two of the auditory ossicles and a portion of the internal ear at the entrance of the acoustic and facial nerves. Gabriel Fallopius (1523-1563) informs us that the third ossicle was discovered in 1548 by Gian Filippo of Ingrassia (1510-1580), who named it the stapes, although both Realdus Colombus (1516?-1559) and Bartholomaeus Eustachius (1520-1574) falsely claimed the discovery. The malleus and incus were known to earlier anatomists, but we owe their present names to Vesalius. Otherwise, Vesalius' knowledge of the internal ear was very sketchy, hence the poor diagram. The second of the two membranes mentioned in Vesalius' caption, the first being the tympanic, is the membranous lining of the labyrinth which he and his contemporaries believed to be formed by the spreading out of the acoustic nerve to constitute the receptor organ. The facial and acoustic nerves were not clearly differentiated until Fallopius discovered the facial canal and the distribution of the nerve to the facial muscles. Nonetheless, the facial is illustrated in the above figure, terminating blindly among the mastoid air cells in what was called the "blind foramen—*foramen caecum.*"

8:3 [I:ix, vi]. *The second figure, representing the base of the skull and the palate, exposes the position of the bones of the upper jaw not seen in the preceding figure. Although there are many letters for identification, we shall explain only those which concern the description of the bones of the upper jaw.*

This illustration, previously employed to demonstrate the bones making up the brain case proper, is now repeated to emphasize the arrangement of the facial bones when viewed from below. For some remarks on the figure, the reader should consult plate 6:3.

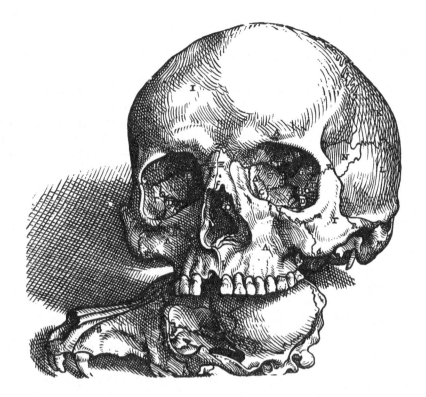

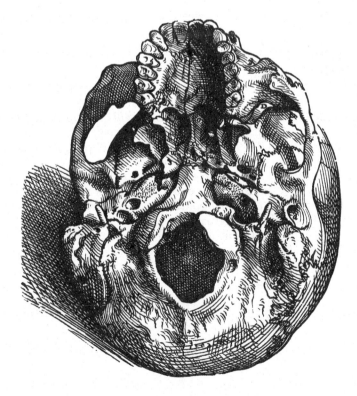

Plate 9

9:1-2 [I:x]. *The first or right [for left] figure of this Chapter exhibits the anterior aspect of the lower jaw together with the teeth. The second figure reproduces the lower jaw with the lower dentition as drawn from the posterior aspect. The figure prefixed to the third Chapter of this book shows the jaw drawn from the side.*

The error of "right" for "left" in the legend is probably not a typographical or editorial slip but indicates that Vesalius wrote his description with the original drawing before him. However, he had apparently forgotten that when transferred to the wood block the illustration would be reversed. In several of the figures there is a confusion between right and left which curiously enough has escaped the attention of the many editors of succeeding editions but which was remarked on by Vesalius himself in the text.

The figures are somewhat out of drawing and we suspect that they belong to an early series possibly the work of van Kalkar.

9:3 [I:x]. *A representation of the special cartilage found in the articulation of the jaws.*

The articular disc of the temporo-mandibular joint would seem to have been first observed by Vesalius. This small drawing appears as an inset in the text of the Fabrica.

9:4 [I:xi]. *In this figure, the teeth of the upper, as well as of the lower jaw are represented only on one side since the arrangement is the same on either side. If it is desired to view the teeth while still fixed in the jaws, the figures of the previous Chapter [9:1-2] will show the inferior series, and the third [5:8] and fifth [6:3] figures of the sixth Chapter, the upper. The fourth figure [6:1] of this Chapter readily shows the sockets in which the extracted teeth were fastened.*

Apart from the upper and lower dentition, a molar tooth has been laid open to expose the pulp cavity to controvert Galen, who had said that the teeth were solid. An incisor and molar tooth lie free at one side to illustrate the crown. The chapter on the teeth from his great folio is by no means the most brilliant example of his writings in originality and was completely superseded a few years later by the monograph on the teeth by Bartholomaeus Eustachius.

9:5 [I:xii]. *Since the present foramen is but obscurely seen in the figures of this Chapter, I have drawn its outline from the right side and have indicated its lower part by δ and its upper part or the angle of the foramen by ε. However, the foramen is beautifully seen on both sides in the eighth figure [7:2] of the sixth Chapter.*

An outline drawing of the superior orbital fissure which, as mentioned, can be seen in the drawing of the isolated sphenoid.

9:6 [I:xii]. *The present figure assists greatly in demonstrating the foramina [carotid] which were noted by X and Y [in Figs. 7:1 and 8:3]. It consists of the course of the foramina of either side placed in the order in which they are observed to be carried by passing setons or lead wires into the skull. The two X's denote the left foramen [carotid canal] prepared for the largest branch of the sleep-inducing artery [internal carotid]. The two Y's indicate the foramen transmitting a small branch running into the cavity of the nose.*

A diagrammatic representation of both carotid canals, and apparently of the pterygoid canals described by Vido Vidi, which Vesalius erroneously believed carried the internal maxillary or even the ophthalmic artery into the nasal cavity.

9:7 [I:xii, vii]. *Since this particular figure from book seven, however rough, is useful for the better understanding of the present passage, I have added it here. A indicates the glandule into which the pituita flows. B, the pelvis formed from a thin membrane of the brain. C, D, E, F, four ducts leading the pituita down from the glandule or, rather, sinus in which it is contained.*

A schematic diagram of the pituitary gland and infundibulum together with four fanciful passages which represent the superior orbital fissure and palatine canal. According to the humoral physiology, the phlegm or pituita was distilled from the brain and passed to the pituitary gland, hence its name, whence it flowed to the nasal passages and pharynx. Galen contended that the phlegm filtered through the cribriform plate of the ethmoid, but Vesalius was compelled because of the anatomical relationships of the pituitary to deny this pathway and to substitute more likely passages, namely via the palatine canal and through the superior orbital fissure into the spheno-palatine fossa to the nose. At first sight the four ducts give the impression of being the optic chiasma which has been displaced. But this is not so, and Vesalius was fully aware of the true position of the chiasma.

9:8 [I:xii, 1st ed.].

9:9 [I:xii, 2nd ed.]. *I have placed this rough figure here so that the passages [leading] from the foramina which we have noted by V, a, and b [in 8:3], may be seen. In this rough Minerva, a will indicate the foramen on either side to the auditory canal. V is the foramen noted at V in the above [plate] and b, that which will soon be explained under the letter b.*

A Minerva is a thought picture. These two quaint illustrations, one of which is a revised version for the second edition, therefore represent to the mind's eye the external and internal acoustic meatus together with the middle and internal ear, theoretically extracted

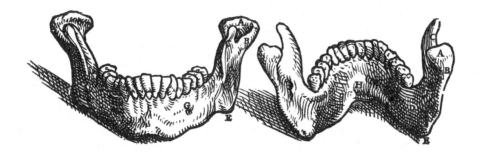

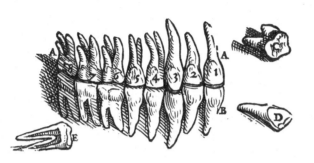

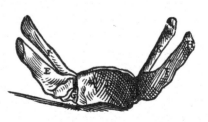

Plate 10

10 [I:xiv]. *In this figure we have represented in side-view the bones of the back as a whole so that, first of all, their complete interconnection may be seen and then each part of the back will be delineated separately.*

In the illustration of the vertebral column as a whole, its various curves have been very imperfectly reproduced due to the technique employed in mounting the preparation, which consisted of threading the vertebrae on a rigid iron bar bent by pure guesswork to fit the curvatures. This same defect is therefore apparent in the full-length plate of the skeleton. It will be noted that a six-piece sacrum is employed throughout which was severely criticized by Fallopius as being unusual, but which Vesalius sheepishly defended on the grounds that it was a very perfect specimen from a young subject and therefore, although not modal, suitable for illustration. The features designated by letters or numerals are sufficiently obvious as to require no comment.

from the views of the base of the skull given previously. V is the osseous portion of the auditory tube associated with the name of Eustachius, and through which Vesalius believed a branch of the acoustic nerve passed. b is the stylo-mastoid foramen and facial canal so beautifully described by Fallopius. Vesalius' knowledge of the middle and internal ear was very hazy, and he attempted to follow the path of these canals by probing with lead wires, hence the curious inaccuracies.

9:10 [I:xii]. An outline of the jugular foramen to show its division into two portions for the exit of the nerves and vein.

9:11-12 [I:xiii]. *The first figure presents the anterior face of the bone resembling the letter u [hyoid] together with its lesser or higher processes and the ossicles which connect them as far as the processes projecting from the temporal bone like a stylus.*

The second figure shows the posterior region of the bone resembling the letter u, together with its upper ribs [processes], but the ossicles which extend to the processes resembling a sort of stylus have not been drawn.

The hyoid bone here shown strongly suggests that it was taken from the dog. Yet in the accompanying text Vesalius compares the human with the quadruped and states that the ossicles shown in the stylo-hyoid ligament are variable in number and may be cartilaginous so that it is possible that he saw an epi-hyal bone, but the general appearances favor the dog as the source of the material.

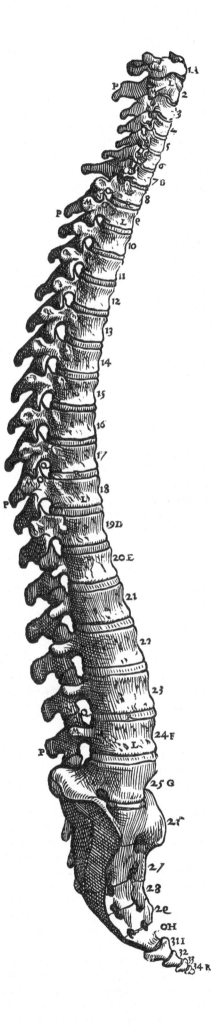

Plate 11

11:1-9 [I:xv]. *The first figure presents part of the occipi-tal bone freed from the other bones and observable on the external aspect of the base of the skull.*

The inclusion of the occipital bone in the series on the cervical vertebrae was not only to reveal the shape of the opposing articular surfaces of the atlanto-occipital joint but also to show that the occipital condyles of man differed markedly in shape from the description of Galen which had been taken from quadrupeds.

The second figure contains the first cervical or verte-bra of the neck represented on its antero-superior as-pect.

The third figure exposes to view the postero-superior aspect of the first cervical vertebra.

The fourth figure exhibits the first cervical vertebra delineated from the postero-inferior aspect.

The fifth figure displays the anterior aspect of the second cervical vertebra.

The sixth figure depicts the posterior aspect of the second cervical vertebra.

The seventh figure offers to view the second cervical vertebra from its inferior aspect.

The eighth figure shows the antero-superior aspect of the third cervical vertebra.

In the ninth figure the postero-superior aspect of the third cervical vertebra is delineated. Since the inferior surface of this cervical vertebra resembles the inferior surface of the second, we have not placed it here so as to avoid the presentation of perhaps an excessive num-ber of illustrations for the present Chapter. For the same reason, we have not depicted individually the rest of the cervical vertebrae lying below the third, especially since their description can be readily gained from the three upper vertebrae.

11:10 [I:xv]. *We have here depicted the special car-tilage of each side, which we have sometimes observed.*

Regarding this interposed figure, Vesalius states that, in addition to the cartilages of encrustation, he has sometimes met with irregular interarticular cartilages in the lateral atlanto-epistrophic joints. The findings suggest that the joints were pathological, chondro-malacia, or that the articular cartilages had flaked off in part due to the method of preparation which was maceration in boiling water.

11:11-12 [I:xv]. *In the tenth figure [of the series] the connection of the first three cervical vertebrae is seen depicted from the anterior aspect.*

The eleventh figure represents the posterior aspect of the first three cervical vertebrae united together.

11:13 [I:xv; II:xxx]. *Although the present figure chiefly and properly belongs to the second book, I have placed it here because it aids not a little in the understanding of matters treated at this time. . . .*

The transverse and apical ligaments of the atlanto-epistrophic joint, as well as the ligamenta flava, are easily recognized. The illustration will be reproduced once again in book II, as mentioned.

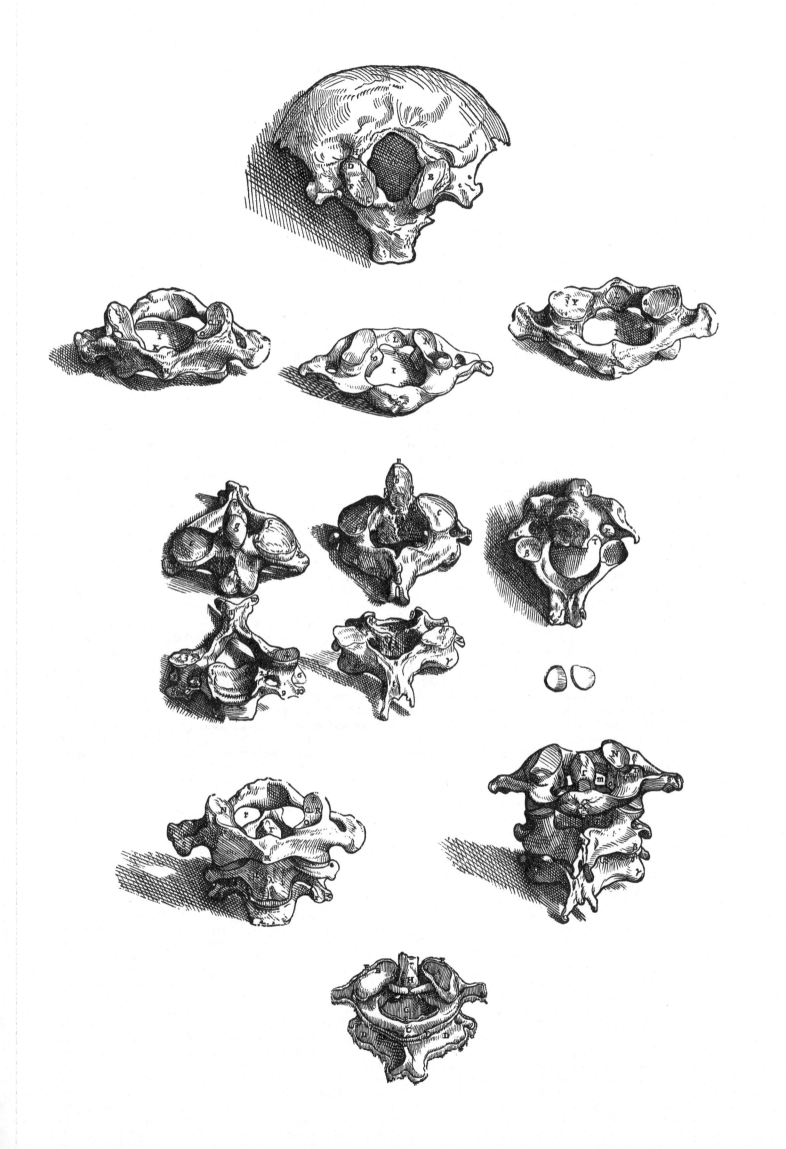

Plate 12

12:1-4 [I:xvi]. *We have here delineated such of the twelve thoracic vertebrae as we decided would suffice for the illustration of their description. The first figure shows one of the middle thoracic vertebrae drawn from its anterior aspect, which the upper ten thoracic approximately resemble.*

The second figure offers to view the posterior surface of the same vertebra mentioned in the first figure.

In the third figure the posterior surface of the eleventh thoracic vertebra is shown.

The fourth figure contains a representation of the posterior aspect of the twelfth thoracic vertebra.

In the representation of the series of thoracic vertebrae it will be observed that the epiphysis of the centrum is still ununited. The majority of the osteological specimens appear to have been derived from the body of a young male approximately sixteen or seventeen years of age.

12:5-7 [I:xvii]. *Since all the lumbar vertebrae are of the same configuration, we have represented here three aspects of only one. The first figure displays the anterior surface of the vertebra, the second, the side, and the third, the posterior aspect.*

Once more we observe the epiphysis of the body and also those of the transverse processes and spine.

12:8 [I:xvii]. *We have represented in the present figure the right [for left] aspect of a lumbar vertebra from the caudate ape so that you may follow individually and without difficulty the position and shape of the processes being described.*

The anticlinal spine and the presence of the accessory or anapophyseal processes at H are to be noticed in particular since it was these features which converted Vesalius' doubts into certainty that Galen had drawn his anatomical descriptions from apes and dogs. He made this particular discovery while preparing, with his friend Professor Andreas Albius, a human and a simian skeleton for a course given at Bologna in the winter of 1539-40.

12:9-10 [I:xviii]. *Since in the context of the present Chapter mention is made, because of Galen, of the sacrum and coccyx of apes and of dogs, we decided it would not be inappropriate also to represent here these bones as observed in apes. . . .*

Galen states that the sacrum consists of three bones but contradicts himself elsewhere by saying that there are four. The medieval anatomists, Avicenna and Mundinus, follow him and describe three sacral and three coccygeal segments. Leonardo da Vinci was the first to cast aside this tradition by introducing a five-piece sacrum. Jacobus Sylvius, Vesalius' teacher in Paris, insisted that the Galenical texts were completely correct with regard to number, hence Vesalius, in order to some extent to accommodate Galen's opinion, grudgingly allowed that by adding the three sacral to the three coccygeal segments of the ape, and assuming that the rest of the coccyx or caudal vertebrae were not ossified, he could harmonize opinion. This was one of the reasons that he selected a six-piece sacrum for the illustration below.

12:13 [I:xviii]. *The present figure represents all the bones of the back lying below the lumbar vertebrae united together. The first figure, which occupies the right [for left] side, exposes to view the anterior aspect of these bones. The second figure, lying on the left [for right], shows the posterior surface drawn slightly from one side to demonstrate the sinus with which the right iliac bone coarticulates. The third figure, placed between those mentioned, exhibits the whole of the coccyx, of such shape and size as is frequently observed in men in the prime of life.*

Unlike most of the other osteological preparations, which were taken from a youth, this specimen of a six-piece sacrum was selected from the body of a middle-aged man because of its great beauty and, as mentioned above, to harmonize to some extent opinions conflicting with the statement of Galen. Fallopius took Vesalius to task for selecting a six-piece sacrum instead of one of five segments as the modal type, and Vesalius defended himself on the grounds that it was the most perfect specimen he had seen. Again it will be noted in his legend that "right" is confused with "left" since he wrote with the drawing in front of him and forgot that it would be reversed in engraving.

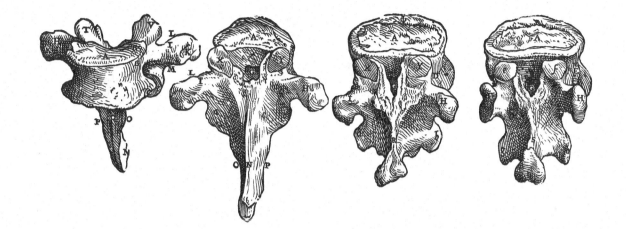

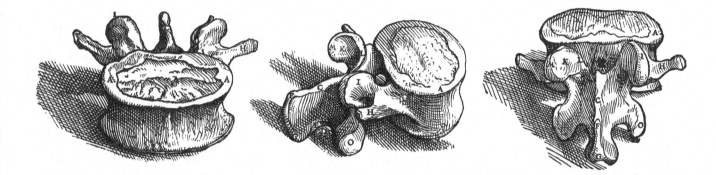

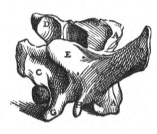
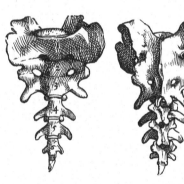

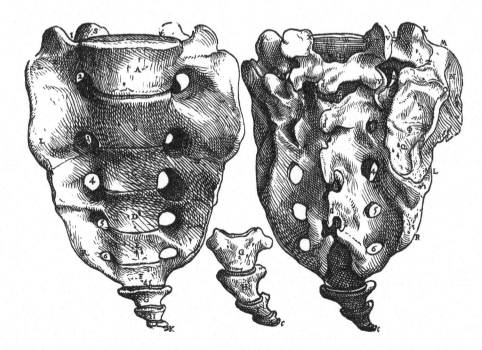

Plate 13

13:1-2 [I:xix]. *The first figure of the nineteenth Chapter represents from the anterior aspect the entire assembly of the bones of the thorax, that is, the twelve vertebrae and the twelve pairs of ribs together with the pectoral bone which is formed from several bones.*

The second figure of the nineteenth Chapter exhibits from the posterior aspect the entire assembly of the thoracic bones.

13:3 [I:xix]. *The posterior portion of a rib nearest to the vertebrae is represented in the fourth figure [of the nineteenth Chapter] so that the capitula [head and tubercle], by which the nine upper ribs are articulated to the vertebrae, are brought into direct view. Furthermore, we have fractured a part of this rib in order that the osseous substance in the interior of the rib, indicated by Φ, may be shown.*

13:4-5 [I:xix]. *The sixth figure exhibits the anterior part of the pectoral bone freed from the costal cartilage.*

The seventh figure demonstrates the posterior surface of the pectoral bone freed from the costal cartilage.

The Vesalian illustrations of the sternum have been severely criticized. It is pointed out that the bone is represented as divided into seven segments, as found in macaques, and is consequently a holdover from the simian anatomy of Galen. This criticism, although valid for his earlier illustrations of the human skeleton, is not entirely justifiable here. In the text Vesalius says, "I can state with certainty that I have never seen the occurrence of all seven bones in the human pectoral bone, nor is their number always the same in man." This statement is unequivocal. How are we to explain the appearances? It will be noted that only three of the lines crossing the body of the sternum are indicated by the letters γ, δ, and ε. These three lines, Vesalius specifically states, are the lines of coalescence found in children. He has, therefore, represented the body as consisting of four centers which, together with the manubrium and xiphoid process, make up correctly the six segments usually found in man and which, Vesalius says, is the maximum number he has ever seen. The letters along the lateral margin of the bone refer to the attachments of the clavicle and the upper seven costal cartilages. The unlabeled line on the body is, of course, the ridge frequently found, as shown here, above the notch for the seventh costal cartilage, and the illustration should be compared with that of a standard textbook such as Cunningham's *Textbook of Anatomy*. There are two possible reasons why it was emphasized in the drawing at all. First, Vesalius was willing, as in many other instances, to give Galen the benefit of the doubt, although he himself had never seen an actual coalition at this point. Second, that the drawing was made early

in the series before he had given up Galen's notion but which, because of the uncertainty, he preferred to amend by means of guide letters rather than by redrawing and re-engraving the block.

13:6 [I:xix]. *The fifth figure [of the nineteenth Chapter] represents a portion of the twelfth rib depicted from its posterior aspect where it is joined to the twelfth thoracic vertebra. We have also broken this rib away from its remaining portion so that the osseous substance of the rib will be shown where the letter Φ is placed.*

13:7 [I:xx]. *This figure diagrammatically represents the roots of the great artery [aorta] and of the arterial vein [pulmonary artery] which have been separated from all bodies or parts attached to it and which resemble two circles. A denotes the root of the great artery, B, the root of the arterial vein, and C, the connection which joins the vessels together at their origin.*

The dense connective tissue about the atrioventricular and arterial orifices of the heart was regarded as part of the skeleton, hence its inclusion in the section devoted to osteology. It was the quaint custom on mounting a skeleton to thread such structures on one of the tendons to form a necklace which was placed on the specimen. The so-called fibrous trigone between the orifices is the representative in man of the os cordis occupying this situation in the ox and some other ruminants. The purpose of the illustration is to show that the os cordis, shown in the following figure, does not exist in man.

13:8 [I:xx]. The os cordis is found on the right side of the aortic ring as a plate of cartilage in younger ruminants, and more or less calcified in old animals. Sometimes a smaller plate exists on the left. Galen, no doubt following Aristotle, described this bone and stated that he had found it in an elephant's heart which was being prepared for the Roman Emperor's table; an inaccurate statement since it is absent in that animal. Vesalius correctly says that to see it one has only to examine the heart of "a decrepit cow." The os cordis, especially from the deer, was in great demand among physicians as a drug, for it was supposed to possess miraculous properties, and it sold at an enormous price. Vesalius was one of the first to deny that the bone had any therapeutic properties whatsoever.

13:9 [I:xix]. *The third figure [of the nineteenth Chapter] contains three thoracic vertebrae from the middle of the series, represented from the right side, together with an intermediate rib of the same side. With the aid of this figure the articulation of the ribs to the vertebrae, as well as the course of the rib, is shown.*

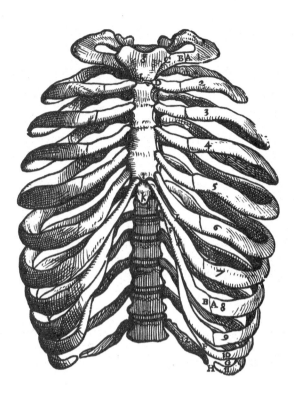
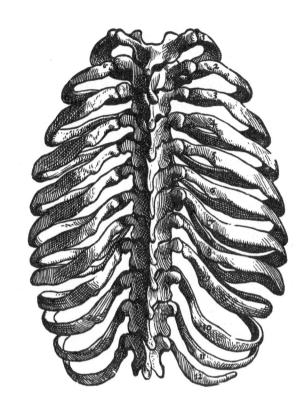

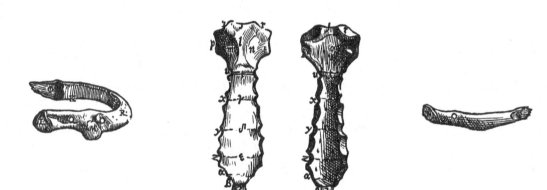
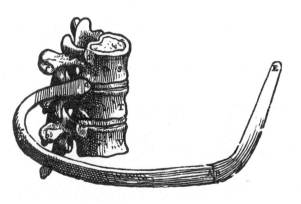

Plate 14

14:1-3 [I:xxi]. *The first figure represents the internal or anterior aspect of the right scapula.*

The second figure shows the external or posterior aspect of the right scapula.

The third figure contains the right scapula depicted from the side so as to present the sinus of the humped or external aspect of the scapula which lies between the higher rib [superior border] and the spine of the scapula.

The epiphyses of the inferior angle, vertebral border, acromion and horizontal portion of the coracoid process will be noted. Vesalius was the first to demonstrate so clearly these secondary centers of ossification.

14:4 [I:xxi]. *We have delineated in the present figure the external or posterior aspect of the scapula of the dog so that the differences between the scapula of man and that of the dog or sheep might be more readily examined as will be noted in the summus humerus or superior process of the scapula [acromion]. A and B together indicate the gibbosity or dorsum of the scapula, A being its inferior aspect, but B, its superior or region nearer the neck or head in the living animal. C and D denote the scapular spine which does not extend beyond the scapular neck. E is the neck of the scapula.*

14:5-7 [I:xxii]. *The first figure of the present Chapter represents the right clavicle from the antero-superior or external aspect.*

The second figure shows the posterior or internal surface of the clavicle as well as its superior aspect.

The third figure demonstrates the inferior aspect of the clavicle.

The letters indicate familiar features of the clavicle, and among details, the third figure shows at G the impression for the costo-clavicular ligament, at O, the conoid tubercle and at M, the trapezoid line. The articular surfaces although indicated in the inferior view are not well shown.

14:8 [I:xxi, 2nd ed.]. *In this figure we have expressed approximately the cartilage which increases the sinus of the scapula.*

The labrum glenoidale represented diagrammatically.

14:9 [I:xxii]. A rough diagram inset in the explanation to the figures of the clavicle in order to show the shape of the articular surface at the sternal end of the clavicle. The letters correspond to those seen in the above three illustrations (14:5-7), thus enabling the student to orient the figure.

14:10-11 [I:xxi, xxii]. In the first of these small diagrams R is the articular disc of the acromio-clavicular joint and in the second, S, the articular disc of the sterno-clavicular joint.

14:12-13 [I:xxiii]. *The first figure of the twenty-third Chapter presents the anterior surface of the right humerus.*

The second figure of this Chapter exhibits the posterior surface of the right humerus.

The epiphysis of the upper end of the humerus has not yet fused indicating, as previously mentioned, that the specimens were derived from a seventeen- or eighteen-year-old youth. The musculo-spiral groove for the radial nerve and the sulcus for the ulnar nerve are indicated at Y and V respectively. Other features such as the bony prominences, torsion of the humeral shaft, articular surfaces, and so forth, are clearly expressed.

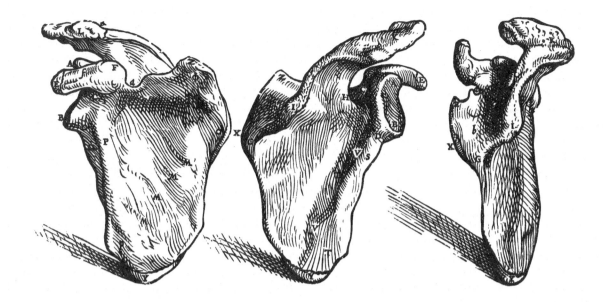

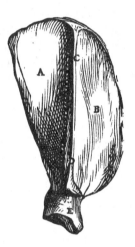

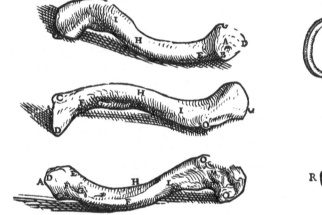

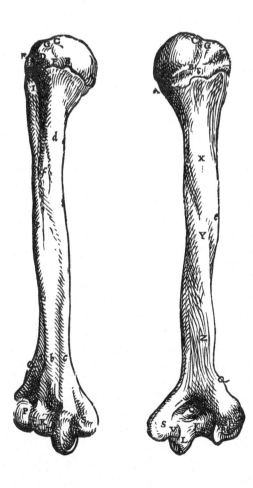

Plate 15

15:1-5 [I:xxiv]. *In the second figure of the twenty-fourth Chapter both bones of the left forearm, that is, the radius and ulna, are represented from the external [posterior] surface. In the third the internal [anterior] aspect of the radius alone is depicted, but in the fourth, the external [posterior] aspect of the radius. The fifth represents the internal aspect of the ulna and the sixth, the external.*

15:6 [I:xxiv]. *The first figure of the twenty-fourth Chapter expresses the two bones of the left forearm drawn from the anterior aspect. In this, as in almost all subsequent figures of this Chapter, the bones of the left side have been presented although, as a general rule, the right rather than the left is usually described [in the text]. Unfortunately it happened accidentally in [preparation of] the wood blocks or plates that we depicted the right instead of the left. However, in the case of the bones it is unimportant whether the right or left is represented.*

The confusion between right and left has been commented upon in connection with other illustrations. We now have an admission from Vesalius that this was due to his having forgotten in working from the original drawings that they would be reversed when transferred to the wood block.

The epiphyses at the lower end of the radius and ulna and at the upper end of the radius will be noted.

15:7-11 [I:xxiv]. *The seventh figure shows the inferior portion of the left radius to which the wrist is articulated. We have delineated this part inferiorly as though facing it from the ulnar aspect so that the sinus near the wrist which receives the head of the ulna may be brought into view. The eighth figure, pertaining to the right forearm like the three following, contains the inferior portion of the radius drawn from the external [posterior] aspect so that the sinus to which the wrist is articulated is exposed. The ninth indicates a small portion of the upper end of the radius in which a sinus is observed which the head [capitulum] of the humerus enters. The tenth exhibits a small portion of the ulna showing the part which faces the wrist. The eleventh offers a representation of the superior part of the ulna on which sinuses, tubers and processes occur to which the groove or pulley [trochlea] of the humerus is fitted.*

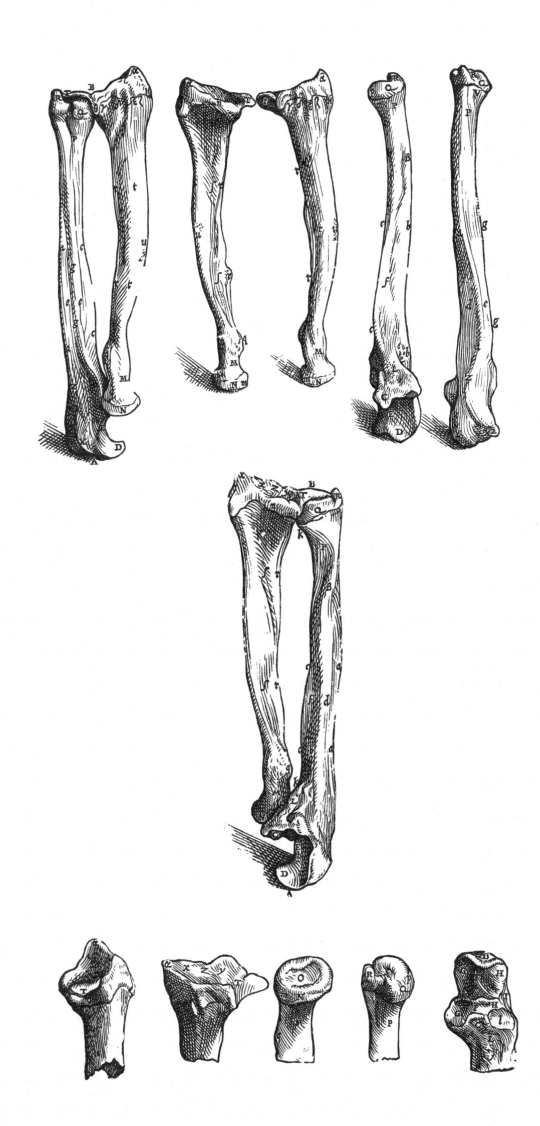

Plate 16

16:1-6 [I:xxv]. *The first two figures serve not only the present Chapter, but also the three immediately follow-ing in which the parts of the hand are also explained. The first figure presents the internal [palmar] aspect of the bones of the hand. The second shows the external [dorsal] aspect of the same bones. The next four figures in order properly relate to this Chapter and represent only the eight bones of the wrist from various aspects. That inscribed as the third figure demonstrates simul-taneously the internal [palmar] surface of the eight wristbones and the commissure on this aspect. The fourth figure comprises the same bones drawn from the external [dorsal] surface. The fifth figure contains the superior part of the wristbones by which they are articu-lated to the forearm. The sixth figure shows the lower aspect of the wristbones to which the first bone of the thumb [metacarpal I] and the four postbrachial bones [metacarpals II-IV] are joined.*

In the Vesalian system the carpal bones are numbered 1 to 4 from lateral to medial side in the proximal row, and from 5 to 8 in the distal row. Although favoring five metacarpals, Vesalius follows Galen in regarding the first metacarpal as the first phalanx of the thumb, hence the remainder are numbered I to IV. In the first two figures of the series the sesamoid bones of the thumb, index and other fingers are shown. Such a com-plete series of sesamoids would be exceedingly rare in man but occurs in lower animals; hence in this respect Vesalius seems to be following Galen. However, Ve-salius regards a sesamoid cartilage, whether ossified or not, as a sesamoid bone, whence these strictures are scarcely valid.

16:7 [I:xxviii]. *In this small illustration are delineated separately the two ossicles placed in the foot beneath the first internode [metatarso-phalangeal joint] of the great toe and which are indicated at ω and Ψ in the* second figure of the thirty-third Chapter [19:2]. *A here denotes the inferior aspect, resting on the ground, of the internal [medial] ossicle. B, the superior aspect of the same ossicle which faces the head of the foot bone [metatarsal I] supporting the big toe. C indicates the superior aspect of the external [lateral] and smaller os-sicle, and D, its lower aspect.*

The sesamoid bones of the great toe are here shown. In the plate mentioned in the legend a com-plete series is shown, but Vesalius remarks that their number is variable; yet there are usually twelve in each hand and foot, sometimes more and sometimes less, and that except for the medial sesamoid of the first metatarso-phalangeal joint, they are as a rule larger in the hand. His account is one of the most complete in the literature and is the source of most of the traditional information found in modern textbooks. The larger sesamoid here illustrated was called, according to Ve-salius, *Albadaran* by the Arabs since philosophers of the occult believed it to be indestructible and from it, like the sacrum, resurrection would come. But such disputations and opinions on the immortality of the soul should be left, he says sarcastically, to the theolo-gians.

16:8-10 [I:xxvii]. *The first two figures [16:1, 2] placed at the beginning of the twenty-fifth Chapter show the series of digital bones, just as the three figures [21; 22; 23] at the end of this book representing all the bones connected together. The figure occurring here, divided, as it were, into three smaller illustrations, places before the eyes the digital joints. . . .*

The bones represented are, from left to right, the dorsal aspect of the second metacarpal and of the first phalanx of the same figure; the palmar aspect of the first phalanx and dorsum of the second; the palmar surface of the second and third phalanges.

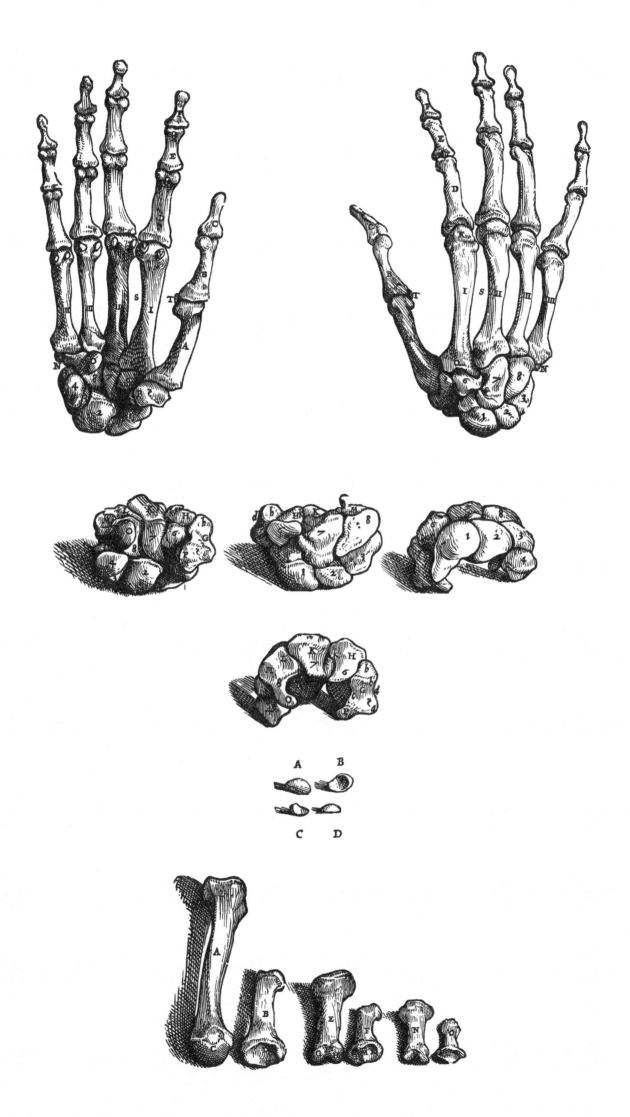

Plate 17

17:1-3 [I:xxix]. *In these three figures the bone [innominate] joined to the right side of the sacrum is delineated. The first figure represents the anterior aspect of the bone in that region which presents itself upon inspection of the skeleton from the front. The second figure represents every aspect of the bone which is external and not facing the interior of the body, that is, the region encountered when one looks at the bones all connected together from the right side. The third figure shows very appositely from the opposite side the internal aspect of the bone.*

The term "innominate" bone was not employed in the sixteenth century. Galen had said that no name had been given to the entire bone which his interpreters, among them Vesalius, called innominate, *i.e.*, unnamed. It had long been divided into the ischium, ilium and pubis but not in the modern manner. Fallopius was the first to discover the existence of the triradiate cartilage in the floor of the acetabulum and thus to appreciate the reason for its division. Certain of the epiphyses, at the crest and for the ischial tuberosity, are well shown in the illustrations.

17:4-5 [I:xxx]. *The first figure of the thirtieth Chapter reproduces the right femur drawn from the posterior aspect.*

The second figure shows the anterior surface of the right femur.

The morphological details of the femur are fairly well represented including the anterior curvature of the shaft. The epiphyses of the head, of the lower end, and of the greater and lesser trochanters indicate a subject of around seventeen to eighteen years.

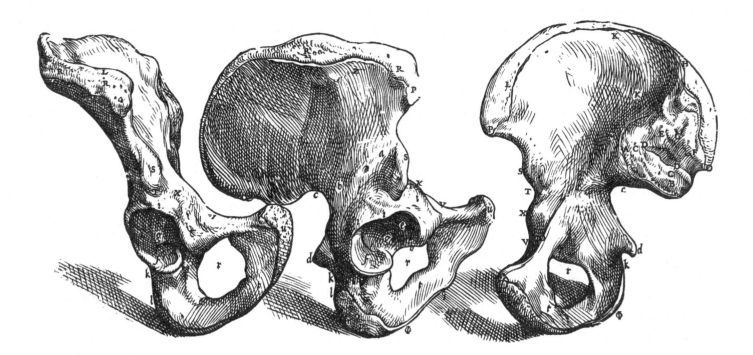

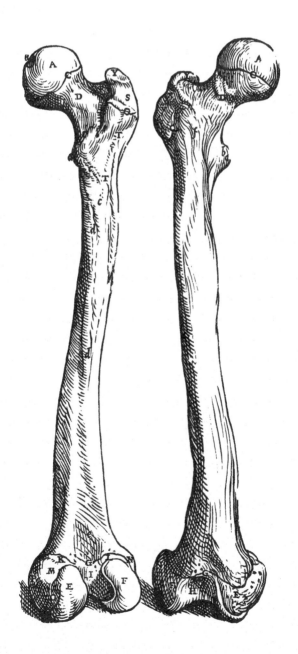

Plate 18

18:1-11 [I:xxxi]. *The eleven figures of this Chapter pertain to the right leg. The first represents the anterior aspect of the two bones placed in the leg, that is, the thicker and more internal which we shall call the tibia, and the more slender placed externally which we shall name the fibula rather than the sura. In the second figure, the tibia, together with the fibula, is delineated most appropriately from the posterior surface. In the third, the anterior aspect of the tibia only is shown. In the fourth, the posterior surface of the tibia is placed before the eyes. The fifth represents the anterior surface of the fibula. The sixth exhibits the fibula delineated from the posterior aspect. The seventh shows the upper aspect of the tibia to which the femur is articulated. The eighth contains the two cartilages which augment the sinuses of the tibia which receive the femoral heads [condyles]. The ninth presents the anterior part of the lower ends of the tibia and fibula so that the cavity prepared for the articulation of the ankle with the leg comes into view. The tenth offers the lower end of the tibia only where the talus is received, delineated from the posterior aspect. The eleventh shows the internal side of the lower end of the fibula which articulates with the talus.*

The term sura for fibula was derived from Celsus but did not come into general use. The word was variously used in classical times to mean the leg, the tibia or the calf and is now employed only as the adjective with the last meaning, as in the "sural nerve." The sinuosity of the shaft of the tibia seen in the illustrations seems unduly exaggerated. The epiphyseal lines at the upper and lower ends of both tibia and fibula are very evident. The semilunar cartilages or menisci are somewhat crudely represented, the lettering referring to the thin, intermediate and thick portions of the structure.

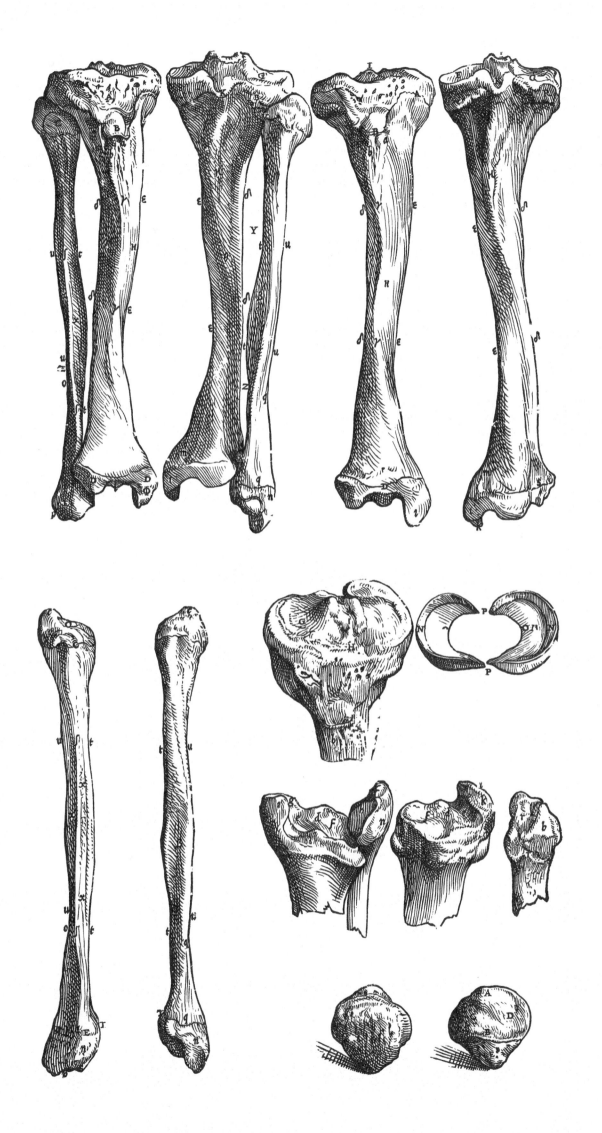

Plate 19

19:1-13 [I:xxxiii]. *The first figure represents the complete structure of the bones of the right foot from the superior aspect. The second also presents the bones of the right foot connected together and delineated from the aspect on which we are supported when standing. In the third, the talus of the right foot is seen from the anterior aspect so that its superior part comes into view. In the fourth, the inferior surface of the same talus is represented from the anterior aspect. In the fifth, the talus is viewed from the internal [medial] side. The sixth offers for inspection the talus depicted from the external [lateral] side. In the seventh, the os calcis of the right foot is represented from the anterior aspect so that its external side shows more than the internal. In the eighth, the os calcis is shown from the internal side. The ninth shows the external side of the os calcis and, as in the two preceding figures, exhibits its superior aspect. In the tenth, the bone of the foot resembling a skiff [navicular] is seen drawn from the anterior [distal] aspect where it is joined to the tarsal bones [cuneiforms]. The eleventh presents the posterior [proximal] aspect of the same bone. In the twelfth is seen the anterior [distal] surfaces of the four bones of the tarsus [cuneiforms and cuboid] as well as of the connections to which the bones of the instep [metatarsals] are artic-* ulated. *In the thirteenth, the posterior surfaces of the four tarsal bones are observed which border on the os calcis and naviform bone.*

At the base of the fifth metatarsal in the first two illustrations of the series on the foot may be seen the small ossicle known as the Vesalian bone. There has been much confusion on the nature of this ossicle, whether it is the sesamoid bone found in the tendon of the peroneus muscle as it passes around the cuboid, the secondary epiphysis of the tuberosity seen at times in roentgenograms of children's feet, or an independent ossicle. An accessory bone in this region is very rare, an epiphysis not uncommon, and the sesamoid usual. Vesalius says that he has seen this bone "not rarely," and his discussion in the text of his work elsewhere suggests that it was the sesamoid which he saw, although the size of the ossicle illustrated would indicate an accessory ossicle.

The tarsus of the Vesalian terminology comprises the three cuneiforms and the cuboid only as generally but not consistently employed by Galen. Galen used the word "pedion," i.e., "the flat" of the foot for the metatarsals which Vesalius renders as "ossa pedii," "the bones of the instep," but by the end of the sixteenth century "metatarsal" had become customary.

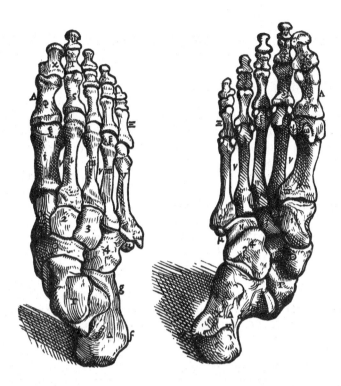

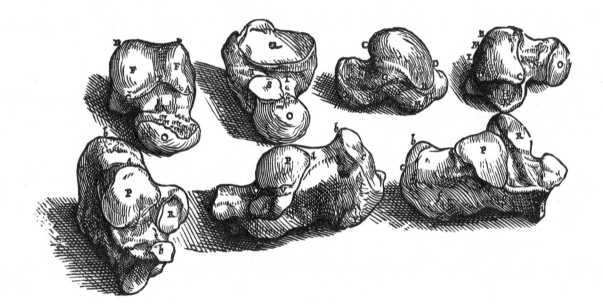

Plate 20

20:1-2 [I:xxxviii]. *The first figure of the thirty-eighth Chapter representing from the anterior aspect the whole of the rough artery [trachea] freed from all parts.*

In the second figure the posterior aspect of the stem only of the hard artery [trachea] is delineated. It was unnecessary to add to this figure the series of branches extending through the substance of the lungs since they are very evident in the first figure.

In the illustrations of the larynx, trachea and bronchi, the secondary bronchi are shown only very approximately. The specimen was obtained by partial maceration in hot water and then allowed to dry so that the hardened connective tissue elements would hold the cartilages together.

20:3-15 [I:xxxviii]. *The first of these figures, inscribed as the third [of the series], shows the first cartilage of the larynx [thyroid] represented from the right side. The figure, which is the fourth of the series, presents the internal or posterior surface of the same cartilage. In the fifth, the same cartilage is delineated from its external or anterior surface. The sixth shows the anterior aspect of the second laryngeal cartilage [cricoid]. The seventh contains the second laryngeal cartilage represented from the right side. The eighth offers the second laryngeal cartilage depicted from the posterior aspect. In the ninth, the third laryngeal cartilage [arytenoid] is delineated from the right side. In the tenth, the anterior aspect of the third cartilage presents itself. The eleventh offers to view the same cartilage from the posterior aspect. The twelfth shows the inferior aspect of the operculum [epiglottis] of the larynx, where it faces the laryngeal cavity. The thirteenth contains the superior aspect of the laryngeal operculum which looks back to the palate. The fourteenth offers for inspection one of the cartilages of the trunk of the hard artery [trachea] constructed like the letter C, from its anterior or external aspect. The fifteenth, the same cartilage from the posterior surface where it faces the internal* cavity of the rough artery [trachea].

The major laryngeal cartilages are well illustrated save for the epiglottis. The small corniculate cartilages at the apex of the arytenoids were discovered by Giovanni Santorini (1681-1737), pupil of Malpighi, and the cuneiform in the ary-epiglottic folds, not always present, still later by Heinrich Wrisberg (1739-1808), professor of anatomy at Göttingen.

20:16 [I:xxxviii]. *A likeness of the ring which the Turks use in archery.*

Vesalius compared the cricoid cartilage to the ring used by Turkish archers as shown, but does not use the word cricoid, which means ring-like. Galen says that this cartilage was left without a name by the ancients, hence it was long called the innominate cartilage. Fallopius accepted the Vesalian image and was the first to call it the cricoid, at least in modern times.

20:17-18 [I:xxxiv]. *In these two figures we have represented the nail as usually observed when avulsed from the hand or foot during the preparation of a skeleton by cooking. The right figure denotes the internal region or concavity of the nail, while the other shows its convexity.*

In his instructions for the preparation of the human skeleton by maceration in boiling water, Vesalius advises the student to avulse the nails once they have loosened from their bed, otherwise they will cook away. He recommends that they be strung on a tendon and, together with other odds and ends, be hung around the neck of the skeleton as objects for study. The root of the fingernail is indicated by the letter B.

20:19 [I:xxxv]. *In this figure we have delineated the cartilage of the upper and lower eyelids, separated from the remaining parts.*

The so-called tarsal plates of the eyelids are here shown as obtained by maceration.

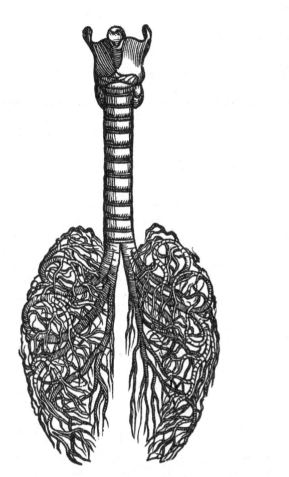
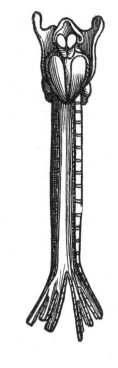

Plate 21

21[I]. *A representation from the anterior aspect of the bones of the human body articulated together.*

Vesalius was strongly convinced that a knowledge of the bones was the essential preliminary to the study of anatomy and therefore provides the student with complete instructions on their preparation and the mounting of an articulated skeleton. The three successive plates illustrating the skeleton from the anterior, lateral and posterior aspects must therefore be viewed in relationship to the muscle figures of the second book of the *Fabrica* and to the nude figures of the *Epitome*. In conformity with a carefully thought out plan certain correspondences, either direct or as mirror images, will be found in the position of the extremities, thus providing a basis for the appreciation of muscle attachments and surface landmarks. However, Vesalius says that the mounted skeleton "to speak the truth, contributes more to display than to instruction." We suppose, therefore, that these illustrations were intended, like certain of the muscle figures, primarily for the instruction of the artist. If this was Vesalius' intent, he has been eminently successful as they have been universally admired for their dynamic qualities and have been reproduced, copied or modified in one form or another on countless occasions.

The skeleton, the spade and the open grave constitute a motive derived from ancient traditional sources in the personification of Death and the Danse Macabre, but the evolution of the pose is not difficult to follow in the Vesalian works. In the chapter on the articulation of the skeleton, Vesalius recommends the insertion into the mounting board of a spear, scythe, trident or similar object to which the hand of the specimen is attached. Its purpose is not only to add decorative value but also to provide additional security and stability to the skeleton. A preparation mounted in this manner is to be seen in the dissection scene of the title page. It is obvious that such an arrangement is responsible for the curious pose of the earlier skeletal figures of the *Tabulae Sex* (q.v.), where the right hand evidently held a staff. The practice doubtless influenced and suggested the pose of the present illustration. The odd position of the horizontal portion of the handle of the spade, set at right angles to the blade, made an admirable support for the specimen but a poor implement for turning the sod.

Although the skeletal figures are so greatly admired, they present many errors of proportion, some of which Vesalius himself recognized. The skeleton is that of a seventeen- or eighteen-year-old male, which has been reduced to approximately a fifth of natural size. However, the thorax is too short, the lumbar spine too long and the entire torso somewhat too short. The spinal curvatures, fully recognized by Leonardo da Vinci, are virtually absent, undoubtedly due to the Vesalian method of mounting the preparation, in which the vertebrae were threaded over a rigid iron bar thrust through the sacrum and bent quite empirically. As a consequence of the loss of the curves the ribs are too horizontal, giving the chest the balloon-like appearance of emphysema, and the normal pelvic tilt is diminished. The ratio of tibia to femur is approximately correct. The arm appears to be too long owing not only to the shortness of the torso but as well to the forearm bones being too long for the humerus which, in turn, is too short so that the proportional length of upper limb to lower, or intermembral index, is far too low for a European subject. These proportional errors are not due to the effects of foreshortening from a low eye point but apparently from the application to the skeleton of one of the classical canons of proportion designed for the intact body.

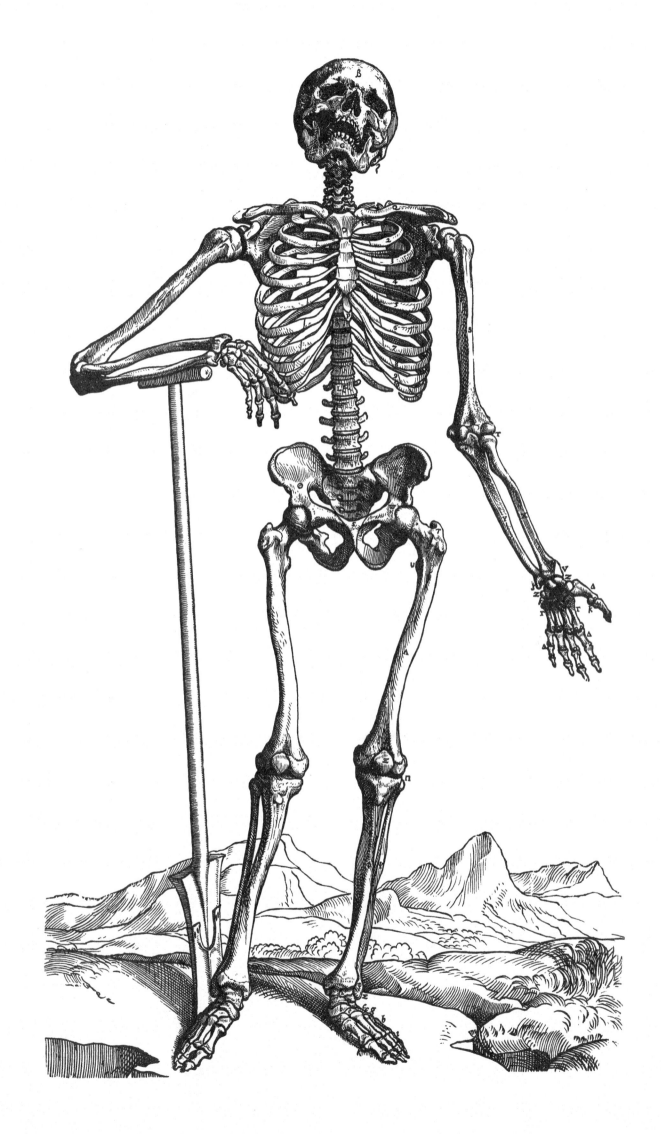

Plate 22

22 [I]. *A delineation from the side of the bones of the human body freed from the rest of the parts which they support, and placed in position.*

The skeletal Hamlet soliloquizing beside the tomb upon some poor Yorick is perhaps the most greatly admired figure of the osteologic series. On the left of the separate skull is the hyoid bone and on the right, marked by an asterisk and "que," lie two of the ossicles of the middle ear, the malleus and incus, which curiously enough and despite the clear labeling of the parts, have been regarded by some as indicating the name of the engraver. The inclusion of these structures was to enable the student to make an enumeration of the bones since their exact number was of great moment to early anat-
omists, who defended their opinions with considerable force. However, Vesalius had long since become bored with the controversy, remarking, "If you count all the bones as seen in children, good God, what a great pile of bones you will heap up!" The figure exhibits errors in proportion similar to those commented upon in connection with the previous illustration, but in order to appreciate the great advance in draughtsmanship the series should be compared with those first published by Vesalius in the *Tabulae Sex.*

In the original version of the above plate the motto *Vivitur ingenio, caetera mortis erunt* —"Genius lives on, all else is mortal"— was inserted on the side of the tomb.

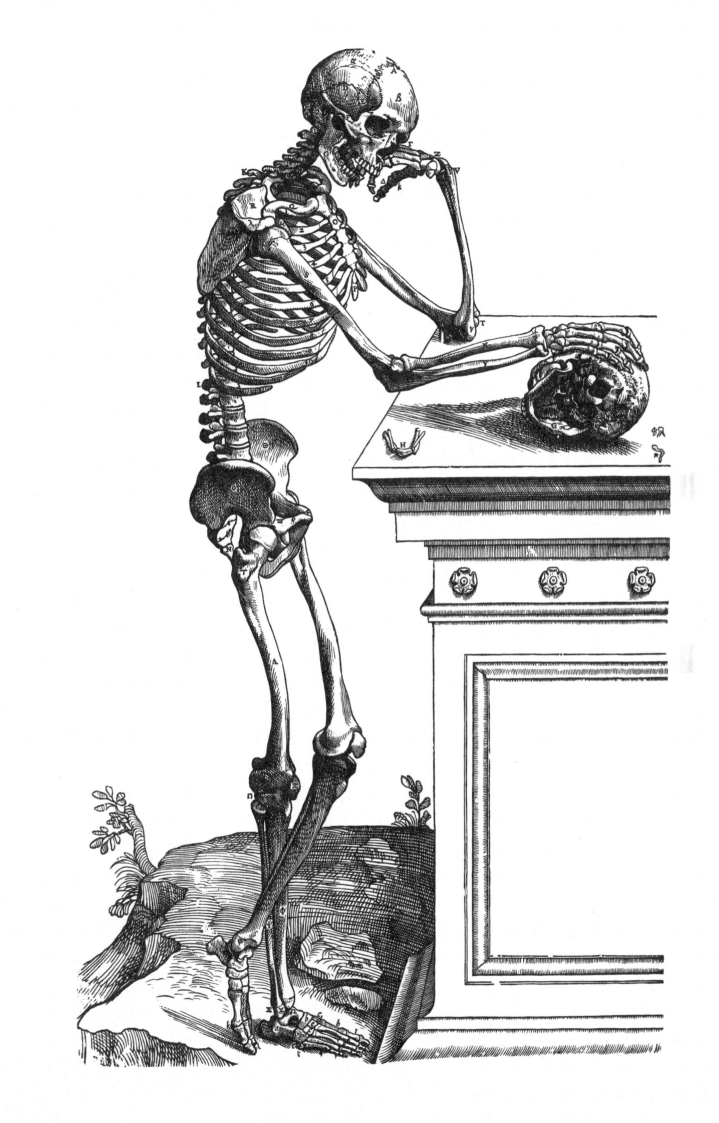

Plate 23

23[I]. *The bones of the human body presented from the posterior aspect.*

In view of the permanence of the skeletal system it is curious that prior to Vesalius no part of the body was more wretchedly treated by the anatomist and so poorly illustrated. There is evidence which suggests that this was due to the influence of a papal decretal issued in 1300 by Boniface VIII and directed against the practice of boiling the bones of persons who had died abroad, in order to facilitate transportation for sepulcher at home, but which was interpreted as extending to anatomical pursuits. Although abundant osteological material was available in the charnel house and cemetery, these sources were seldom used since the authorities looked upon grave robbing as a sacrilegious violation of consecrated ground. Nonetheless, Vesalius, while a student at Paris, was able to gain access to the Cemetery of the Innocents where great heaps of bones, disinterred to make way for an extension of the city wall, were stored in an ossuary. As Vesalius points out, material from these sources was not entirely suitable for the preparation of a mounted skeleton because of the difficulty of obtaining bones from a single subject. He

therefore considered himself lucky to find outside the walls of Louvain the almost intact skeleton of a criminal who had been roasted and suspended from a stake, and whose bones had been picked clean by the birds. With the assistance of his friend Regnier Gemma, the notable mathematician, astronomer and physician, he climbed the gallows and secretly transported home his great prize. The hardened remnants of tissue clinging to the specimen made it necessary to macerate in boiling water, and when it was clean, he constructed his first articulated skeleton to which he added the foot and hand and two patellae obtained from other sources. From this experience was introduced the technique of maceration which he fully describes and which rapidly became universal. How many preparations Vesalius articulated we are unable to say. We know that he constructed a skeleton with the assistance of Andreas Albius for his course at Bologna in the winter of 1539-40, and while waiting for the publication of his great work he articulated another which he presented to the town of Basel in 1543 and which, in part, is still preserved, the oldest anatomical preparation in existence.

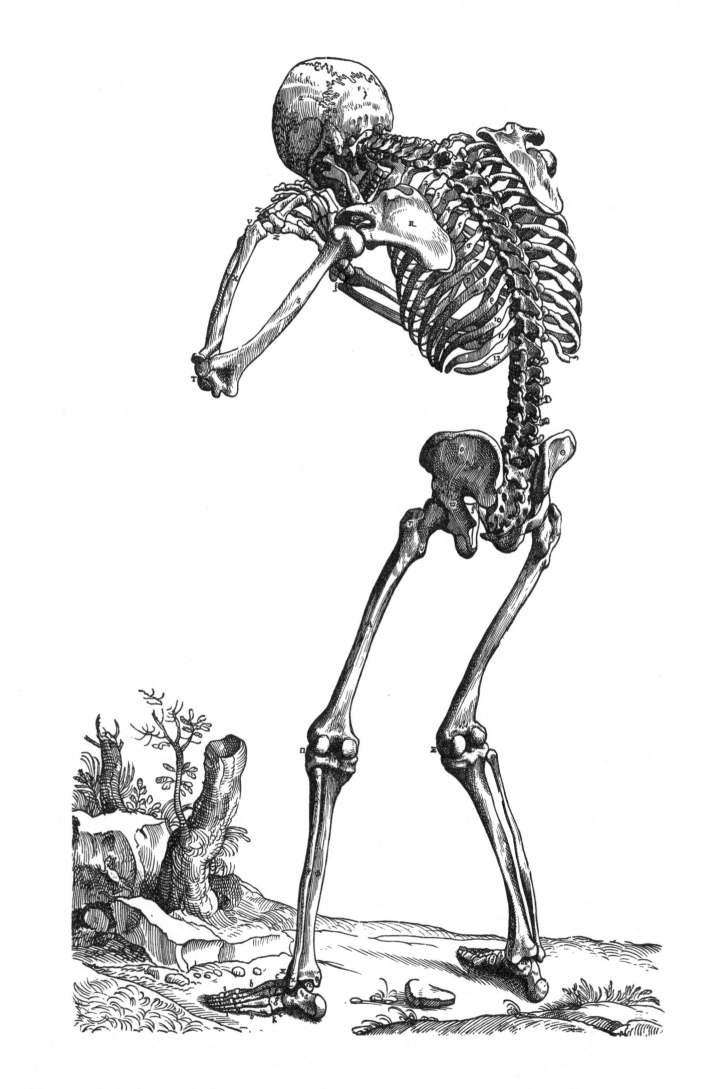

THE PLATES

FROM

THE SECOND BOOK

OF THE

DE HUMANI CORPORIS FABRICA

Plate 24

THE FIRST PLATE OF THE MUSCLES

24 [II]. *The first plate illustrates the anterior view of the body from which I have cut away the skin together with the fat, and all the sinews, veins and arteries existing on the surface. No portion of the membrane which we call fleshy [deep fascia] has been left, even in those regions in which this becomes muscle-like. This we have displayed in the third plate, there dissected in many regions, so that in that plate, as well as in the second and the ninth, the fleshy membranes are not so obscure. These plates display a total view of the scheme of muscles such as only painters and sculptors are wont to consider.* . . .

The first, together with the second, third and ninth plates of the muscles series, was apparently designed not only to reveal to physicians the superficial arrangement of the muscles but also, as indicated by Vesalius' own introductory statement, for the special use of artists and sculptors. Indeed, it has been in the latter use that these illustrations, especially plates 25 and 26, have been employed almost continuously for the past 400 years and may be found in modified form in a great number of textbooks on anatomy for art students today. Likewise, from plate 25 an écorché has been constructed of which occasional examples may be encountered in art supply shops.

One of the characteristic features of all Vesalian figures is the attempt to represent the dissected body in dynamic fashion with greater emphasis on the living than the dead. In the dissections at a deeper level this has given rise to a rather bizarre and ragged appearance of the figures, but it serves to emphasize the fact that in the sixteenth century there was no separation between morphology and function. On the significance of the backgrounds to the figures the reader should consult the introduction.

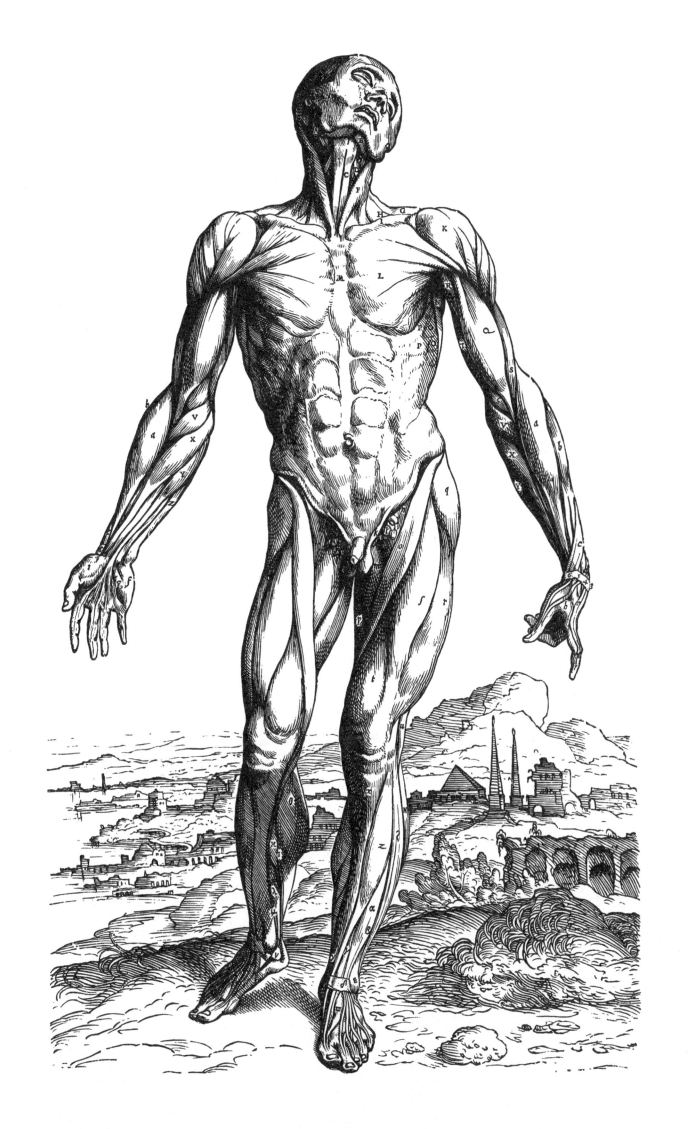

Plate 25

THE SECOND PLATE OF THE MUSCLES

25 [II]. The second plate corresponds entirely to the first since it concerns the dissection, which has been turned to the side to display the same muscles as the former, together with the bony regions, prominent on the surface and somewhat excarnate. Therefore almost the entire surface, as well as the head since it is osseous in only a little less than its entirety, is consequently indicated by very few letters.

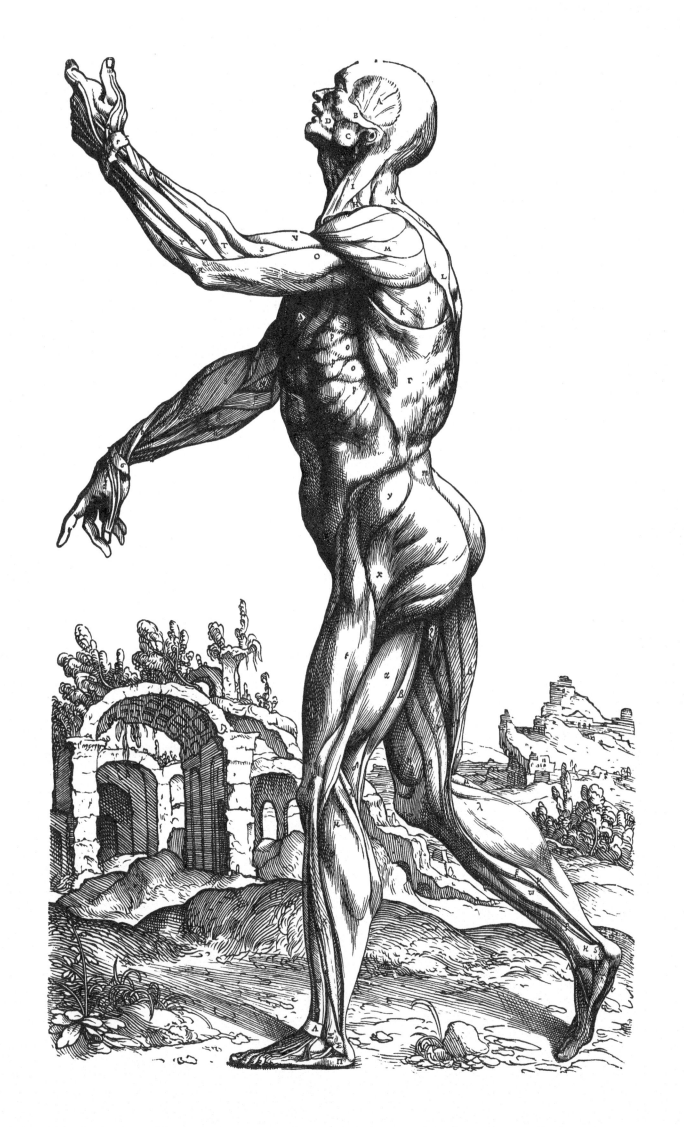

Plate 26

THE THIRD PLATE OF THE MUSCLES

26 [II]. *The present plate illustrates the anterior view of the body and differs from the first plate of the muscles in this way, that it displays the muscles constituted of fleshy membrane, and also several of the facial muscles, completely freed of fat. Wherefore it is more conducive than the first two to teaching these latter muscles. . . .*

Owing to the influence of Galen and the dependence of anatomists on the dissection of animal bodies, the question as to whether the panniculus carnosus was to be found in man was a subject of very considerable dispute. Vesalius clearly recognized that such a panniculus, except for the platysma muscle, was absent in man. However, the term "fleshy membrane" continued to be used in the modern sense of deep fascia, that is, the membrane covering the flesh, which was regarded as being infiltrated by true muscle tissue in certain regions and so giving rise to the platysma, the facial muscles and the superficial muscles of the scalp. Although Vesalius was able to demonstrate the existence of certain of the more obvious of the facial muscles, he was rather obscure as to their details, and this section is one of the poorest in his discussion on myology.

It will be observed by comparison of the first three plates and plate 32 that almost every aspect of the superficial muscles is revealed. The Vesalian myological illustrations are specifically designed so that the reader may, by reference to several of the plates, observe the shape and attachments of the individual muscles from every point of view.

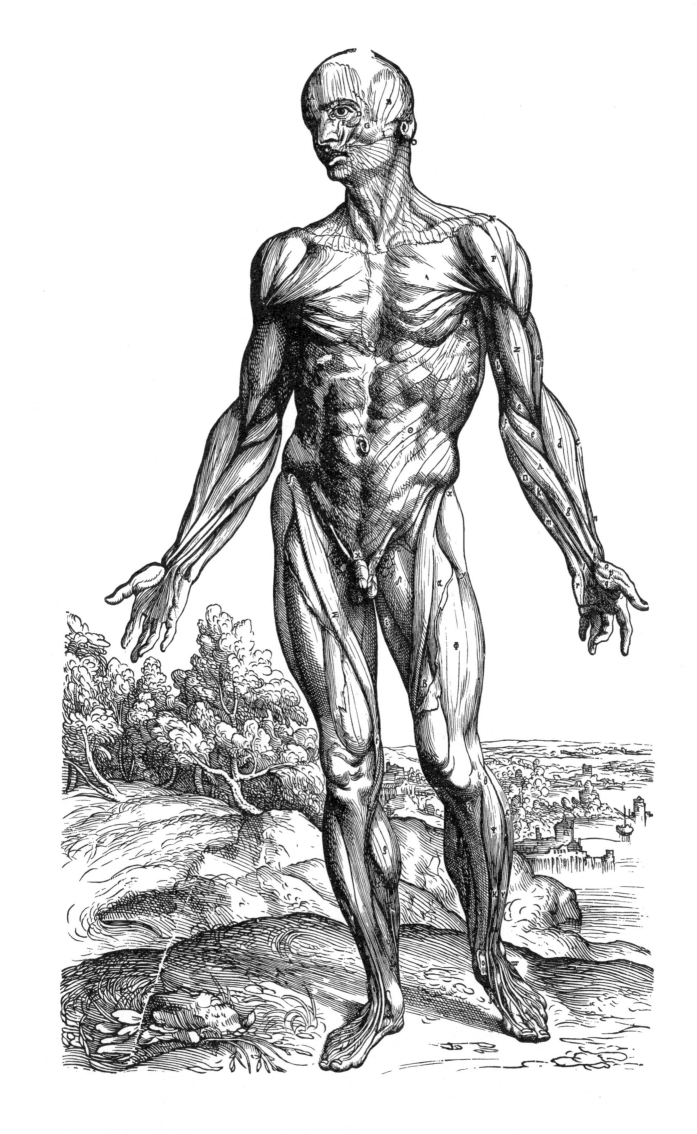

Plate 27

THE FOURTH PLATE OF THE MUSCLES

27 [II]. *The fourth plate shows as many as possible of the muscles of the preceding plate, lifted away in the progress of dissection, and thereupon offers for inspection many which have not yet come into view in the earlier plates; though all the subsequent muscles are exhibited to some extent as far as the eighth plate of the muscles when the anterior surface of the bones becomes denuded.*

Vesalius, having displayed in the first three plates the anterior and lateral aspects of the superficial muscles of the body, both with and without their fascial coverings, proceeds in the next four plates to the systematic exposure of the deeper muscles, layer by layer. Plates 27 to 31 are designed to complement one another so that in almost all instances a more superficial muscle is turned down but left attached before being entirely removed on the opposite side of the same plate or in a subsequent illustration. This feature receives considerable emphasis in the text of the *Fabrica*, with which the plates are closely correlated by means of marginal references, so that the student may acquire an intimate knowledge not only of the general appearances of the muscles but also of their precise attachments.

In what Vesalius terms his "order or sequence of dissection" the platysma and some of the more superficial of the facial muscles are removed to expose the buccinator, masseter, temporal and nasalis muscles in the facial region and the superficial muscles of the anterior and posterior triangles. In the trunk, the pectoralis major and external oblique muscles have been turned laterally on the right side of the subject and excised on the left to expose the internal obliques. In the right forearm, the dependent muscles are the flexor carpi radialis and palmaris longus with the palmar fascia, which are removed on the left. Tensor fascia lata and the sartorius are turned down in the right lower extremity and cut away on the left. The right tibialis anterior has been dissected free from its origin and is seen lying on the ground behind sartorius while the tendon of the left muscle appears as a tag in the region of its insertion into the foot.

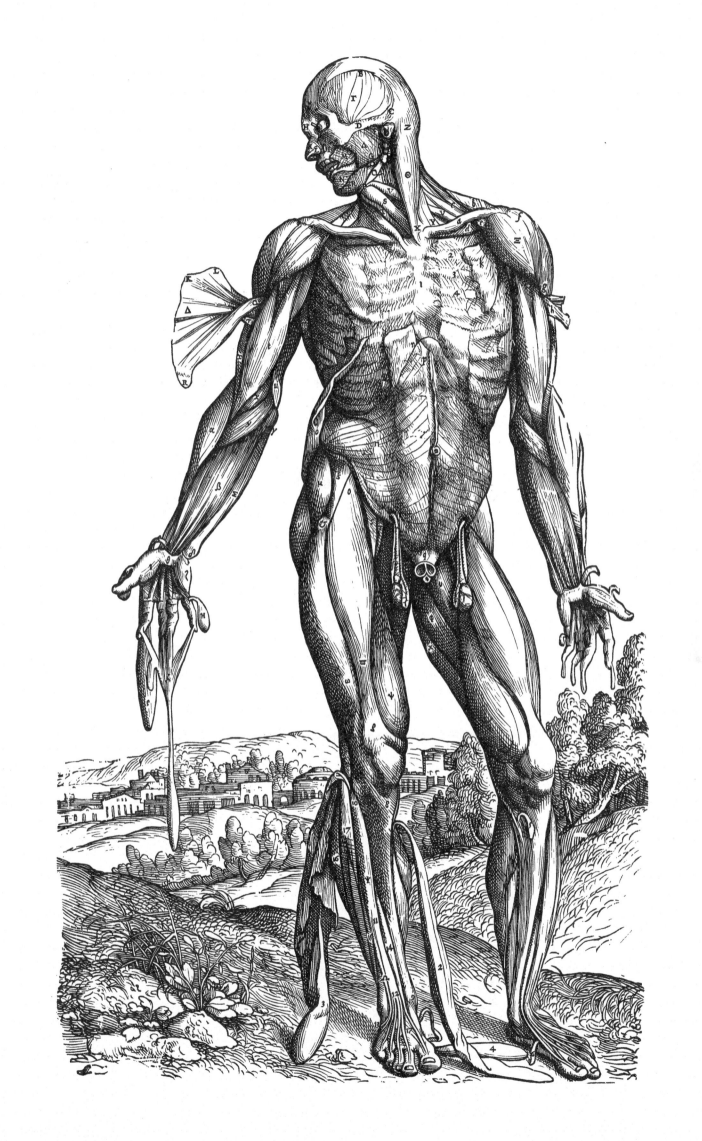

Plate 28

THE FIFTH PLATE OF THE MUSCLES

28 [II]. *Just as the fourth plate shows many muscles dissected and lifted away, which were seen intact in the third plate, so the fifth in the sequence of dissection has many removed which were fully uncovered in the fourth. This plate also exposes many which will be shown reflected in the sixth. Meanwhile it should not be neglected that we have advised the reader immediately at the beginning of this book that the plates expressing the anterior surface of the body mutually correspond in order with the dissections which display the posterior surface; that is to say, just as if this were to follow the tenth plate, for the present [plate] nowhere makes apparent muscles which are shown reflected in the tenth plate.*

The extension of the rectus abdominis muscle to the level of the first rib, an arrangement found only in lower forms, appears at first sight to be a glaring blunder on the part of Vesalius. However, it should be recognized that Vesalius not infrequently incorporated many of his observations on comparative anatomy in his illustrations of the human figure. This may have been done to economize on space but is perhaps more truly a reflection of his teleological outlook since Vesalius characteristically introduces into his text theoretical arguments as to what position a structure found in animals would occupy if it occurred in man, thus revealing the errors of Galen. The telescoping of human with other mammalian findings in the illustrations is very confusing unless careful attention is given to the text, and superficial judgments of the illustrations alone have often resulted in Vesalius being unjustly accused of committing errors of the Galenical sort. In this particular instance Vesalius specifically states that the upper part of the muscle is a tendinous extension found in apes and dogs. The massiveness of the scalenus anterior muscle is to demonstrate the findings in dogs and is better seen in the next plate.

The continuation of the dissection consists of the excision of the sternomastoid displacement of the digastric, removal of the mylohyoid and sternohyoid muscles and separation of the sternothyroids to reveal the trachea. The right clavicle has been hinged laterally on the acromio-clavicular joint. The left pectoralis minor has been removed. The left internal oblique is now seen hanging from the side of the subject, and the right has been excised. In the upper extremities the right deltoid and right flexor carpi ulnaris are detached from their origins, but only their tendons are apparent on the left. The muscles turned down in the right thigh are rectus femoris and gracilis and in the right leg, extensor digitorum longus. Extensor hallucis longus has been left intact.

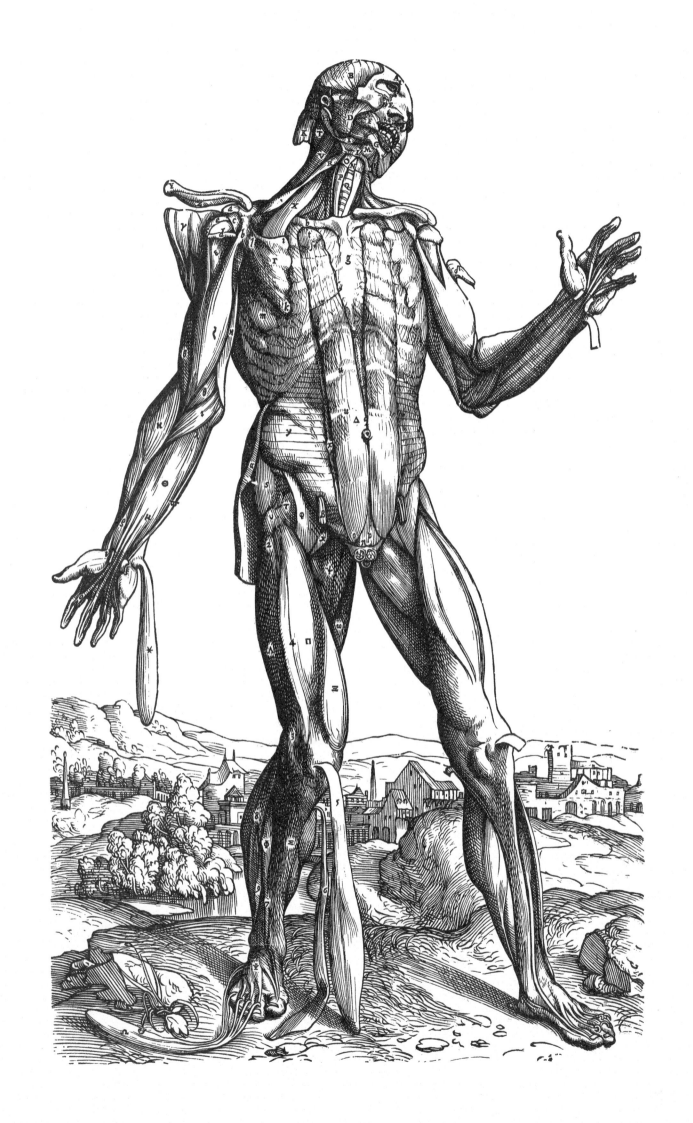

Plate 29

THE SIXTH PLATE OF THE MUSCLES

29 [II]. *The head in the sixth plate has been bent backward and represents the lower jaw divided at the point of the chin and drawn to either side.*

The scalenus anterior muscle is extended beyond the first rib to reveal one of Galen's errors and to demonstrate that his knowledge of this structure was derived not from man but from the dog. A fuller discussion on the incorporation of animal findings in illustrations of the anatomy of man is given in connection with the previous plate.

The dissection deepens. The fauces, tonsils, tongue and internal pterygoid muscles are revealed by splitting the jaw. Nowhere will the external pterygoids be found since these were discovered a few years later by Fallopius. The dependent tag hanging from the mastoid region is the digastric muscle. The bizarre appearance of the anterior scalenus has been commented upon above. The dependent rectus abdominis with its tendinous inscriptions is easily recognized. The pyramidalis muscle was not segregated until the time of Fallopius, although discussed by the Vesalian school. The abdominal muscle now exposed is, of course, transversus. In the forearm, flexor digitorum sublimus is quickly identified. In the lower limb, gluteus medius has been removed to expose gluteus minimus. The muscle dependent from the patella is now the left vastus lateralis, the right appearing only at its divided tendon. A portion of the long head of biceps femoris, corresponding to the stage seen in the eleventh muscle plate, appears on the lateral side of the left knee. It is such correspondence of details which makes one believe that a single subject was employed in the preparation of the muscle plates and that the anterior and posterior series were drawn at the same time by one or more artists. In the left leg, extensor hallucis longus is observed on the ground, and the peroneal muscles have been separated to reveal a small portion of peronaeus brevis. The calf muscles project far behind.

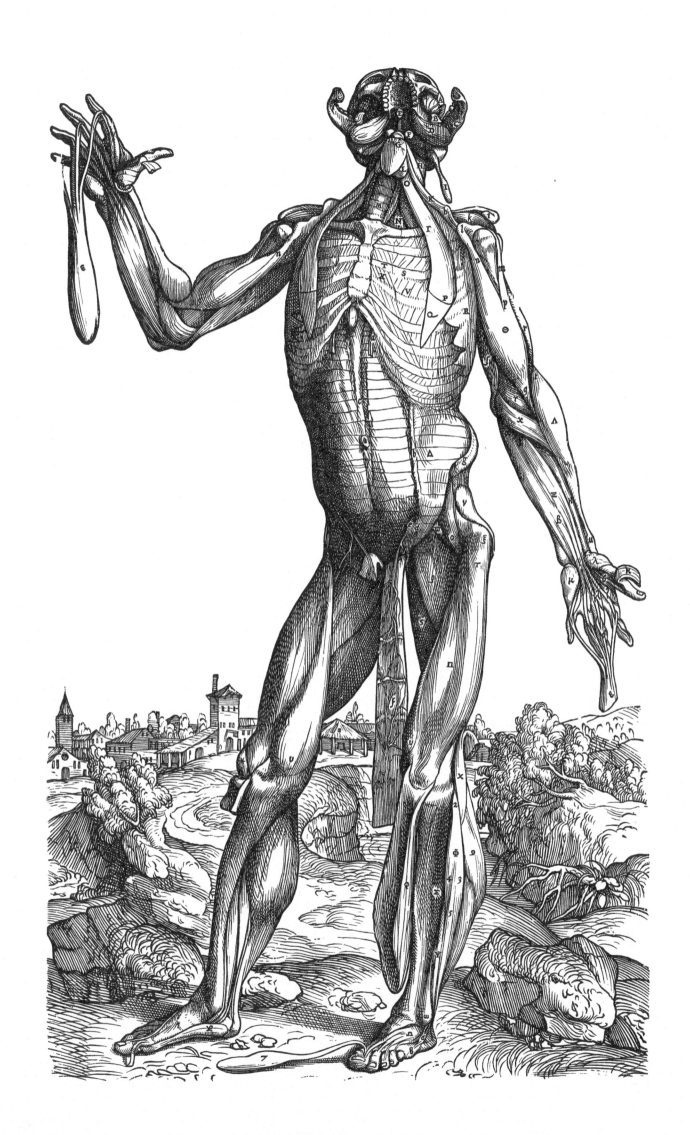

Plate 30

THE SEVENTH PLATE OF THE MUSCLES

30 [II]. *In the seventh plate of the muscles, owing to the slackness of the rope by which the body hung during delineation, it falls somewhat to the rear, and inasmuch as the peritoneum and everything enfolded in it has already been reflected, it provides a view of the septum transversum [diaphragm] which will also be observed in the present plate depicted on the left in that form in which we saw it when excised and, owing to its flexibility, adhering to the wall. Furthermore, to prevent the right scapula from falling downwards like a broken wing, we so suspended it by a rope that the whole of its hollow surface was brought into view.*

The display of the diaphragm and the precise position of the caval, esophageal and aortic openings together with the distribution of the inferior phrenic vessels was of special significance to Vesalius since it was one of the earliest matters in which he had openly announced his disagreement with Galen. His opinion was first published in his *Venesection Letter* of 1539.

In the dissection procedure, longus colli and capitis, levator scapulae, scalenus medius and posterior treated as a single muscle, are revealed. All the abdominal muscles have been removed except psoas major, iliacus and quadratus lumborum. In the upper arm, biceps brachii is turned down on one side and excised on the other. The divided tendon of latissimus dorsi is seen below teres major in the right arm. In the left forearm the dependent muscles are flexor digitorum profundus and flexor pollicis longus, and in the right, brachio-radialis. Pronator teres and pronator quadratus are easily recognized. Although the lumbricles can be identified, too great attention should not be paid to the small muscles of the hand since they were grouped in a manner quite foreign to modern conceptions. In the thigh pectineus, disproportionately large, the adductors treated as a single muscle, and vastus intermedius and medialis, also regarded as one, are observed. Extensor digitorum brevis is turned back in the left foot and its belly to the hallux, regarded as a separate muscle (extensor hallucis brevis), is observable on the right.

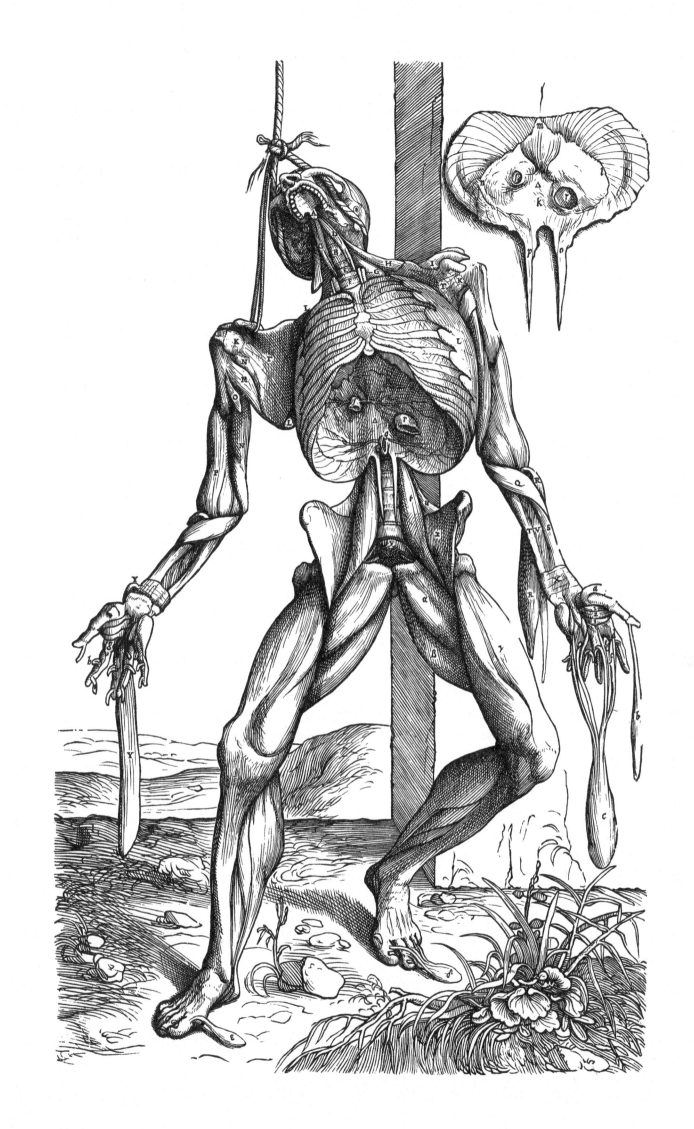

Plate 31

THE EIGHTH PLATE OF THE MUSCLES

31 [II]. *This is the last of the plates portraying the anterior surface of the body, presenting the remaining muscles of the anterior region in the sequence of dissection. In order to show the internal intercostal muscles and those in the interior of the thorax which are stretched to the sides of the pectoral bone, that bone together with the costal cartilages has been dissected, and you will observe it placed below the index finger of the right hand so as to present the internal surface which faces the thoracic cavity.*

The final plate of the anterior series leaves the skeleton almost entirely denuded of all except the deepest muscles. The anterior scalene is now shown as it appears in man. The muscles of the torso are much as seen in the prior plate. In the upper extremity, subscapularis hangs from its insertion in the right arm, and all but its tendon, on the left. In the right forearm, the tendon of biceps brachii, pronator teres, and flexor pollicis brevis hang free. In the left forearm, pronator quadratus is turned back. Brachialis and the interossei of the hand are chiefly demonstrated. In the right lower limb, vastus intermedius and medialis, treated as a single muscle, have been turned down. In the left thigh, the adductors have been removed to expose obturator externus, and in the left leg, the two heads of gastrocnemius have been detached and trail on the ground.

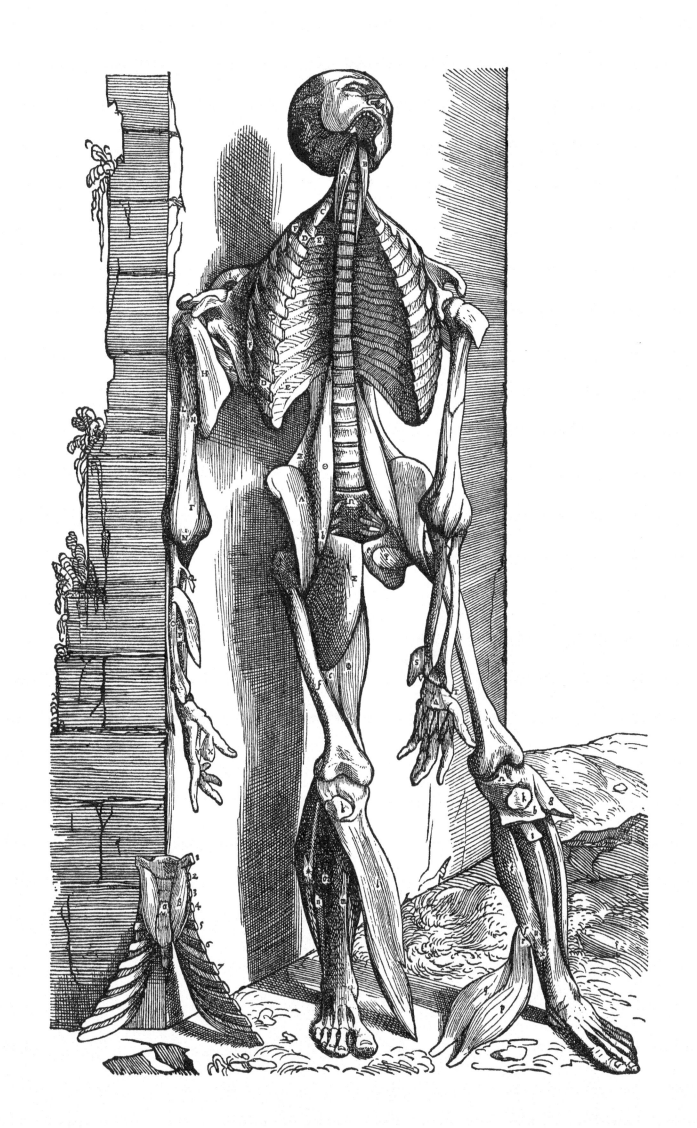

Plate 32

THE NINTH PLATE OF THE MUSCLES

32 [II]. The ninth plate is the first of all those portraying the posterior surface of the body. No muscle has been dissected away except those which constitute the fleshy membrane, and made apparent in the third plate. But here we have dissected the transverse ligaments lying on the outer aspect of the forearm near the wrist, because they were clearly to be seen in the first and second plates and denoted by numerals.

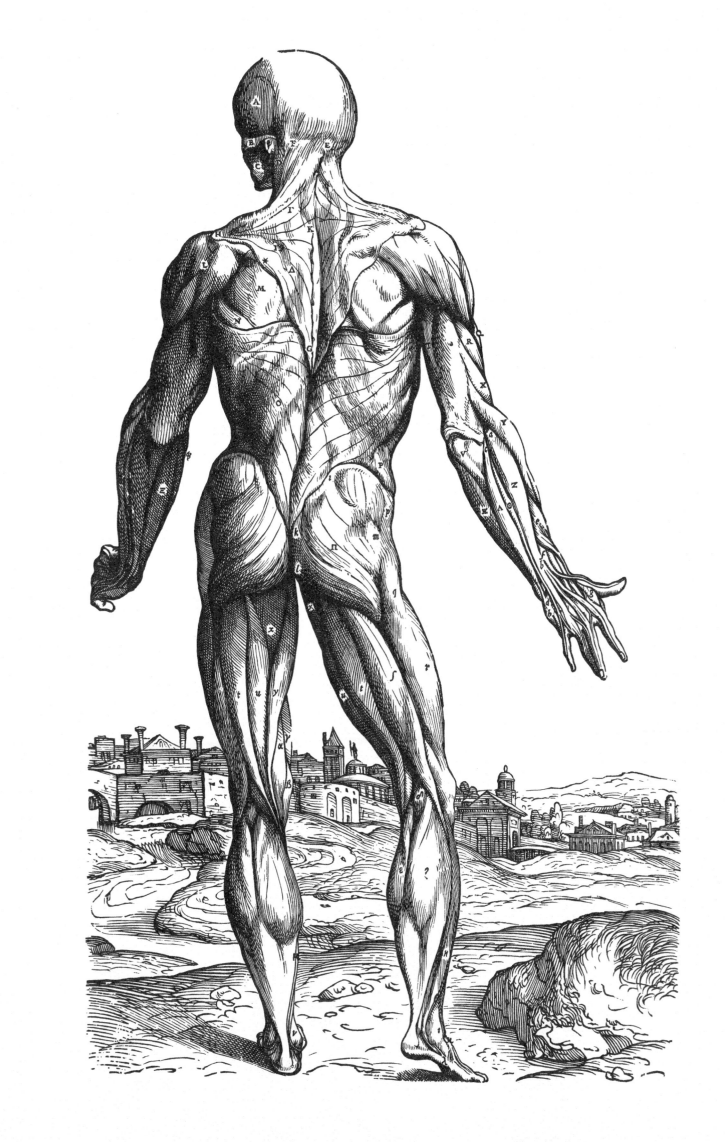

Plate 33

THE TENTH PLATE OF THE MUSCLES

33 [II]. *In this plate, the tenth of the entire series and the second of those portraying the posterior surface, several muscles which were seen intact in the preceding plate now hang free in the sequence of dissection, and many, not met with in the latter, are here shown. However, that muscle which we indicated in the ninth plate by Γ and Δ [trapezius m.] has been entirely removed, because it was impossible to show its shape appropriately, and it interfered with the inspection of certain muscles.*

As Vesalius mentions, the trapezius has been removed to expose the rhomboids, not yet divided into major and minor, the splenius and semispinalis capitis. In the upper extremity the extensores, digitorum communis, digiti quinti and carpi ulnaris, are seen dependent from their insertions to expose the supinator; the abductor and extensors of the thumb and extensor of the index finger, the tendons of the extensor carpi radialis longus and brevis and, on the ulnar side, the medial collateral ligament of the wrist joint. In the lower extremity, the gluteus maximus has been turned down on one side and excised on the other to reveal gluteus medius, the lateral rotatores of the hip and the sciatic nerve. This, we believe, is the first illustration in the history of anatomy to show the piriformis, gemelli and obturator internus muscles.

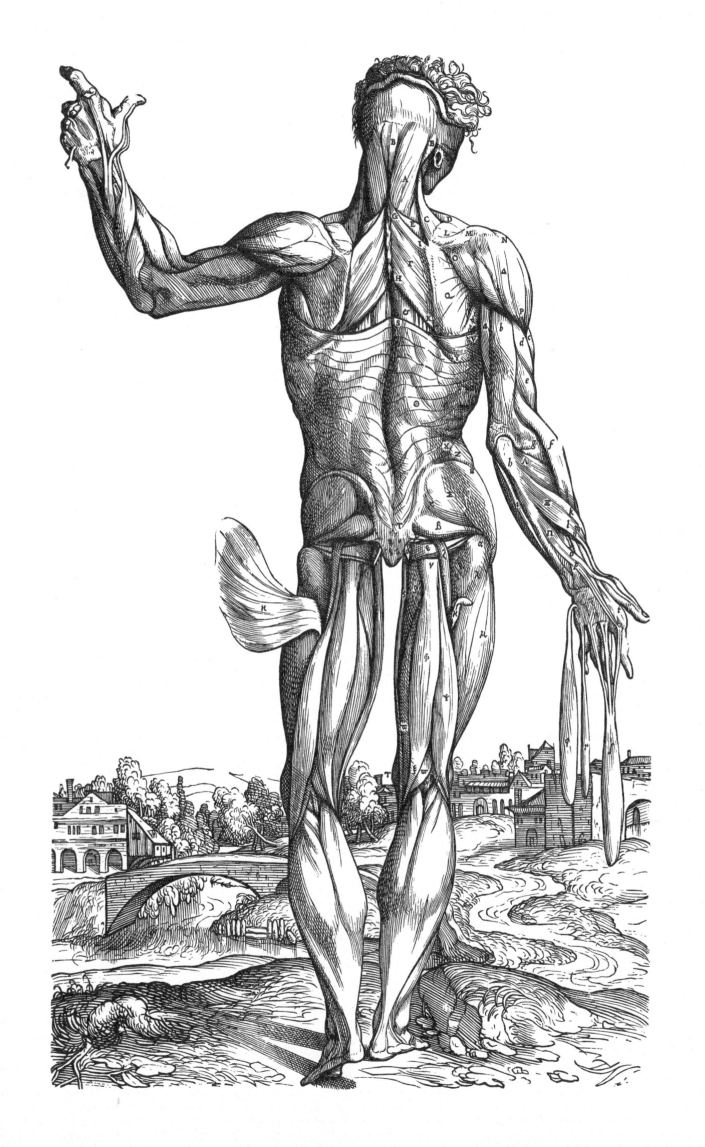

Plate 34

34 [II]. Vesalius provides no introductory remarks to this plate. The dissection has been carried a stage further by the reflection, in the case of the torso, of the latissimus dorsi which is seen hanging from its insertion on the left side of the figure. Serratus posterior superior and inferior are crudely represented, no doubt due in part to the difficulty of expressing such delicate muscles in woodcut. The three essential elements of the sacrospinalis, spinalis, longissimus and ilio-costalis, are well shown. In the upper extremities, the deltoid muscles have been reflected exposing the lateral rotators of the shoulder, but the teres minor muscle was not recognized until after the publication of Fallopius. On the dorsal aspect of the right forearm the obliquely placed muscles passing to the thumb and index finger have been turned back exposing more clearly the supinator and the extensor carpi radialis longus and brevis. In the lower extremities, gluteus medius has been excised to expose gluteus minimus, and in the leg, the long head of biceps femoris turned back on one side and excised on the other to show its short head; the same has been done in the case of the semitendinosus to reveal semimembranosus and the adductor mass.

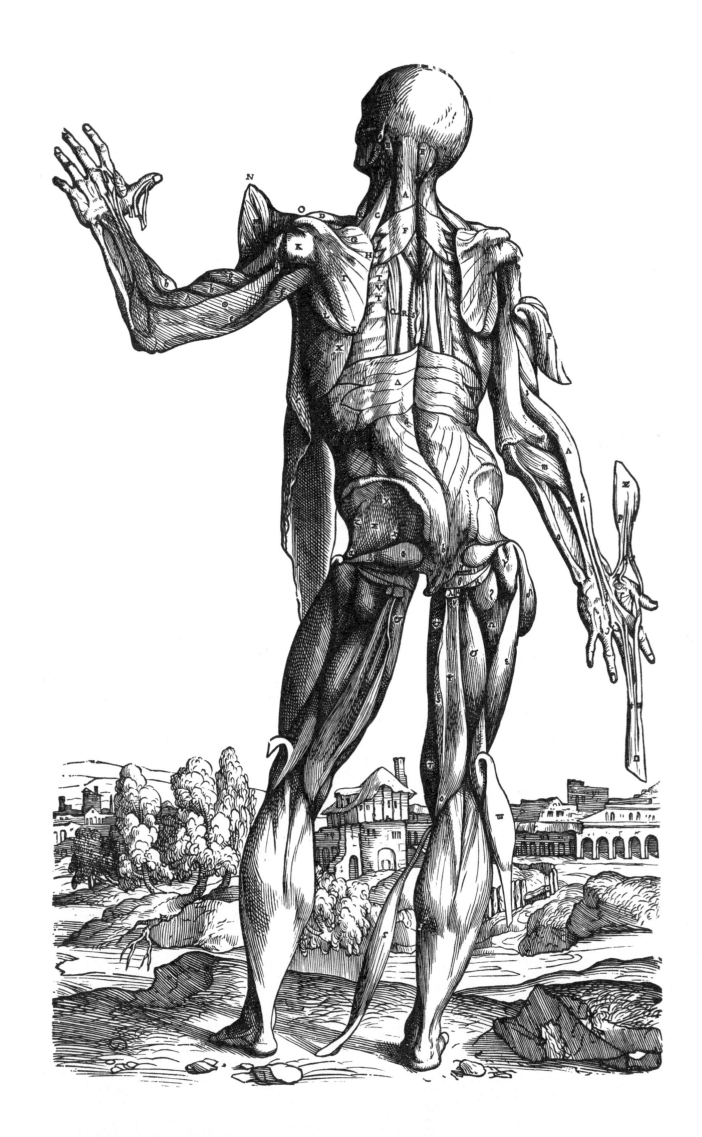

Plate 35

35 [II]. "The order of the dissection" continues with the further exposure of the spinal muscles. The scapulae have been denuded of muscles; the infraspinatus turned forward on the right and excised from its tendon on the left. Likewise, the lateral head of triceps is turned down on the left and excised on the right. Dissection of the forearm proceeds with the reflection of the radial extensors of the wrist, seen dependent on the left, and the severance of their tendons on the right to show the brachio-radialis muscle, the supinator and the interosseus membrane. In the lower extremities, gluteus medius and minimus have been reflected or removed, and the two heads of the biceps femoris are seen hanging from their insertion on the left, and semimembranosus on the right.

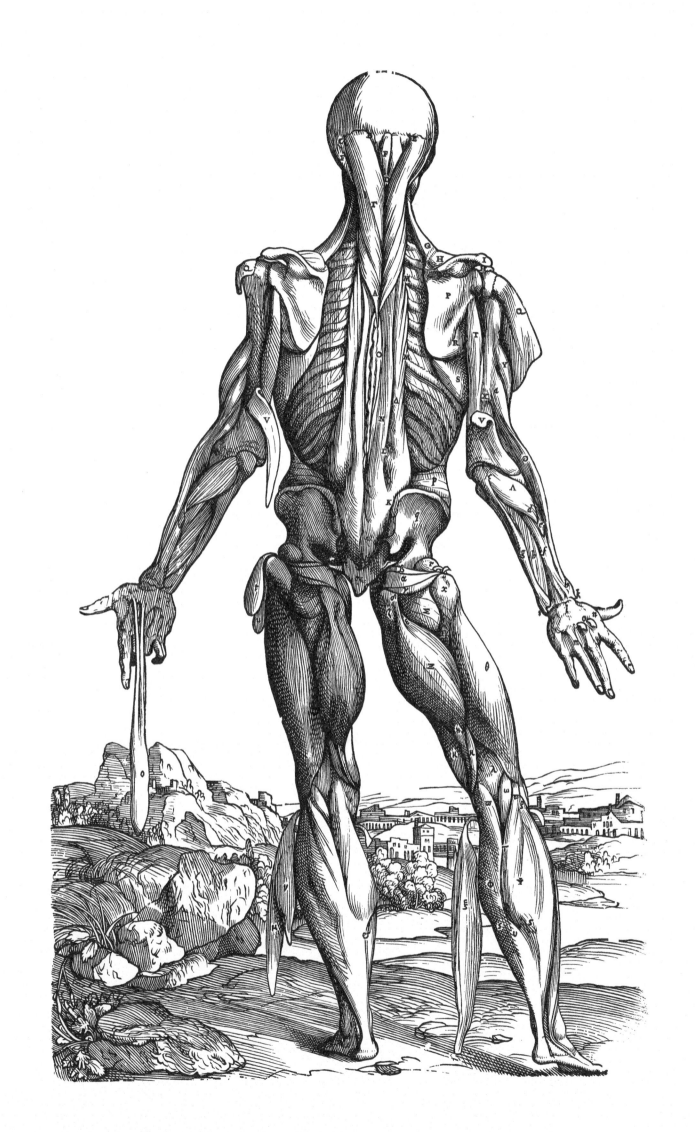

Plate 36

THE THIRTEENTH PLATE OF THE MUSCLES

36 [II]. In this, the penultimate plate of the posterior series, the deeper spinal muscles are exposed, but Vesalius was very confused on their arrangement. On the right, iliocostalis is seen dependent and quadratus lumborum more clearly exposed. Teres major, the three heads of triceps hanging from the olecranon, brachialis, pronator teres and supinator seen hanging, are the muscles illustrated. In the gluteal region, apart from the other short lateral rotators of the hip, obturator externus is demonstrated with internus turned down on the left. In the thigh, the adductor mass has been turned down on the left, exposing vastus lateralis and medialis. In the leg, reflection or excision of the gastrocnemius displays the deeper muscles, plantaris, popliteus and soleus. The superficial dissection of the sole of the foot reveals the plantar fascia.

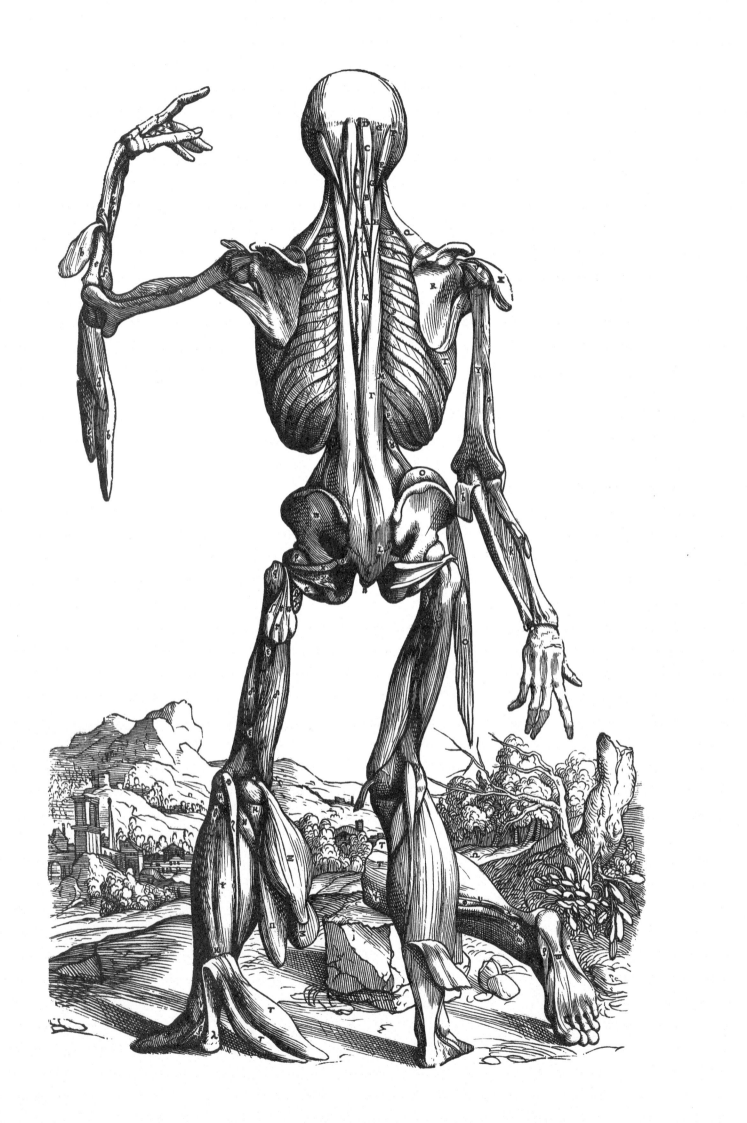

Plate 37

37 [II]. *The figure in this plate lacks particularly the scapulae and arms, already seen in the sequence of dissection. The knees are bent to expose the sole of one foot to the observer. Near the knees, in order to avoid the drawing of another complete plate, is placed the head together with the first two cervical vertebrae to show the fourth pair of muscles moving the head [rectus capitis posterior minor]. Then beside the right foot (which in the sequence of dissection follows that shown in the figure placed near the more complete representation of the body in the thirteenth plate and indicated by the letter Ω) rests another figure which in the order of dissection follows here the foot seen in the more complete representation and which is indicated by the letter Δ.*

The sequence of dissection of the muscles from behind is now complete. The recti and oblique muscles of the suboccipital region are beautifully shown, but not too much attention should be paid to the back muscles since Vesalius was understandably lost in their complexities. The ilio-costalis has been separated from the rest of the sacrospinalis to reveal between them the quadratus lumborum. Obturator externus and the tendon of obturator internus and gemelli are seen hanging from their insertions at the upper end of the left femur. The curious structures dependent from the right femur are the psoas major and iliacus muscles. In the left leg, the triceps surae has been turned back to expose the deep flexor muscles, not very accurately portrayed, and on the right, triceps surae has been excised to show the same muscles more clearly. The short flexors of the toes in the intact figure and the long flexor tendons in the detached specimen are fairly adequately represented.

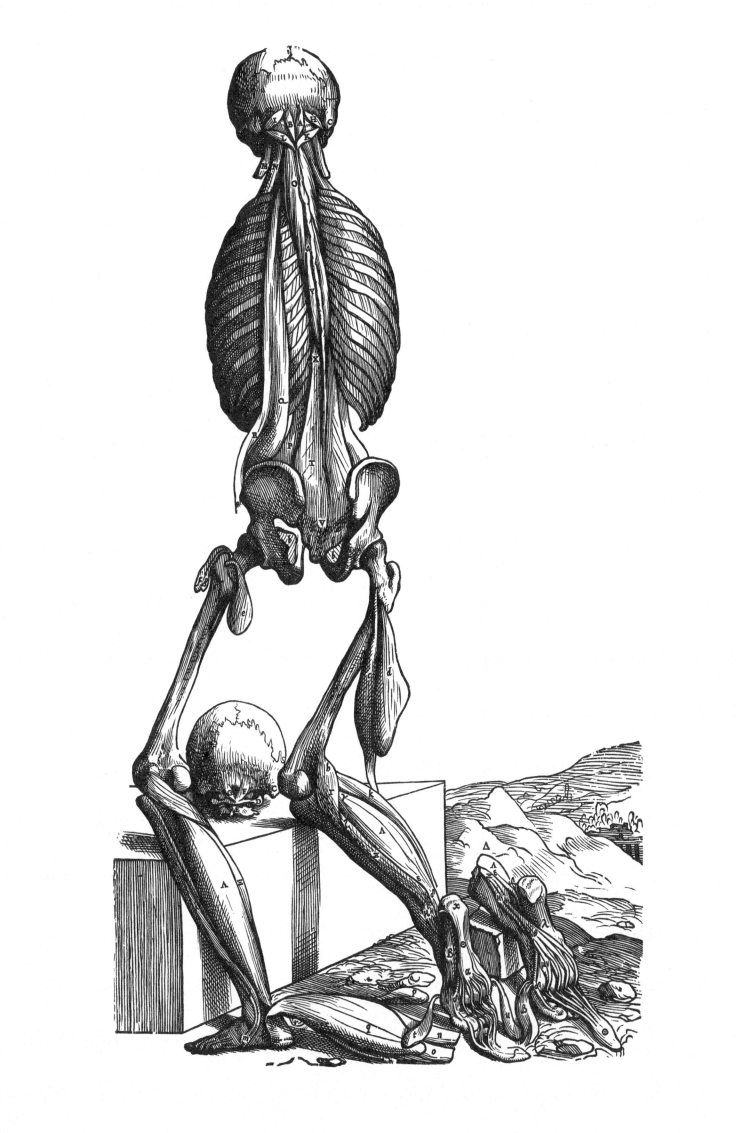

Plate 38

THE FIFTEENTH PLATE OF THE MUSCLES

38:1 [II]. *The two figures of the present plate are pre-
served in that form in which the right leg together with
the foot is displayed in the more complete representa-
tion of the fourteenth plate. Here the first figure follows
in the sequences of dissection in the figure which was dis-
played in the preceding plate and noted by the letter* Δ.
However, the second figure of this plate follows the first.

In the figure on the left the short and long flexors
have been turned back to display more fully the tibialis
posterior muscle and the interossei, and these structures
have in turn been reflected in the figure at the right to
expose the tendon and insertion of the peroneus longus
muscle.

THE SIXTEENTH PLATE OF THE MUSCLES

38:2 [II]. *The sixteenth plate might have been placed
immediately after the third plate of the muscles; but
since it contains only a part of the body, it seemed better
to place it here. The internal surface of the left thigh,
the leg and foot, no muscles being freed, is expressed
together with the sacral bone and the bone joined to its
left side [innominate], so that the tenth muscle moving
the femur [obturator internus] can be seen in that part
which occupies the internal region of the pubic bone*
and the bone of the coxendix [ischium].

Naturally a complete view of the medial aspect of the
lower extremity could not be shown in drawings of the
intact body and is included here to complete the series,
every detail of which was most carefully thought out.
The illustration provides an opportunity of represent-
ing the obturator internus muscle which Vesalius divid-
ed into three portions, one of which was no doubt the
coccygeus muscle.

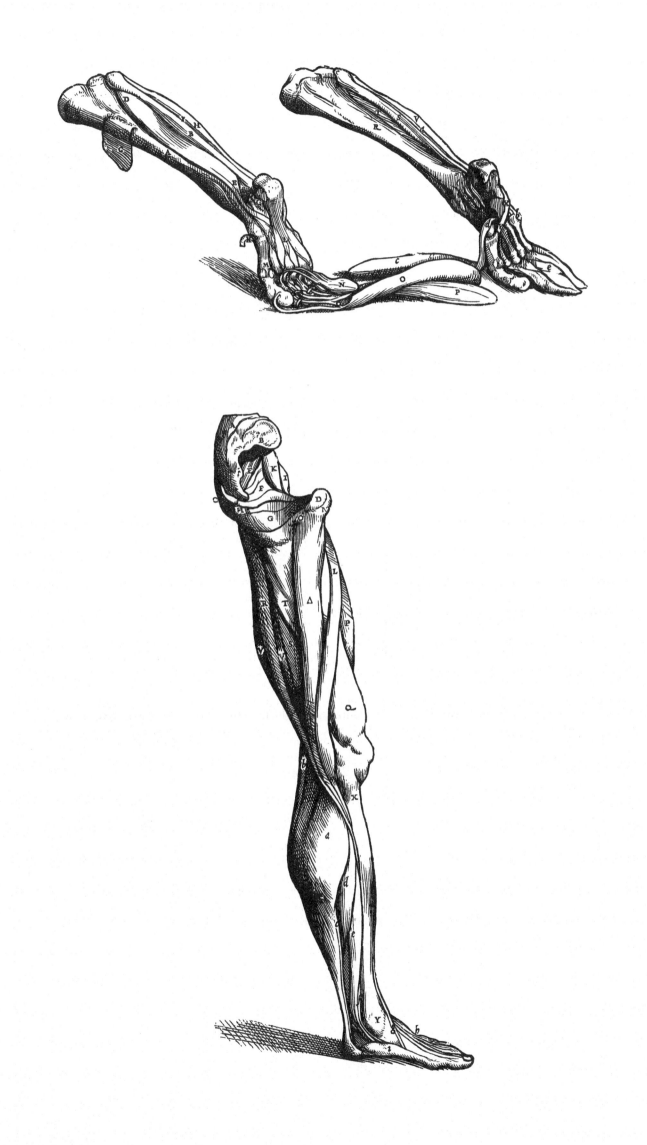

Plate 39

39:1 [II:i]. *The figure here placed to one side [of the descriptive matter] represents the entire femur, tibia and fibula to which still remain attached those ligaments which serve for the comprehension of the context of the first Chapter.*

The above illustration was employed to supplement certain general remarks on the nature of ligaments, joint capsules and tendons. As some of the soft structures shown may give rise to difficulties in interpretation, their identifications are here given, proceeding from above downward. The ligamentum teres and hip-joint capsule attached to the head and neck of the femur respectively are easily recognized. The frayed-out structure hanging from the greater trochanter is the freed tendon of vastus lateralis. At the knee, the collateral ligaments, the anterior portions of the capsule at S, and the cruciate ligaments are shown. At Y is the capsule of the superior tibio-fibular joint, and below it lies the interosseous membrane. The muscle belly and tendon pulled to the lateral side of the fibula is the soleus, and at N, the blending of the tendon of the gastrocnemius. The capsule of the ankle joint has been divided and turned up as a cuff about the lower end of the tibia. The collateral ligaments at the ankle, seemingly transposed by mistake, hang from the malleoli.

39:2 [II:ii]. *The first figure of this Chapter represents the manner in which muscle is constructed, as asserted by all professors of dissection up to this time.*

One of the most controversial arguments of the times revolved around the question of the nature of muscle. From the early Greek period there had been no clear distinction drawn between nerve and tendon, both of which were called "nerve," and, furthermore, the opinions of Aristotle and Galen differed widely. The above diagram illustrates the Galenical opinion which was accepted largely by physicians in contradistinction to the philosophers. A portion of a nerve trunk, A, is seen giving off a motor branch, B, to a muscle. The motor nerve then was supposed to break up into finer and finer fibers which became sinew and thus provided the tendon of origin, C, proportional in size to the nerve and to the tendon. Between the fibers was the flesh which formed the muscle belly and provided nutriment. The tendinous fibers were therefore supposed to be the active element. Vesalius cast grave doubts on this theory.

39:3 [II:ii]. *The second figure shows the fibers, to some extent freed of flesh, of the muscles surrounding the humerus or arm bone, the bones of the forearm and the external aspect of the hand, and, in addition, the fourth nerve [radial] entering the arm. Thus, as far as conveniently practicable, the nature of the muscle fabric is exposed to view.*

In order to overthrow Galenical theory on muscle structure (see annotation to 39:2), Vesalius macerated the muscles to expose the connective tissue elements, here illustrated. He was able to show that sinewy material extended from origin to insertion and that its bulk, whether measured at the tendon of insertion, in the middle of the belly or at the origin, was approximately the same. He thus concluded that the nerve was a separate element and did not become tendon.

39:4 [II:index to 11th muscle plate]. A small cut representing the deltoid muscle removed from the body, which was added as an inset to the explanatory legend accompanying the eleventh muscle table in order to demonstrate the precise shape of the muscle not clearly evident in the series.

39:5 [II:xxx]. *The present figure represents the first and second cervical vertebrae delineated from their posterior aspect, together with their ligaments to be described in this Chapter.*

Vesalius was inordinately proud of his elucidation of the movements of the head, the joints at which they occur and the muscles which control them. He was able to controvert the erroneous conclusions of Galen and devoted portions of several chapters of the *Fabrica* to a discussion of the atlantooccipital and atlantoaxial joints. The drawing showing the transverse ligament of the atlas and the apical ligament is one of several treating of this theme. His conclusions were essentially correct but gave rise to great controversy. His former master Jacobus Sylvius of Paris (1478-1555) attacked him in most bitter and vituperative language, especially on this topic.

39:6 [II:xl]. *That you may follow with little difficulty what I have considered here, two thoracic vertebrae from the body of a youth have been depicted from the anterior aspect.*

The five structures enumerated in the drawing are, in order, the epiphyseal cartilage, the inferior epiphysis of the centrum, the intervertebral disc, the superior epiphysis of the centrum and its epiphyseal cartilage of conjugation.

39:7 [II:li]. *The portion of the rectum excised from the body with its muscles drawn here is almost always left in the body when we remove the rest of the intestines.*

The figure shows the rectum, the levatores ani muscles on either side and the external sphincter. The small tag of tissue labeled D is reported by Vesalius as attaching to the root of the penis and is therefore with little doubt the rectourethralis muscle described centuries later by Roux.

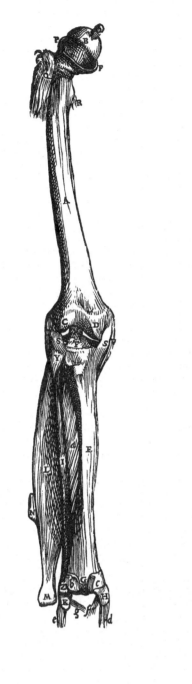

Plate 40

40:1 [II:ix]. *Although these muscles are represented at the letters C, D, and E in the third muscle plate, we have placed here a special figure of them in which A indicates the first muscle of the eyelids with b and C their origin, and D its insinuation into the second muscle, the beginning of which is denoted by e. The mutual junction of the two muscles is signified by F.*

It would seem that Vesalius was somewhat confused in his lettering of the orbicularis oculi muscle which he correctly described in the text.

40:2-3 [II:xi]. *Since the muscles of the eye are not depicted in the complete muscle plates, and the eye itself must be avulsed from the skull to show the muscles, we place here a drawing of them but out of proportion to the rest of the muscles. In the first figure the eye, together with its muscles still lying in position, is depicted from one aspect. The second figure shows the first six of the ocular muscles spread out from their insertions while the seventh is still left in position on the visorius [optic] nerve.*

This is one of the few occasions on which Vesalius would seem to have illustrated the anatomy of animals without indicating the source of his material. His figure is taken probably from the ox since his seventh muscle, indicated by the letter O, is the choanoid or retractor bulbi muscle which is absent in man but which is present as an unbroken cone surrounding the entry of the optic nerve in some ruminants. The blunder was promptly discerned by Realdus Colombus and by Gabriel Fallopius who severely criticized Vesalius for adopting a practice which he had himself condemned in others. However, it is clear from his dissection procedure where this muscle is referred to as a "membrane" that Vesalius had confused the fascia bulbi of man with the choanoid muscle of lower forms.

In the first figure the muscles, fascia and bulbar fat are shown intact, and in the second, the four recti and the two oblique muscles. H is the superior rectus, K, the lateral rectus; it will be observed that the tendon of the superior oblique, M, is incorrectly related to superior rectus. The levator palpebrae superioris was unknown to Vesalius, being first discovered by Fallopius a few years later.

40:4-6 [II:xix]. *The first figure of the tongue, together with its muscles freed from the rest of the body, shown from the right side. The figure represents as closely as possible the nature and position of the muscles of the right side.*

The second figure displays the same structures seen in the first. In order that the nature of the first [root of tongue] and ninth [genioglossus] muscles of the tongue may be seen in another way more clearly, we have turned upwards the third [hyoglossus, posterior portion] and seventh [hyoglossus, anterior portion] muscles of the tongue, while the fifth [styloglossus] hangs from its insertion.

The third figure has the nine muscles of the tongue dissected. The tongue is seen divided longitudinally. The ligament [median septum] of the tongue has been stripped from each half of the body and the surfaces of these bodies bounded by the ligament are here exposed. The construction of the human tongue has been represented (to repeat myself) in the manner in which it was stated that we would follow it in our picture.

The extrinsic muscles of the tongue are rather crudely portrayed but readily identified. The Vesalian description of the intrinsic muscles is, however, too complicated and confused to warrant discussion here, particularly since they are not represented in the drawing which shows only the median septum and the two halves of the body of the tongue.

Plate 41

41:3 [II:xxi]. *Since in the complete muscle plates placed in series at the beginning of the present book all the muscles of the larynx cannot be exposed to view, I believed it would be of advantage to present at the beginning of this Chapter the muscles of the larynx separately by means of numerous figures.*

The first figure illustrates the anterior view of the bone resembling the letter U [hyoid], freed here of all its own muscles, together with the anterior aspect of the larynx and the stem of the rough artery [trachea] (which lie in the neck), but thus far with no laryngeal muscle reflected. . . .

The hyoid, thyroid and cricoid cartilages are easily identified. The muscles shown are the thyrohyoid, cricothyroid and sternothyroid. A small portion of the pharyngeal wall is observed behind the larynx on the right of the figure.

41:1 [II:xxi]. *The second figure shows the same structures as the first but from the right side, although we have not preserved as much of the stem of the rough artery [trachea] (which would have been to no purpose); then we have also dissected the superior side of the bone resembling the letter U [hyoid].*

The lateral view of the larynx is a little more difficult to interpret. The lesser cornu of the hyoid has been removed. The epiglottis, at L disproportionately small, has been depressed over the aperture to reveal the hyoepiglottic ligament which Vesalius believed was a muscle. The other structures observed are the thyrohyoid and sternohyoid muscles, the lower portion of the pharynx and the beginning of the esophagus.

41:2 [II:xxi]. *The third figure corresponds fully to the second except that it shows the same structures from behind instead of from the side. But here, as in the first figure, the superior sides of the bone resembling the letter U are carefully drawn.*

In the posterior view we again see the hyoepiglottic ligament at K, the epiglottis depressed at L and the corniculate tubercles of the arytenoid cartilages below the epiglottis. The pharynx, esophagus and other structures are readily identified.

41:4 [II:xxi]. *The fourth figure displays the anterior aspect of the larynx with a portion of the stem of the rough artery [trachea], the bone resembling the letter U [hyoid] having now been resected together with the muscles which extended from the pectoral bone to it [sternohyoid] and to the larynx [sternothyroid]. Therefore the fifth and sixth [inferior constrictors] of the muscles common to the larynx as well as the special muscles of the laryngeal operculum [hyoepiglottic lig.] are preserved.*

41:5 [II:xxi]. *The fifth figure differs in no way from the*

order of dissection seen in the fourth, but brings into view more clearly the same structures as the fourth, from the left side.

The lower portion of the pharynx formed by the inferior constrictors was regarded as an intrinsic laryngeal muscle since it apparently had no other attachments but to the larynx. The cricothyroid muscle and its posterior portion, regarded as a separate muscle, are evident. The structure labeled M Vesalius calls a glandule, probably one of the paratracheal lymph nodes.

41:6 [II:xxi, 1st ed.]

41:7 [II:xxi, 2nd ed.]. *The present figure corresponds in every way to the sixth placed at the beginning of this Chapter except that this exposes to view especially muscles which I have sometimes seen passing from the spine of the second cartilage [vertical ridge of cricoid] to the inferior processes of the first cartilage [thyroid].*

The two figures here shown were appended to the chapter on the laryngeal muscles as an insert. They do not differ remarkably and no reason is forthcoming as to why it was re-engraved for the second edition. Perhaps that of the first edition was mislaid at the time of printing. The muscles shown at C and D passing from the inferior horn of the thyroid cartilage to the lamina of the cricoid, if not some rare anomaly, are possibly artifacts.

41:8 [II:xxi]. *The sixth figure illustrates the larynx freed from the rest of the rough artery [trachea] in such a way that I have left on its posterior aspect no portion of the esophagus nor any part of the common muscle [inferior constrictor]. However, so far none of the laryngeal cartilages has been removed from its position.*

This posterior view reveals the epiglottis, abnormally small, the corniculate cartilages at l, a portion of the oblique arytenoid muscles at V, and the posterior cricoarytenoid muscles at P.

41:9 [II:xxi]. *The seventh figure contains the larynx portrayed from the right side so that its operculum [epiglottis] together with the muscles connecting the second cartilage [cricoid] to the first [thyroid] have not been resected. Then, the inferior process of the first cartilage [inferior cornu of thyroid cartilage] has been freed from the second cartilage on this side. The first cartilage itself is in a forward position and so reflected from the second that the posterior aspect of its intermediate region is nakedly exposed to view.*

In addition to the structures such as the oblique arytenoid and posterior cricoarytenoid muscles seen in the previous figure, the folding forward of the thyroid lamina and resection of the epiglottis allows exposure of the thyroarytenoid muscle at a, the lateral cricoarytenoid at R, and the ventricular folds or possibly the

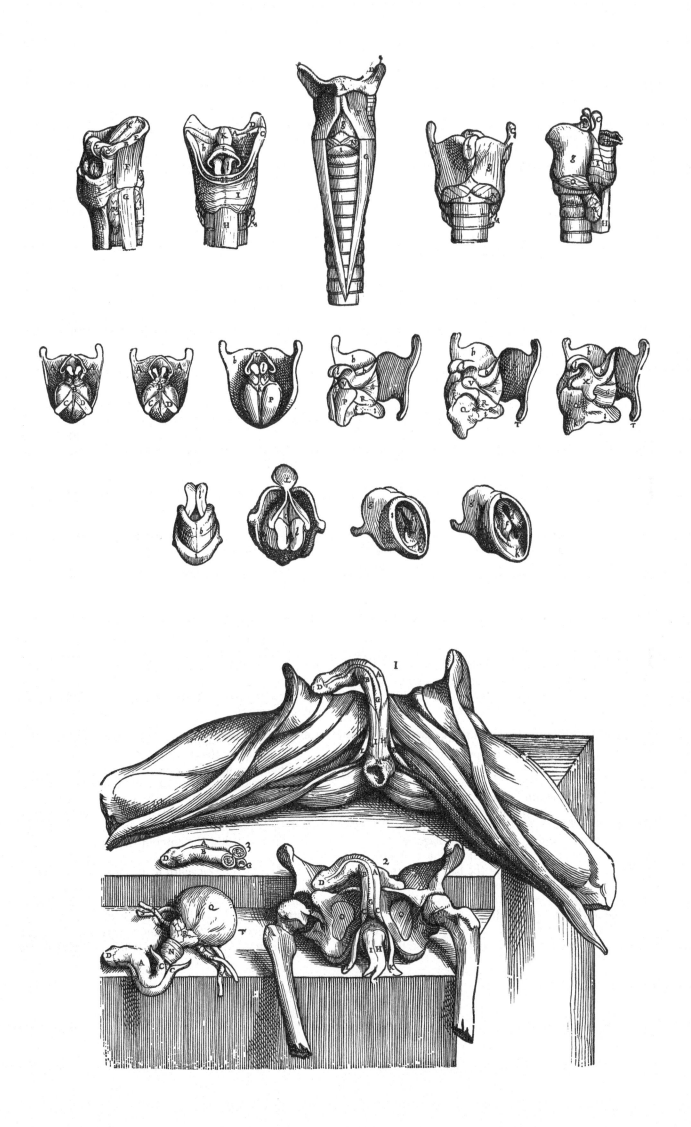

Plate 42

42:1 [II:xxxviii]. *In the present figure we have roughly outlined the sides, and nature and arrangement of the fibers of the muscle which we here describe....*

A marginal figure to show the outline of the scalene muscles, so named from their resemblance to a scalene triangle. Vesalius regarded the three scalenes as one muscle.

42:2 [II:xxvi]. A schematic figure to illustrate the outline of the trapezius muscle in which DE represents the scapular spine, above; and below, the shape of the trapezius as described by Galen in his work *On the Administration of Dissection*, book 4.

42:3 [II:xxxviii]. *The present figure represents to some extent the boundaries of the muscle, here discussed.*

Another marginal figure to show the outline of the quadratus lumborum muscle and how it receives its name.

42:4 [II:i]. A small figure inset in the text to illustrate the function of certain ligaments such as the transverse ligament of the ankle in preventing tendons from rising out of their beds during contraction.

42:5 [I:xl, 2nd ed.]. *We illustrate in this figure the instrument with which the harder bones are perforated with little difficulty.*

Vesalius initiated the technique of articulating the skeleton which has not changed materially up to the present. For this purpose he appended to the second edition of the *Fabrica* this illustration of a crude drill to facilitate the introduction of the wire supports.

42:6 [VII:xix]. *In this figure you will observe a pig tied to the board which we usually provide for the administration of vivisections and which we represented together with the rest of our anatomical instruments in the last Chapter of the first book, so that the manner in which it is employed in our schools will to some extent be apparent.*

This figure properly belongs to the chapter of the seventh book in which Vesalius repeats after the lapse of more than a thousand years the experiments in physiology described by Galen. However, it is convenient to view it here in order to appreciate the manner in which his vivisection board illustrated below was employed.

42:7 [II:vii; I:xli, 2nd ed.]. *In the present figure we have placed a board such as we employ in vivisections, resting on a table. On this board we have arranged almost everything which could be used in the administration of dissections or in an entire Anatomy.*

"An administration," a term derived from Galen, was the step-by-step technical procedure employed in dissection, whereas "an Anatomy" was the term used to describe a course of anatomical instruction which included the preparation of teaching specimens often other than the parts of man.

vocal cords at b. The poorly defined structure labeled i is the cricoid ring.

41:10 [II:xxi]. *The eighth figure differs from the seventh in this respect, that here we have resected the four straight muscles [posterior cricoarytenoids] which connect the third cartilage [arytenoid] to the second [cricoid], thus revealing the second cartilage more clearly.*

The illustration closely resembles the previous figure except that the removal of the posterior cricoarytenoid muscles reveals the lamina of the cricoid.

41:11 [II:xxi]. *The ninth figure differs from the eighth since in addition to the muscles already mentioned, we have lifted away the four oblique muscles [lateral cricoarytenoid] joining the third cartilage [arytenoid] to the second [cricoid], as well as the two muscles [oblique arytenoids] placed at the base of the third cartilage, preserving together with the three cartilages only those muscles [thyroarytenoids] which bind the third cartilage to the first [thyroid].*

The muscular process of the arytenoid cartilage is now clearly exposed, which would lead one to believe that the structure which Vesalius contends is a deep portion of the thyroarytenoid muscle is, in fact, the cricovocal membrane.

41:12 [II:xxi]. *The tenth figure offers for observation the anterior aspect of the larynx itself in which the first cartilage [thyroid] has now been removed and only the muscles joining the third cartilage [arytenoid] to the first together with the second [cricoid] and third cartilages themselves appear.*

The removal of the thyroid cartilage reveals what Vesalius believed to be a deep portion of the thyroarytenoid muscles but which, for reasons stated above, are probably the cricovocal membranes incompletely dissected so that the ventricular folds are left attached. Above and posteriorly are the apices of the arytenoid cartilages and below the anterior ring of the cricoid.

41:13 [II:xxi]. *The eleventh figure, as in the two which follow, we have delineated in order to display the "reed" or fissure of the larynx. Therefore the larynx is here illustrated freed from the rest of the stem of the rough artery [trachea] and the common [extrinsic] laryngeal muscles. In addition, its operculum [epiglottis] is still*

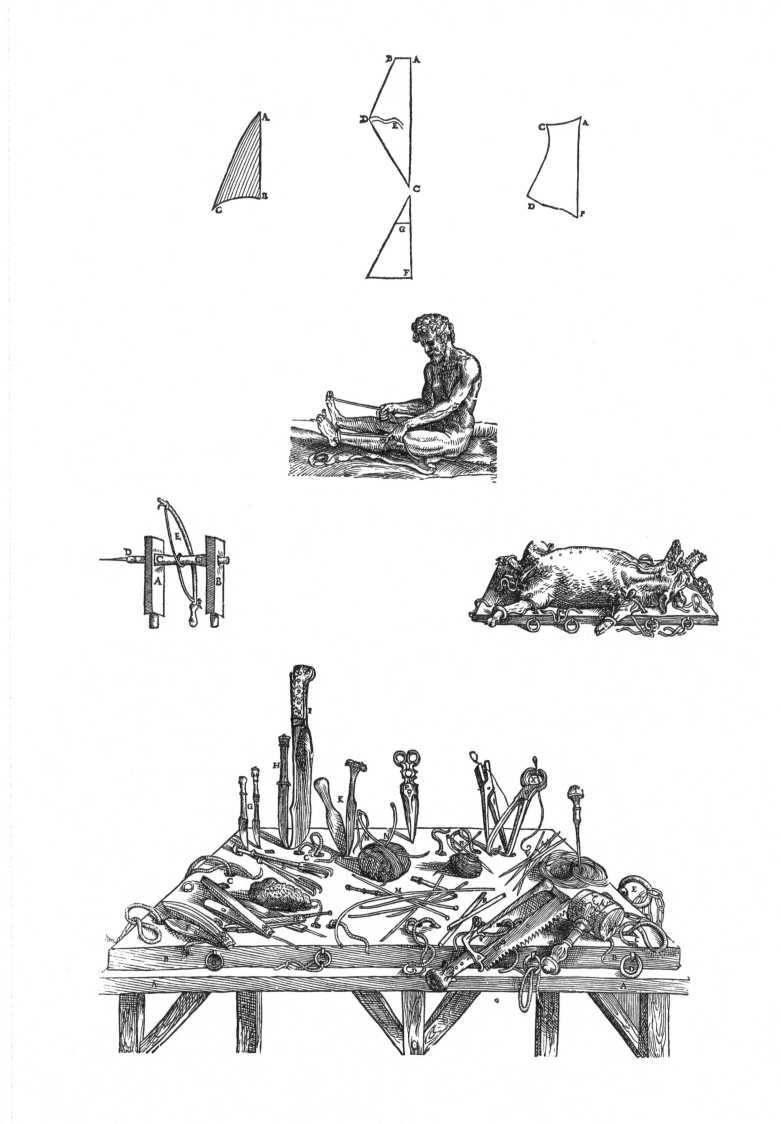

preserved lying on the posterior [for superior] aspect of the larynx and shows its superior surface.

The Vesalian illustration of the superior aspect of the larynx is extremely poor. His "reed" or "tongue" is evidently not the vocal cord but the ventricular fold. The Vesalian term, *lingula*, is a literal translation of the Greek, *glottis*, by which was meant the mouthpiece of a wind instrument in which was inserted the reed or tongue.

41:14 [II:xxi]. *The twelfth figure differs from the eleventh in that it contains a delineation of the inferior aspect of the larynx.*

41:15 [II:xxi]. *The thirteenth figure varies from the twelfth in that it represents the fissure or "reed" more compressed or closed. . . .*

The laryngeal "reeds" of Vesalius shown from below in 41:14, 15 are now the true vocal cords. Those of 41:15 are pathological since nodes, probably the common singer's nodules of nodular laryngitis, are described and indicated by the letters f and d.

41:16 [II:xlix]. *This plate of the forty-ninth Chapter, comprising four figures indicated by number, will be useful not only to this Chapter but also to several others. In order to avoid prefixing it to more Chapters, I am going to explain here all letter references.*
 1. *The first figure shows the thighs of a body resting on a table and stretched outwards, as well as the body of the penis. The whole of the scrotum with the testes, skin, fat, veins, nerves and arteries has been entirely cut away.*
 2. *The second figure displays the denuded bones joined to the side of the sacrum [innominate bones]*

to which portions of the femora are attached, together with the muscles of the anus and penis which we have represented hanging from their origins, so that the origin of the penile bodies and of the common seminal and urinary passage are brought into view where they turn upward beneath the pubic bones.
 3. *The third figure shows the penis in cross section so that the substance of the penile bodies and their connection with the urinary passage is exposed.*
 4. *The fourth figure illustrates the entire penis with the bladder stretched out so that the special muscle of the bladder neck can be inspected to some extent.*

There are several features worthy of observation in the illustrations of the male genitalia. The general anatomy of the region is sufficiently clear not to require comment except to point out that the ischiocavernosus and bulbocavernosus muscles seen in the first figure have been turned down in the second. It will be noticed that Vesalius refers to the urethra as the common seminal and urinary passage. This had special significance since it was currently believed that a special canal existed for the sperm which will be found illustrated by so acute an observer as Leonardo da Vinci. The idea came from Mundinus (1270?-1326), derived in turn from Avicenna (980-1037), who described no less than three passages, no doubt regarding the corpora cavernosa as well as the urethra as canals. In figure 4 of the series above, the urethral sphincter, N, is seen a confused mass representing the prostate and seminal vesicles combined which Vesalius regarded as a single gland. The confusion long remained and was due to the uncertainty created by Galen's terminology and description of the epididymus of the testis.

THE PLATES

FROM

THE THIRD BOOK

OF THE

DE HUMANI CORPORIS FABRICA

Plate 43

43 [III:v]. *A delineation of the entire portal vein freed from all parts to which it is joined, represented in the same relationship in which the liver, gall bladder, stomach, spleen, omentum, mesentery and intestines would be depicted in accordance with the present figure as to magnitude and especially as to position.*

A scheme of the portal system of veins which would appear to be an elaboration of an earlier illustration found in the *Tabulae Sex* (q.v.). Numerous errors will be observed. The portal vein is noted as terminating in the liver by division into five branches, which is a holdover from animal anatomy of the medieval notion of a five-lobed liver. The right and left gastric veins are erroneously shown forming a common trunk tributary to the splenic vein. The pancreatico-duodenal vein at D, and the right and left gastroepiploic veins at H and Z, are fairly correct. The vessels labeled C represent cystic veins. From the Vesalian description the vein at S joining the splenic is in part the inferior mesenteric although the latter vessel receiving the superior haemorrhoidal is also shown joining the superior mesenteric vein. On the other hand, the correct arrangement of the inferior mesenteric vein is described in the text, and the illustration here shown is amended by a small diagram inserted in the margin and to be found in plate 46:10. Further, we know from the *Venesection Letter* of 1539 that Vesalius regarded this as an original discovery since previously the haemorrhoidal veins were believed to join the caval system. The evidences of animal anatomy and the several errors described suggest that this illustration was one of an earlier series probably drawn, like its counterpart in the *Tabulae Sex*, by Vesalius himself.

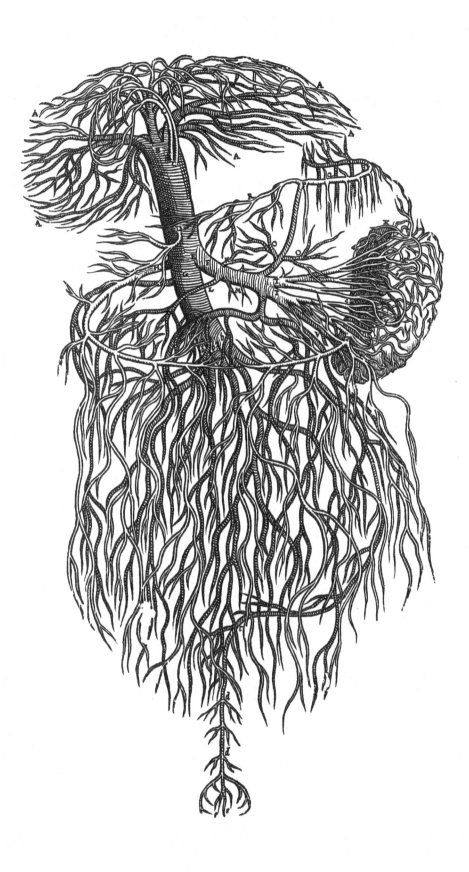

Plate 44

44 [III:vi]. *A delineation of the entire vena cava freed from all parts.*

In the general scheme of the venous system several unusual features may be observed. Following traditional views, the vena cava is regarded as a single continuous vessel. This was due in part to reliance upon the anatomy of the domestic animals, and especially that of the ape, and in part to the conception that the heart was a two-chambered organ. The portion of the vessel seen connecting the superior to the inferior vena cava is therefore the left atrium of modern anatomists, hence the aperture observed in this region represents the right atrioventricular orifice, and the vein marked E is the coronary sinus. Posteriorly at F is the vena azygos greatly exaggerated in size and concerning the therapeutic importance of which Vesalius wrote his *Venesection Letter.* The arrangement of the veins at the root of the neck is certainly not human and suggests the brachio-cephalic vessels of lower animals. Oddly enough, Vesalius usually shows the external jugular as larger than the internal jugular veins, once again indicating that he had not rid himself of the Galenical influence. Too much attention should not be given to the representation of the venous sinuses of the cranial cavity since he was very confused and uncertain as to their disposition. Note the nonhuman position of the renal veins, the right being higher than the left, as derived from the opinions of Aristotle and Galen.

The arrangement of the venous system was of first importance to the sixteenth-century physician since it formed the basis for phlebotomy, the sheet anchor of the therapeutics of the day. It will be observed that in consequence the venous system is portrayed in great detail whereas the arterial system is glossed over and only the major vessels shown.

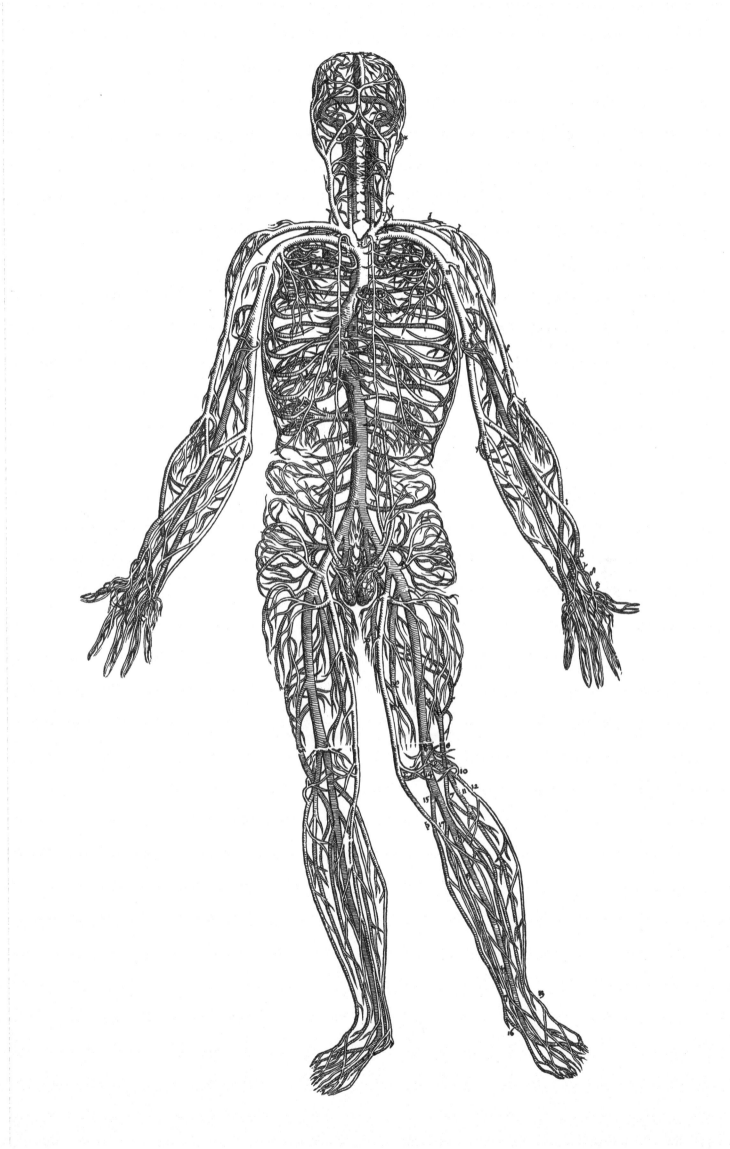

Plate 45

45 [III:xii]. *A complete delineation of the entire great artery [aorta] freed from all parts.*

The general scheme of the arterial system, like that of the venous, shows numerous instances of the persistence of traditional views based on the anatomy of animals. Although the arrangement of the branches of the aortic arch here illustrated may be found on rare occasions in man, the type of branching is typical for apes. The vessel at H ascending obliquely into the neck from the subclavian is probably the inferior cervical of the dog. The lateral thoracic artery arising from the axillary at M is excessively large for man and suggests the dog or pig. The branches of the external and internal carotid vessels are confused. The pear-shaped bodies in which the internal carotid arteries appear to terminate are the choroid plexuses. The positions of the renal vessels are reversed.

The Venetian physician Nicolò Massa (c.1480-1569) had described a method of revealing the arrangement of the vessels in some organs by maceration. We doubt that Vesalius employed this technique in the preparation of his schemes of the vascular tree. He would seem to have built them up gradually from dissections of various animals as well as man, and the disparity between his diagrams and the text suggests that they were the work of his earlier years and probably drawn by himself. The reader should compare the corresponding drawings of the venous and arterial systems published in the series known as the *Tabulae Sex.*

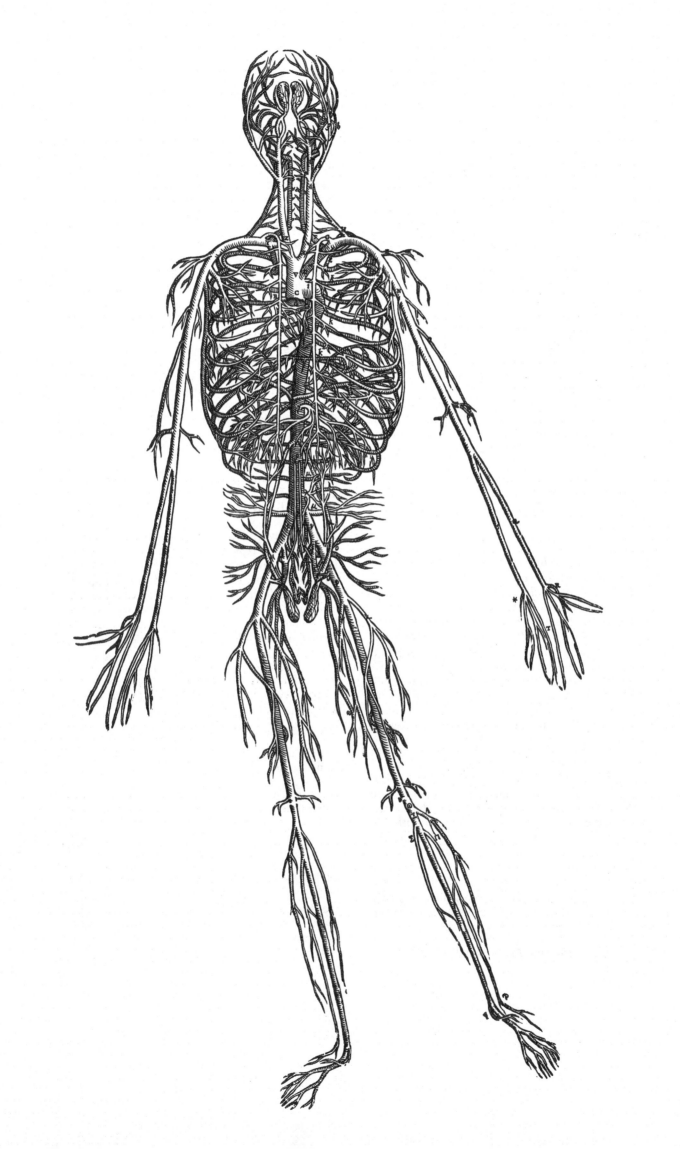

Plate 46

46:1 [III:i]. *A rough drawing of the fibers in which A indicates the transverse, B and C two different types of oblique,' and D the straight. E represents the three types of fibers interwoven which the picture of the vein below will later show more accurately.*

In the humoral doctrine the tissues and organs of the body were thought of as being endowed with the specific power of attracting and retaining nourishment and expelling the excess. Those functions were supposedly effected by straight, oblique and transverse fibers respectively which made up the coats of the organs and of the vessels. The fibers are the equivalent of unstriated muscle and connective tissue fibers, and evidence for their existence was substantiated by the arrangement of the muscular coats of the stomach with the longitudinal layer to attract, the oblique to hold and the transverse to expel food. The question of their presence in the connective tissue and muscular coats of vessels was of great importance, for through them the extraction and excretion of metabolic products were carried out. Furthermore, they also controlled, especially in the case of the veins, the flow of noxious humors in disease and constituted one of the main anatomical arguments supporting the theory of bloodletting. In the case of veins, Vesalius, at the insistence of Fallopius, gave up the notion of fibers and agreed that they came only from the imagination of authors.

46:2 [III:ii]. *We have here sketched a portion of the great artery [aorta] where it emerges from the heart, which has been dissected out and laid open so that the arterial tunics may be observed.*

The opened aorta is probably that from an ape as indicated by the branches from the arch and the position of the renal arteries. Vesalius describes three coats. At A, the intima which he described as being made up of cobweb-like threads, at B the muscularis and at C, the adventitia, likewise a network of fibers, the significance of which has been discussed above. E and D are the openings of the coronary arteries and the semilunar valves of the aortic orifice are numbered 1, 2 and 3.

46:3 [III:i]. *The portion of the vena cava ascending from the right sinus [ventricle] of the heart to the root of the neck on which we have carefully sketched for teaching purposes the arrangement of the fibers of the venous wall. If one is desirous of identifying the severed branches, compare this portion of the vein with the delineation of the entire vena cava at the end of the fifth Chapter [44]. . . .*

A figure of the superior vena cava and tributary veins, the arrangement of which suggests the simian pattern. The azygos vein, as in all Vesalian diagrams, is greatly exaggerated. The three types of fibers making up the venous wall discussed above [46:1] are shown.

46:4 [III:vi]. *In this figure I have sketched the arrange-*

ment of the cava as would have to be done if, having arisen by proceeding from a single origin, it were to divide into two trunks near the right side of the heart. Thus you may follow more accurately Galen's argument, so often repeated and, until now, accepted as a point which has been fully demonstrated. Compare the present figure with some of those in the sixth book and especially the fifth, and also with the figure of the entire cava, to understand the fact that the cava on this side of the division would then have to turn back in order to extend eventually from the right side of the spine to its middle.

Galen contended that the caval system had its origin in the liver whence a single trunk arose to divide into ascending and descending branches like the root and stem of a cotyledonous plant. He denied that the cava arose from the heart; otherwise there would exist a single vessel which would then divide into two. Vesalius, who is opposed to Galen in this matter, has here illustrated Galen's argument. This figure should be compared with that of the hepatic portion of the inferior vena cava (46:11) where Vesalius shows that the anatomy of the parts does not support Galen on a hepatic origin, but comparisons of the relative size of the calibers of the vessels establish the heart as the true source of the system.

46:5-7 [III:vii]. *The delineation of the bare cava [44] shows the first type of distribution of the external jugular vein. I have now represented the remaining three types by separate diagrams placed here in sequence. . . .*

Vesalius describes four types of variation in the tributaries of the superior vena cava, none of which seems to be human. Those shown in the three illustrations approach the ungulate and simian arrangement but not man.

46:8-9 [III:vii]. *In these two figures we have represented two varieties in the arrangement of the vein without a mate [azygos], which differ from that indicated in the complete delineation of the vena cava [44]. . . .*

The azygos, hemiazygos and accessory hemiazygos veins are here shown.

46:10 [III:v]. A small diagram showing the inferior mesenteric vein at V entering the splenic at T, inserted to amend the scheme of the portal system (43, q.v.).

46:11 [III:vi]. *This figure places before the eyes the portion of the vena cava extended on the posterior aspect of the liver which I have dissected open by an incision along its posterior surface and then stretched out so that the openings of the branches which are distributed to the liver, or which constitute the cava, might come into view.*

The hepatic portion of the inferior vena cava has

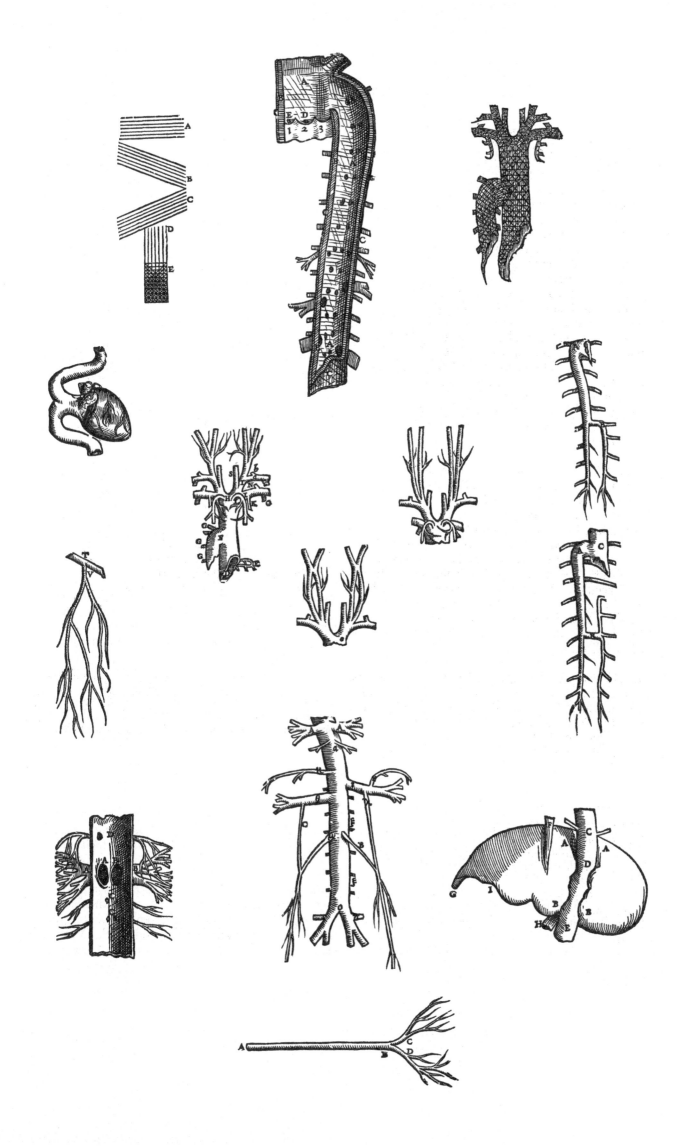

Plate 47

47:1 [III:xiv]. *In the present figure a drawing is presented of the cerebral vessels laid bare, beginning with the arteries and veins before they have entirely entered the skull. However, to prevent the numerous branches from obscuring everything, you will observe that the series of vessels of only one side has been drawn (except when otherwise required).*

Vesalius went far astray in his description of the various sinuses of the dura since he believed that the internal carotid artery largely emptied into them. In the figure, A is the internal jugular vein receiving C, the transverse sinus and F, the middle meningeal vein. B is the internal carotid artery giving off a branch (? occipital branch of external carotid) opening into the transverse sinus and providing erroneously the middle meningeal and internal maxillary seen extending forward at t, in addition to cerebral branches and the choroid plexuses. The superior and inferior sagittal, straight, transverse and occipital sinuses are described. The great vein of Galen, internal cerebral, ophthalmic at G, inferior anastomotic at S, and other cerebral veins are shown.

47:2 [III:xv]. *In the first figure is exhibited a delineation of the naked arterial vein [pulmonary artery] freed from all parts. I have depicted its orifice as open so that the three membranes preventing the blood from regurgitating from the lung into the right cavity of the heart come into view. Moreover, they are denoted 1, 2, 3.*

The pulmonary artery, valves and branches are not represented very accurately. Statements such as that in the legend would seem to imply knowledge of the lesser circulation, but no clear discussion of this important transit is to be found in Vesalius. However, his pupil, Realdus Colombus, was one of the first to describe the lesser circulation (1559).

47:3 [III:xiii]. *We have sketched in this figure a portion of the artery from behind so as to present in another way the series of branches distributed from its posterior aspect to the costal intervals.*

A segment of the descending aorta to show the origin of the intercostal arteries.

47:4 [III:xv]. *This figure represents a delineation of the venal artery laid bare and freed from all parts. . . .*

The companion picture to that of the pulmonary artery discussed above. The venal artery is frequently rendered as the pulmonary vein but in fact is the left atrium which, in the conception of a two-chambered heart, gave off as branches the four pulmonary veins.

47:5 [III:xiv]. *Each triangle, the upper and the lower, is formed by three borders, noted 1, 2, 3, curved like a quarter circle. In the upper, the two sides, 1 and 2, move obliquely inwards, and the third, noted by 3, outwards. The lower triangle exhibits the three sides, noted by 1, 2, and 3, curved inwards.*

Diagrams to illustrate the statement that the dural venous sinuses are not round in cross section but triangular, sometimes like the upper and at others like the lower figure.

47:6 [III:xiv]. *The* [upper] *triangle is the type resembling the cavity of the fourth sinus* [straight sinus].

The [lower] *triangle is the type resembling the cavities of the first, second and third sinuses of the dural membrane* [right and left transverse, superior sagittal].

Similar diagrams as above to illustrate the cross-sectional appearances of the sinuses mentioned.

47:7 [III:xi]. An interposed figure to go with the general scheme of the arterial system (45) showing in greater detail the branches of the coeliac artery. The following vessels can be discerned: hepatic, left-gastric, splenic, right gastric, superior pancreatico-duodenal, cystic, right and left gastroepiploic, as well as the superior and inferior mesenteric arising from a common stem. The position of the renal arteries suggests an animal source.

NOTE: The third book of the *Fabrica* contains two additional plates which were originally drawn for and reproduced in the *Epitome*. These plates will be found among those of the latter work and are numbered 82 and 83.

been opened to expose the entrance of the hepatic, right inferior phrenic at D, and at C the right suprarenal veins. For the significance of the figure the reader should consult the annotation to 46:4.

46:12 [III:ix]. *Since we have represented in the complete figure of the bare vena cava* [44] *the origin of the veins extending to the kidneys and to their covering of fat and the origin of the seminal* [spermatic]

veins as they usually occur upon dissection, the present figure is seen to depict certain differences which are here described [in the text].

A diagram of the inferior vena cava, renal and spermatic veins used to demonstrate the asymmetry of origin of the spermatic veins contrary to then current teachings. The several views are combined in one illustration. Johann Guinther of Andernach, Vesalius' teacher, gives all credit for the discovery of the asym-

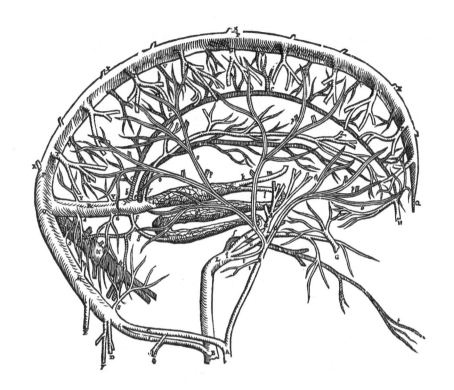

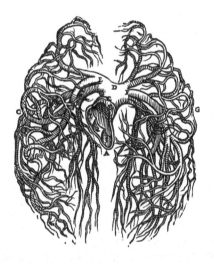

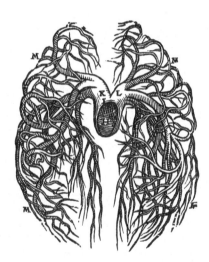

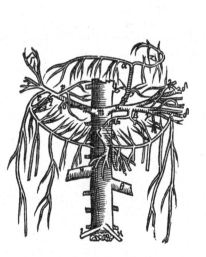

metry of these vessels to his pupil, although this fact was well known to earlier anatomists and can be traced to Galen himself.

46:13 [III:vi; V:fig. xvii]. *The present figure shows the gibbosity of the liver and its posterior aspect.*
　The posterior aspect of the liver, inferior vena cava, suspensory ligament and portal vein at H, are shown. The illustration was used again in the fifth book.

46:14 [III:xi, 1st ed.]. *A delineation of the bare umbilical vein, that is, of the part which is evident at birth. Here A denotes the region of the vein facing the umbilicus; B, the region where it is inserted into the liver. C and D roughly represent its distribution in the substance of the liver. The observer should turn to the fifth book and examine principally the figures, that is to* say, *the thirtieth [61:1-4], in which the foetal coverings and the foetus itself are presented in four plates. The second figure of that book [52:2] shows a portion of the umbilicus which remains in the sequence of dissection, and in addition to the umbilical vein [ligamentum teres] and arteries, the urinary passage [urachus] which, peculiarly in the foetus, leads forth the urine. Besides these, he should inspect the figures of the same book which bring into view the insertion of the umbilical vein into the liver, namely, the twelfth [56:1] and the twentieth [57:1].*
　The above rough diagram was omitted in the second edition of the *Fabrica* by which time (1555) Vesalius had had an opportunity of dissecting the human foetus and its coverings and was able to correct blunders which had been due to reliance on the developmental anatomy of the dog.

THE PLATES

FROM

THE FOURTH BOOK

OF THE

DE HUMANI CORPORIS FABRICA

Plate 48

48 [IV:i]. *The first of the two figures common to the nine Chapters which follow represents the base of the entire brain and cerebellum freed from the surrounding membranes so that the origin of the cerebral nerves may be suitably exposed to view. In addition to the primary origin of these nerves, the whole of that portion of the dorsal medulla which extends from its primary source to the position where it slips into the cervical vertebrae has been delineated.*

It is curious that, in an otherwise reasonable facsimile of the base of the brain, such a prominent structure as the pons should be represented by an amorphous mass which Vesalius terms the beginning of the dorsal medulla. The discovery of the pons is most frequently associated with the name of the Bolognese physician Costanzo Varolio (1543-1575), and yet in the illustration drawn by the latter the pons is almost as crudely portrayed and, indeed, would seem to have been in-spired by the Vesalian plate.

In the classification of the cranial nerves Vesalius follows Galen by dividing them into seven pairs in approximately the following manner. The olfactory is regarded as cerebral processes and is not included. The optic constitutes the first pair. The oculomotor, incorrectly attached, is the second pair. The third pair is the sensory root of the trigeminal, M, and the trochlear, L, incorrectly attached and confused in its peripheral distribution with the ophthalmic division of the fifth. The fourth pair is the motor root of trigeminal, Z. The fifth pair consists of a major root, the facial-acoustic complex passing to the auditory organ, Φ, and gives off the facial at c, and a minor root, d, the abducens which was distributed to the temporal muscle and buccal cavity. The sixth and seventh pairs, e and v, are the glossopharyngeal, vagus, accessory group confused in their peripheral distribution.

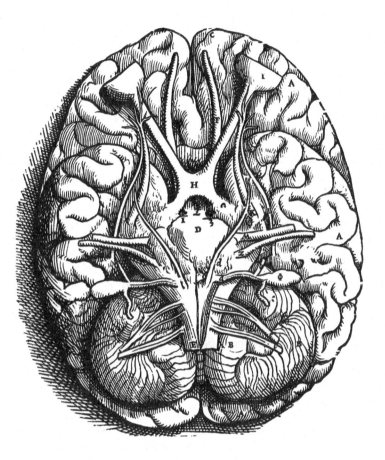

Plate 49

49 [IV:i]. *The second of the two figures common to the nine Chapters which follow presents the entire brain and cerebellum from the right side, as well as the portion of the dorsal medulla mentioned in the previous figure, together with the series of seven pairs of cranial nerves which have been laid bare and also represented from the right. However, we have also drawn the left nerves of the sixth and seventh pairs because of the difference in the series of the sixth pair on either side. Furthermore, the entire figure is depicted in such comparative relationship to an outline of the body and of such size that the bladder would lie in the lower part of the figure, the thorax and abdomen being observed from the anterior aspect, while the face is turned towards the left arm so as to present itself entirely from the right side.*

In the general scheme of the peripheral distribution of the cranial nerves many gross errors are to be found, but, nonetheless, the standard of knowledge is well in advance of then current conceptions. The nerves shown are not easy to identify in all instances. F is the olfactory tract. G, the optic nerve expanding into the retina at I. P is the naso-ciliary (anterior ethmoidal) breaking up into nasal branches, but its central end is confused with the trochlear nerve. The oculomotor, badly misplaced lateral to the temporal lobe, is seen at K. The ophthalmic division of trigeminal at L, confused centrally with the trochlear, gives off the supra-orbital N, and mythical branches Q, to the temporal muscle, and O, to the maxilla (? maxillary division of trigeminal). The masseteric nerve (?) at d is confused centrally with abducens. M is the mandibular division of trigeminal, receiving b (?), chorda tympani from the acoustico-facial complex, giving off R, possibly the buccinator seen joining the facial, and finally dividing into Y, the lingual entering the tongue, also Y, and T, the inferior alveolar with its dental branches at X. Φ is the "auditory organ" providing at a the acoustico-facial and giving off c, the facial. The nerve Z centrally is the motor root of trigeminal but peripherally is distributed to the palate, also Z, as possibly the palatine nerves. Finally, the glossopharyngeal, vagus, accessory group of both sides are shown. The complex joins together at o, on the right, but first gives off the spinal accessory at f, and then at ξ the glossopharyngeal, below which lie the pharyngeal and superior laryngeal branches of the vagus. The vagus itself gives off the sympathetic trunk at h on the right, the recurrent laryngeal nerves at l and o, to terminate in branches to the stomach and viscera. Other branches of the vagus shown cannot be identified. As mentioned, the sympathetic trunks were long regarded as branches of the vagus and are therefore seen extending inferiorly on either side forming visceral plexuses and ending approximately at the level of the bladder with "obscure" branches.

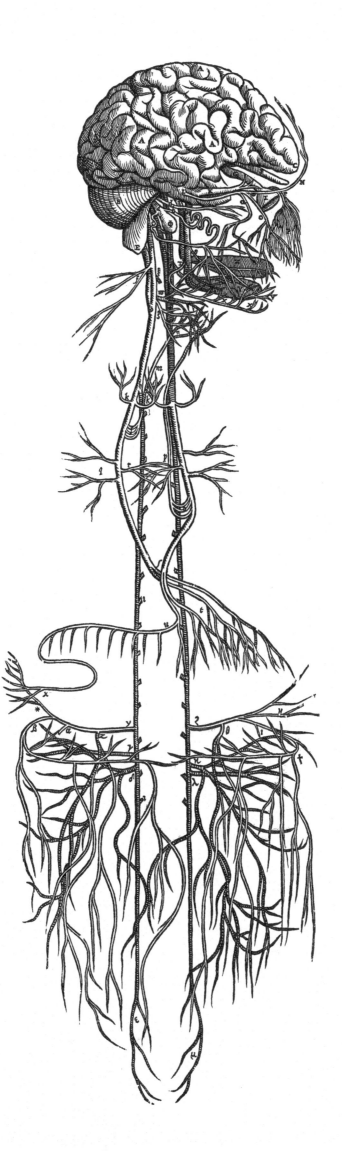

Plate 50

50 [IV:x]. *A naked delineation of the thirty pairs of nerves which take origin from the dorsal medulla contained in the backbone, and which is numbered as the second of the three figures common to the subsequent Chapters.*

A general scheme of the spinal nerves. The salient features are the greater and lesser occipital nerves at M, the cervical plexus providing the phrenic nerve, the series of intercostal nerves, the radial, median and ulnar nerves of the upper extremity as well as several of the chief cutaneous branches, the ilio-inguinal, lateral cutaneous nerve of the thigh, femoral, obturator and sciatic nerve with its branches. The arrangement of the brachial and other plexuses is very approximate, and only the main branches can be identified with any certainty.

The first figure in the series is seen on Plate 52:3.

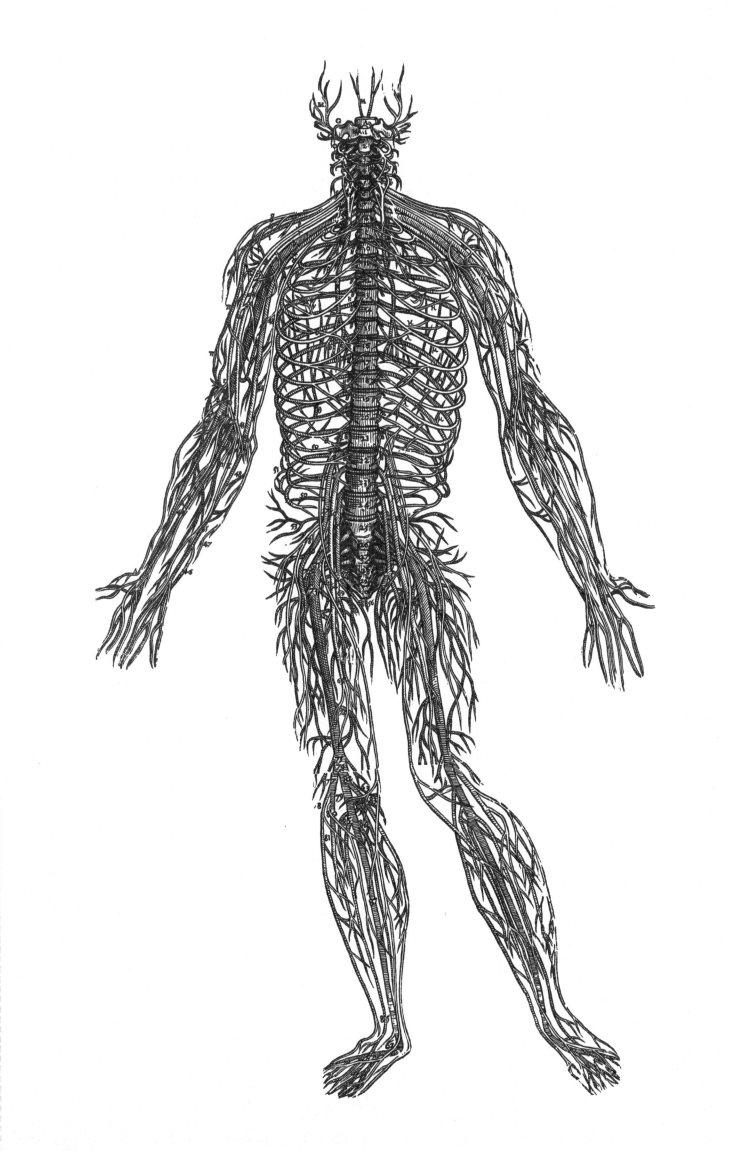

Plate 51

51 [IV:x]. *The third of the three figures common to the subsequent Chapters demonstrates the connected backbone from the posterior aspect just as the preceding figure exposed to view the anterior surface. Then this figure depicts the entire series of nerves from the dorsal medulla which can be seen less easily in the previous figure where identifying characters could not be satisfactorily appended. Furthermore, we have sketched in both these figures the dorsal medulla still lying in the backbone so that the number of pairs of nerves and* their exit into the surrounding area may be more easily observed. *We have already presented in the first figure a picture of the dorsal medulla freed from the bones.*

The third of the spinal nerve series. The posterior primary division of the spinal nerves, the occipitals, phrenics and the dorsales scapulae nerves may be identified. The main branches of the brachial plexus have been severed except for the radial nerve shown in its entirety.

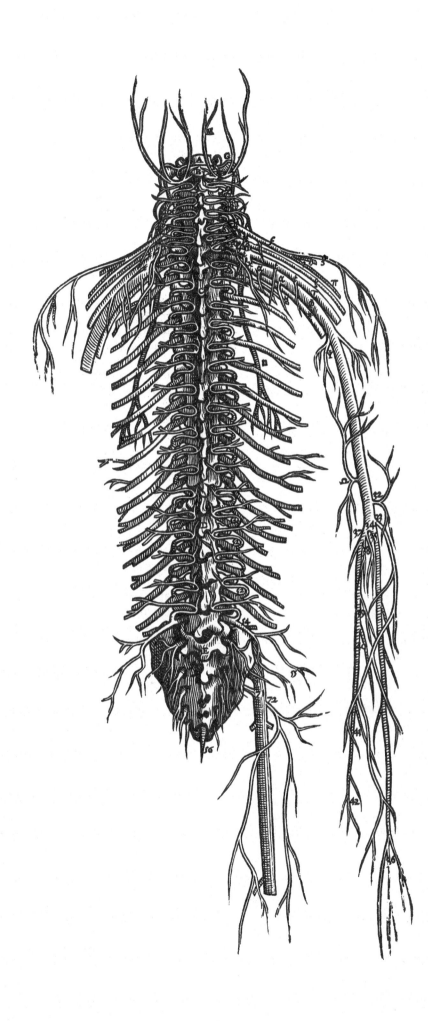

Plate 52

52:1 [IV:iii]. *The course of the right and left ventricles is seen approximately in this way. A and B indicate the superior portion of the left ventricle; A being the anterior part of this region and B the posterior. C denotes the region which is led inclining downwards and forwards to D, which in turn indicates the extremity and termination of this portion of the ventricle. However, these things are far clearer in the plates of the seventh book representing the brain and especially in the fourth plate and the four immediately following.*

An outline of the cerebral ventrical showing the anterior and inferior horns.

52:2 [IV:ix]. *Although the naked delineation of the seven pairs of cranial nerves, placed at the end of the first Chapter, shows the entire distribution of the sixth pair [vagus] and thus also represents the recurrent nerves, I believe it would not be amiss if I were here to interject in the context of this Chapter a special plate of these nerves together with portions of the great and rough arteries [aorta and trachea], that is, inasmuch as it is useful in showing their distribution, since mention is so frequently made of these nerves by physicians and likewise since nothing is more delightful to contemplate than this great miracle of Nature.*

A companion to the general scheme of the cranial nerves (49) showing the relationships of the recurrent nerves in greater detail. The branches of the arch of the aorta are of the simian type, a common trunk providing both carotids and the right subclavian artery. The vessels at the root of the aorta are the coronary vessels. The structure on either side of the upper end of the trachea is described as a gland, possibly portions of the thyroid gland, which is placed incorrectly in most of the Vesalian illustrations.

52:3 [IV:x]. *The first of three figures which are common to the subsequent Chapters.*

The present figure supports in particular the two following [50 and 51] which show the series of nerves laid bare and proceeding from the dorsal medulla. In it the dorsal medulla alone is delineated from the region where it takes origin at the base of the brain all the way to its termination where it slips out of the sacrum.

The region A to B is the medulla oblongata and pons providing the lower five of Vesalius' seven cranial nerves which are numbered. B to D is the cervical cord with seven pairs of spinal nerves, the first of modern terminology being omitted. This is followed by the thoracic cord, D to E, and its twelve pairs of spinal nerves; the

lumbar cord, E to F, with five pairs; the sacral and coccygeal cord, F to G, with six pairs. Hence to Vesalius there were thirty pairs of spinal nerves as indicated by the numerals on the left-hand side of the illustration. H is the filum terminale.

52:4 [IV:iv]. *The course of the nerves [optic] described here is represented in the present figure. A indicates a small portion of the brain.*

A diagram of the intracranial course of the optic nerves from a case in which Vesalius states that he was unable to find the optic chiasma.

52:5 [IV:x]. An interposed figure to correct an omission by the engraver, of the lettering indicating the roots of the phrenic nerve on the left side of the general scheme of the spinal nerves (50). n is the phrenic nerve receiving its three roots, b, c, and m, from C, 3,4,5. The nerve behind the phrenic is C,5, the sixth pair of Vesalius, since C,1 was omitted.

52:6 [IV:xiv]. *The present figure is of the nerve plexus approaching the arm, which will be considered in the text of this Chapter. It lies in the side of the neck above the first rib of the thorax, and I have attempted to represent it laid bare as I found it in my last dissection at Padua. In order that the drawing might be clearer, I have dissected away all branches led from the fifth, sixth, seventh, eighth and ninth pairs other than into the arm. On the other hand, everything is to be seen in the figure attached to the end of this book, which provides a picture of this plexus and a further opportunity of inspecting it so that no one should be disappointed.*

A very approximate diagram of the brachial plexus probably drawn by Vesalius himself. The roots from C, 5,6,7,8, and T,1, are shown forming the upper, middle and lower trunks imperfectly dissected out. A is the suprascapular nerve; B, the musculo-cutaneous; C, the median; D, the radial; F, the ulnar; G, the medial cutaneous of the forearm and E, the posterior division of the lower trunk joining the radial, i.e., the posterior cord.

The further illustration of the plexus mentioned in Vesalius' caption will be found in the *Epitome*, plate 82.

NOTE: The fourth book contains an oversized figure of the entire nervous system drawn initially for the *Epitome* and therefore not repeated here. See plate 82.

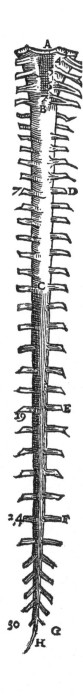

THE PLATES

FROM

THE FIFTH BOOK

OF THE

DE HUMANI CORPORIS FABRICA

Plate 53

53:1 [V:fig. 1]. *In the present figure only so much of the human body is drawn as is sufficient to show the peritoneum. Here the anterior aspect of the peritoneum is represented which has been freed in the order of the dissection from the eight abdominal muscles but nowhere actually dissected.*

Vesalius adopted a regular procedure in exposing the viscera. The abdominal muscles have been demonstrated in the illustrations of the second book, and the contents of the peritoneal cavity are now to be exposed. The rectus abdominis muscle is turned down revealing the superior and inferior epigastric arteries, the spermatic cords and subcostal vessels laterally.

53:2 [V:fig. 2]. *This figure follows the first in the dissection series, for here the peritoneum has been divided in a straight line from the mucronate cartilage of the pectoral bone [xiphoid] to the pubic bone so that I have injured none of the umbilical vessels. Then a transverse incision has been carried from the left to the right flank, and the four angles of the peritoneum are observed reflected posteriorly from the anterior aspect of the body. Furthermore, a part of the umbilicus together with its vessels which were previously connected to the peritoneum are exposed to view. In addition, the present figure discloses a portion of the liver, the position of the stomach and the situation of the omentum covering the intestines which the last occupies when drawn down by the hands towards the pubis during dissection if, as frequently happens, it is found retracted upwards towards the left side.*

The ligamentum teres, urachus and obliterated umbilical arteries are well shown.

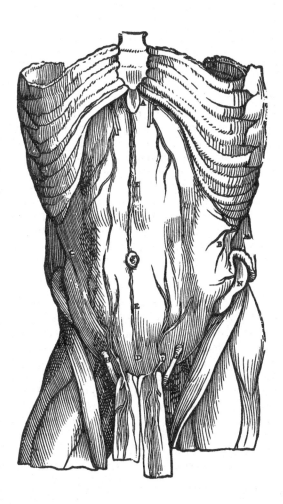

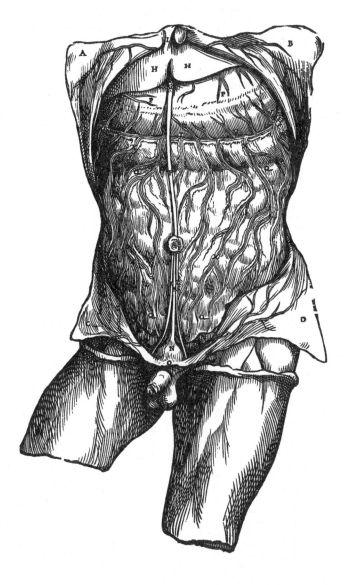

Plate 54

54:1 [V:fig. 3]. *The third figure follows the second [53:2] in the order of administration and shows the lower membrane [posterior layers and transverse mesocolon] of the omentum torn and pulled free from the upper [anterior layers]. The upper membrane of the omentum has been spread out on the anterior aspect of the thorax, having been forcibly pulled upwards together with the stomach from the peritoneal cavity. The series of vessels, which are very numerous and lie posterior to the stomach in the superior part of the inferior omental membrane, will thus be brought into view and the origin and nature of the inferior omental membrane more easily observed. Otherwise, the greater part of the omentum covers over the intestines unless it is seen gathered upwards on the left side, as often occurs, and so it is pulled up during dissection. However, the intestines have been nowhere disturbed and lie in position; as also the spleen, a portion of which is exposed to view in this figure.*

The administration of an anatomy was a technical term derived from Galen; it was employed by early anatomists and had reference to the formal sequential procedure and conduct of a dissection. The greater omentum has been freed from its colic attachment and drawn up to expose the omental bursa in which the superior mesenteric and splenic veins have been dissected out.

54:2 [V:fig. 4]. *In this figure the omentum is delineated freed from the parts to which it is attached, or rather from which it takes origin, but separated in no other region. Its entire construction, especially the series of veins, arteries and nerves distributed through it and the glandular bodies [pancreas] arising in it, is shown. In addition, the close resemblance of the omentum to a small sac or bag, or very small fish net, may also be learned from the figure.*

The omentum of Vesalius is the greater omentum together with the transverse mesocolon. In the floor of the lesser sac are seen the superior mesenteric and splenic veins forming the portal, 1. In the shadow just above the middle of the splenic vein is a vessel indistinctly labeled β, which is the coeliac artery. The pancreas is regarded as several glands, no doubt broken up by the dissection to expose the vessels. The structure marked m is the hepatic artery accompanied by a nerve, and the anterior circumferential vessels at o are the gastroepiploic arteries. The median vein joining the splenic is said to be associated with an artery, presumably the middle colic.

54:3 [V:fig. 5]. *In the fifth figure we have a representation of the omentum quite different from that in the fourth, for here we have replaced the greater part of the colon dissected from the body, which extended from the region of the liver along the body of the stomach to the spleen and which is contained dorsally in the membrane we have called in man the lower. Where the lower omental membrane is exposed to view in the region of the colon, a large portion of the upper omental membrane has been divided and cut away so that the connection and fusion of the omentum to the colon may be demonstrated to some extent. However, the lower membrane is not so contracted as in the third figure and has been somewhat stretched out above the colon.*

The posterior layers of the greater omentum and transverse mesocolon have been exposed by removal of the anterior portion of the omentum. The transverse colon was first dissected free and then placed in position. B, C, and D are colic veins, each of which is said to be accompanied by an artery and small nerve. D is presumably the inferior mesenteric vein since it is stated that it is not entirely distributed to the neighboring colon and omentum.

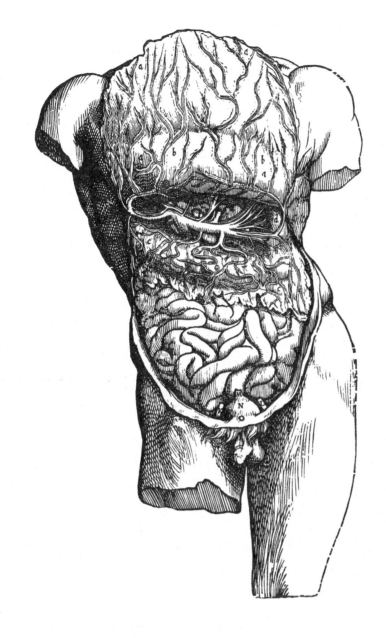

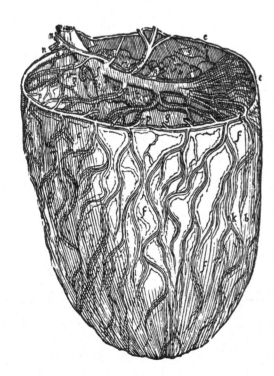

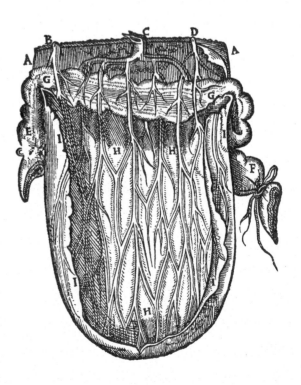

Plate 55

55:1 [V:fig. 6]. *The sixth figure of the fifth book follows the third in the sequence of dissection and shows the liver, stomach and intestines in their true positions. The omentum, where it arose from the stomach and was in continuity with the colon, has been entirely resected, for had it been left it would perhaps cover over the position of some other organ. Furthermore, that the individual organs might be exposed to view more conveniently, we have fractured the ends of some of the ribs (as was done when making the drawing) bending them posteriorly together with the peritoneum and the transverse septum [diaphragm] attached to them. In addition the bladder here corresponds to those seen in the second and third figures [53:2 and 54:1]....*

In addition to the organs mentioned, the falciform ligament, ligamentum teres, spleen, caecum and appendix are all indicated by letters.

55: [V:fig. 7]. *The seventh figure of the fifth book where we have delineated not only the thin intestines but have also kept a small portion of the stomach and the colon together with the caecum [appendix] so that the present figure might more easily be compared with that immediately following. The beginning of the colon is seen moved away from the thin intestines a little more than is correct. This I consider expedient only to bring into view more fully [the termination of] the more slender intestine, especially since the sixth figure [55:1] presents very beautifully the position of the colon and the entrance near the thin intestine [ileocaecal junction].*

Although Vesalius employed the term appendix and draws attention to its vermiform appearance, he pre-ferred the word caecum, i.e., the blind intestine. The use of the latter term in this way is a reflection of the earlier dependence upon animal anatomy where it is perhaps more appropriate. These are not the first illustrations of the appendix, for it was well figured by Johann Dryander of Marburg in 1541, but there is some evidence that he stole many of his illustrations from the early sketches of Vesalius.

55:3 [V:fig. 9]. *In this ninth figure of the fifth book we have represented a portion of the rectum and also the colon, where it is continuous with the rectum, with the intention of showing to some extent the intestinal tissues.*

The pelvic colon with its mesentery, k, is below and the rectum above. L is the peritoneal coat; i, the muscular which Vesalius states is made up chiefly of circular fibers, but some straight, especially in the neighborhood of the rectum; and h, the mucous membrane or rather, submucous layer also considered to be made up of fine, circular fibers (connective tissue).

55:4 [V:fig. 8]. *The eighth figure of the fifth book wherein the appearance and course of the caecum [appendix], colon and rectum are demonstrated, together with the termination of the ileum and the special muscles of the rectum.*

Vesalius calls attention specifically to the ileocaecal junction, appendix, caecum, the hepatic and colic flexures, the taenia coli, the sacculations, remnants of the levatores ani muscles and the external sphincter.

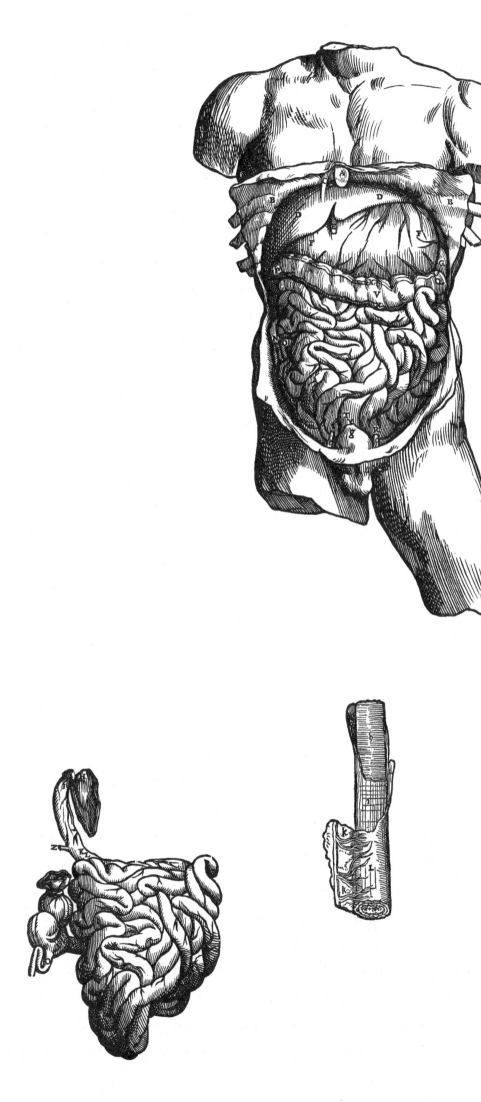

Plate 56

56:1 [V:fig. 10]. *In order that the tenth figure, which follows the sixth in the sequence of dissection, might expose to view the position of the mesentery as clearly as possible, it comprises the slender intestines manually separated from one another on all sides, laterally, upwards and downwards. Likewise it demonstrates the center of the mesentery and the manner in which the mesentery distributes vessels to the intestine and connects the intestine to the back. In addition, it also shows the portion of the mesentery which binds the end of the colon, as well as the rectum, to the spine.*

The structures shown are sufficiently evident to require no comment except to mention that K, at the root of the mesentery, represents a lymph node and that the mesentery of Vesalius is more extensive than that of modern terminology (see below).

56:2 [V:fig. 11]. *In the eleventh figure only the mesentery itself has been drawn. It has been removed from the body and freed from all parts attached to it, except for a portion of the lower omental membrane [trans-verse mesocolon] by means of which the colon is bound to the back, where it proceeds along the inferior aspect of the stomach.*

The mesentery of Vesalius consists of all peritoneal attachments to the colon and small intestine except the transverse mesocolon (seen superiorly) which is regarded as part of the greater omentum. The elevation at L is said to be the pancreas.

56:3 [V:fig. 12]. *The thirteenth figure of the fifth book represents a naked delineation of the gall bladder and the bile duct.*

A companion picture to figure 57:1, showing details of the biliary apparatus. The following structures are noted: Z, a branch of the hepatic vein; Y, a branch of the portal vein; X,X, right and left hepatic ducts uniting at a, to form the common duct; V, the gall bladder and b, the cystic duct entering the bile duct, c; S, the first part of the duodenum and d, the ampulla; g, are cystic veins; e, the hepatic artery giving off the cystic artery and accompanied by f, a branch from the vagus nerve.

Plate 57

57:1 [V:fig. 12]. *The twelfth figure of the fifth book which immediately follows the preceding complete figure in the sequence of dissection. In it the peritoneum has been dissected away, the omentum removed, and we have also fractured some of the ribs so that the entire hollow of the liver could be drawn more conveniently. Then the orifices of the stomach are seen since it, as well as the intestine, has been pushed down to the left in order to bring into view part of the mesentery, the arrangement of the portal vein in it, and especially the insertion of the biliary passage into the intestine. . . .*

Structures which may present difficulty in identification are: h, the portal vein; c, the bile duct crossed anteriorly by the hepatic artery and branch of vagus (for details see companion illustration 56:3); p is the kidney in shadow providing q, the ureter crossed by the seminal vessels at r and the ductus deferens at ʂ; n is a branch of the superior haemorrhoidal vein.

57:2 [V:fig. 14]. *The fourteenth figure of the fifth book represents the anterior aspect of the entire stomach and esophagus, together with the veins, arteries and nerves inserted into the stomach.*

The curious structures labeled E are said to be "Two tonsils which lie not far from that aspect of the esophagus extending into the oral cavity." F is a glandular body (lymph nodes?) "not infrequently attached to the esophagus where it rests on the body of the fifth thoracic vertebra." T and V are the vagi; d, the coronary vein; e, gastric vessels; g, the short gastric vessels; f and c, the gastroepiploic vessels.

57:3 [V:fig. 16]. *In this figure we have freed the stomach from the esophagus and intestines, and then turned it inside out so that the internal aspect of the stomach, or the surface surrounding the food and drink, comes into view. Here the posterior part of the stomach is encountered but not, as in the subsequent or fourteenth figure, the anterior.*

57:4 [V:fig. 15]. *The fifteenth figure of the fifth book exhibits the posterior surface of the entire stomach and esophagus.*

The notations are as in figure 57:2.

57:5 [V:fig. 17]. *The present figure shows the arrangement, number and nature of the coats of the stomach as far as it is possible to follow them in a picture.*

The three coats shown are k, the serosa; l, the muscularis; and m, the submucosa. On the significance of the fibers indicated by cross-hatching the reader should consult the annotations to figures 46:1-3 of the third book.

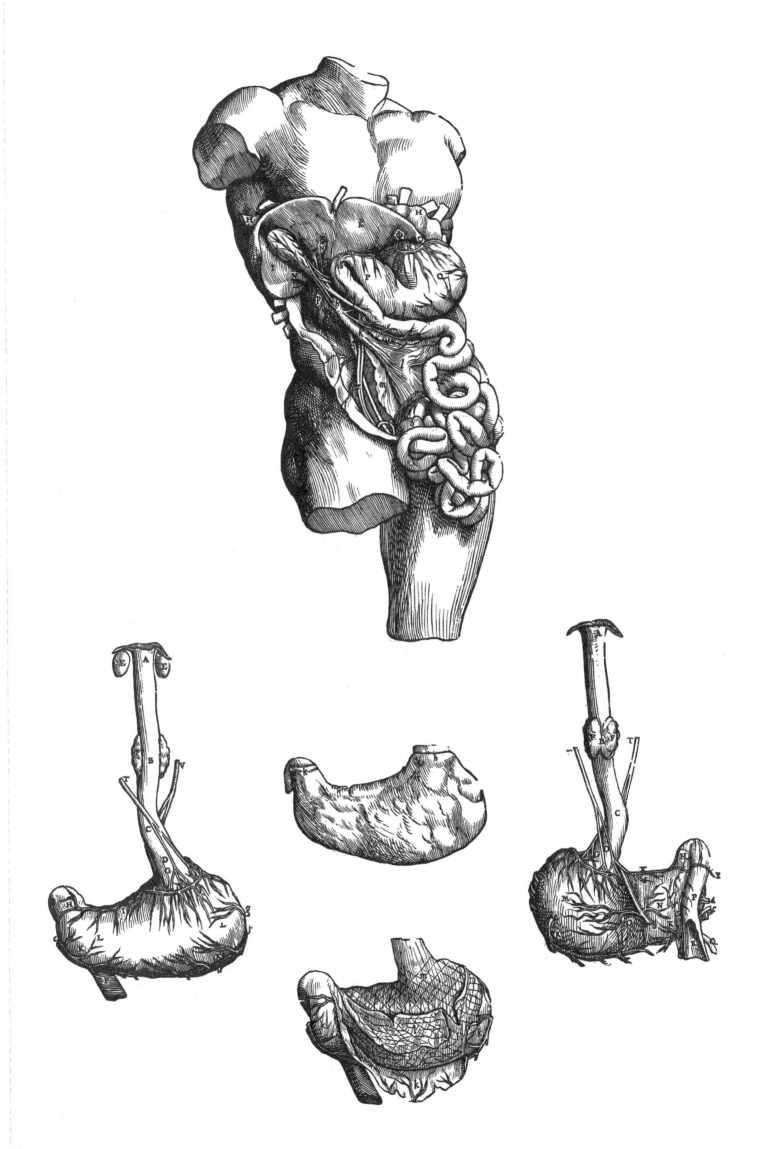

Plate 58

58:1 [V:fig. 20]. *The present figure in the sequence of dissection succeeds the twelfth* [57:1], *for from it we have excised all the intestines leaving only a portion of the stomach....*

A further stage in the dissection of the abdominal cavity. A portion of the fundus and cardiac end of the stomach has been retained. F is the cardiac orifice and E the gastric impression. K and M represent hepatic branches of the vagus nerve; L, the hepatic artery giving off the cystic. The omental tubercle and renal impression are both indicated by G. I is the portal vein; N, the severed bile duct; R and S, the coeliac and superior mesenteric arteries arising from a common stem. Although O and P indicate the spleen, X is not the splenic vein but a vein distributed through the perirenal fat. Note the position of the kidneys as in the ape. The renal and spermatic vessels are easily identified. k is the inferior mesenteric artery. m is iliolumbar vessels which only very occasionally arise from the common iliac. The scrotal coverings of the testis have been reflected on the left side of the specimen, t being the dartos muscle.

58:2-3 [V:fig. 19, 1-2]. *The nineteenth figure of the fifth book consisting of four plates or pictures which show the spleen from all aspects. Its position and proportionate size will be shown by the letters O, O, P, in the twentieth figure immediately following* [58:1].

The spleen with the splenic pedicle in place and after removal to illustrate the gastric and renal impressions. The two further members of the series are seen below (58:6-7), showing the diaphragmatic surface and the parenchyma with two vertical incisions to show the pulp.

58:4 [V:fig. 18]. *The eighteenth figure presents the gibbus and posterior aspect of the liver together with a portion of the trunk of the vena cava.*

An illustration of the liver repeated from the third book (46:13). The gibbus or humped portion of the liver corresponds to the superior surface.

58:5,8,10 [V:fig. 21, 1-3]. *The twenty-first figure of the fifth book consists of three small special plates which follow one another in the sequence of dissection and show very clearly the sinus of the kidneys and the origins of the urinary passages.*

The kidney of these three illustrations is a very accurate representation of the arrangement of the pelvis of the ureter and calyces as observed in the dog. Vesalius was severely criticized by his contemporaries and by modern authors for passing off the kidney of this animal for that of man. However, in the text he clearly states that he used the dog's kidney as he regarded the human organ as too fatty to demonstrate what he had in mind, namely that the existing "sieve theory" of kidney filtration was absurd. For illustration of this theory see below.

58:6,11 [V:x]. *In these two figures I have attempted to represent the false teaching of physicians on the straining of the urine. In the upper figure I have sketched the kidney dissected from its hump towards the sinus or hollow, but in the lower, only the central portion is seen.*

These figures illustrate the then current notion that the pelvis of the kidney was divided by a sieve or filter E, into two chambers. The blood was supposed to pass through the vessels A, into the upper chamber B, where the urine was filtered off into the lower chamber C, which led into the ureter. Vesalius would have none of this theory which was supported by his predecessor at Padua, Gabriele de Zerbis (Gerbi) who died in 1506 under torture by the Turks.

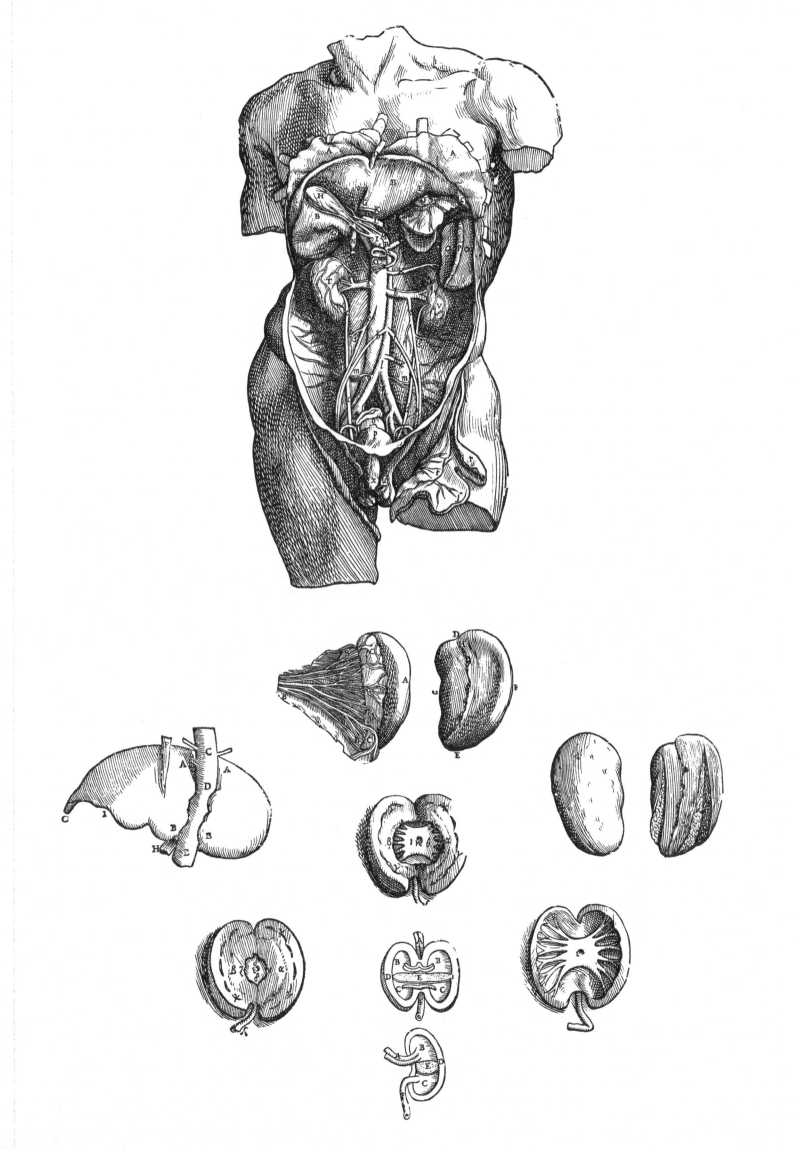

Plate 59

59:1 [V:fig. 22]. *The present figure follows the twenti-eth [58:1] in the sequence of dissection. In it the ends of several ribs have been fractured and turned upwards and outwards so that the hump of the liver is here seen in the same way that its hollows are brought into view in the twentieth figure. The kidneys stripped of their fatty covering present themselves, and the origin and course of the seminal veins and arteries are shown. We have expressly drawn in the figure a small branch [y] which arises from the stem of the vena cava and is joined to the left seminal vein. Furthermore, the peritoneum, which provides a channel for the seminal vessels, to-gether with the covering extended from it to enfold the testis and seminal vessels of its side, has been dissected out; hence the seminal vessels and the testes with their muscles [cremasters] are evident. In addition, the pubic bones are seen to have been divided and so separated from one another as to gape open markedly, and the bladder, the glandular body [prostate] special to the neck of the bladder together with its muscle [sphincter urethrae], and the penile bodies and their course are submitted to view. However, the fact that in the figure we have stripped the skin entirely from the right thigh and partially from the left will, I imagine, confuse no one.*

Vesalius' caption is quite clear, and the structures shown present no difficulty of identification. The per-itoneal process mentioned and seen on the right side of the illustration suggests the finding of a congenital hernial sac in the specimen.

59:2-11 [V:fig. 23]. *The twenty-third figure, containing many special representations or small plates, like that immediately preceding which was the twenty-second in order, in particular presents for inspection the male organs serving generation. I was inclined to present both these figures in the thirteenth Chapter of this book since attention is there first drawn to the letter-ing; hence precisely the same scheme of lettering occurs in both places. Because I now believe that it will be more satisfactory to arrange all the figures of the present book in order here, I shall provide a separate index for this, the twenty-third figure, and the characters which are common to it and to the twenty-second figure which I am not going to explain at length. In this, the twenty-third figure, are two special plates of which I shall ap-propriately call one the right and the other the left. In each plate we have depicted the kidneys, bladder and seminal organs resected from the body with portions of the vena cava and the artery. On the right these struc-tures are delineated from the anterior aspect, and on the left, from the posterior. On the right we have opened in particular the bladder and its neck [urethra] or common passage for the semen and urine which are still intact on the left. I am going to discuss these structures at greater length in the explanation of the characters as soon as I have discussed the small plates indicated by Roman capitals which lie on the left side and below the present twenty-third figure.*

Owing to the extremely small size of the prostate in some animals, the absence of the seminal vesicles in others, and difficulties over the question as to what organ the word epididymis should be applied, great con-fusion existed among contemporary anatomists depend-ing upon which animal was selected for dissection of the generative organs of the male. Vesalius cleared up much of this confusion but represented the seminal vesicles very poorly if at all, which suggests that he de-pended to some extent on his findings in the dog where the latter organs are absent. The smaller illustrations show various aspects of the testis and epididymis either together or separately, and in one the testis has been divided to reveal its internal structure.

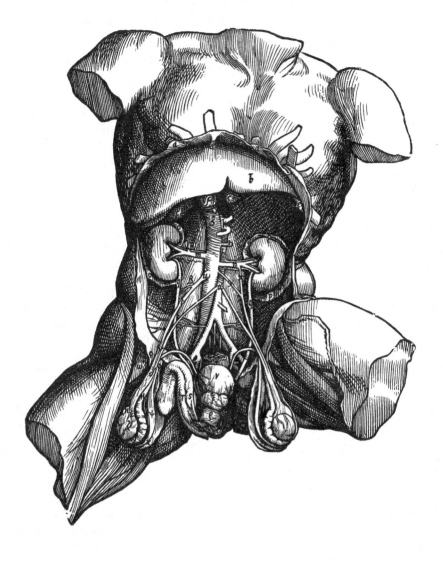

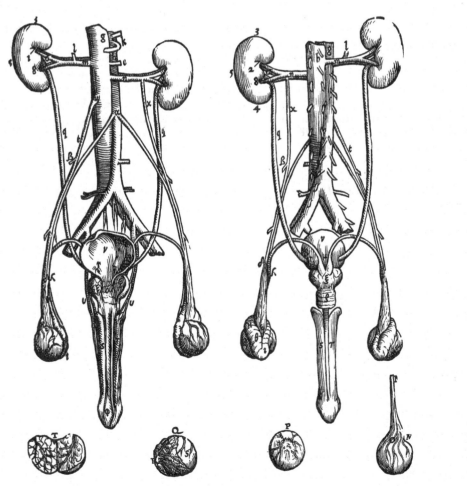

Plate 60

60:1 [V:fig. 24]. *In this figure the trunk of the female body is represented lying on the ground. The peritoneum, together with the abdominal muscles, has been opened and (as occurs during dissection) has been pulled to the sides. Then we have resected all the intestines from the mesentery, leaving the rectum still in the body as well as the whole of the mesentery, the membranes of which we have separated to some extent so that its nature is exposed to view. However, the present figure has been drawn for the special purpose of showing the position of the uterus and bladder just as they occurred in this woman and without our disturbing the uterus in any way. None of the uterine membranes has been destroyed, but everything is seen intact just as it appears to the dissector immediately upon moving the intestines to one side in a moderately fat woman. Women are so fat that even when emaciated by long illness and very lean, they do not show any of the series of vessels (unless the membranes have been separated from one another).*

Vesalius tells us that he had few opportunities to dissect the female body and had to rely on autopsy findings or grave-robbing for material (see below). The above drawing suggests a sketch made at autopsy. The bladder with the urachus and the obliterated umbilical arteries is seen anteriorly. The fundus of the uterus, the broad ligaments and ovaries are evident, and behind these the severed pelvic colon and portion of the mesocolon at H.

60:2 [V:fig. 29]. *In the present figure I have delineated the body of the uterus and a portion of its neck [vagina] from the cow. A large part of the uterine body and neck has been stripped of its external covering so that the internal tunic is exposed to view.*

60:3 [V:fig. 28]. *This figure represents the non-pregnant uterus of the dog which, on account of the descriptions of the Ancients, is seen here adjacent to the human uterus, as also the larger one from the cow which we shall add.*

The above two illustrations constitute the earliest attempt to show that the traditional conception of uterine cornua or "horns" had its basis in animal anatomy.

60:4 [V:fig. 27]. *The present figure represents the uterus excised from the body and of the same size as the one in the last dissection at Padua. It is the uterus of a woman* of very tall stature who had often given birth. In dimensions it greatly exceeded the normal. In order to portray the boundaries of the uterus we have divided its body through the middle so that its sinus might come into view, as well as the thickness of both uterine coverings in the non-pregnant.

This extraordinary figure of the female genitalia has been the subject of much comment. Some have called it "monstrous" and others have implied that a Freudian quirk in the author had resulted in its assuming a resemblance to the male organ. However, if one is familiar with the circumstances under which Vesalius obtained the specimen, it is not difficult to interpret. It was obtained from the body of a woman who had been the mistress of a certain monk. Vesalius and his pupils, hearing of her death, snatched the body from the tomb, but, unfortunately, the monk together with the parents of the girl complained of the outrage to the city magistrates so that the anatomist and his students were compelled to dismember and free the body from all skin as rapidly as possible to prevent its being recognized. Since they had stolen the body expressly to examine the female organs, the best they could do was to encircle the external genitalia with a knife, split the symphysis and excise the vagina and uterus in one piece after severance of the urethra. Later, the uterine cavity was exposed by sectioning the body longitudinally and turning up the anterior half. We imagine that the uterine tubes were lost in the hurried method of preparation.

In the Vesalian terminology the uterus consisted of the fundus or body, the uterus proper, the cervix or neck, which is not the cervix of the modern anatomist but the vagina, and the vulva. The illustration therefore shows: A,A,B,B, the uterine cavity; C,D, a slightly elevated line compared to the raphe of the scrotum; E,E, the muscular wall called the internal or proper tunic of the uterus; F,F, a protuberance of the wall into the uterine cavity; G,G, the cervical canal; H,H, the external or peritoneal tunic; I,I, the broad ligament incorrectly shown extending along the lateral border of the vagina; K,K, the divided edge of the vagina; L, the urethra, in Vesalian terminology the neck of the bladder. The rest, referring to the vulva surmounted by the pubic hairs, is self-evident, says Vesalius. Note the cut edge of the skin encircling the vulva and indicating the method of the urgent excision.

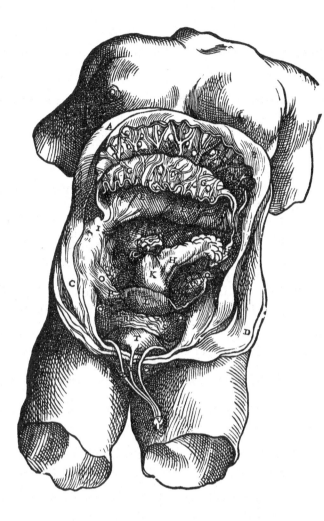

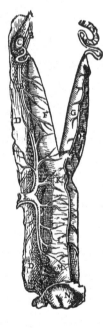

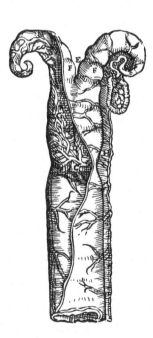

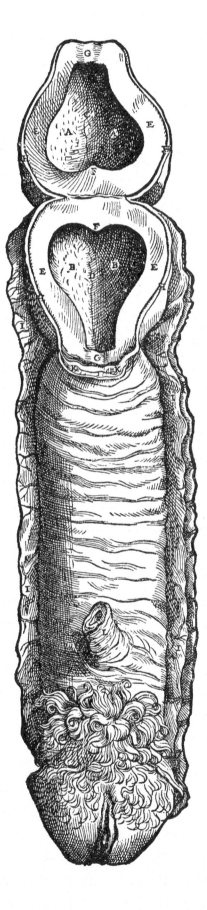

Plate 61

61:1 [V:fig. 25]. We have removed the skin from the right breast of the present figure so that the nature of the breasts might be exposed to view as far as possible. Then we have cut away the stomach, the mesentery with the intestines, and the spleen, while leaving the rectum as in the immediately preceding figure [60:1]. In addition, we have stripped the uterus from the external covering which is extended to it from the peritoneum, excising very carefully all membranes wherever possible so that the vessels carrying down seminal material to the testes [ovaries], and others, leading the semen from the testes to the uterus, might come into view. We have reflected the bladder downwards and to the left side, as well as severing the passage [ureter] which carries the urine from the right kidney down to the bladder so that the insertion of the urinary passage is rendered apparent, and that the bladder itself may not block inspection of the uterus. Finally, we have excised in this figure a portion of the pubic bones so that the neck of the uterus [vagina] and the neck of the bladder [urethra] might be seen more conveniently.

The emphasis in this figure is on then current physiological theory as illustrated in the anatomy of the generative organs. The precursor of semen and nourishment was thought to be carried by the spermatic vessels, d, g, h, e, to the ovary or female testicle r, which was a homologue of the male testis and therefore depicted surrounded by an epididymis t, where the true semen was filtered off. The semen now passed by way of a "deferent duct" u, not the uterine tube but probably the suspensory ligament of the ovary (see below) and emptied into the uterine cavity. The uterus itself was supplied by branches from the spermatic vessels n, confused with the uterine or Fallopian tube and by the uterine vessels y, whence came the menstrual blood. In pregnancy suppression of the menstrual flow was due to the diversion of this blood via the anastamoses between the inferior epigastric vessels η and near G, and the superior epigastric and internal mammary I, K, to the breasts which therefore became enlarged and converted the menstrual blood into milk.

The other structures are easily recognized. a is the severed end of the right ureter, the distal portion having been turned down at b with the bladder; x is the vagina and γ the bladder sphincter.

61:2 [V:fig. 26]. The present figure shows the uterus, together with the membranes binding it to the peritoneum, excised from the body. Its neck [vagina] is turned upwards and everted so that the orifice of the uterine body is brought into view. We have opened the body of the bladder and likewise its neck [urethra] by an incision so that the bladder cavity and the insertion of the urinary passages [ureters] may be uncovered.

A more detailed view of the uterus and appendages. In order to acquaint the reader with the state of knowledge immediately preceding the classical account of Fallopius, the Vesalian index to the letters is given in full.

A. The anterior aspect of the uterine body stripped of none of its membranes.

B, B. The neck of the uterus [vagina] turned inside out as just mentioned.

C. Part of the uterine body [cervix] projecting into the upper portion of the uterine neck [vagina] almost like the glans [penis].

D. The orifice of the uterine body [external os].

E, E. The membranes connecting the uterus to the peritoneum and containing its vessels [broad ligaments].

F. The left testis of the uterus [ovary].

G. The seminal [spermatic] artery and vein.

H. A portion of the seminal artery and vein approaching the superior aspect of the uterine body [? confused with uterine tube and its vessels].

I. A portion of the seminal artery and vein approaching the testis [ovary].

K. The vessel leading the semen from the testis [ovary] into the uterus [suspensory ligament of ovary and mythical epididymis (see above 61:1)]

L. The cavity of the bladder.

M. The insertion of the urinary passages [ureters].

N. The severed urinary passages [ureters] hang here.

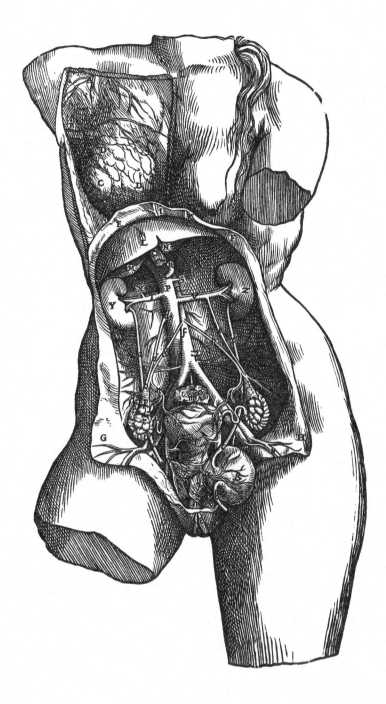

Plate 62

62:1-4 [V:fig. 30, 1-4, 1st ed.]. *The thirtieth figure of the fifth book consisting of four special plates.*

In the first plate we have divided the uterus, distended by a male foetus, by longitudinal and transverse incisions on its anterior aspect, reflecting the parts of the uterine tunics to one side and separating them from the outermost foetal covering.

The second plate shows the foetal coverings removed untorn from the uterus.

In the third plate we have divided the outermost foetal covering by a longitudinal incision and, having withdrawn two of the coverings from the third, we have represented these together with the third covering which is still intact.

The fourth plate presents the foetus freed from all its tunics and lying just as it is placed by the great providence of Nature, and contrary to the common opinion of anatomists, in the very middle of the uterus. For it is quite untrue that it lies gathered into a ball, or (so to speak) in a sphere with its knees touching its face and that it is so found at the extreme end [of the uterus]. On the contrary, if you were to observe its true position, you would find the motion of no joint more, equally or less restricted than that which obtains at each of the joints here shown.

In his figures of the foetus and its coverings which appeared in the first edition of the *Fabrica*, Vesalius committed the unpardonable error of illustrating the annular placenta of the dog as part of the human investments. Writing some three years later, he excuses himself on the grounds that he had had no opportunity of examining the human foetus and that Jacobus Sylvius had informed him that the arrangement in the dog also held for man. This and other errors he corrected in the second edition (see below). His three membranes are the placenta, at F, K, and Q; the chorion, at G, L, P and O; and the amnion at M; but not as we understand them. He confused the placenta, his outermost investment, with the chorion, as described by Galen. His second investment, the true chorion, he mistakenly described as though the allantois of the dog. His third investment, the amnion, he believed, following traditional ideas, contained the foetal sweat from which the foetus was protected by the vernix caseosa which he observed.

62:5-8 [V:fig. 30, 1-4, 2nd ed.]. *In the thirtieth figure consisting of four small tables or special pictures I have attempted to represent the tunics or coverings of the human foetus, which are generated anew with the foetus in the cavity or sinus of the uterine body.*

In the first small table we have pictured the uterus as projecting more at its right apex as if distended by a male foetus. We have incised the anterior aspect of the uterus by one longitudinal and a second transverse incision so that when the uterine wall is turned outwards and to the sides and separated from the external covering of the foetus, the latter together with the fleshy substance [placenta] attached to it will come into view. ...

The second small table concerns the foetal coverings as they occur when the fleshy substance [placenta], which is attached to the external covering and contains the vessels, is detached from the uterus, and the foetus together with its coverings, otherwise undamaged, is freed from the uterus by dissection and removed to be placed on a table or in a basin.

In the third small table we have opened the more external covering as in the order of dissection, and having pulled it away from the internal covering, we have placed it on one side so that the more internal covering, still intact with the foetus contained within, may be easily seen.

The fourth small plate also has the outermost covering reflected from the internal. It shows its internal surface more extensively than in the third figure so that the appearance of its fleshy substance [placenta], not unlike the flesh of the spleen, is here displayed. The appearance of this substance, represented through the pellucid membrane, on its internal surface is quite different from that lying on the external surface of the investment. Then, in this small plate the innermost covering has also been divided by a longitudinal incision and removed from the foetus and presents both its surfaces. And so here, besides the course of the umbilical vessels running between the foetus and its coverings, the foetus is also seen in almost the position in which it usually lies in the uterus and which will be observed is exactly in the middle of all parts and therefore less subject to fatigue.

In the second edition of the *Fabrica*, Vesalius corrected his blunder and now illustrates the discoidal placenta of man. He now believes that the Greeks called the entire afterbirth the chorion and that it corresponds to the secundine. The placenta, a term introduced by Realdus Colombus and Gabriel Fallopius, is no longer referred to as the outermost investment but is called the fleshy substance. There are now but two membranes, the chorion and the amnion, but he still confuses the first of these with the allantois of animals.

62:9 [V:xvii, 2nd ed.]. *In this figure we have represented the membranous bladder which, since the foetal urine does not flow down by wandering between its coverings, is an expansion of the passage [urachus] carrying urine through the umbilicus. A signifies the outermost foetal covering incised longitudinally and separated from the inner investment indicated by B and still intact. The soft and somewhat thin membrane or bladder holding the foetal urine in the uterus is indicated at C.*

Vesalius was very confused as to what was meant by the allantois. Here he has committed another serious blunder in figuring the sac-like allantois of animals as though occurring in man. Later, he confessed that this was based upon his observations on the calf and that he

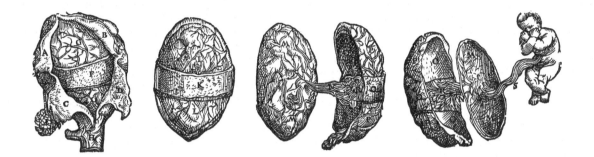

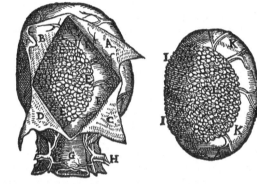

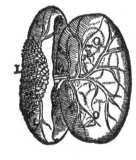
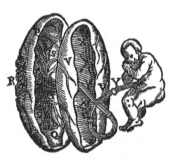

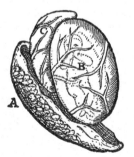

had not seen such a structure in man but had accepted the opinion of Jacobus Sylvius.

62:10 [V:fig. 31,2nd ed.]. Owing to Galen's descriptions, the outermost covering of the foetus of the dog is delineated in the present figure so that variations whereby it differs from the human investment may be observed. This figure corresponds in the sequence of dissection to the second small plate of the thirtieth figure [62:6] where the foetal coverings of man are represented as though pulled out of the uterus intact and undissected. In addition to the fact that this figure is proportionately longer than that in the small plate, it also shows a completely different appearance of the fleshy substance [placenta] which is attached to the outermost investment and which I have likened to the substance of the spleen. . . .

An illustration showing the girdle or belt-like placenta of the dog together with the investing chorion (see below).

62:11 [V:fig. 32, 2nd ed.]. We have drawn in this figure the foetal coverings of the buffalo in the same way in which the foetal coverings of the dog were represented in the thirty-first figure [62:10] and those of man in the second small plate of the thirtieth figure [62:6], that is

to say, as if on opening the uterus by an incision and without in any way damaging the foetal coverings they were withdrawn from the uterus and were placed here separately. We shall also employ this figure with those which by showing the parts of man cause differences to appear. Thus the foetal coverings of the cow, buffalo, goat, stag and horned animals, as well as the acetabula [cotyledones] in the uteri of the designated animals after conception, differ from the foetal investments of man, the dog or swine, or any animal I have dissected which produces several foetuses at the same time. For it is remarkable how the writings of authors are confused by such differences, giving rise to ardent debate since they believe no differences exist in the uterus and investments of animals, and because those who assert that everything mutually corresponds do not state what animal in particular they have dissected or described. . . .

The conceptus of the water buffalo (Bos bubalus), domesticated in Italy, to show the diffuse cotyledonary placenta of ruminants. Vesalius made a real contribution by initiating comparative studies of the uterus and foetal coverings, which enabled him to illustrate for the first time the differences between the discoidal, zonary and cotyledonary placentae of man, the dog and the buffalo and thus clear up much of the confusion and contradiction existing in the classical writings.

THE PLATES

FROM

THE SIXTH BOOK

OF THE

DE HUMANI CORPORIS FABRICA

Plate 63

63:1 [VI:fig. 2]. *The present figure, in which we have depicted the body erect rather than lying on the ground, follows the first [63:2] in the sequence of dissection. For when the anterior aspect and sides of the thorax have been denuded of skin, the muscles and the cartilages freed from the bones to which they are attached, and the bones themselves have been fractured outwards, we have finally released the pectoral bone together with the cartilages joined to it from each of the two membranes [mediastinal pleura] dividing the thorax, and lifted it upwards so that the internal surface of the thorax is exposed and the fabric of the membranes is still more precisely represented than in the first figure.*

The second in the series on the thoracic cavity; for the first, see below. F is the thymus gland, and on either side the internal mammary vessels are indicated by D, B, C, E. Although Vesalius was aware of its existence, the horizontal fissure is not shown in the right lung. The cut edge of the pleura is marked by G, G, and I, I, on either side, while L, L is the mediastinal interval and H, K represents the pleura of the mediastinal wall. M is the pericardium and R, R, the diaphragm. A quaint conceit, exaggerated in a very bizarre manner by the Spanish anatomist Valverde (fl. 1556) who copied the Vesalian figures, is the clothing of the nether limbs in britches and a cod-piece.

63:2 [VI:fig. 1]. *The present figure shows from the left side as great a part of the human body, lying on its back, as we considered sufficient to demonstrate the seat of the thorax. And so here we first removed the skin from the internal [anterior] aspect and sides of the thorax and from a portion of the region of the neck. Then, having reflected the muscles which cover the ribs, we freed the ribs from their cartilages as well as the pectoral bone. Having fractured the ribs (as occurs in the process of dissection) we pulled the cartilages of the ribs upwards towards the right side so that the thoracic cavity and the membrane dividing it [mediastinal pleura], the lung and the rest of the structures might come into view....*

The first of the series illustrating the thoracic cavity. The left lung has been retracted dorsally exposing the phrenic nerve P, and the pericardiaco-phrenic vessels, Q. The pericardial sac is indicated by L, and the diaphragm at I. E is the clavicle, F, the brachial plexus and axillary vessels, and G, the external jugular vein.

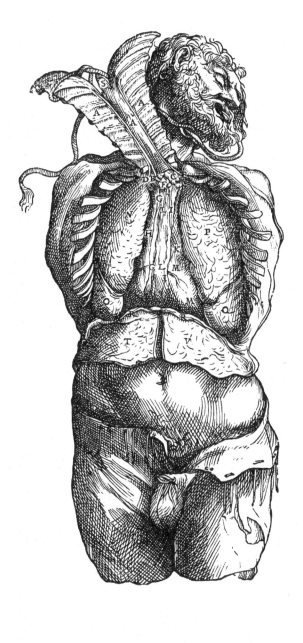

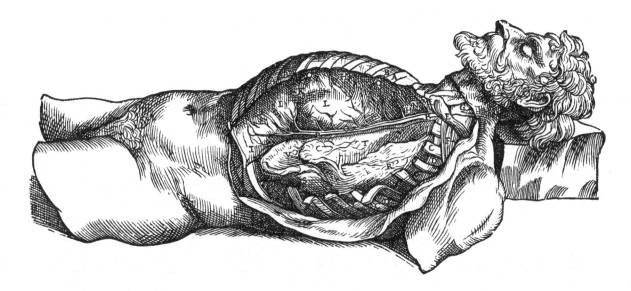

Plate 64

64:1 [VI:fig. 3]. *Since the two preceding figures [63:1-2] indicate fully the position of the heart and lungs, we have drawn the present one (as in all the subsequent) as though evulsed from the thoracic cavity, for had we depicted the trunk of the body in each of the figures, our task would have been rendered more difficult and to no purpose. And so the third figure, after the membranes dividing the thorax have been separated, contains the heart invested by its covering, together with the lung and a portion of the transverse septum [diaphragm] to a large part of which the covering of the heart is attached in man.*

The heart and roots of the great vessels enclosed by the pericardium and resting on a portion of the diaphragm are shown between the retracted lungs, with the phrenic nerves coursing down on either side.

64:2 [VI:fig. 4]. *In this figure we have divided the covering of the heart by a long incision and, turning it down to the sides, we have uncovered the anterior aspect of the heart and its vessels, the heart itself being undisturbed.*

The pericardium has now been incised to expose the superior vena cava, F, the aorta, H, the pulmonary artery, G, the auricles at I and K, and the ventricles, S. The remaining letters indicate the lungs and diaphragm as previously.

64:3 [VI:fig. 5]. *The present figure represents the heart together with the lungs, now entirely freed from its covering in the sequence of dissection. The heart has been turned over to the left side so that the continuity of the vena cava at the base of the heart is exposed to view.*

In the sixteenth century the vena cava D, C, F was regarded as a single vessel in continuity through the left atrium. G is the vena azygos; H and I, the root and arch of the aorta; K, the left vagus nerve; B, the right auricle, somewhat abbreviated; P, the root of the right lung. The right coronary artery goes unlabeled.

64:4 [VI:fig. 6]. *The present figure presents the heart rolled over to the right side as the figure immediately preceding showed it turned over to the left. Just as the former figure indicated the continuity of the vena cava at the base of the heart, so the present one offers the venal artery [left atrium], the left auricle of the heart, and finally the cardiac nervules. In order that their course might be more clear, we have left attached to this figure some of the branches of the great artery [aorta] and certain portions of the rough artery [trachea] and of the sixth pair of cerebral nerves [vagus nn].*

The globular heart and the arrangement of the branches of the aortic arch suggest that this series of illustrations was influenced by appearances in animals, possibly apes. The left side of the heart is here shown. The pulmonary artery is indicated by I and its right and left branches by L and K. G is the left atrium, F, the left auricle, and H, H, the pulmonary veins. The aortic branches are easily recognized. a and d are the vagus nerves giving off at b and f, the right and left recurrents, and in addition, the left vagus is seen contributing a branch, e, to the pulmonary plexuses and h, to the cardiac. The left coronary artery is marked D and the interventricular vessels, E. The superior and inferior vena cava are seen in the shadow at N, N.

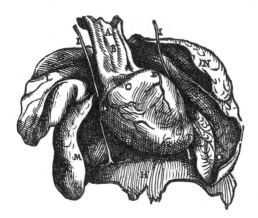

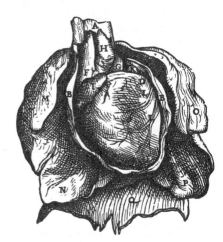

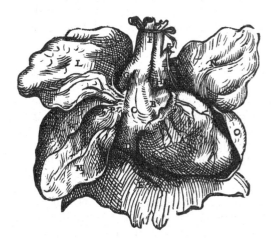

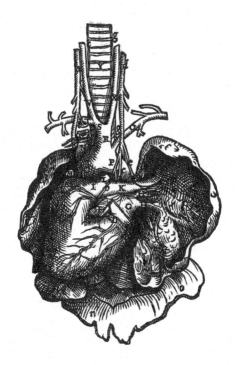

Plate 65

65:1 [VI:fig. 7]. *This figure shows the heart freed from the lungs and transverse septum [diaphragm], the right ventricle of which we opened by a single incision led from the anterior aspect of the orifice of the vena cava [right A-V orifice] to the apex of the heart. We have stretched it out as much as possible so that this orifice of the vena cava extending into the ventricle and its guardian membranes [valves] might come into view. Then, that the internal surface of the right auricle of the heart might also be exposed, we have sketched it turned inside out.*

To Vesalius and all sixteenth-century physicians the heart was regarded as a two-chambered organ. Thus the inferior vena cava, A, and the superior vena cava, B, are in continuity through the right atrium which gives off, as a trunk, the coronary sinus, orifice at G, and opens as the orifice of the vena cava (right A-V or tricuspid orifice) C, D, into the right ventricle. The tricuspid valve, K, L, M, the papillary muscles, O, and the chordae tendineae, N, are all shown. At F is the right auricle turned inside out to expose the musculi pectinati.

65:2 [VI:fig. 8]. *The eighth figure differs from the seventh [65:1] in that we have led an incision into the cavity of the arterial vein [pulmonary artery] from the position in the right ventricle of the heart which was marked P in the seventh figure. We have stretched out the orifice of that vein [pulmonary artery] so that its membranes conveniently come into view.*

A second incision has now been carried into the pulmonary artery as far as its right and left branches, C, D, thus exposing the septal wall, H, the pulmonary orifice and semilunar valves, E, F, G. A is the superior vena cava, B, the root of the aorta, and I, the septal cusp of the tricuspid. Prior to William Harvey, the ebb and flow theory of the circulation of Galen considered the right heart as venous, hence the pulmonary artery was called the artery-like vein.

65:3 [VI:fig. 9]. *The present figure presents the heart into which a single incision was directed from the orifice of the venal artery [left A-V orifice] to the apex of the heart so that the orifice of the venal artery together with the left ventricle of the heart might be stretched out to reveal the guardian membranes of the orifice. The left auricle of the heart has been turned inside out to show its internal surface.*

In the ebb and flow theory of the circulation the left heart is arterial, hence the left atrium is regarded as a vein-like artery C, C, giving off the pulmonary veins, not shown. The left A-V or mitral orifice and the left ventricle have been opened exposing the valves, E, F, the papillary muscles, H, and the chordae tendineae, G. A is the aorta.

65:4 [VI:fig. 10]. *In the tenth figure the same heart as that in the immediately preceding is presented, but here we have carried a more extensive incision from the right upper aspect of the left ventricle of the heart into the cavity of the great artery [aorta] so that by also stretching out its orifice its three guardian membranes are observed at the same time.*

A second incision has been carried into the aorta and the left atrium, H, auricle (inside out) L, and mitral valve, I, K, displaced to one side to expose the aortic cusps B, C, D, the septal wall R, and the orifices of the coronary arteries, E, F. O is the pulmonary artery and the other letters refer to obvious structures. However, S is to indicate the position in which the os cordis is found in animals. This bone was believed to possess extraordinary therapeutic powers, and Vesalius was one of the first to clear up the mystery surrounding it. The Galenical theory required that blood "sweat" through pores in the interventricular septum. Vesalius had accepted their existence at the time of the first edition of the *Fabrica* but had grave doubts as to the rightness of the theory by the time the second edition was published.

65:5 [VI:fig. 11]. *This figure shows the whole heart sectioned transversely so that the relative thickness of the ventricular substance of the heart comes into view and, as it were, the representation of the ventricles and noteworthy structures is offered at the same time.*

This is, perhaps, the earliest example of the use of cross-sections, apart from Leonardo da Vinci, to show the relative thickness of the ventricular walls of the heart and the shape of its cavities.

65:6 [VI:fig. 12]. *In the present figure the anterior aspect of the lungs, from which the heart and the neighboring membranes have been cut away, is delineated; which is seen to be not very dissimilar in configuration to the inferior aspect, facing the ground, of the hoof of a buffalo.*

The water buffalo (*Bos bubalus*), to the cloven hoof of which Vesalius compares the appearance of the anterior aspect of the two lungs, was quite common as a domestic animal in Italy. In the figure, A is the esophagus; B, the trachea; C, the pulmonary artery; D, a portion of the left atrium and pulmonary veins. The other letters refer to the four lobes and the diaphragm. The figure is very amateurish.

65:7 [VI:fig. 13]. *This figure denotes the posterior aspect of the lungs pulled out of the thorax which to some extent resembles in shape the upper part of the hoof of the buffalo.*

Although aware of the horizontal fissure of the right lung, Vesalius always illustrates four lobes. Like its companion above, the figure is very primitive.

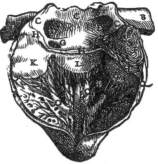

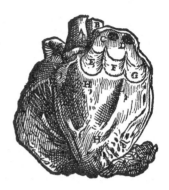

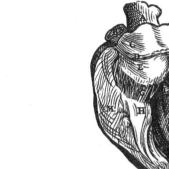

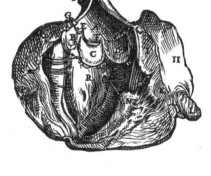

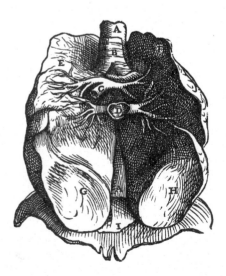

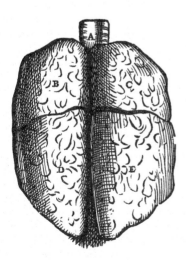

THE PLATES

FROM

THE SEVENTH BOOK

OF THE

DE HUMANI CORPORIS FABRICA

Plate 66

66:1-2 [VII:fig. 1]. The first figure of the seventh book represents the human head arranged for the purpose of demonstrating the brain, in which manner it is freed by neatly severing it from the neck and lower jaw. In addition, we have taken away in circular fashion with a saw as large a part of the skull as is customarily removed to observe everything contained within its cavity. In order that a picture of the portion removed might also occur here, we have included with the present figure the seventh figure of the sixth Chapter of the first book [7:3], because the internal surface of that part of the skull which before section covered and surrounded the whole of the region principally exposed in the first figure, is exactly represented therein. The present figure exposes to view the dural membrane of the brain still undamaged and nowhere perforated or injured, although we have torn the bonds of this membrane which extended through the sutures of the skull for the purpose of forming the membrane [periosteum] surrounding its exterior. Then, the small vessels accompanying the latter fibers have likewise been broken. These vessels which course through small foramina and the sutures of the skull are considered common to the dural membrane itself and that which surrounds the skull. Furthermore, of the two circles seen going around the figure, the lower consists of the skin and the membrane underlying it, and the upper is the skull itself. The whole region encompassed by the latter circle and indicated by many letters is the dural membrane of the brain.

In the first stage in the dissection of the cranial contents the letters A and B indicate the dura which was regarded as giving off intersutural fibers, G, H and I, which spread out on the surface to form the pericranium. C is the superior sagittal sinus; D, the middle and E, the anterior meningeal vessels believed to be veins only; F, emissary veins; K, an arachnoid (Pacchionian) granulation; and L, the frontal sinus. The second figure belongs, as mentioned in Vesalius' legend, to the series of the first book (7:3) which should be consulted.

Vesalius tells us that he constantly importuned the magistrates to allow him to take the heads of executed criminals so that he might dissect the brain while still warm. No doubt the heads in this series were from this grisly source.

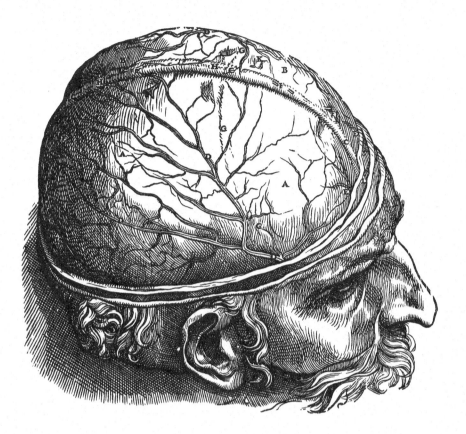

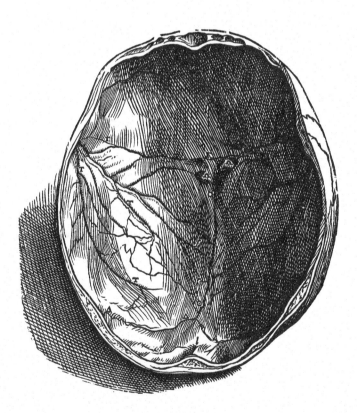

Plate 67

67:1 [VII:fig. 2]. *The second figure follows the first in the sequence of dissection and shows the third sinus [superior sagittal] of the dural membrane laid open by a long incision carried in the length of the head. In addition, at the sides of the third sinus I have led two incisions also in the length of the head, that is, one on either side of the sinus, which penetrate the dural membrane only and separate the sides of the dural membrane from that process [falx cerebri] of the membrane which divides the right part of the brain from the left. Besides the three incisions just mentioned, I have made another on each side which, extending from the region of the ear to the vertex, also divides the dural membrane only so that afterwards it can be conveniently separated from the thin membrane [pia-arachnoid] and reflected downwards (as you observe to have been done here). It so happens that the membrane of the brain seen here is entirely uninjured and, while closely enveloping the brain, elegantly displays the arrangement of its vessels in the region so far exposed.*

The notations are as follows: A, the upper edge of the falx cerebri; B, the superior sagittal sinus laid open to expose at C, the orifices of the cerebral veins; D, the terminations of F, the superior cerebral veins; E, the pia-arachnoid called the thin membrane; G, meningeal vessels; H, the dura reflected.

The representation of the gyri is only very approximate since Vesalius did not concern himself with their precise arrangement.

67:2 [VII:fig. 3]. *In the third figure we have stripped off both membranes of the brain, that is, the thin and the dural, from the entire portion lying above the section (which we have made around the skull with a saw to display the brain). The process [falx cerebri] of the dural membrane separating the right portion of the brain from the left, which is still preserved in position in the second figure [67:1], we have divided from the osseous septum [crista galli] which intervenes between the sinuses of the olfactory organs. This process we have left spread out over the left side of the brain so that its shape might be examined. The portions of the brain on the right and left have been separated from one another manually so that the superior aspect of the corpus callosum presents itself for inspection.*

A and B indicate the left and right cerebral hemispheres; C, the convolutions; D, the falx cerebri; E, the terminations of the severed cerebral veins; F, G, the inferior sagittal sinus; H, veins of the falx; I, K, internal cerebral veins at the beginning of the straight sinus; L, M, the corpus callosum; N, the crista galli; O, pia-arachnoid; P, the dura.

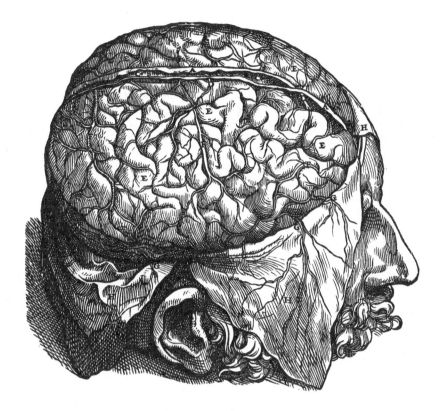

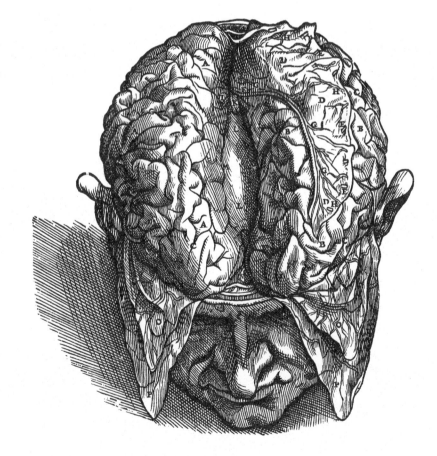

Plate 68

68:1 [VIII:fig. 4]. *In the fourth figure we have resected all portions of the dural and thin membranes which occurred in previous figures. Then we have removed in the sequence of dissection the right and left portions of the brain so that the cerebral ventricles now begin to come into view. First, we made a long incision along the right side of the corpus callosum where the sinus denoted by one of the M's exists, which was led into the right cerebral ventricle. Next, we removed the right part of the brain lying above the section where we cut the skull in circular fashion with a saw. When we had finished the same on the left side, we placed here the left part of the brain so as to show to some extent the upper aspect of the left ventricle, while the corpus callosum still remains in the head.*

A and B denote the sectioned surfaces of the right and left hemispheres; C, the cut surface of the upper portion of the left hemisphere placed on one side; D are lines to indicate the extent of the gray matter; E, F, G, H, the white matter; I and K, portions of the corpus callosum; L and M, the right and left lateral ventricles; N, the roof of the lateral ventricle; O, the choroid plexus; P, branches of vena terminalis; Q, anterior cerebral vessels.

68:2 [VII:fig. 5]. *The fifth figure, since it concerns the portion of the brain left in the skull, differs in no way from the preceding and has only this special significance, that here for the first time we have freed the corpus callosum in its anterior part from the brain; then, having elevated it, we have reflected it posteriorly, rupturing the septum [septum pellucidum] of the right and left ventricles, and we expose to view the upper surface of the body [fornix] constructed like a vault.*

The lettering is the same as above (68:1) except that R indicates the inferior aspect of the corpus callosum with Y, the torn attachments of the septum pellucidum; V, S, T, the body and posterior crura of the fornix with X, the ruptured lower attachment of the septum pellucidum.

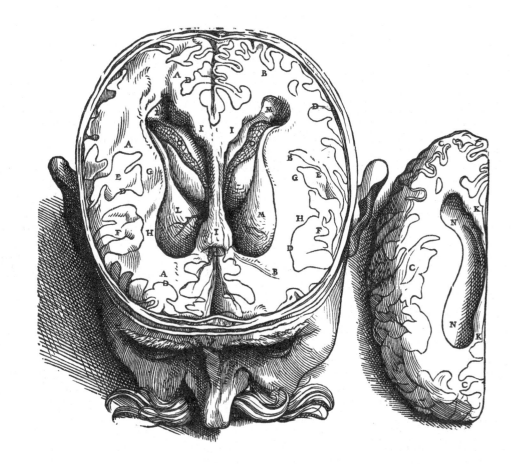

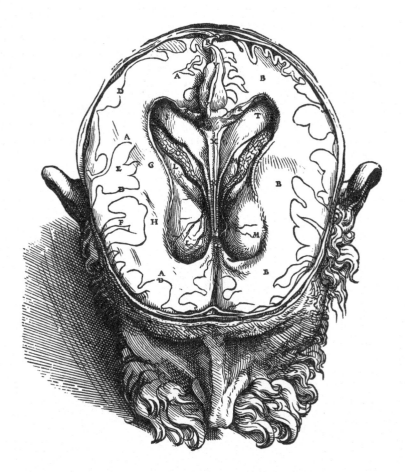

Plate 69

69:1 [VII:fig. 6]. *This figure, inasmuch as it concerns the portion of the brain remaining in the skull, also resembles the fourth [68:1] and differs from the fifth [68:2] in that we have freed the anterior aspect of the body constructed like a vault [fornix] from the brain substance, reflecting it upwards and posteriorly so that its inferior surface might come into view, and that the vessel [vena magna] which is extended from the fourth sinus [straight sinus] of the dural membrane, might be seen. This vessel is carried beneath the body constructed like a vault and eventually constitutes not the smallest part of the plexuses [choroid] which the ancients compared in likeness to the secundines [chorion].*

The anterior pillars of the fornix A have now been severed and the body reflected dorsally on the posterior crura to expose at H, the great vein of Galen draining the vessels of the tela choroidea I. K and L indicate the commencement of the internal cerebral veins by the union of the choroid veins from the plexuses M and N and the terminal veins at O. D and E refer to the right and left lateral ventricles; R and S to the sulci terminales leading into the interventricular foramen of Monro at Q. B and C indicate the posterior columns of the fornix. F and G represent the position of arteries supplying the plexus, presumably the posterior choroid.

The interventricular foramen, although associated with the name of Alexander Monro, secundus (1733-1817) from his classical work, was well known to Galen and Vesalius.

69:2 [VII:fig. 10]. *We have represented in this figure that portion of the brain which gives rise to the origin of the dorsal medulla, after the cerebellum has been taken away from the part of the dorsal medulla which is seen here. The cerebral testes [superior colliculi], the buttocks [inferior colliculi] and the glans resembling in shape a pine nut [pineal], and finally, the cavity of the dorsal medulla which together with the cavity of the cerebellum forms the fourth ventricle of the brain, are likewise represented here.*

A posterior view of the brain stem in which A indicates the portion of the brain from which the "dorsal medulla" takes origin. B and C represent the position of the aqueduct; E, F, G, H, the lamina quadrigemina;

I, K, the restiform bodies; L, M, N, O, the boundaries of the floor of the fourth ventricle; and P, the spinal cord proper.

69:3 [VII:fig. 7]. *The present figure differs considerably from the three immediately preceding, for that part of the substance of the brain, which in the sequence of the dissection we had still left in them and which in those figures constituted the principal seat of the right and left ventricles, is seen to have been removed. Then, all that portion of the brain which still remained attached to the cerebellum has also been cut away here, so that the process of the dural membrane [tentorium cerebelli] intervening between the cerebrum and the cerebellum is encountered. In addition, in this figure we have also opened the sinuses of the dural membrane [straight and transverse] found lying here. The vessel [vena magna] extending from the fourth sinus [straight] of the dural membrane into the cerebral ventricles has been elevated from the third ventricle of the brain and torn free from the plexuses similar to the secundines [chorion]. We have reflected this vessel posteriorly so that the position of the third ventricle of the brain, or common cavity of the right and left ventricles, might come into view the better together with the passageways of that cavity.*

The third ventricle H has now been exposed and the posterior half of the hemispheres cut away to allow inspection of the incisura tentorii, tentorium cerebelli O, straight sinus T, transverse sinuses P, Q, lower end of superior sagittal sinus S, and the confluens sinuum R. The tela choroidea together with the internal cerebral veins, V, has been reflected on the great vein of Galen, Y. X represents the cerebellum, M and N, the lamina quadrigemina, L, the pineal body, and Z, the petrous temporal. F and G indicate the position of posterior choroidal arteries. I is the infundibulum which was believed to drain off the pituita or phlegm from the brain, and K points to the aqueduct of Sylvius, described by Vesalius' teacher. The remaining letters simply indicate the outlines of gray and white matter. The caudate nucleus, lentiform nucleus, thalamus, internal capsule, etc., are beautifully shown in section but are not specifically named.

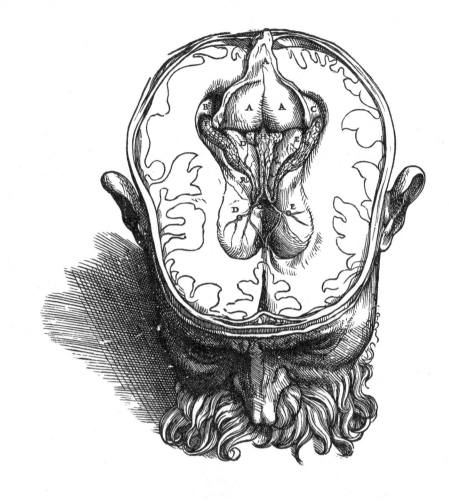

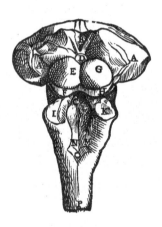

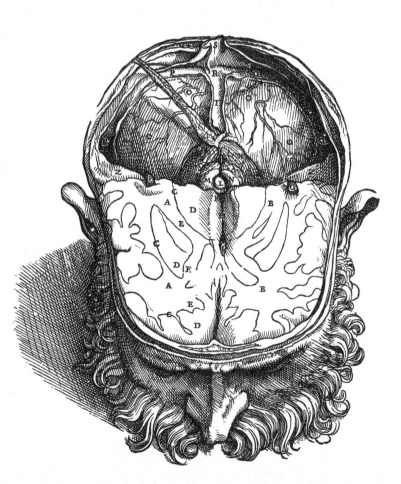

Plate 70

70:1 [VII:fig. 8]. *The eighth figure differs from the seventh in this respect, that here we have resected still more of the brain and have divided the testes of the brain [lamina quadrigemina] by a long incision so that the passageway extending from the third into the fourth ventricle is encountered. Furthermore, a portion of the dural membrane covering the cerebellum has been dissected and is seen reflected posteriorly. And since the present figure has much in common with the seventh, the letters AA, BB, CC, DD, EE, F, G, and H here indicate the same structures as in the seventh. However, the notable arteries F and G [posterior choroidal] here turn forwards more than in the seventh figure in the same proportion as the greater amount of the brain towards the base, resected in the seventh figure, as compared with the sixth.*

The tentorium cerebelli has now been reflected and the anterior half of the cerebral hemispheres sectioned horizontally at a slightly lower level. The lettering corresponds to that of the previous illustration except that L, indicating the cerebral aqueduct, has been designedly displaced posteriorly lest it be lost in the shading; the inferior colliculi of the lamina quadrigemina, P, Q, in addition to the superior N, O. In the terminology of the times these structures were known as the buttocks and testes. The pineal body M (L in the previous picture) is displaced to the left. The superior cerebellar vessels are indicated by S and compared, because of the thinness of their walls, to veins. It was this characteristic which caused Vesalius great confusion in his description of the cerebral vessels.

70:2 [VII:fig. 11]. *In this figure the cerebellum has been pulled out of the skull and cut away from the dorsal medulla. It lies on its back showing its lower aspect where it faces the dorsal medulla. Likewise, it shows the regions which are continuous with the dorsal medulla and, in addition, the sinus which forms the other portion of the fourth ventricle common to the cerebellum and dorsal medulla. At the lower part of the present figure we have depicted the extremities of the middle part of the cerebellum [vermis] as though excised from some other cerebellum, so that the nature of these processes resembling a worm in shape may be seen more precisely.*

The anterior or ventral aspect of the cerebellum is shown to reveal the roof of the fourth ventricle at E. The cerebellar peduncles are indicated as having been severed at G. C is the vermis, the "extremities" of which, the lobus centralis and lingula, the uvula and nodule, are indicated by D, d. These structures have been excised from another cerebellum and lie below at H and I to show their worm-like appearance, as described by Galen, justifying the term vermis.

70:3 [VII: fig. 9]. *In this figure the same portion of the brain as in the eighth has been preserved. However, the present figure has been laid upon its face, and the process of the dural membrane [tentorium cerebelli] which separates the brain from the cerebellum has been cut away. Then the cerebellum here has been pulled downwards by the hands from its position in the skull and hangs down somewhat inverted so that the region otherwise in contact with the skull might be exposed to view, and the cavity of the dorsal medulla constituting the second part of the fourth ventricle might be seen. In addition to the progress of certain veins and nerves, the first and second sinuses [right and left transverse sinuses] of the dural membrane are here opened and accurately represented.*

The cerebellum has been displaced forwards to expose the inferior aspect of the lateral lobes B, D, the inferior vermis C, and the uvula E. F, G, H indicate the extent of the medulla. I is the inferior part of the fourth ventricle described as similar to the point of a pen, hence the modern term calamus scriptorius. P, Q, R identify the posterior cranial fossae related to B, C, D, respectively. The transverse sinuses are shown at S and T. M, N, O refer to the fifth, sixth and seventh pairs of cranial nerves in the Galenical and Vesalian terminology, that is, approximately the facial-acoustic, the glossopharyngeal-vagus-accessory, and the hypoglossal. K is said to be a vessel similar to a vein which empties into the transverse sinus, but not always present.

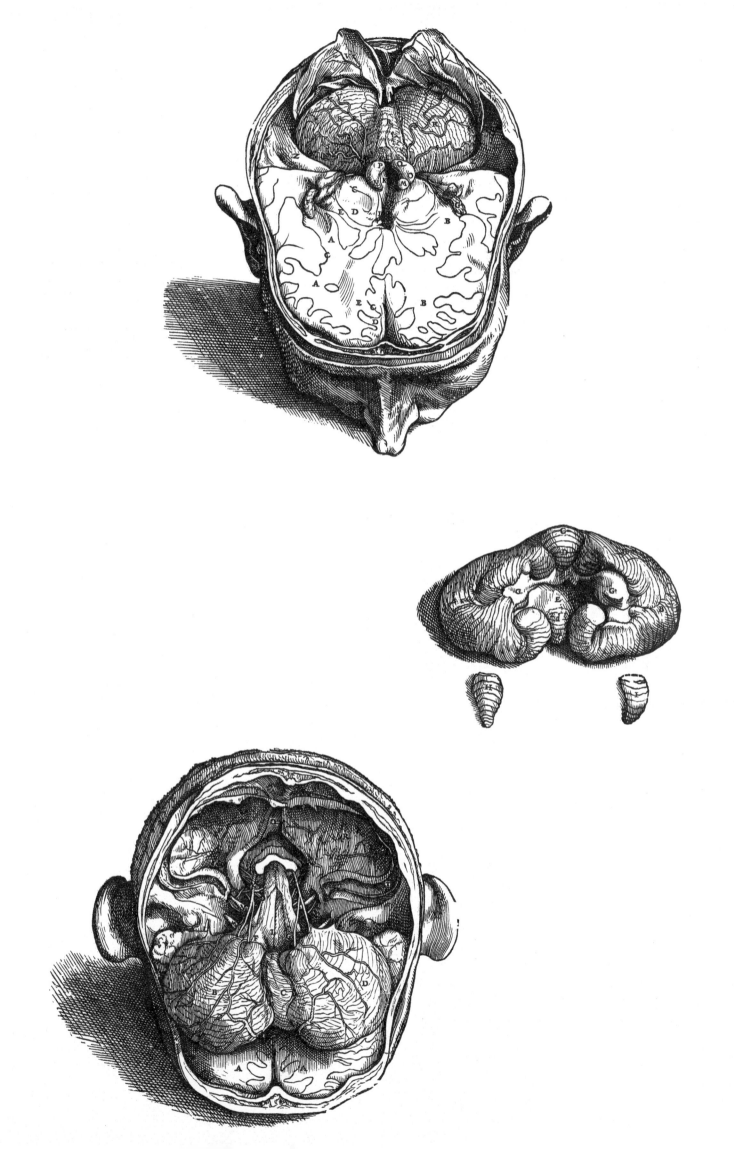

Plate 71

71:1 [VII: fig. 12]. *In this figure the head is represented from the left side, the right being somewhat elevated. Here we have evulsed the cerebellum from the cavity of the skull while only that portion of the brain remains which was still preserved in the eighth and ninth figures [70:1, 70:3]. However, this portion of the brain does not lie in position but has been elevated and reflected to some extent posteriorly from the base of the skull so that the processes [olfactory] of the brain, in form not unlike nerves and which subserve smell, may come into view. The left process has been lifted up with the brain from its position while the right still remains connected to the dural membrane of the brain where it covers the eighth bone of the head [ethmoid].*

Following Galen, the olfactory are not classified with the cranial nerves but, owing to appearances in animals, regarded as hollow processes or extensions of the lateral ventricles. The remaining structures here seen are readily identified.

71:2 [VII: fig. 13]. *This figure rests entirely upon its occiput, and all the brain substance which still remains hangs reflected downwards into the posterior parts so that the olfactory organs, the connection of the visual nerves and the largest branches of the sleep-inducing [carotid] artery might come into sight.*

The optic chiasma, O, M, N; the infundibulum, S; the internal carotid P, dividing into the anterior and middle cerebral arteries R and Q, but not correctly identified; and the olfactory tracts L, are exposed. I is a cerebral vein connecting with the sphenoparietal sinus; H and K are the anterior and middle meningeal vessels. Other lettering refers to the brain, attachment of the falx cerebri and the ethmoid.

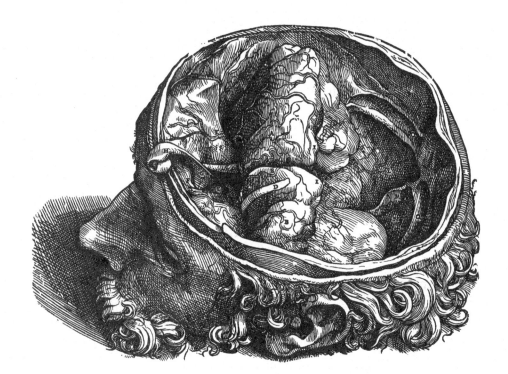

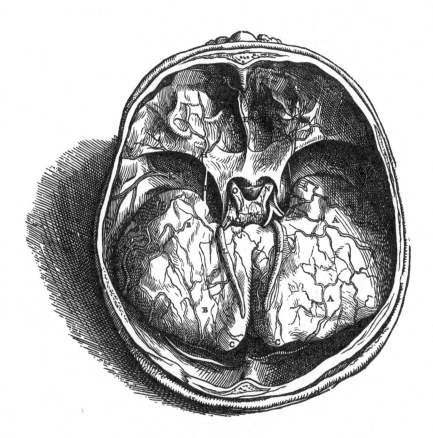

Plate 72

72:1 [VII:fig. 14]. *Here the head lies reclining on the left ear and presents the base of the skull cavity still surrounded by the dural membrane of the brain. As large a portion of the brain and of the dorsal medulla is preserved as is sufficient for seeing the pairs of cerebral nerves. I have cut away the origin and connection [chiasma] of the visual nerves so as not to hide the pelvis [infundibulum] which receives the pituita of the brain.*

The amorphous mass, A, is the remnant of the brain and brain stem which suggests the difficulties of sixteenth-century dissection due to lack of fixatives. B is the cut optic nerve. C, D, the infundibulum and pituitary body which constituted the receptacle for the pituita or phlegm in the Galenical physiology. E and F are branches of the internal carotid arteries. G is the oculomotor nerve (second pair of Vesalius); H, the trochlear (classified with the third pair); I and K, the trigeminal (third and fourth pairs); L, the abducens (minor root of the fifth pair); M, the facial-acoustic complex (fifth pair); N, the glossopharyngeal-vagus-accessory (sixth pair); O, the hypoglossal (seventh pair). On the cranial nerves consult the note to 48:1.

72:2 [VII:fig. 15]. *We have depicted in the present figure a part of the cavity of the skull still covered by the dural membrane of the brain which lies above the middle of the wedge-like bone [sphenoid], together with the organs now to be pointed out. For it was unnecessary to draw the entire skull for the sake of these details.*

A more detailed illustration of the relations of the pituitary gland to show the pathway along which, according to Galenical physiology, it was believed that the phlegm passed on its way to the gland and thence to the nasal cavities. A and B are the severed optic nerves. C, D, the arteries (internal carotid) "which, on perforating the dura, are distributed partly to the third membrane [pia-arachnoid] and partly to the ventricles." E, the infundibulum or, as Vesalius calls it, the basin or pelvis "which receives the phlegm flowing down from the third ventricle." F, the dural foramen leading to the pituitary gland. G, the second pair of cranial nerves of Vesalius (i.e., oculomotor).

72:3 [VII:fig. 16]. *In this figure we have depicted the exposed [pituitary] gland which receives the phlegm from the brain. With it is the pelvis or infundibulum along which the phlegm is conveyed to the gland and which hangs flaccidly downwards. At the sides are portions of the sleep-inducing [carotid] arteries which are alleged to form a reticular plexus and which we have represented just as we have encountered them upon dissection. As these portions of the arteries are found to vary by the dissector, we have drawn variants of them.*

The pituitary gland A, infundibulum B, and carotid arteries C, are shown. From the carotid a vessel, E, is said to extend forwards to the nasal cavity. The main trunk, F, is shown divided on one side as a variant. H

is said to be the ophthalmic artery. Other branches are cerebral vessels.

It is assumed that the obvious errors in the distribution of the artery were due to the practice of freeing the vessel from the specimen and laying it on paper from which the drawing was made. Thus we take it that E is in fact the ophthalmic artery; H, the anterior cerebral; G, the middle cerebral; and D, possibly the posterior communicating.

72:4-5 [VII:fig. 17]. *In the first of these figures we have sketched the reticular plexus as it ought to be to agree with Galen's description in his book "On the Use of Parts." Therefore, A and B indicate the arteries entering the skull and then supposedly breaking up into that remarkable plexus. C and D are the branches into which the shoots of the plexus are reunited and which correspond exactly in size to the arteries we indicated at A and B. In addition, E denotes the gland receiving the pituita from the brain.*

We have depicted in the second of these figures the series of arteries extending along the side of the gland admitting the phlegm from the brain which we have commonly observed in the heads of cattle and sheep. I am disposed to present this lest anyone should think we have concealed the fact that differences exist between these animals and man. In this figure A indicates the often-mentioned [pituitary] gland; B and C, the position of the arteries where they first enter the skull.

The so-called *rete mirabile*, found in the ox and sheep where its function is unknown, is a large and elaborate plexus in the floor of the cranium, the emergent artery of which is distributed like the internal carotid. In the Galenical physiology it was believed to separate the animal spirit from the blood to provide the "force" for the action of the nervous system. Its existence in man had been universally accepted, and before Vesalius, only Berengario da Carpi (1522) doubted its presence.

72:6 [VII: fig. 18]. *In this small figure we have depicted the pelvis or cup [cyathus] set upright by which the pituita of the brain distills into the gland underlying it, and then we have sketched in the four ducts carrying the pituita down from the gland through foramina in the neighborhood of the gland. Therefore A indicates the gland into which the pituita is distilled and B, the pelvis along which it is led. C, D, E, F are the passages provided for the easier exit of the pituita passing down here....*

A diagram of the infundibulum and pituitary gland which were supposed to receive the pituita or phlegm which, in turn, escaped into the nasal passages. The four ducts are quite fanciful but represent the foramen lacerum and superior orbital fissure along which the phlegm was presumed to pass to the nasopharynx. The phlegm theory was accepted almost to the nineteenth century and when the phlegm was in excess, it was believed to cause respiratory and arthritic complaints.

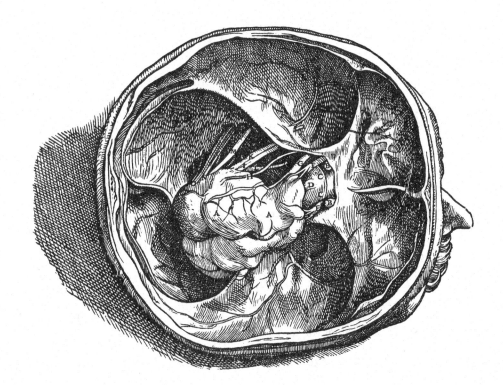

Plate 73

73:1 [VII:xiv]. *This figure, the first of those appended to the present Chapter, represents one half of the eye divided by a single antero-posterior incision passing through the visual nerve; that is to say, just as if one were to draw half of an onion divided lengthwise from that surface which had been in contact and continuity with the other half. It is in this way that we customarily depict the heavens with the four elements on a plane surface.*

The following structures are indicated: A, the crystalline lens; B, a portion of the capsule; C, the vitreous body; D, the optic nerve; E, the retina; F, pia-arachnoid coat of optic nerve; G, the choroid; H, the iris; I, the pupil; K, the ciliary processes; L, the dural coat of the optic nerve; M, the sclera; N, the cornea; O, the aqueous humor; P, ocular muscles; Q, the conjunctiva.

Vesalius depended largely upon the eye of the ox for his demonstrations. The central position of the lens is a medieval conception and long a bar to the correct understanding of the dioptrics of the eye. Realdus Colombus, a pupil of Vesalius, was the first to recognize its true position.

In view of the importance of astrology to the sixteenth-century physician, all would be familiar with the sectional charts of the earth and heavens to which Vesalius refers.

73:2. *The second figure represents the crystalline humor [lens] from its anterior aspect only when freed from all surrounding parts and as it occurs when viewed directly.*

73:3. *The third figure demonstrates the crystalline humor, completely naked, and showing that aspect when viewed by someone from the side. The letter R denotes the rough region of the crystalline humor to which the ocular tunic resembling eyelashes [ciliary processes] is attached.*

73:4. *The fourth figure shows the vitreous humor executed as though it had preserved the shape which obtains in the eye and had been seen from the anterior aspect when the crystalline humor had been removed from it. The letter S indicates the cavity in which the central part of the crystalline humor was set.*

73:5. *The fifth figure represents the same aspect of the vitreous humor as in the fourth, but the crystalline humor, indicated by T, is still swimming in it.*

73:6. *The sixth represents the vitreous humor from the side together with the crystalline humor, indicated by V, swimming in it.*

73:7. *The seventh figure represents the aqueous humor (as it is otherwise fluid) just as though it occurred in the eye and still covered the anterior aspect of the crystalline humor. For the letter X denotes the crystalline hu-*

mor in the present figure, and Y indicates that portion of the aqueous humor which contains (when the eye is intact) a part of the uveal tunic [iris] which falls away and is separated from the cornea.

73:8. *The eighth figure shows simultaneously the vitreous humor, denoted by a, and the aqueous humor, indicated by b, separated from one another as though they were divided by that tunic [ciliary processes] which we compared, not without due consideration, to the arrangement of the eyelashes. The position of this little tunic lying between these humors is indicated by c.*

73:9. *The ninth figure represents from the side the tunic [part of lens capsule] which covers the anterior aspect of the crystalline humor and is quite transparent. It has been freed from its humor.*

73:10. *The tenth figure shows the crystalline humor from the side still covered by the small tunic [part of lens capsule] represented in the ninth figure. The letter d indicates this small tunic, while e denotes the posterior part of the crystalline humor not covered by this tunic but which, when the eye is intact, swims in the vitreous humor.*

73:11. *The eleventh figure indicates the anterior or posterior part of the tunic [zonule of Zinn] extended from the uvea [ciliary body] and which resembles the eyelashes. These arise from the uvea at the circle indicated by g and g, but are inserted or attached to the crystalline humor [lens] at the circle noted by f and f.*

73:12. *The twelfth figure contains the tunic, shown in the eleventh, to which the crystalline humor is still attached. For h and h indicate the tunic and i, the crystalline humor.*

73:13 *The thirteenth figure shows the tunic [retina] which those skilled in dissection compare to a net. This is here represented from the side together with the visual nerve freed from the membranes of the brain and noted by k.*

73:14. *The fourteenth figure shows the internal surface of the uveal tunic. Here we have drawn the tunic inside out just as it is sometimes reversed or everted on dissection. Therefore, l denotes the small portion of the tunic into which the substance of the visual nerve is dissolved, while m represents the position in which the anterior region of the uvea was compressed inwards and posteriorly.*

73:15. *The fifteenth figure contains the external surface of the uvea delineated from the side together with the substance of the visual nerve still covered by the thin membrane [pia-arachnoid] of the brain. The letter n*

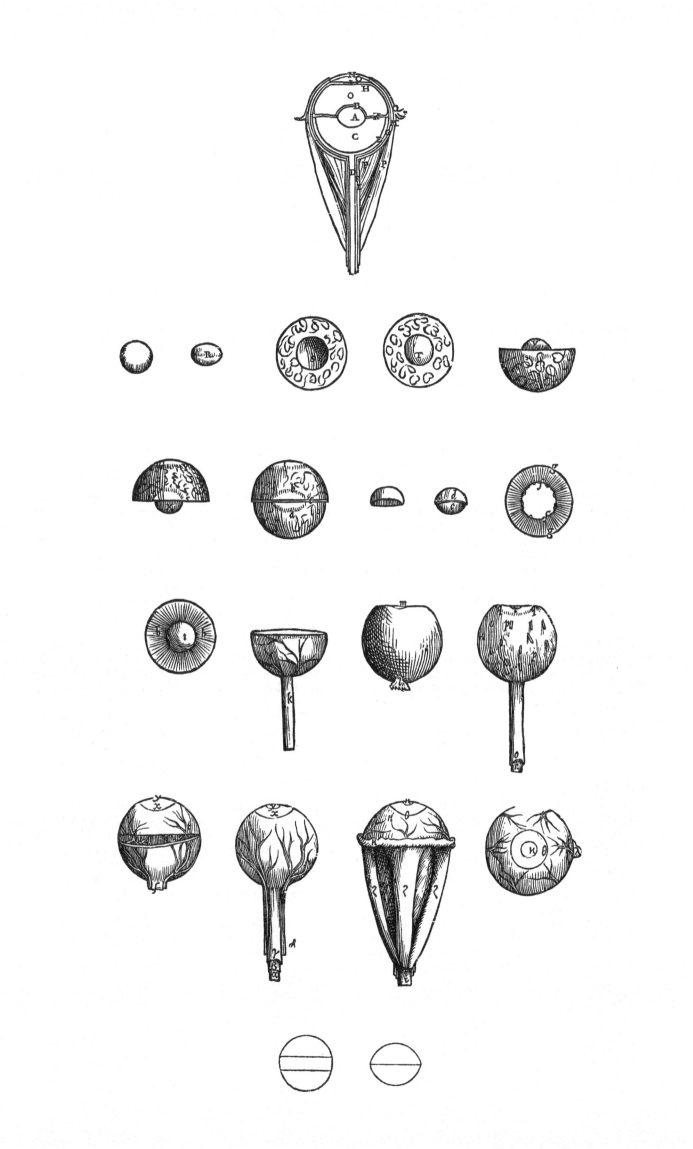

denotes the substance of the visual nerve, here freed from the thin membrane which surrounds it. The thin membrane is noted at o, covering the substance of the visual nerve, and here denuded of the dural membrane which envelopes it before dissection. The letters p, p are small portions of the veins and arteries [choroid] extending into the uvea from the hard tunic [sclera] of the eye, but not broken in the course of dissection. q, q is the position where the uvea is flattened in the anterior part [iris] and cut away from the cornea. r constitutes the foramen or pupil of the uvea.

73:16. The sixteenth figure shows the hard tunic [sclera] of the eye from the side, divided by a transverse incision so that the series of vessels [choroid] extending from it to the uvea are brought into view. Therefore, ς indicates the visual nerve together with the two membranes surrounding it and accompanying veins and arteries, cut short. The letters t,t are the veins and arteries running through the hard tunic. u and u is the uveal tunic, observable here because of the incision in the hard tunic, and receiving small branches of the hard coat. Furthermore, x indicates the position where the hard tunic is smooth and horn-like and is seen to be transparent. The foramen of the pupil corresponds to the position noted by y.

73:17. The seventeenth figure exhibits from the side the entire, naked, external surface of the hard tunic [sclera], together with a large portion of the visual nerve in which α denotes its substance, β the thin membrane [pia-arachnoid] with which it is covered, γ the dural membrane of the brain, and δ the accompanying veins and arteries of the visual nerve. Then x and y here indicate

the same structures as in the sixteenth.

73:18. The eighteenth figure represents from the side the eye freed from the eyelids and plucked from its seat in the skull, together with its muscles not yet removed. The letter ϵ indicates the visual nerve; ζ and ζ, the muscles moving the eye; η and η, the adherent tunic [conjunctiva] of the eye. θ is the larger circle of the eye or iris, where the adherent membrane ends and is attached very firmly to the cornea; but κ denotes the position constituting the region of the pupil or smaller circle.

73:19. The nineteenth figure represents the anterior aspect of the entire eye freed only from the eyelids. Here λ denotes the caruncle placed in the larger angle of the orbit. However, θ and κ indicate here the same structures as in the preceding figure. However, should anyone think it requisite to follow the description of the eye from the outermost part first, let him reverse the order of the figures and take the nineteenth in place of the second, the eighteenth in place of the third, and so on.

73:20-21 [VII:xiv]. The crystalline humor.
A marginal diagram of the lens to show that it is not a perfect sphere but of lenticular form. In the first diagram Vesalius shows how a globe must be cut to remove the central portion and then the outer segments must be glued together as in the second figure to approach the true shape of this structure.

[VII:xix]. The figure of the pig on the dissecting board, 42:6, was also reproduced in the seventh book to illustrate the chapter on vivisection.

THE PLATES

FROM

THE *EPITOME*

OF THE

DE HUMANI CORPORIS FABRICA

To the Reader

The Compendium of the books De Humani Corporis Fabrica which we now present is divided into two parts. The first, consisting of six chapters, contains a very brief account of all the parts, and the second presents in several plates a delineation of the same structures. Therefore, when you have considered our arrangement (which we selected from various possibilities as the most suitable with respect to typography and method of illustration) you will first begin, insofar as you deem it of value to your purpose, either with the description of the parts or with the illustrations and explanatory notes, starting specifically from the figures representing likenesses of the nude male and female where the terms for the external features occur as an index to them.

The figure [79] printed on the back of that of the male presents all the bones articulated together; although the figures, especially the fourth and fifth [75 and 74], drawn to the same scale as the male, and even if designated illustrations of the muscles, also represent the bones in the process of dissection.

The delineation of the muscles and ligaments must be sought first from the figure [78] which we have placed opposite that representing all the bones and which, on this account, has been designated the first figure of the muscles. Following this is the figure numbered the third, and then the fourth and fifth.

The organs of nutrition, which exist for the food and drink, the heart and the parts assisting its functions, together with the series on the nerves, are placed in figures following the representation of the nude female, where the female instruments of generation are seen, as well as where the male organs occur in figures to be [cut out and] glued to the fifth plate [74] on the muscles.

In addition to the plate provided to demonstrate the nerves, the figures on the muscles carry adequate representations of the structures which are enclosed by the skull. The first of these is the head of the first figure [78], then that of the second [77], followed by the fourth [75], together with the representations of the head held in the hands of that figure, and following these, the representation seen in the left hand of the fifth figure [74] and another seen lying there on the ground beside the picture of the parts of the eye.

Farewell, and make good use of our well-meant efforts.

HOW TO VIEW THE ILLUSTRATIONS OF THE "EPITOME"

The Epitome of the De Humani Corporis Fabrica, published simultaneously with the larger work, was intended to act as an introduction for the tyro in medicine. It stands, says Vesalius, like a pathway beside the highway of the larger book, and in the case of a beginner it is more advantageous, after discussing the muscles, to combine the study of the viscera with the distribution of the vessels; a course followed in the Epitome. The approach is, therefore, what we would call today topographical.

In pursuance of this plan, the work is divided into two parts, and the reader in viewing the illustrations is supposed to start with the nude figures of the male and female at the middle of the series.

Having inspected the surface of the body and acquainted himself with the terminology descriptive of the various regions, he now proceeds in one of two directions. Preferably, he first goes backwards plate by plate to the beginning of the series and on turning the leaf and, as it were, removing the skin, exposes the first layer of muscles followed in succession by progressively deeper layers until little more than the skeleton is encountered. Then returning to the nude figures, he goes forwards in order to expose the nervous system, the cardiovascular system and the viscera. In the latter section several of the plates are repeated, and from these the student may construct by means of "cut outs" two manikins, male and fe-

male, which reveal the relative positions of the structures. Vesalius' instructions on the preparation of these manikins will be found in the descriptive matter on these plates. Apparently it was possible for the student to purchase, no doubt at an additional price, copies in which the manikins had been assembled and which were colored by hand. Such copies of the *Epitome* are occasionally encountered.

Representations of the body in which the viscera are drawn on separate, superimposed layers to suggest their sequence within the body cavities had been employed prior to Vesalius. For example, two sheets were issued at Venice in 1539 representing the male and female body by Nicolaus de Sabio which may have suggested the series in the *Epitome*, but there were still others which may have been the source of the idea. However, those of Vesalius are among the earliest and are certainly the most accurate and elaborate.

A further feature to be observed upon examining the illustrations of the *Epitome* is that many of the smaller figures inserted in the larger plates are reduced versions of similar figures found in the *Fabrica*.

Plate 74

The figure printed on this sheet, to which others composed of various parts may be glued, is to be numbered the fifth in the order of the figures showing the muscles. It presents all the remaining structures which are to be seen from the anterior aspect. Since these are very few, it is not remarkable that the present figure presents in large part, like the preceding [79], the bare bones. The figure of the brain, held in the left hand, follows that which is grasped in the left hand of the fourth figure and that in the present figure which lies on the ground (where the central part of the eye occurs). What is left for observation in the cavity of the skull is to be seen in those figures which lie behind that of the female [82 and 83], where is also explained the figure with its parts which, you will observe, is to be glued to the present figure, with the exception of the organs peculiar to the male which must be mentioned on the present page.

The figure here shown was to form the base of a manikin containing the male generative organs by superimposed figures from plates 83-85. For instructions on the construction of the figure consult the annotations to these plates. The illustration demonstrates the final stage in the order of dissection with little more than the naked skeleton left. The muscles indicated are the longus capitis and cervices, scalene, transversus thoracis, the intercostals, and the iliopsoas. The smaller figures are all reduced versions, slightly modified, of those shown in the Fabrica. Explanations of the small figures will be found in relationship to plates 70:2, 70:3 and 73:1.

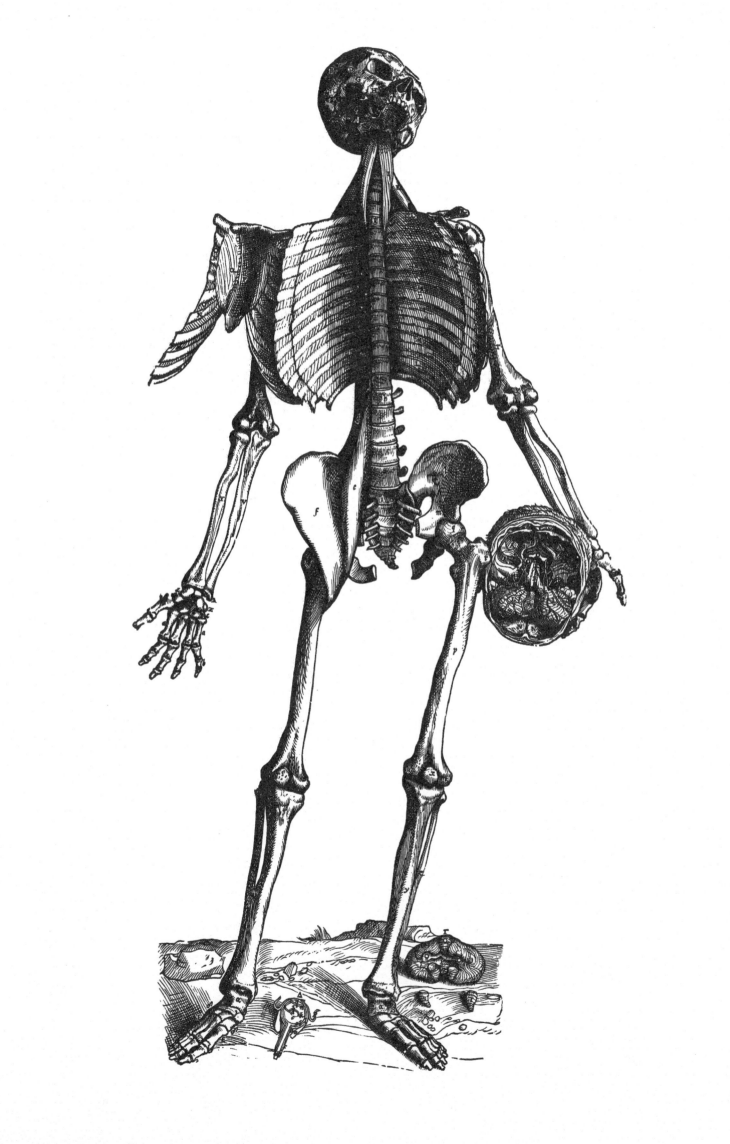

Plate 75

The fourth figure of those demonstrating the muscles represents all the muscles on the posterior aspect of the body, lying concealed beneath those exhibited on the left side of the second figure [77]. On the right side [of the present figure] are those which occur first, but on the left, those still lying beneath them. The demonstration is further assisted by the head and foot placed on the ground. The three pictures of the parts of the brain seen in this figure follow one another in the order of dissection. Of these, the first, constituting the head of the complete man, follows on from the left side of the head of the second plate [77], but that here contained in the right hand comes after the first; while that grasped in the left hand occupies last place.

This figure follows plate 77 to show the third and fourth layers of muscles. The more superficial group on the right includes the three components of the sacrospinalis; longissimus cervicis and capitis, costalis and costocervicalis, portion of semispinalis capitis. In the upper extremity are shown rhomboids severed from their origin, levator scapulae, triceps, and supinator. In the lower extremity may be identified gluteus minimus, obturator internus and gemelli, portion of adductor magnus at θ, the hamstrings, popliteus, soleus and the peroneals. The separate foot on the right, compare plate 37, shows the tendons of flexor digitorum brevis turned back, flexor digitorum longus, flexor hallucis longus and tibialis posterior.

The deep layer on the left reveals the short rotators of the head, semispinalis cervicis and thoracis, multifidus and quadratus lumborum. In the thigh, obturator internus and the gemelli are turned back showing obturator externus. In the leg, popliteus is reflected as well as flexor hallucis and digitorum longus and brevis (misplaced) thus exposing tibialis posterior and the smaller muscles of the foot. The skull beneath the left foot is from the *Fabrica*, see plate 37. The dissections of the brain are to be seen on plates 68:2, 69:1 and 69:3, which see for details.

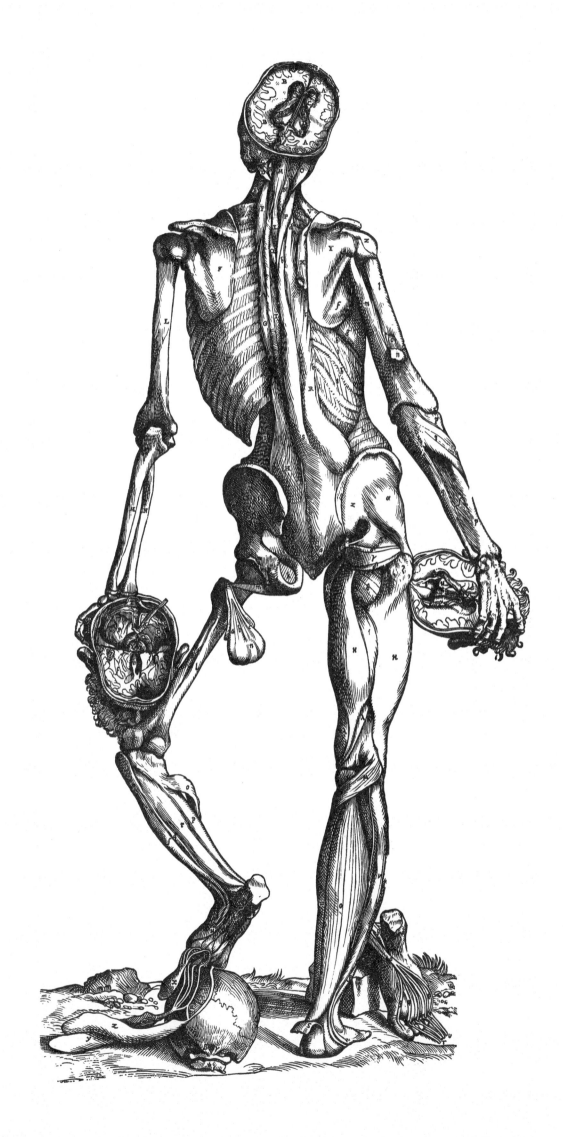

Plate 76

The third figure showing the muscles follows the first and second. On the right side it presents from the anterior aspect the muscles lying immediately beneath those illustrated on the left side in the former figure [78]. Then, on the left side it depicts those which are under the muscles of the right side. In addition, the muscles of the tongue and of the larynx and the cartilages are here placed on the ground.

The mandible has been divided and the two halves retracted, exposing on the right side at C the internal pterygoid muscle which has been removed on the left to reveal the inferior alveolar and lingual nerves. Posterior to the tongue at H is the epiglottis, and on either side within the shadow the tonsils are indicated. The remaining muscles should present no difficulty in identification. The small figures of the tongue, larynx and laryngeal cartilages seen on the ground may be viewed more advantageously in plates 20, 40 and 41 from which they are apparently derived.

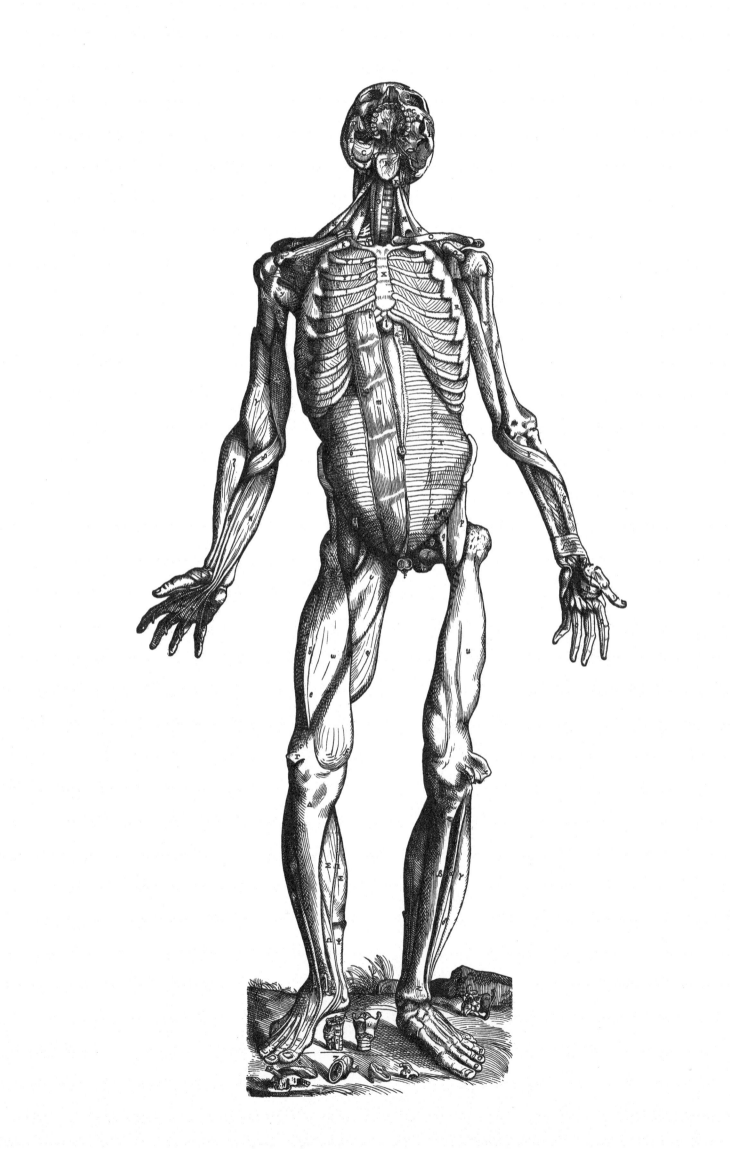

Plate 77

The second figure prepared for the demonstration of the muscles exhibits the posterior aspect of the body, just as the first did the anterior. On the right side it shows the muscles extended beneath the skin, but on the left side those which lie under them in the sequence of dissection. Furthermore, the head follows perfectly, in order of dissection, the head of the first figure [80].

The first and second layers of the muscles of the back, none of which is difficult to identify. The dissection of the brain corresponds in part to the stage shown on plate 68:1. The separate dissection of the foot shows flexor digitorum brevis.

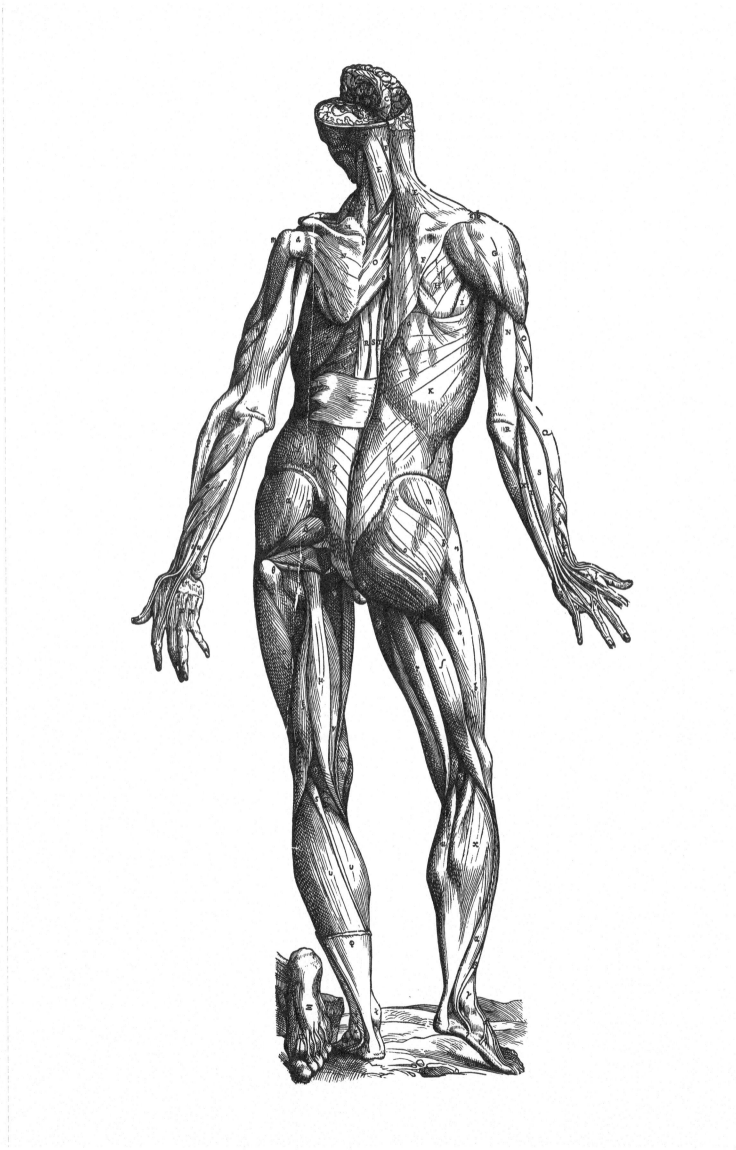

Plate 78

The first of the figures which we have prepared principally for showing the muscles. On the right side the muscles hidden directly beneath the skin are observed from the anterior aspect, but on the left are evident those which immediately underlie the muscles of the right side when the latter have been cut away. That the present figure might be rendered more comprehensive, we have begun, following the order of dissection, to delineate representations of those structures which occupy the skull, such as the ocular muscles placed on the ground. . . .

The first and second layers of muscles are shown from the anterior aspect. Identification of the various muscles is relatively simple except in the case of the facial group where, apart from some of the more obvious, there was much confusion. The figures of the ocular muscles are similar to those shown on plate 40 which should be consulted on the non-human characters displayed such as the choanoid, or retractor bulbi muscle.

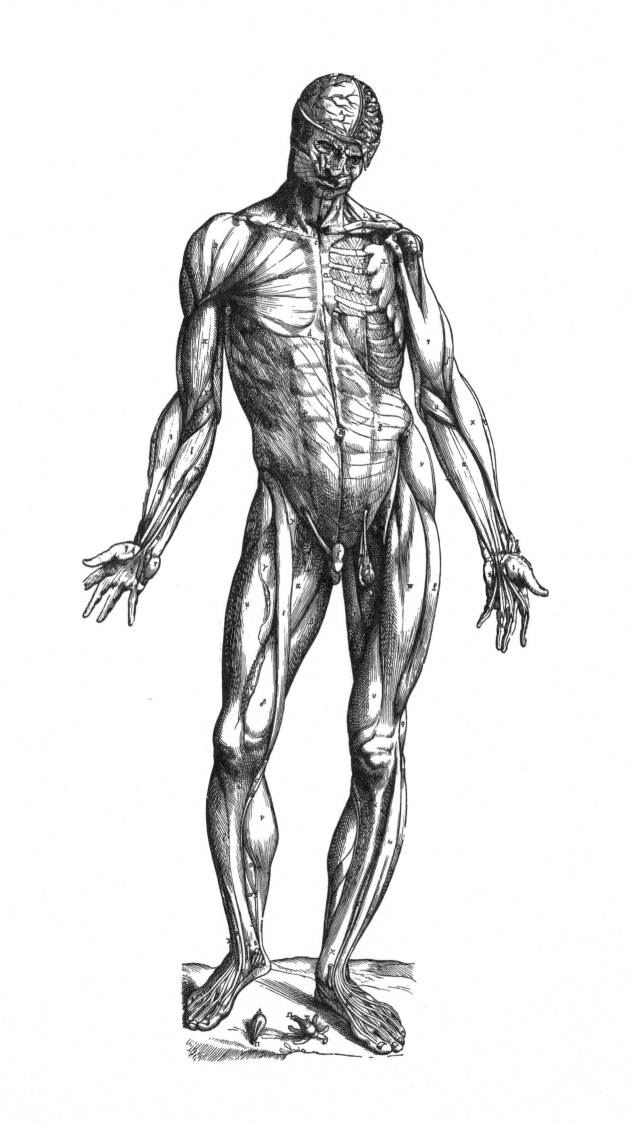

Plate 79

A complete delineation of all the bones of the human body, as well as the positions of their joints, freed from all parts which they support and whatever is attached to them or extends from them.

Even if the bones do occur in the figures prepared for the present Epitome of the De Humani Corporis Fabrica and drawn to the same scale as the representations of the male and female which immediately follow, and although this happens frequently, nonetheless all the bones are not seen united together, denuded and uncovered in one and the same figure at the same time. Therefore, it will not be amiss to reproduce here, on an otherwise empty page, an illustration from the first book [of the Fabrica] of one of the three figures there representing all the bones simultaneously. This figure presents more of both anterior and posterior aspects and, furthermore, also offers to view the base of the skull, on which the right hand rests, together with the bone resembling the letter U [Hyoid] and the auditory ossicles. . . .

The figure is identical with that of the Fabrica reproduced on plate 22, except that in the original the panel of the tomb carried a Latin distich which may be rendered:

> All splendor is dissolved by death, and through
> The snow-white limbs steals Stygian hue to spoil
> The grace of form.

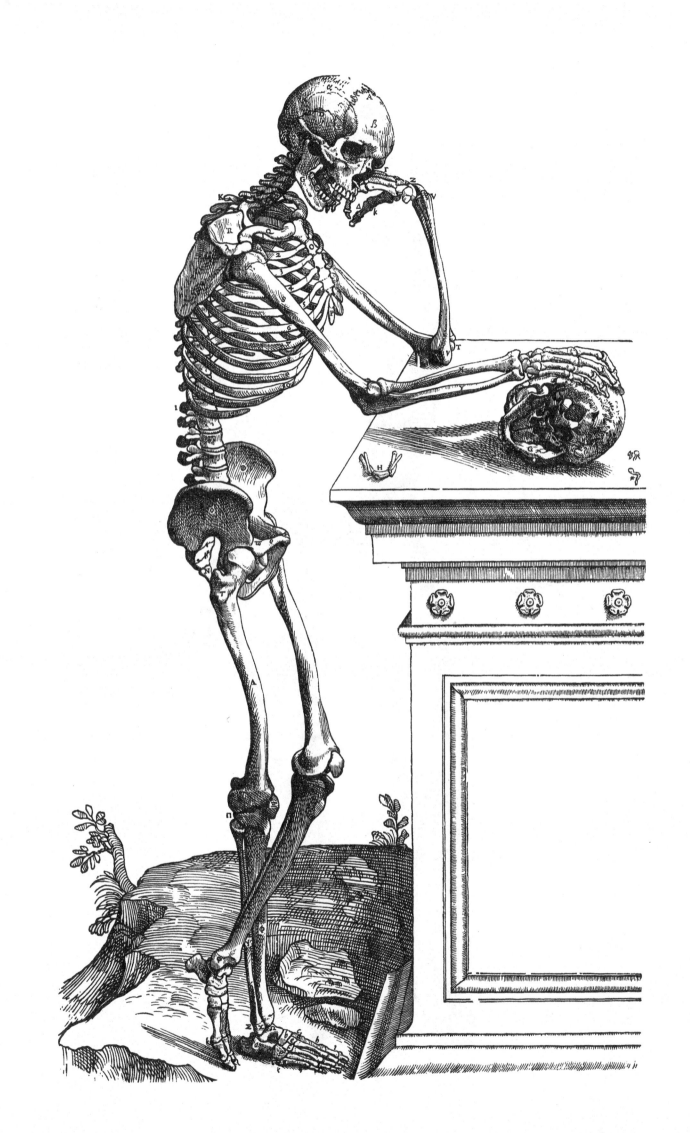

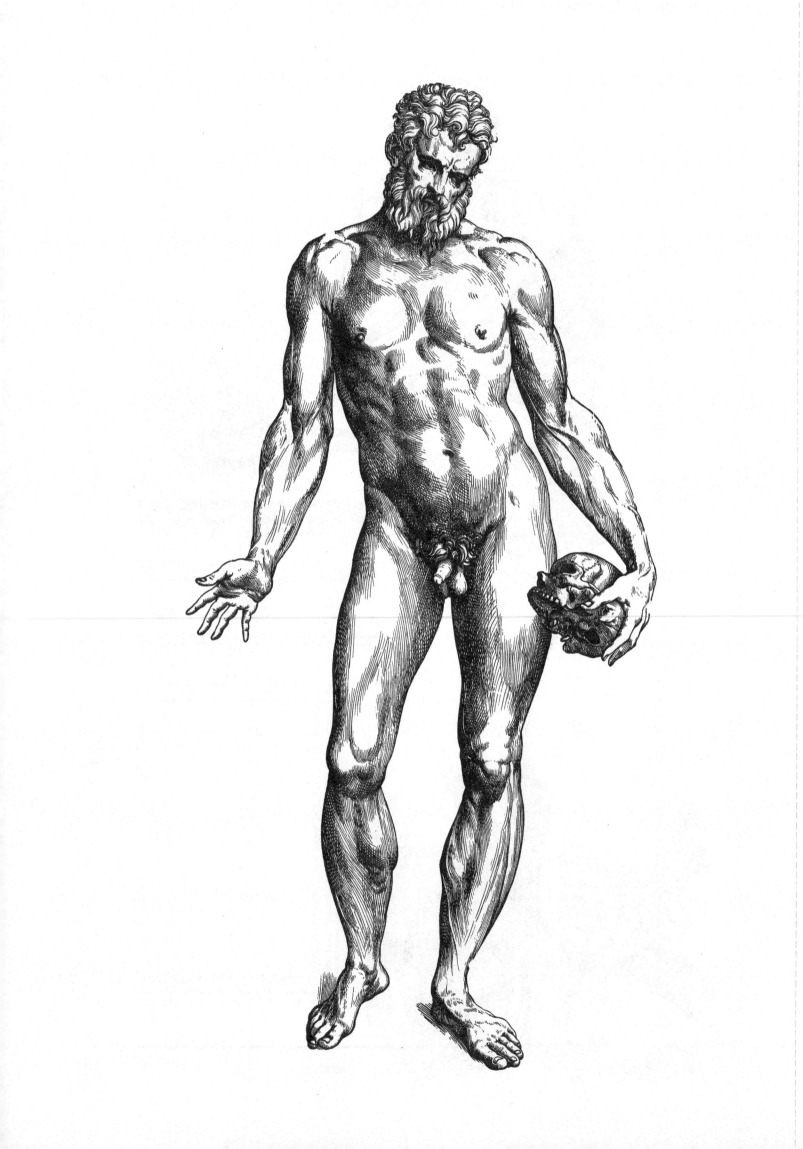

Plates 80 and 81

The male and female nudes were designed to accompany a special chapter of the *Epitome* devoted to a brief enumeration of the terms employed in the description of the surface features of the body. These terms were given in both Latin and Greek and are, for the most part, almost identical with those in common usage in the descriptive anatomies of today. A feature of this chapter is the dropping of all terms of Arabic origin which were still in common usage, although these terms are also given in the *Fabrica*, usually in Hebrew characters and with spurious pretensions to learning. The purification of terminology under humanistic influences was not due to Vesalius alone. Although he introduced many terms still in current usage, he was largely indebted to his teachers, Johann Guinther of Andernach and Jacobus Sylvius of Paris. Indeed, it is to Sylvius that we owe the greater debt for modern terminology.

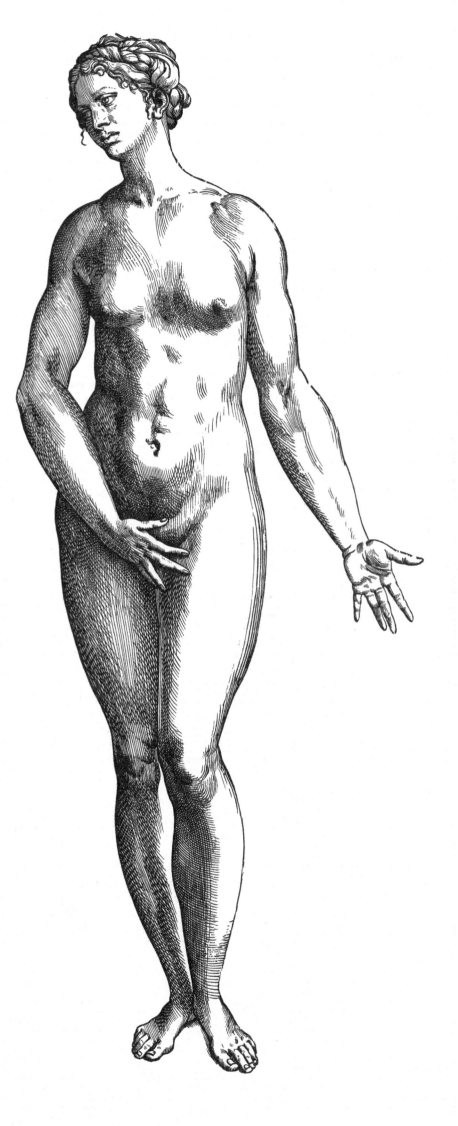

Plate 82

The figures reproduced in plates 82-85 were to be cut out and used in the construction, by superimposition, of two manikins, one of which was to show the topography and relations of the viscera in the female and the other, in the male. For this purpose some of the figures were duplicated, such as plate 83 and many of the figures seen in plates 84 and 85. Plate 82 forms the base of the first, that is of the female manikin, and plate 74 the base of the second. Apparently it was possible for the student to purchase these plates unbound or with the manikins already made up and colored by hand. Thus in extant copies of the *Epitome* it is not uncommon to find these figures missing or bound up in irregular positions.

Below will be found Vesalius' own instructions on the preparation of the two manikins. In following these instructions the reader should remember that since the duplicates have not been reproduced, some of the figures pertain to both manikins. With regard to anatomical details, the notes to the corresponding figures in the section on the *Fabrica* should be consulted. All of the structures here shown are to be found in identical views in one or more of the plates of the latter book.

A sheet from which may be conveniently prepared the figure to be attached to that representing the series of nerves.

82. *All the figures printed on this sheet have in view [the construction of] a single illustration which is to be attached to the head, or however you may consider more convenient, of the figure representing the series of nerves [82] which is seen reproduced on folio m or last of all. We wish to advise those who obtain unprepared copies, and put them together by their own efforts and industry, on the method of cutting each from the superfluous paper and pasting them on, and then of coloring them according to their ability and desire. In order to provide strength, it will be useful to glue a piece of parchment to the back of the entire sheet so that it may not in vain be divided into as many pieces as there are figures comprising it. I shall add a number to the figures so that I may explain in what place each is to be attached and provide as much advice as I can to facilitate the student's endeavors.*

83. *The FIRST figure we have drawn to act chiefly as a base for all the others and to the same scale, like all the rest seen here, as the figure representing a nude female.*

81. *This figure must first be cut away from the rest of the sheet along its borders, as close as possible to the drawing. However, a slightly wider portion is to be preserved at the top of the head to which the rest of the parts can be glued later and so appear to have been joined to the figure.*

84:4. *To the SECOND figure, of the esophagus and anterior aspect of the stomach with the superior [anterior] omental membrane and of the vessels and nerves of these parts, several others must be glued before it is attached to the first figure [83].*

84:2. *The THIRD figure representing the posterior region of the entire extent of the inferior [posterior] membrane which lies under the colon where the latter extends beneath the stomach, must be so glued in relationship to the superior [anterior] omental membrane that it reproduces the shape of the omental sac.*

84:3. *The FOURTH figure, which offers for inspection a picture of the intestines, is to be joined to the back of the third in the position where the inferior orifice of the stomach is in continuity with the intestine. The letter 3 placed in the second [84:4] and fourth [the present] figure indicates this position. When you attach the fourth, attempt to preserve a portion of the sheet at either end at ζ, and glue this portion to the third figure [84:2] so that it will adhere more strongly. You are now ready to attach the second figure [84:4] to the first [83]. Make a transverse cut in the first figure where the letter s, indicating the hollow of the liver, occurs on the lower aspect of the septum transversum [diaphragm] through which a passage is provided for the esophagus. Pass the esophagus through this opening so that it lies under the rough artery [trachea], and the stomach occupies its own position. Now undertake its attachment to the back of the first figure in the neighborhood of the aforementioned opening.*

84:1. *The FIFTH figure represents the portion of the inferior omental membrane [transverse mesocolon] which lies beneath the posterior aspect of the stomach and which supports the division of the portal vein as well as the arteries and nerves coursing here. In addition to vessels of this kind, the spleen, together with the veins and arteries distributed through the mesentery, is seen. The entire figure is to be glued to the first [83] in the region of the hollow of the liver so that the letters ν,φ,τ,s, occurring in both figures correspond to one another.*

85:3. *The SIXTH figure representing the uterus with the testes [ovaries] and seminal vessels, after having been cut out like the rest, is joined to the first on the right and left sides where the seminal artery and vein come together as seen on the left side at κ in both the first [83] and [the present] sixth figure. When you have joined this, then —*

85:2. *The SEVENTH, which represents the bladder and umbilical vessels together with a portion of the passages carrying the urine down from the kidneys, must be glued to the same region of the first so that the uri-*

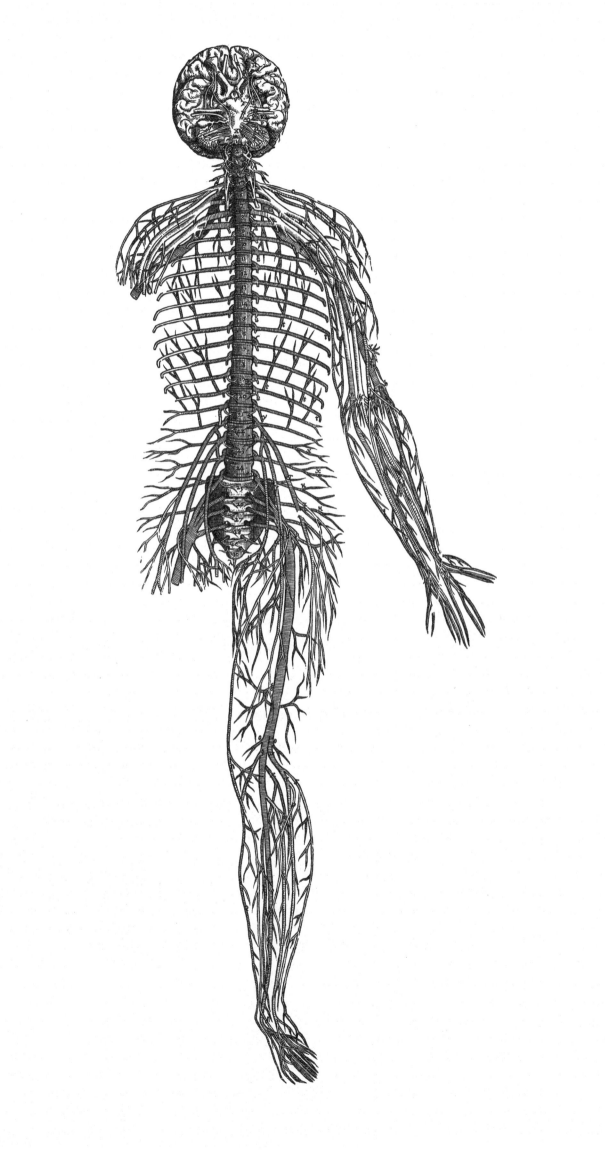

Plate 83

nary passages are attached beneath the seminal vessels while the bladder itself rests on the uterus. Observe here as far as possible the proper relationships which the delineation of the parts and the continuity readily show.

85:5. The EIGHTH figure, containing a delineation of that portion of the gibbous aspect of the liver which occurs facing the anterior region of the body, also presents the fissure of the liver into which the vein extending from the umbilicus is inserted. Therefore unite this figure to the liver of the first [83] only at the point where A is seen between F and s.

85:8. The NINTH figure, showing the arrangement of the vein without a mate [azygos v.], is to be joined to the back of the first [83] where the trunk of the cava gives off the vein without a mate. This will be easily accomplished if attention is paid to the letter o in both figures.

85:6. The TENTH figure consists of two parts when cut from the superfluous paper. It contains in its upper part a vein and artery drawn from the right side which creeps downwards beneath the pectoral bone and seeks the upper aspect of the abdomen. This part is glued at

its letter q to the q in the root of the neck of the first figure [83], but [corresponds] at the branch in the first figure which is seen cut on the right side at z and m. The lower part of the tenth figure shows the vessels running on the inferior aspect of the abdomen and this must be joined to the first figure on the right side where l is seen near the vessels seeking the leg, and where the beginnings of the former vessels appear.

Now join the first figure [83] to the sheet representing the series of nerves [82] and you will observe with little difficulty the position in which each must be placed if only you will employ the index of characters and the description of the parts for the task.

The figures provided for attachment to the plate which is to be glued to that [74] designated as the fifth or last of the figures prepared for the demonstration of the muscles.

To the figure representing the series of nerves [82] on the last leaf of the entire Epitome, a figure constructed from many parts is to be glued. This figure, in addition to the series of veins and arteries, of the organs of nutrition existing for the food and drink, and representations of the heart and parts subserving it, also presents the female instruments of generation.

Because the instruments of the male must be viewed

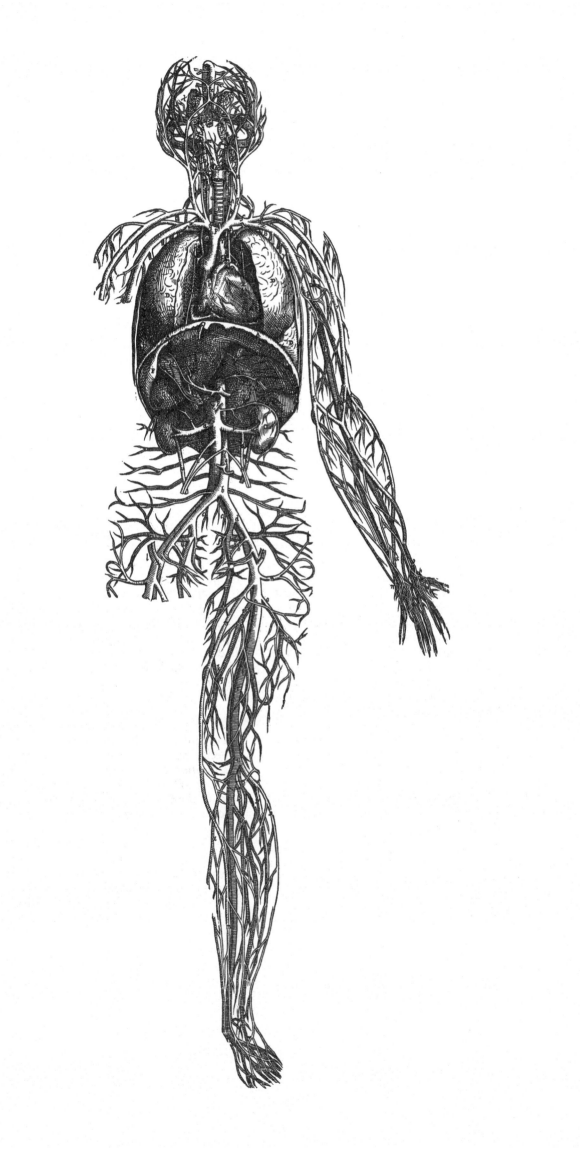

Plate 84

elsewhere, we have provided the present sheet which differs in no way from that containing the figure to be joined to the last page except for the organs of generation. Although the several figures printed on this sheet correspond to those placed on the previously mentioned sheet, it will be no disadvantage to prepare from all these illustrations a single plate which you will attach to the fifth muscle figure [74]. Therefore, glue a piece of parchment under the entire sheet and cut out all the figures from the superfluous paper, except in the case of the first [83], which is distinguished from the rest as a base for the others, where it is convenient to preserve a small portion above the head from which it may hang when the whole is pasted on. Then the veins and arteries running to the bladder must not be cut away from the excess paper, so that —

The FOURTH figure [84:3] representing the intestines, can be glued to it [83] where the letter κ is inscribed, unless perhaps —

84:4. You wish to join it to the back of the SECOND figure (which represents the stomach, esophagus and superior omental membrane) so that it corresponds to the letter ζ of each figure.

84:2. The THIRD figure showing the posterior surface of the lower omental membrane where it lies under part of the colon and extends to the stomach, is attached to the second [84:4] so that K is opposite L, and the shape of a small sac is formed. Now you are ready to join the second to the first [83] in the region of the transverse septum [diaphragm] where the letter ς occurs and the liver gives place to the esophagus. Make an opening through which the esophagus can be passed so as to lie under the rough artery [trachea], and make it fast to the back of the opening.

84:1. The FIFTH figure showing the portion of the lower omental membrane placed beneath the posterior aspect of the stomach, together with the spleen and the distribution of the portal vein and of the arteries extending to the latter, will be glued to the hollow of the liver in the first figure [83] where the letters υ, φ, χ and ς occur in both figures.

85:1. The SIXTH figure which represents a portion of the passages [ureters] carrying urine from the kidneys down to the bladder, and shows part of the seminal vessels with the testes and their coverings, is to be joined to the first [83] where the seminal [spermatic] veins and arteries are seen resting on the urinary passages or

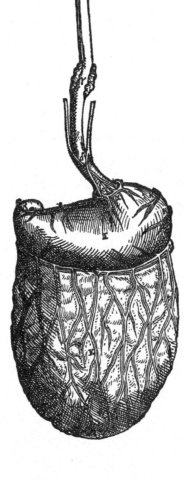

Plate 85

where the letter κ is seen on the left side in each figure.

85:7. The SEVENTH figure showing the inferior sur-face of the penile bodies and the common passage [urethra] for both urine and semen together with the muscle [sphincter] surrounding the latter, must be glued in relationship under the eighth figure [85:4] so that the letters ae, ae, ψ and ω mutually correspond.

85:4. The EIGHTH figure showing the bladder, the umbilicus with its vessels, the glandular body [prostate] attached to the neck of the bladder, and the penis, is to be united to the sixth [85:1] where the letter φ is seen [since the wood block was damaged, the letter is miss-ing]; that is to say, so that the letter φ of the seventh [85:7] is united to the letter φ of the sixth figure [85:1] and then, fold the penis in the form of the letter S.

85:5. The NINTH figure presenting a portion of the gibbous aspect of the liver, is glued with advantage at one point where A lies between s and F in the larger or first figure [83].

85:8. The TENTH figure which presents the distribu-tion of the vein without a mate [azygos v.] must be

joined to the back of the large figure [83] where the trunk of the cava gives off this vein and o is seen written in both figures.

85:6. The ELEVENTH figure when cut from the excess paper consists of two parts. The upper repre-sents the vein and artery [internal mammary] of the right side seeking the upper region of the abdomen beneath the pectoral bone. The q of this part is fixed to the q of the large figure [83] and the * to the branch which occurs on the right side in the large figure at m and z. The lower part of the figure representing the vein and artery [inferior epigastric] spreads out on the infe-rior aspect of the abdomen, and is to be joined where their roots are seen near l on the right side.

85:9. The figure designated the TWELFTH, although printed on this leaf, must not be joined to the first figure [83] but to that called the fifth muscle plate [74]. For here is drawn the anterior aspect of the pubic bones with the intervening cartilage of the bony coalition. You will immediately observe what is to be glued when you attempt to join the part cut from the superfluous paper where the pubic bones are seen separated from one an-other.

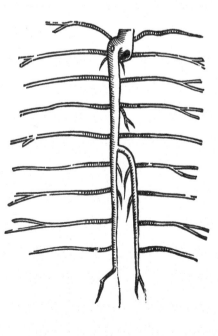

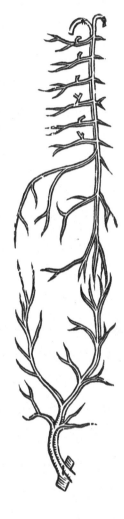
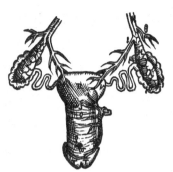

A LETTER

TEACHING THAT THE AXILLARY VEIN

SHOULD BE CUT AT

THE RIGHT ELBOW IN DOLOR LATERALIS

PLATE FROM THE EDITION OF 1539

Plate 86

In this accurate, although somewhat rough figure, the letter A signifies to us the axillary vein [basilic v.] of the right arm extending all the way to the elbow and there cut off. The letter B denotes the left axillary [basilic] and C, the great bifurcation at the thymus or root of the neck. D and E are the two veins [internal mammary vv.] creeping under the pectoral bone to the anterior thorax. F is the small vein [superior intercostal v.] nourishing the three upper ribs on the left. H, the trunk of the vena cava dissected free where the cava touches the right auricle of the heart and enters its right sinus [ventricle]. I is the vena azygos arising from the cava. K, K, etc., are nine branches of the azygos vein nourishing nine right ribs; L, L, etc., indicate the branches of the same vein supplying nourishment to the nine lower ribs on the left. M, then, is the termination of the aforementioned vein which runs all the way to the lumbar vertebrae through the inferior foramen of the diaphragm through which the [aortic] artery descends.

A diagram of the azygos system, undoubtedly by Vesalius' own hand, appeared in the Venesection Letter of 1539 to illustrate a new theory on the rationale of bloodletting in the disease then known as dolor lateralis and regarded as being pleurisy. The simian characters at the bifurcation, the absence of the hemiazygos, and other errors, should not be taken too seriously in view of its schematic nature. For a more exact representation see plate 46. The monograph which this figure accompanied contributed to one of the most violent controversies in medical literature, but its true significance lay in the use of the observational method which was to herald the achievement of the Fabrica. Furthermore, it was this controversy which eventually yielded information on the venous valves to lead William Harvey to the discovery of the circulation.

VENAE THORACEM NUTRIENTES

IN hac vera, quamvis rudiori figura, A litera significabit nobis venam axillarem dextri brachii, ad cubitum usque deductam, ibique abtruncatam: B sinistram axillarem, C magnam in glandio aut iugulo bifurcationem denotabit. D et E ambas venas ad anteriora thoracis sub pectoris osse perreptantes. F venulam nutrientem tres costas superiores lateris dextri. G venam alentem tres elatiores costas sinistras. H venae cavae truncum plane dissectum, ubi dextram cordis auriculam cava tangit, atque in cordis sinum dextrum ingreditur. I venam sine pari ex cava natam. K, K, etc. novem ramos venae absque pari, nutrientes novem costas dextras. L, L, etc. soboles eiusdem venae novem humilioribus costis sinistris alimentum suppeditantes indicant. M vero, dictae nunc venae finem, qui per inferius septi foramen, per quod arteria delabitur, ad lumborum vertebras usque excurrit.

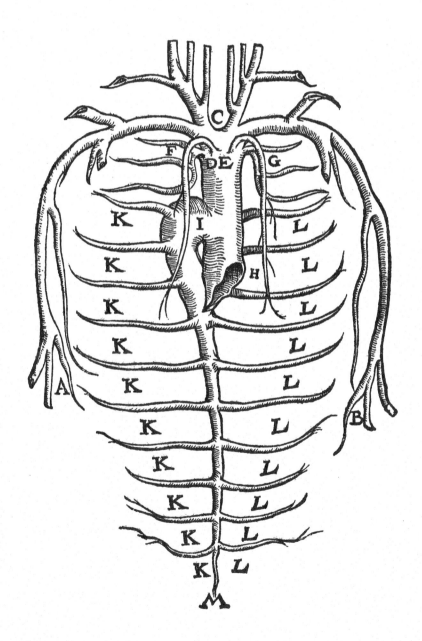

THE *TABULAE SEX* (1538)

ANDREAS VESALIUS OF BRUSSELS SENDS GREETINGS
TO HIS MASTER AND PATRON,
THE MOST EMINENT AND ILLUSTRIOUS
DOCTOR NARCISSUS PARTHENOPEUS,
FIRST PHYSICIAN TO HIS IMPERIAL MAJESTY

Not long ago, most learned Narcissus, upon being chosen lecturer in surgical medicine at Padua, I was discoursing on the treatment of inflammation. In the course of explaining the opinion of the divine Hippocrates and of Galen on revulsion and derivation, I happened to delineate the veins on a chart, thinking that thus I might be able easily to demonstrate what Hippocrates understood by the expression κατ' 'ι'ξιν for you know how much dissension and controversy on venesection was stirred up, even among the learned, by this term, since some affirm that Hippocrates had indicated the agreement and straightness [rectitudo] of the fibers, others I know not what.

My drawing of the veins pleased the professors of medicine and all the students so much that they earnestly sought from me a diagram of the arteries and also one of the nerves. Since the administration of Anatomy is part of my professional duties, I could not disappoint them, especially as I knew that illustrations of this sort would be extremely useful for those who might attend my dissections. I believe that it is not only difficult, but entirely futile and impossible, to hope to attain an understanding of the parts of the body or of the use of simples from pictures or formulae alone, but no one will deny that they assist very greatly in strengthening the memory in such matters. Furthermore, since many have attempted vainly to copy these figures, I have committed them to the press, and to these plates I have added others in which Jan Stefan [van Kalkar], an outstanding artist of our time, has most appropri-

ately depicted in three positions my σκελετον recently constructed for the benefit of my students. They are, indeed, of great value to those who deem it not only noble and beautiful but profitable and essential to contemplate the ingenuity and workmanship of the Great Architect and to examine that which Plato calls the "domicile of the soul." In addition, we have ascribed to each part its name, although at present this could not be done as fully as desired, nor have we excluded barbarian terms which in most books the more learned are wont frequently to hold back. To be truthful, be assured that there is nothing here beyond what my students at Padua will testify has been demonstrated by me in the course given this year, not to speak of my teachers at Paris, by far the most learned, and the physicians of Louvain before whom I publicly performed an Anatomy more than once.

In order that this new endeavor of ours may see the light, rendered more acceptable by the recommendation and patronage of someone, to undergo more tranquilly the uncertain hazards of opinion, I have ventured to inscribe it to the fame of your name, partly because, in addition to an incomparable command of various tongues, you have gained an extraordinary and singular knowledge of Anatomy as well as of medicine and philosophy, so that you are deservedly regarded by the most erudite of all nations as a distinguished leader and ornament of the most skilled physicians and literary men; partly because among the most famous you prevail by prudence of mind, integrity and an extraordinary gentleness and sweetness of nature toward all, so that Charles the Fifth, the Invincible and ever August Emperor of the Romans, a most penetrating judge of ability, especially established a position for you, not only to guard his health, or to regain it if lost, but also appointed you in the very prime of life as the most trusted censor over all physicians and pharmacists of the Kingdoms of Spain and Naples and has singled you out most splendidly, even among so many eminent men, with many honors and gifts.

Accept therefore, most honored sir, this trifling gift on paper with that graciousness with which

you once received me when you declared yourself, with many tokens of benevolence, as being particularly well disposed towards me. If I shall find this work acceptable to you and to students, some day I hope to add something greater. Farewell. Padua, the First day of April in the year of our Salvation 1538.

The six plates here presented were originally published devoid of title but have since come to be known as the *Tabulae Anatomicae* or *Tabulae Sex* of 1538. They belong to the class of publications called "fugitive sheets" which were intended largely for the use of students or for the dissemination of popular knowledge. By their very nature they tended consequently to become scattered and lost so that examples are usually of the greatest rarity. Thus only two, or possibly three, complete copies of the *Tabulae* have survived to this day.

Apart from certain items included in an edition of the *Institutiones Anatomicae* of his former master Johann Guinther, which Vesalius edited and issued in the same year, the *Tabulae* constitute his first venture in anatomical publication and were, as indicated in the dedication, in the nature of a preliminary to the larger enterprise which he had in mind. Therefore the plates occupy a transitional position and are of the greatest importance in the history of scientific progress since they establish a point of departure in which the currents of the old blend with the earliest beginnings of the new science. In them we find the application of the new art to scientific illustration, the influence of Renaissance classical scholarship admixed with medieval tradition in the development of modern terminology, and the earliest signs of the emergence of modern observational science in the midst of historic authority. Charles Singer in his intensive study of these plates appropriately refers to them as the prelude to modern science.

Unlike the *Fabrica* and the *Epitome*, we possess definite information as to the authorship of the drawings. The first three plates illustrating the portal, caval and arterial systems were drawn by Vesalius himself, whereas those of the skeleton

came from the hand of the Flemish artist Jan Stefan van Kalkar. However, a puzzling feature is the statement on the final plate of the series that they were published "at the expense" of Kalkar. This statement has engendered a variety of highly speculative opinions to the effect that Vesalius was no more than a literary hack hired by Kalkar to write the commentaries accompanying the drawings. However, it should be mentioned in passing that a variant of the final plate is known in which this statement is absent. Whereas this variant may be no more than a proof, it is quite conceivable that it is part of an edition distributed by Vesalius to members of his classes at Padua, while Kalkar was given the right of publishing at his own expense editions for general distribution in lieu of payment for his services.

Narcissus Parthenopeus Vertunus, to whom the *Tabulae* are dedicated, was of Spanish extraction. His family had moved to Naples in the middle of the fifteenth century. Narcissus was born at Penna, northeast of Rome, in 1491 but became a citizen of Naples and entered court service, eventually being appointed protomedicus to Charles V in 1524. He fell from favor over a mistaken diagnosis in the case of his master's son, the future Philip II of Spain, and retired to Naples where he died in 1551.

Finally, a few words are required to explain some of the terms used at the beginning of Vesalius' fulsome introduction. These all concern the subject of bloodletting over which a violent controversy was raging at this time. The controversy had been stirred up by Pierre Brissot, a Parisian physician who had attempted to introduce what he believed to be the true method of Hippocrates and Galen in opposition to traditional views based on Arab sources. In theory the purpose of a venesection was to evacuate any re-

dundancy of humors which were the cause of disease. This could be done in one of two ways known as "revulsion" and "derivation." Revulsion was to be employed in the incipient stages of the malady or as a prophylactic measure. At this time the noxious humors were thought to be in a state of flux but had not yet settled in a local region or organ to cause an inflammatory lesion. Under these circumstances the physician bled the patient at a point as far from the presumptive site of the disease as possible, thereby diverting or reversing the flow of the humors. On the other hand, once the humors had settled in the tissues in the later stages of the disease, it then became necessary to bleed by derivation, that is, from a point as close to the site of the local lesion as possible. To revulse at this stage would be extremely dangerous since the accumulated humors had undergone corruption and would be led back through healthy organs to their detriment and possibly with fatal consequences.

Galen, interpreting Hippocrates, stated that revulsive bleeding must be carried out κατ' ἴξιν, that is, "in a straight line." This expression proved very troublesome to sixteenth-century controversialists. The sense of the term can perhaps be best expressed by saying that the vein selected for venesection must be *en rapport* with the site of the disease. Consequently it was necessary for the physician to have a precise knowledge of the venous system; hence the great value of the charts provided by Vesalius in the *Tabulae Sex*. Furthermore, the technique of venesection required that attention be paid to the arrangement or "straightness" (*rectitudo*) of the fibers thought to exist in the venous wall. These fibers (see plate 46: 1-3) were supposed to exercise an attractive influence on the humors and direct their flow, and the incision in the vein therefore had to be made with precision.

Plate 87

87:1. *The liver, workshop of sanguification, receives the chyle from the stomach and intestines through the Portal Vein, called the στελεχιαια [stelechiaia] by the Greeks and the WERIDH HA-SHO'ER or Varidhascoer by the Arabs, and discharges the black bile into the spleen.*

The illustrations in the first three tables of the series are intended to convey a great deal more than the simple anatomy of the vascular and generative systems. Their purpose is essentially to express in diagrammatic fashion the physiological principles of Galen. In this respect they are unique. In addition, an attempt is made, with an erudition often spurious, to correlate the new or "modern" terminology coming into being under the influence of classical humanism with the traditional terms derived from medieval, Arabic and Hebraeo-Arabic sources.

The diagram shows a schematized five-lobed liver as accepted by traditional authoritative opinion but ultimately derived from the animal anatomy of Galen. Even at this early stage in his career, Vesalius had begun to challenge traditional beliefs in matters anatomical but was, as yet, unwilling to expose his anti-Galenism. This is hinted at by the inclusion in the inset drawing of a bi-lobed liver evidently intended to represent the human organ.

The portal vein with its tributaries, the superior mesenteric, the splenic and other branches represented with very approximate anatomic accuracy, is seen entering the liver. This vein, through its mesenteric tributaries, was supposed to convey the "chyle" or products of digestion from the alimentary tract to the liver. Here, a portion of the nutritive material was considered to be converted into the blood, the first of the four humors, which was then discharged into the caval system as illustrated in the next plate of the series.

In the liver the second humor, the yellow bile or choler, was extracted to pass to the gall bladder, which is shown with its duct on the under surface of the liver, where it was stored and the excess discharged into the intestines to assist in the process of digestion.

Impure blood passed from the liver via the splenic vein to the spleen (seen on the right side of the diagram). The spleen extracted the black bile or *succus melancholicus* from the blood. The black bile, according to some authorities, was then discharged into the stomach and served to whet the appetite. However, this gave rise to an anatomical difficulty since no vessel could be found to serve as a duct from the spleen. Vesalius suggests that the branch at O, left epiploic vein, may serve this purpose, or perhaps the black bile is purged into the intestine through branches of P, the superior mesenteric vein. Later, in his *Venesection Letter*, he was constrained to propose another pathway with the discovery that the haemorrhoidal veins are tributary to the portal system since haemorrhoids were believed to be due to an excess of black bile.

87:2-4. *The organs of generation, above of the male, below of the female. The third figure shows the implantation of the vessels carrying down the semen.*

In the figures of the generative organs an attempt is made to illustrate the homologies of the two sexes. Parallelisms are sought between the bladder of the male and the uterus of the female, the penis and the vagina, testis and ovary, epididymis and possibly the ampulla and fimbria of the uterine tube, ductus deferens and uterine tube, and spermatic and ovarian vessels. Such attempts represent an old tradition dating back to early medieval times and ultimately derived from Galen. In the male figure will be observed the prostate, illustrated for the first time, which is apparently homologized with the *cornua* or "horns" seen at the junction of the uterus and vagina in the lower figure. The conception of *cornua*, possibly representing the round ligaments, caused great confusion up to the time of Fallopius. Almost all early illustrations of the uterus show these mythical structures, and they are very evident in the well-known drawings of Leonardo da Vinci.

The small figure shows the bladder, prostate, deferent ducts, ampullae and ureters, the last incorrectly related. The seminal vesicles are not shown, and the figure suggests the anatomy of the dog in which the vesicles are absent.

✠ PRAESTANTISSIMO CLARISSIMOQVE VIRO DOMINO

D. NARCISSO PARTHENOPEO, CAESARIAE MAIESTATIS MEDICO PRIMARIO.

Domino suo & patrono, Andreas VVesalius Bruxellensis S. D.

ON ita pridem, Narcisse doctissime, quum Patauii ad medicinæ chirurgicæ lectionem delectus, inflammationis curationem pertractarem, diui Hippocratis & Galeni de reuulsione ac deriuatione sententiam explicaturus, uenas obiter in charta delineaui, ita ratus quid per κατ᾽ ἴξιν Hippocrates intellexisset facile posse demonstrari. Nosti namque quantum hac tempestate, ea dictio dissentionum atque contentionum, etiam inter eruditos, de uena secanda concitauerit, dum alii fibrarum consensum ac rectitudinem, alii aliud nescio quid, indicasse Hippocratem affirmant. Verum illa uenarum delineatio tantopere medicinę professoribus studiosisque omnibus arrisit, ut arteriarum quoque & neruorum descriptionem, à me obnixe contenderent. Quia uerò ad meam pertinebat professionem Anatomes administratio, ipsis deesse non debui, potissimum quum scirem eiusmodi lineamenta, his qui secanti adfuissent, non mediocre commodum allatura. Alias siquidem aut partium corporis, aut simplicium pharmacorum cognitionem ex solis picturis, seu formulis uelle assequi, ut arduum, sic quoque uanum ac impossibile omnino arbitror: sed ad memoriam rerum confirmandam apprime conducere, nemo negauerit. Ceterum cum plurimi hęc frustra imitari conarentur, rem prælo commisi, atque illis tabellis, alias adiunximus, quibus meum σκέλετον nuper in studiosorum gratiam constructum, Ioannes Stephanus, insignis nostri sęculi pictor, tribus partibus appositissime expressit, magno sane usu eorum, qui non modo honestum, aut pulchrum, sed etiam utile ac necessarium iudicant summi opificis solertiam artificiúmque contemplari, & domicilium illud animę (ut Plato ait) introspicere. Præterea singulis partibus, quaquam id in presenti negocio non admodum ex sententia confici potuit, sua nomina asscripsimus, barbaris, quæ etiam peritiores in plurimorum libris subinde remorari solent, minime prætermissis. Quòd autem ad rei ueritatem attinet, nullum hic apicem ductum puta, quem Patauini studiosi in huius anni confectione, à me demonstratum non attestabuntur: ut interim sileam de Parisinis præceptoribus meis longe doctissimis & Louaniensibus medicis, apud quos non semel Anatomen publice administraui. Porrò ut nouus hic noster conatus, alicuius patrocinio commendatior in lucem auspicato prodeat, & ancipitem iudiciorum aleam securius experiatur, celebritati illum nominis tui nuncupare uisum est: partim quòd præter incomparabilem uariarum linguarum cognitionem, eximiam quandam singularémque Anatomes, sicuti etiam medicinę & philosophię, scientiam adeptus sis: adeò ut meritò apud nationes omnes, tanquam præcipuum peritissimorum medicorum & literatorum hominum, decus ac ornamentum ab eruditissimis quibúsque prędiceris: deinde quòd inter clarissimos uiros ea polleas animi prudentia, integritate, mira erga omnes naturę mansuetudine & gratia: ut CAROLVS QVINTVS Inuictissimus Romanorum Imperator semper Augustus, acerrimus ingeniorum æstimator, non suæ dumtaxat sanitatis tuendę, aut amissę recuperandæ præcipuum tibi locum concrediderit: uerum etiam te uniuersis Regni Hispanię ac Neopolitani medicis pharmacopolarúmque officinis, in florente etiánum ætate tua, ceu fidissimum censorem prefecerit, compluribúsque honoribus & muneribus, inter tot præclaros alioquin uiros, amplissime illustrauerit. Suscipe itaque Vir ornatissime, hoc chartaceum munusculum, ea humanitate, qua me quondam excepisti, dum non exiguis beneuolentię signis, animum erga me tuum peculiariter declarasti: quod si gratum tibi ac studiosis fore intellexero, aliquando maiora adiiciam. Vale Patauii Calē. Apri. An. salutis. M.D.XXXVIII.

✠ IECVR SANGVIFICATIONIS
OFFICINA, PERVENAM PORTAM, QVAE GRAECIS
πυλαία, Arabibus verò ᴍᴀᴅᴛᴀ varidhascoer appellatur, ex ventriculo & intestinis chylum transsumit, ac in lienem melancholicum succum expurgat.

GENERATIONIS ORGA,
NA, SVPERIVS VIRI, INFERIVS MVLIERIS.
Tertia figura semen deferentium u asorum implantationem refert.

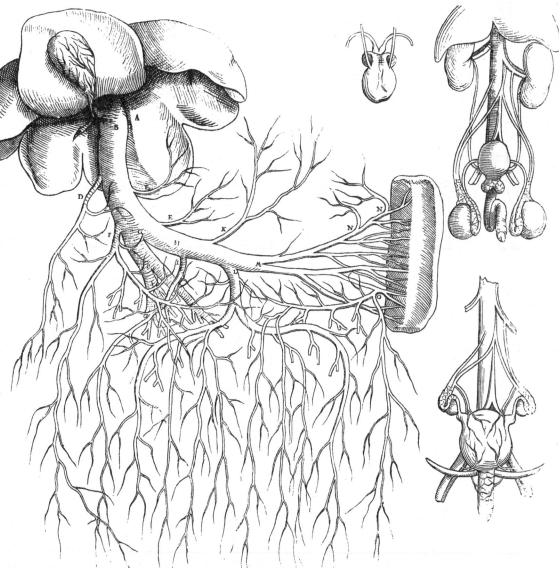

A Cauum, seu simum iecoris.
B Vena porta, iecoris manus.
C Ramuli in flauæ bilis vesiculā.
D Ad pancreas & ecphysim, seu duodenum intestinum.
E Ad dextrum gibbi ventriculi.
F Ad dextrum fundi ventriculi & superiorem omenti membranam.
G Portæ bifurcatio maxima.
H Per omenti inferiorem membranam & pancreas delata, varie diffunditur.
I In omenti membranam inferiorem, parte dextra.
K Per ventriculi cauum, eius os tandem numerosis propaginibus amplectens.
L In membranam omenti inferiorem parte media, quę primum in duas, deinde in plurimas exiguas venulas diuaricatur.
M Multifariam diuisa, per rectam lineam lienis imo implantatur: hac feculentus sanguis in lienem transmittitur.
N Vtraque ad ventriculi gibbi sinistrum, & secunda satis obscure ad ventriculi os procedit.
O In sinistrum fundi ventriculi, & superiorem omenti membranam: hac non mediocrem excrementi lienis portionem in ventriculum excerni putauerim.
P Numerose inter mesarei membranas distributa in intestina excurrit: ab hac ne, an à caua, hęmorrhoides sint? non ausim certo affirmare. Nam ex utraq; vena rami in eam partę ptinent, & etiam maiores a porta: nec per portam melancholicum sanguinem expurgari, forte alienum animaduertenti, apparebit.

GALENVS VENAE PORTAE RAMOS PRAECIPVOS SEPTEM ENVMERAT.

Plate 88

A description of the Vena Cava, Jecoraria, κοιλη [Koile], HA-ORTI or Hanabub by which the blood, nutriment of all the parts, is distributed throughout the entire body.

The second scheme on Galenical physiology illustrates the caval system. The conventional five-lobed liver carries the legend "The liver source of the veins." It was believed that the blood, manufactured from the chyle, was charged in the liver with "natural spirit" which gave to the tissues and organs the power or faculty of extracting from it the necessary nutriment and provided the force for their growth and increase. The blood, therefore, passed from the liver into the cava and its tributaries where it ebbed and flowed. Each organ selected its nutritive requirements according to its "nobility." The most "noble" parts, such as the heart, took up what was needed and discharged the excess or "excrement" which would be used by the less "noble" parts such as the hair and nails.

The cava is treated as a single continuous trunk from which springs, as a diverticulum, the right ventricle of the heart. The opening C is, therefore, the right atrioventricular orifice; hence the related part of the cava is the right atrium observed receiving D, the coronary sinus. Other branches, too numerous to detail here, are very approximately shown, and there are many errors. The general arrangement of the innominate veins and their branches suggests the influence of animal anatomy. At B is seen the azygos vein, and in the margin certain comments are made on the significance of this vessel in the treatment of pleurisy by venesection. These remarks were elaborated by Vesalius into a monograph, the *Venesection Letter* of 1539, concerning which the reader should turn to plate 86. Schemata of this kind were enormously important to our forebears since venesection was the sheet anchor of therapeutics. The term HA-ORTI in Hebrew characters in the caption has been erroneously interchanged with HA-NABHUBH in the succeeding plate.

ꙮ VENÆ CAVÆ, IECORARIÆ, ΚΟΙΛΗΣ, אורש HA‑
NABVB DESCRIPTIO, QVA SANGVIS OMNIVM PARTIVM NVTRIMENTVM PER
VNIVERSVM CORPVS DIFFVNDITVR.

A Vena post aures, et ad tempora.
B Ad nares, frontem et superiorem maxillam.
C Ad linguam, laryngem, fauces et palatum.
D Interne iugulares, Apopleticæ, Profundæ.
E Iugulares externæ, Guidez, quas etiam Apople‑
 ticas vocant.
F Ad colli musculos posteriores.
G Per transuersos vertebrarum ceruicis processus,
 in spinalem medullam et cerebrum excurrunt.
K Ad scapularum gibbum et loca contermina.
L Humeraria, cubiti exterior, Chephalica, Capitis.
M Ad anteriora pectoris et mamillas.
N Ad musculos thoracis superiores.

O Axillaris, cubiti interior: dextra iecoris, sini‑
 stra lienis dicitur, Basilica.
P Ramus ab humerali ad mediam.
Q Ramus ab axillari ad mediam.
R Ad cubiti articulum ab humeraria.
S Ad cubiti articulum ab axillari.
T Media, communis, Mediana, Nigra, Funis bra‑
 chij, Mater. Hæc interdum ad cybiti articulum
 incipit, et aliquando paulo inferius.
V Varia in extrema manu venarum propagatio.
A Ad superiores quatuor costas, nonnunquam tres.
B Ad octo inferiores costas, Grecis αζυγος hoc est
 paris expers dicta. Considera ex dextra parte venæ
 cauæ hanc produci.
C Portio cauæ in dextrum cordis sinum producta.
D Coronalis vena στεφανιαια vocata, quæ interdum
 gemina, queadmodum coronales arteriæ apparet.
E Septi transuersi venæ, quæ aliquando tres vi‑
 suntur.

G Ad spinæ musculos et loca lieni vicina.
H Ad renum adiposam membranam.

I Sanguinem serosum in renes deferentes Emul‑
 gentes appellatæ.
K Seminalis sinistra, quæ interdum ramulum à ca‑
 ua assumit; qui vna cum ipsa coit.
L Seminalis vena dextra.
M Ad singulas lumborum vertebras.

N Ad lumborum musculos, et transuersos obli‑
 quósque abdominis.

O Ad ossis sacri foramina.
P Ad rectum intestinum et loca circumiacentia.
Q Ad vesicam et vterum.
R Ad penem, seu vuluæ collum et fundum.
S Ad pubē, et transuersos abdominis musculos,
 et magna huius pars ad rectos musculos pro‑
 ducta cum pectoris venis coit.

T Ad coxendicis exteriores musculos.
V Per fœmur in extremum vsque pedem.
X Ad coxendicis articulum et exteriora fœmoris.
Y Per interiora fœmoris sub cute in extremum vs‑
 que pedem excurrit.

A Hi duo rami à maiori vena ad fœmoris medium
 enati poplitis venam constituunt.
B A poplitis uena, in exteriorem fœmoris cutem.
C In poplite latitans diuisio.
D Ad suræ cutem, in qua vena et in politis venis va‑
 rices oboriri solent.

E Exteriorem malleolum perreptans, et in exterio‑
 rem pedis partem diffusa: Schiatica, quòd coxen‑
 dici medetur appellata.
F Interiorem malleolum perreptans et deinde pedis
 interiora, Matricis vena quòd vteri malis abigen‑
 dis faciat dicta, Saphena.

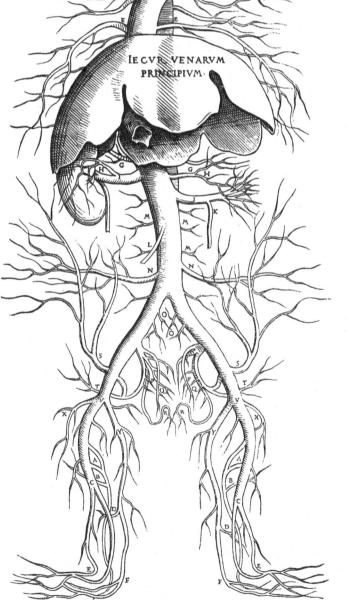

IECVR VENARVM
PRINCIPIVM.

Quemadmodum iugularis interna, ac ea quæ per
transuersos vertebrarum ceruicis processus propaga‑
tur, in cerebrum eiusq́ membranas et ventriculos
excurrunt, hic delineari nequit.

Hæc venæ in gladio bifurcatio, nonnunquã paulò
inferius apparet, sic vt ab altero ramo axillaris, quem‑
admodum modò humeraria deduci videatur. Præterea
pectoris venæ quæ ad mamillas quoque diffunduntur
ob axillaribus interdum propagatæ apparent. Adde
externas etiã iugularias subinde geminas vtrimque
in collo conspici.

Non te solicitū habeat venaru in extrema manu
propagatio, quã vix inter viginti, duos ęquali venarū
distributione inuenias, ita tres illi insigniores rami im‑
plicantur. Quamobrem, et ob loci distantiam, vena‑
rumq́ exiguitatem Gręci in hac parte venas nun‑
quã secuerunt, nisi forte rarissime in diuturnis lienis
affectibus, eam que inter auricularem et anularem di‑
gitos manus sinistræ repit, quam Y Syelem in vtra‑
que manu aliqui appellat, vt eam quæ ad pollicem ex‑
currit, X Saluatellam: licet et priorem eo nomine etiã
vocatam reperimus.

B Hanc sine pari venam, quæ octo inferiores co‑
stas nutrire dicitur, nunquam sub dextra cordis auri‑
cula propagatam vidimus, imò vt in canibus et simijs
paulò supra auriculam. Quare dolore laterali ad
inferiora vergente, magis quoque venæ sectione,
quàm purgante medicamento vtendum erit, et pro‑
pter Hippocratis sententiam, Galenum in secundo li‑
bro de victus ratione in morbis acutis, obscurè de hac
vena locutū opinor. Præterea ex venæ illius ortu, sem
per interiorem dextri cubiti venam, in laterali dolo‑
re sub quarta, aut tertia costa ad inferiora declinante,
secandam esse, ob fibrarum seu filamentorum consen‑
sum ac rectitudinem, forte non absurdum animaduer‑
tenti putabitur. Et plurimum dolor thoracis medium
occupat, quare dextra potissimū diuidenda colligitur,
quod ab Anatomicis speculationis gratia latius perpen‑
di optauerim.

Prima venę cauę diuisio non extra iecur est, sed in
iecoris corpore, si modo propriè diuisio nuncupanda
sit. quod immisso per longum stilo ab Anatomicis ani‑
maduerti velim.

Vt venę emulgentis in renum corpore propagatio
in conspectum veniret, alterum dumtaxat renem de‑
pinximus.

Hic facile fibrarum vnius cruris et alterius mutu‑
um concensum videre licet, aliter scilicet quàm in gla‑
dio.

S Qualiter bę venæ cum pectoris venis commu‑
nicantur, ne reliqua obscuriora fiant, præsenti tabula
depingi nequeunt.

C Hæc in poplite bifurcatio, aliquando in tres ve‑
nas satis insignes deduci apparet.
Quemadmodum varia in extrema manu vena‑
rum est diuaricatio, sic quoque in pedis extremo, et ob
eam causam Gręcos aut malleoli, aut poplitis venas se‑
cuisse legimus: non quidem in pedis extremo, vt alij
frustra venas absque vllo sanguinis profluuio diuiden‑
tes. Qui à poplitis venis abstinent, quòd tanquam pro‑
prij vngues illis ob cutis crassitiem in conspectum, non
veniunt.

ALIQVI VENAE CAVAE RAMOS INSIGNIORES CENTVM ET SEXAGINTA OCTO POSVERVNT.

Plate 89

The great artery, αορτη [Aorte], HA-NABHUBH or Haorti, arising from the left cavity of the heart, carries the vital spirit to the entire body and tempers the natural heat by contraction and dilatation.

The third plate of the physiological series shows the heart and arterial system. According to existing theory, a portion of the venous blood and its natural spirit contained in the right ventricle sweated through minute pores in the septum of the heart to gain the cavity of the left ventricle. Here the natural spirit is refined by the "pneuma" or air, carried to the heart from the lungs by the "vein-like artery" shown at Q, to give rise to the "vital spirit" which is distributed to all parts of the body by the arteries and provides its heat. The heart, therefore, bears the inscription: "The heart, nurse of the vital faculty and source of the arteries." At the same time, the pneuma from the lungs serves to temper the natural heat and the dross or products of combustion are carried back to the lungs to be exhaled.

The vital spirit ascends to the brain to be converted in the *rete mirabile* at B (see also plate 72:4-5) into a still more refined and subtle substance, the "animal spirit." This spirit provided the nervous force necessary for motion and sensation in flowing through the nerves, believed to contain minute channels.

Likewise, it was in the brain that the fourth humor, the "phlegm" or "pituita," which was blood incompletely concocted by the natural heat, was condensed. This humor then dripped downwards through the infundibulum to the pituitary body and thence was evacuated through the nasal passages (see plate 72:1-2). Completion of the physiological series required the provision of a plate showing the nervous system. Vesalius had prepared such a plate, which we know only through a plagiarized version issued by Aegidius Macrolios at Cologne, but this plate was not published at the time. A modified version appeared in the *Fabrica* and constitutes plate 49.

It is evident from the shape of the heart, the position of the kidneys and the branches of the aorta that the present diagram is based largely on forms other than man, possibly the monkey. Special attention should be drawn to the middle and lateral sacral arteries, marked F, at the bifurcation of the aorta into the common iliac arteries. Of these vessels, Vesalius says in the margin ". . . some customarily but incorrectly show these as the haemorrhoidal veins." This remark refers to his teacher Jacobus Sylvius of Paris who so demonstrated them.

The term HA-NABHUBH in Hebrew characters has been erroneously interchanged with HA-ORTI in the previous plate, and like it is incorrectly transliterated.

✠ ARTERIA MAGNA, AOPTH, הנכוב HAORTI EX SI=

ÑISTRO CORDIS SINV ORIENS, ET VITALEM SPIRITVM TOTI CORPORI DEFERENS, NATV=
RALEMQVE CALOREM PER CONTRACTIONEM ET DILATATIONEM TEMPERANS.

A Plexus choriformis in cerebri anterioribus ven-
triculis ex arterys & venis constitutum.
B Plexus reticularis ad cerebri basim, Rete mirabi
le, in quo vitalis spiritus ad animalē præparatur.
C Post aures, & ad tempora, & faciem arteriæ.
D Ad linguam, laryngem & fauces.

E Arteriæ καρωτίδες id est soporariæ, Apopleticæ,
Subeticæ, ٯ٭ﺭﺴٯ banirdamim.

F Ad transuersos vertebrarum ceruicis processus
ad cerebrum vsque excurrentes.

Sinistram carotidem, aliquando ab ea quæ in sinistrum
brachium fertur, deductam vidimus. sicut etiā ambas
pectoris, ab ea quæ in dextram manum propagatur di
auricatas reperimus.

G Ad pectoris os & mamillas, quæ cū illis quæ
in rectis musculis sunt, communicantur.
H Ad humeri musculos & gibba scapularū.
I Ad supercostales musculos & mamillas.
K Sub axillari vena in brachium excurrit.
L Ad cubiti articulum vtrimque vna.
M In interna parte manus, & ramulus ad par-
tem exteriorem pollicis.
N Ad superiores thoracis costas.
O Diuisio maxima, cuius maior ramus ad in-
feriorem corporis partem diffunditur, à quo
mox in singulas costas propagines diuarican
tur.
P Vena caua in dextrum cordis sinum aperta.
Q Arteria venalis in sinistrum sinum aerem
ex pulmonibus deferens.
R Vena arterialis ex dextro sinu sanguinem
pulmonibus communicans.
S Septi transuersi arteriæ satis insignes.
T In lienis sinū, pro visceris ratione maximæ.
V Ad iecoris cauum, & bilis vesicam.
X Ad ventriculum, & omentum.
Y In mesenterium par te superiori.
A Ad renes, Emulgentes dictæ, venis ipsis mi-
nores.

B Arteriæ seminales: vtrimque vna.

C Per mesenterium ad intestina vsque diffusa.

D Ad lumborum vertebras, musculos abdomi
nis transuersos & obliquos.
F Ad foramina osis sacri, quas nōnulli pro ve
nis hæmorrhoidibus malè demonstrare solēt.
G Ad vesicā, in viris ad penē, in mulieribus ad
vuluæ fundum et collum.
H Arteriæ per quas fœtui spiritus in vtero cō
municatur, quæ interdum in maiores truncos
implantatæ conspiciuntur.
I Ad rectos abdominis musculos, cum pecto
ris arterijs coeuntes, per quas vtero cum ma
millis communio est.

K Ad coxendicis articulum, & fœmoris exte-
riorem regionem.

L In poplite bifurcatio in alto latens.

M Ad interiorem pedis partem latitans.
N Exteriorem pedis partem (licet profunda)
perreptans, à quibus minimi rami in pedis su
periorem partem excurrunt, ramulum ta-
men manifestū ad exteriora pollicis diffun
dunt.

Arteriæ magnæ inæqualis diuisio, aliquando cordi vi
cinissima visitur, aliquando verò nonnihil à corde
paululū remota, quemadmodum hic delineauimus.

Coronales arteriæ, in suo ortu demonstrari præsen ti
tabula nequeunt, latitāt enim post membranulas spi
ritum ex magna arteria in cor referri prohibentes.

Arteriæ quæ in iecur, lienem, ventriculum, omentum
& mesenterium diffunduntur, nonnunquam binas
quemadmodum hic, sortiuntur radices, interdū tres,
& aliquando (licet in hominibus rarius) vnam.
Verum semper propemodum ad hunc modum in
transuersa ferri inuenimus.

Seminales arterias vtrasqʒ, postquam primū animad
uerti, semper ab arteriæ magnæ corpore, aliter scili-
cet quàm venas seminarias enatas inueni. licet etiam
sinistram semel certissimè deesse repererim.

Hanc arteriam ad medium tibiæ vsque indiuisam
ferri aliquando obseruauimus.

Hæc in extremo pede ac malleolo, sicuti etiam in ex-
trema manu arteriarum distributio, subinde variari
conjueuit. Verum quemadmodum sœpius nobis ap-
paruit, hic detraximus.

NOTATV DIGNAE ARTERIAE MAGNAE SOBOLES CENTVM ET QVADRAGINTA SEPTEM APPARENT.

Plate 90

The bones of the human body represented from the anterior aspect.

The three illustrations of the skeleton found in the *Tabulae Sex* are the only Vesalius illustrations which we can state with absolute certainty to have been drawn by Jan van Kalkar. Although, with the sole exception of the skeletal drawings of Leonardo da Vinci, immeasurably superior to anything which had preceded them, they are stiff, defective in proportions and full of errors. Artistically, the series can in no way be compared to the magnificent skeletal figures of the *Fabrica* (plates 21, 22, 23); so much so that, as Charles Singer has pointed out, it is difficult to believe that Kalkar had any hand in the latter.

The curious pose is the outcome of the method of articulation employed by Vesalius. The skeleton was erected on a circular board to which was attached a vertical iron rod over which the vertebral column was threaded. To gain further stability the right hand grasped a staff or spear, also inserted in the board, as may be seen in the articulated skeleton appearing on the title page of the *Fabrica* (plates 2 and 3). The specimen was obtained from a seventeen- or eighteen-year-old youth who undoubtedly suffered from rickets as is evi-

denced by the shape of the skull, the irregularity of the long bones and the enlargement of the epiphyses. The errors of draughtsmanship and of anatomy are too numerous to mention in any detail. Among the more outstanding are the misarticulation and misrepresentation of the clavicles, the poor representation of the scapulae, a sternum of seven segments (Galen's number), the apparent misarticulation of the right hand due to poor perspective and the badly drawn pelvis and vertebral column.

In the margins are given the Greek, classical and medieval Latin, Hebrew and Arabic terms for the various parts. These are derived from several sources, and many are corrupt or spurious. However, they are exceedingly important for the student of terminology and have been closely studied by Charles Singer and C. Rabin in a recent work.

At the foot of the illustration appears a statement on the number of the bones. *Some reduce the bones of the human body to 248, others to some other number. Excepting the hyoid which is fashioned from six ossicles united by synchondrosis almost into one, and omitting the seeamsoids, I reckon there are 246 as comprised in the distich of the plate following.*

HVMANI CORPORIS OSSA PARTE ANTERIO-
RI EXPRESSA.

Foramina quæ in harum triũ chartarum delineatione conspici possunt, sunt in temporum osse auditorius meatus : post mamillarem processum vnum, per quod interna iugularis in cerebrum mergit: in facie circa oculorum sedem quatuor, primum ad frontem, secundum ad nares, tertium ad maxillam superiorem, quartum ad temporalem musculũ: duo quoq; in maxilla inferiori. Et per hæc singula ramulus tertij partis neruorum excidit.

Ὀδόντσσ, dentes, ᵐᵐᵖ scinaim, plurimum triginta duo. ᵗᵒᵐₑͥᵉ, incisorij, ᵐᵉᵇᵃᵗʰᵇⁱᵐ mecbathchim, octo : κυνόδοντσσ, canini, ᵖᵖˡ calbym quatuor: μύλιται, molares, maxillares, ᵗᵇᵒᶜʰⁿⁱᵐ tbochnim viginti. omnes disparibus radicibus suos alueolos subeunt.

B Clauiculæ, κλῆδια, claues, iugula, ᵗʰᵃʳᵏᵘᵇᵃ tharkuba, Furculæ: vtrumq; os literam.f.refert, figura inæquabili.

C Ἀκρώμιον, summus humerus, processus superior scapulæ, à Galeno in lib.de vsu par.κορακοειδίε̃ ad rostri corvini similitudinem nominatus, ᵃˡᶻᵉᵍᵃᵐ charton alzegam charton, huius appendix cuius principio claues per arthrodian dearticulantur, proprie κατακλειδ'η quasi ad clauiculas dicitur, Rostrum porcinum.

D Processus scapulæ interior inferiórque ab anchoræ similitudine ἀγκυροειδής dictus, ej hunc sæpe κορακοειδία ej sigmoeide Gale. vocauit. ᵃʸⁿ ᵇᵃᶜᵃᵗᵇᵉᵖʰ ayn bacatbeph, Oculus scapulæ.

E Pectoris os, ςέρνον, ᵇᵉᶜʰᵃˡᵉᵇ bechaleb, Cassos, septem constat ossibus, sicuti costæ quæ illi alli guntur, per vnionem potius, quàm per coarticulationem, parte inferiori iunctis: id ab vtroq; la-tere lunatum est.

F Cartilago ξιφοειδὴσ, ensiformis, quo nomine totum os quoque dicitur, ᵃˡᶜʰᵃⁿᵍʳⁱ alchangri, Ensi-foidis, Malum granatum, Epiglottalis cartilago.

G Βραχίων, brachium, humerus Celso ej C. sari, ᶻᵉʳᵒᵃᶜʰ Zeroach, Adiutorium brachij, Asethː hoc tibiæ osse minus est.

H Sinus, humeri caput veluti in duo tubercula diuidens.

I Humeri orbita trochleis similis.

K Cubitus, πῆχυσ, ᵇᵏᵃⁿᵉᵇ b:kaneb, Asaid, quibus nominibus etiam tota hæc pars dicitur, vlna. Fo-cile maius, ᶻᵉⁿᵃᵈ ᵉˡⁱᵒⁿ zenad elion. huius acutus processus ad brachiale ᵞ ⁿᵒᵐⁱⁿᵃᵗᵘʳ nominatur

L Radius, κερκίσ, ᶻᵉⁿᵃᵈ ᵗᵇᵃᶜʰᵗᵇᵒⁿ zenad tbachtbon, Focile minus brachij.

N Brachiale, καρπόσ, ᵃⁿ reseg, R.aseta, Rascha, ossibus disparibus octo ej duplici ordine di-stinctis constat, in superiori tribus, in inferiori quatuor: hæc simul figuram intrinsecus cauam, extrinsecus gibbam constituunt: istorum cum Celso non incertus numerus est.

O Μετακάρπιον, palma, pecten, ᵐᵉˢʳᵉᵏ mesrek, Postbrachiale ossibus quatuor Galeno, non quinque, vt alij cumplurimis, conformatum est.

P Δάκτυλοι, digiti, ᵉˢᵇᵃᵒᵗʰ esbaoth, singuli ex ternis ossibus conformantur, priori semper interno diu in subsequentis sinum subeunte.

Q Μύλη, ἐπιγονατίσ, patella, rotula genu, ᵐᵃᵍᵉⁿ ᵇᵃʳᶜᵘᵇᵃᶜʰ magen barcubach, scutum genu, Are-fatuː os rotundum breuis scuti instar.

R Ἀςράγαλοσ, talus, ᵏᵃʳˢᵘˡ karsul, Balistæ os, Cauilla, Chabab, Alsochiː aliqui malleolum hodie male vertunt.

S Nauiforme, σκαφοειδ'ισ, nauiculare, ᶻᵒʳᵏⁱ zorki.

T τάρσοσ, ᵃⁿ reseg, R.aseta pedis, quatuor ossibus constat, quorum maximum extrinsecus situm à cubi figura dicitur κυββοειδ'ισ, tesseræ os, ᵗᵇᵃʳᵈⁱʲ tbardij, Exagonon, Grandinosum, Nerdi. Re-liqua tria nominibus carent, sed καλκεοειδ'ἡ nonnullis nominantur. Bis vidimus dextrum pedem vno abundare.

V Planta, plenum, πέλον, pecten ᵐᵃˢʳᵉᵏ mesrek, ossibus quinque constructum est, cui succedunt pedis digiti, X. qui omnes ex ternis internodijs constant, magno tantũ excepto, qui inter alios ex du-plici osse constructus est.

Ossiculum illud quod ad primum pollicis articulum apparet, vnum ex sesaminis ossibus est : ej in illo duntaxat loco duo in vtroq; pede obseruauimus.

HVMANI CORPORIS OSSA NONNVLLI IN DVCENTA QVADRAGINTA OCTO, ALIQVI VERO,
in alium numerum rediguat, ego excepto h;oi.de quod integrum fere ex sex osiculis per syncondrosim vnitis conformatur, ej sesaminis ducenta ej quadraginta sex putauerim sequentis tabelle disticho comprehensa.

Plate 91

A representation of the lateral aspect of the skeleton.

In the second of the skeletal series the loss of the spinal curves and the incorrect tilt of the pelvis are very apparent and are due to the manner of articulation denoted previously. The epiphyses of the long bones are clearly shown, and the appearance of the crest of the ilium is no doubt due to the loss of the epiphysis during the process of maceration of the specimen. Once again numerous defects in draughtsmanship are observable, and the scapulae are very crudely represented.

At the foot of the illustration is the distich mentioned on the preceding plate, which reads as follows:

A distich embracing the number of the bones

Add to four times ten, twice a hundred, and six, and You will immediately know of what a large number of bones you are composed.

Offa κρανίου, caluariæ, capitis offis, ראשׁ גלגלת kadroth bamuach , Offæ ca- pitis, Aſoan.

A Offa duo βρέγματος, κορηφῆσ, ſincipitis, verticis, Parietalia. Locus hic apud Auicēná in arabico ↋ latino exemplari falſus eſt.

B Offa duo ad vtrãꝗ; aurem κροταφῶν, temporum, Aurium: Singulorum βελκνουδίον id eſt acui, aut telo ſimilis ↋ mamillaris, ↋ ad os iugale proceſſus, partes exiſtunt.

C Os μετώπου , frontis, עצם etzem bametzah, Coronale: interdũ ob protenſam ad na ſum vſque rectam ſuturam, geminum apparet, quod nonnulli in omnibus mulieribus eſſe falsò putarunt.

D Os vnum ινίου, occipitis, עורף orepb, cuneiforamen maximum haeſt per quod ſpiralis me- dulla excidit.

E Offa ξυγώματα , iugalia , aut ξυγοειδῆ , זוג zog , Pars : vtrinque vnum ex duorum oſtium conſtantia proceſſibus: quamobrem propria circunſcriptione carent.

F Os ſφηνοειδῆσ, cuneiforme, baſilare, aliquando à multiplici forma πολύμορφον, מצחב mſchab bamoach, Colatory, Cauilla, Hoc inter maxillæ ſuperioris offa decimũ quintũ numerari conſueuit. Sunt enim ſex quæ ad radicem oculorum ſubeunt: duo maxima molas ac molarium dentium alueolos continentis: narium duo : inciſorios dentes ſuſci- pientia duo: ad finem palati circa narium foramina duo, ↋ ante hæc omnia nuper dictum os cuneiforme. Niſi fortaſis octo, aut ex aliquorum Græcorum ſententia duodecim, hic offa enumerare mauis, prout ſcilicet exiguas ſuturas, commiſſuras ↋ harmonias aut numeras, aut præteris.

G Offa duo maxillæ inferioris, parte anteriori per coalitum firmiſſimè annexa: nec ſat ſcio, an malè cum Celſo in hominibus vnum dicere poſſimus , nam quauis etiam decoctione ſeparari haudquaꝗ poſſe obſeruaui, ↋ ſi ipſa cultro dirimenda ſit, nullibi difficilius quã in medio illam diuides.

H κερανὸν .

I Maxillæ inferioris tuberculum ↋ ceruix , hæc ſola in omnibus animãtibus præterquã crocodilo mobilis dicitur.

K Duo cubiti proceſſus, quorum poſteriorem ὠλεκρανὸν nominant. Hi in medio ſinum ba bent antiquæ Græce literæ ς, aut noſtræ C ſimilem.

Coſtæ, πλευραὶ צלעות tzelaotb, viris ↋ mulieribus viginti quatuor vtroꝗ; latere duodecim. Ex ijs ſeptem cũ metaphreni ſeu thoracis vertebris cunꝗ; offe pectoris vtrinꝗ; coeunt, quæ veræ ↋ perfectæ dicuntur. Cæteræ quinque poſteriori parte ſpinæ duntaxat adue- ctuntur, ex quibus tres priores antica parte, ſuis cartilaginibus, veris cohæret, aliæ duæ inui cem debiſcunt. hæ ſpuriæ ↋ nothæ ↋ falſæ vocantur. ſola autem duodecima vnica arti- culatione duodecimæ vertebræ iungitur.

L Offa validiſsima, quæ offi ſacro cōmittuntur, שׁני gaſ berua. Superne λαγόνον, iliũ offa, ירך יַרְכָה atzar gepba, Anchæ . ad fœmoris ingreſſum ἰσίον, coxendicis, כָּף הַיָּרֵךְ ezem baiarech, Pixis coxæ, כָּף baiarech, Althauorat. O Parte anteriori qua tenuia ac forata mutuòque inter ſe per ſynchondroſim connexa ſunt, ἦβον, pubis, pecti- nis, altaiga, Penis dicuntur. Totũ os, Celſo coxæ os, quemadmodum authori introducto- rijj ſeu medici ἰσχον , appellatum eſt. Nonnulli falsò putarunt hæc offa in viris ad pubem non eſſe per cartilaginem alligata.

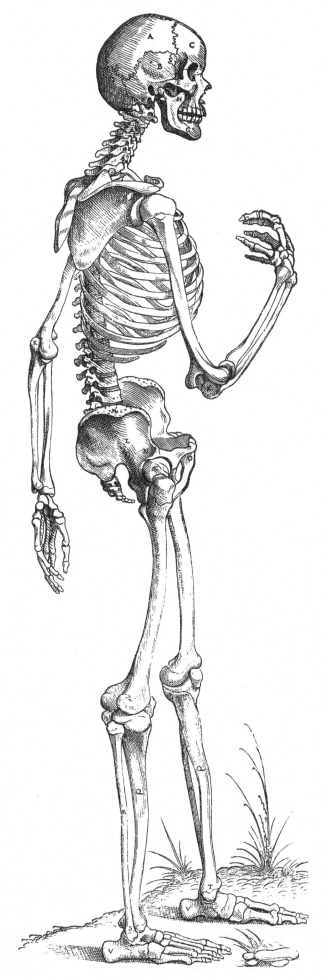

Q Tibia, κνήμη, עצמות השׁוק abtzmoth baſcok, ꝗbus noïbus tota hæc pars noïatur שׁוֹק קנה gadol, Canna maior, Focile cruris maius. Huius pars anterior excarnis ↋ tenuis crea nominatur, huic tantummodo quoque fœmur annectitur: præterea facilè tibiæ ſinus qui bus fœmoris capita recipit, apparent.

R Fibula, ſura, os minus tibiæ, περόνη, קנה קטון caue katon, Cāna ↋ arundo minor. Hoc os ti biæ craſſitudine admodum cædit, nec ita protenditur , vt genu ipſum contingat: verum ſupra infraꝗ; tibiæ per ſynnartbroſim coarticulatur. Tota hæc pars Celſo crus no- minatur.

S.T Malleoli, σφυρὰ , קרסׁלות arcuboth , Clauiculæ extremæ tibiæ ſuræque proceſſuum partes ſunt.

V Omnium pedis maximum os, καλκόνιον πτέρνα , calcis os, עקב aekeſ. huius pars po- ſterior tibiæ rectitudinem longè excedit.

Adde quater denis his centum ſenáque , habebis
Quam ſis multiplici conditus oſſe , ſemel.

Plate 92

The skeleton drawn from behind.

The poor draughtsmanship of Kalkar is perhaps most evident in the posterior view of the skeleton. The lack of proportion and crudity of representation in the vertebral column, sacrum, pelvis and scapulae as well as the lower limbs suggest the work of a relatively unskilled artist.

On the scroll at the foot of the tree stump is written "Printed at Venice by B. Vitalis of Venice at the cost of Johann Stefan van Kalkar. For sale in the shop of Signor Bernardo." This puzzling statement has caused a great deal of speculation, and it has been suggested that Kalkar was given the rights in lieu of a fee. At the foot is the customary "privilege" or copyright granted to Vesalius by Pope Paul III, Charles V and the Senate of Venice.

✣ΣΚΕΛΕΤΟΝ A TERGO DELINEATVM.

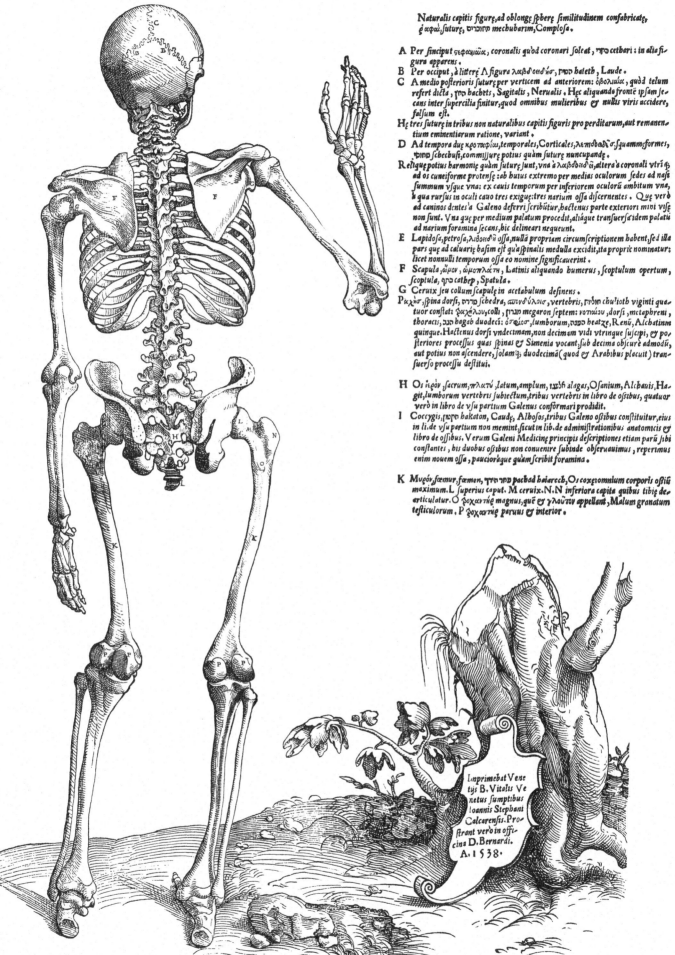

Naturalis capitis figuræ, ad oblongæ fphẹræ fimilitudinem confabricatæ, ẹ ἀφαί, futurẹ, תחוברים mechubarim, Complofa.

A Per finciput ςεφαχιώα, coronalis quòd coronari foleat, רטס cetbari : in alia figura apparens.

B Per occiput, à litterẹ Λ figura λαβδ᾽οειδησ, לאם bateth, Laude.

C A medio pofterioris futurẹ per verticem ad anteriorem: ὀβολιάια, quòd telum refert dicta, חץ bachets, Sagitalis, Neruialis. Hẹc aliquando fronte ipfam fecans inter fupercilia finitur, quod omnibus mulieribus ey nullis viris accidere, falfum eft.

Hẹ tres futurẹ in tribus non naturalibus capitis figuris pro perditarum, aut remanentium eminentiarum ratione, variant.

D Ad tempora duẹ κροτaφίαι, temporales, Corticales, λιπιδοδὴ σ, fquammẹformes, שבמ fchecbufi, commiffurẹ potius quàm futurẹ nuncupandẹ.

Reliquẹ potius harmoniẹ quàm futurẹ funt, una à λαβδ᾽οειδὴ ũ, altera à coronali vtriᵹ ad os cuneiforme protenfẹ : ab huius extremo per medias oculorum fedes ad nafi fummum vfque vna: ex cauis temporum per inferiorem oculorũ ambitum vna, à qua rurfus in oculi cauo tres exiguẹ : tres narium offa difcernentes . Quẹ verò ad caninos dentes à Galeno deferri fcribũtur, hactenus parte exteriori mihi vifẹ non funt. Vna quẹ per medium palatum procedit, aliáque tranfuerfa᾽idem palatũ ad narium foramina fecans, hic delineari nequeunt.

E Lapidofa, petrofa, λιθοειδῆ offa, nullã propriam circumfcriptionem habent, fed illa pars quẹ ad caluariẹ bafim eft quà᾽fpinalis medulla excidit, ita propriè nominatur: licet nonnulli temporum offa ab eo nomine fignificauerint .

F Scapula ὦμον, ὠμοπλάτη, Latinis aliquando humerus, fcoptulum opertum, fcoptula, חצ cathep, Spatula.

G Ceruix feu collum fcapulẹ in acetabulum definens.

Ρ᾽αχιν᾽α, fpina dorfi, שדרה fchedra, σπονδύλιοσ, vertebris, חליות chuʼioth viginti quatuor conftat: βαχέλιου, colli , צורן megaron feptem: νωτaίου, dorfi, metaphreni, thoracis, בב bagab duodeci: ὀσφιοσ, lumborum, בצם heatzẹ, Renũ, Alchatinum quinque. Hactenus dorfi vndecimam, non decimam vidi vtrinque fufcipi, ey pofteriores proceffus quas fpinas ey Simenia vocant, fub decima obfcurè admodũ, aut potius non afcendere, folamᵹ duodecimã (quod ey Arabibus placuit) tranfuerfo proceffu deftitui.

H Os iερὸν facrum, πλατύ, latum, amplum, עצה alagas, Ofanium, Alchauis, Hagit, lumborum vertebris fubiectum, tribus vertebris in libro de offibus, quatuor verò in libro de vfu partium Galenus conformari prodidit.

I Coccygis, אקרה bakaton, Caudẹ, Albofos, tribus Galeno offibus conftituitur, eius in li. de vfu partium non memint, ficut in lib. de adminiftrationibus anatomicis ey libro de offibus. Verum Galeni Medicinẹ principis defcriptiones etiam parũ fibi conftantes , bis duobus offibus non conuenire fubinde obferuauimus , reperimus enim nouem offa , paucioráque quàm fcribit foramina .

K Μηρòν, fẹmur, fẹmen, ירך ofar pachad baiarech, Os coxẹ omnium corporis offiũ maximum. L fuperius caput. M ceruix. N.N inferiora capita quibus tibiẹ de-articulatur. Ο ὁοχαντὴρ magnus, quẹ ey γλουτον appellant, Malum granatum tefticulorum . P ὁοχαντὴρ paruus ey interior .

Imprimebat Venetijs B. Vitalis Venetus fumptibus Ioannis Stephani Calcarenfis. Proftrant verò in officina D. Bernardi. A. 1538.

Plates 93, 94, 95, 96

The four following plates show the evolution of the famous title page of the first edition of the *Fabrica*. The *first* is a reproduction of a rough line and wash drawing preserved in the National Museum at Stockholm and is presumed to be the first stage in the development of the woodcut. It carries the name "Jean Calkar," not in a contemporary hand, and the date 1675, so we must assume that this is a late attribution. The general features of the composition are similar to the final version except for the absence of the skeleton. That it is no more than a preliminary effort is further suggested by the several corrections in the drawing.

The *second* would appear to be a more advanced stage in the design. The drawing has now been reversed in preparation for the engraver. The skeleton has been added and other minor modifications made, but the architectural features have been omitted or, at least, are only lightly suggested. There is no evidence of "pricking" or other method of transfer, and the purpose of the drawing would seem to have been for the working out of details of line and shading. This sketch is the first leaf of a codex in the Hunterian collection of the University of Glasgow, which is entitled "Desseins origin. de l'anatom. de Vesale." The codex was purchased by William Hunter at the sale of Richard Mead's library in 1755 and contains, in addition, several anatomical sketches, many of which appear in the *Fabrica* in modified form. At the time of their acquisition the sketches were attributed to Titian but have

since come to be regarded as the work of Kalkar largely on the basis of the watermark of several of the sheets which is the same as that of the paper employed in the printing of the *Tabulae Sex* of 1538.

The *third* is a reproduction of a pen drawing in sepia ink purchased from the Senngracht collection by the late LeRoy Crummer and now in the possession of Edward E. Bodman of Pasadena, California. At the foot of the drawing is the inscription "Joh. Stephanus, inv. 1540 Venetiis," likewise in sepia ink. This would seem to be conclusive evidence of the identity of the artist, and, moreover, François de Feyfer in his detailed study of Kalkar is of this opinion. Nevertheless, after the most careful inspection of the original and close examination of the color of the ink we are of the opinion that the inscription is not contemporary and, furthermore, is not in a sixteenth-century hand. In addition, the date 1540 is for many reasons decidedly suspect. The drawing is reversed and reproduces almost line-for-line the finished woodcut. It may have been prepared for the guidance of the engraver, but odd features are the absence of the cartouche, coat of arms and scroll carrying the privilege. It has been suggested that these were later pasted on, but no evidence of this is to be found.

The *fourth* is a reversed print from the original wood block to enable the reader to compare more easily the preliminary sketches with the final form.

1675.

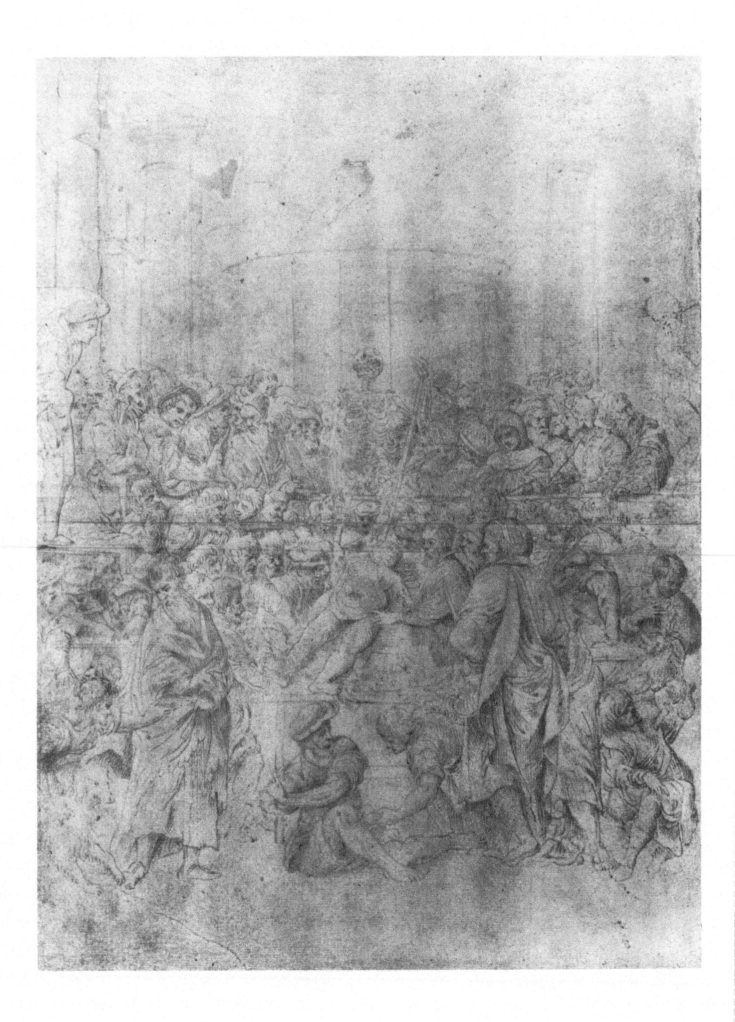

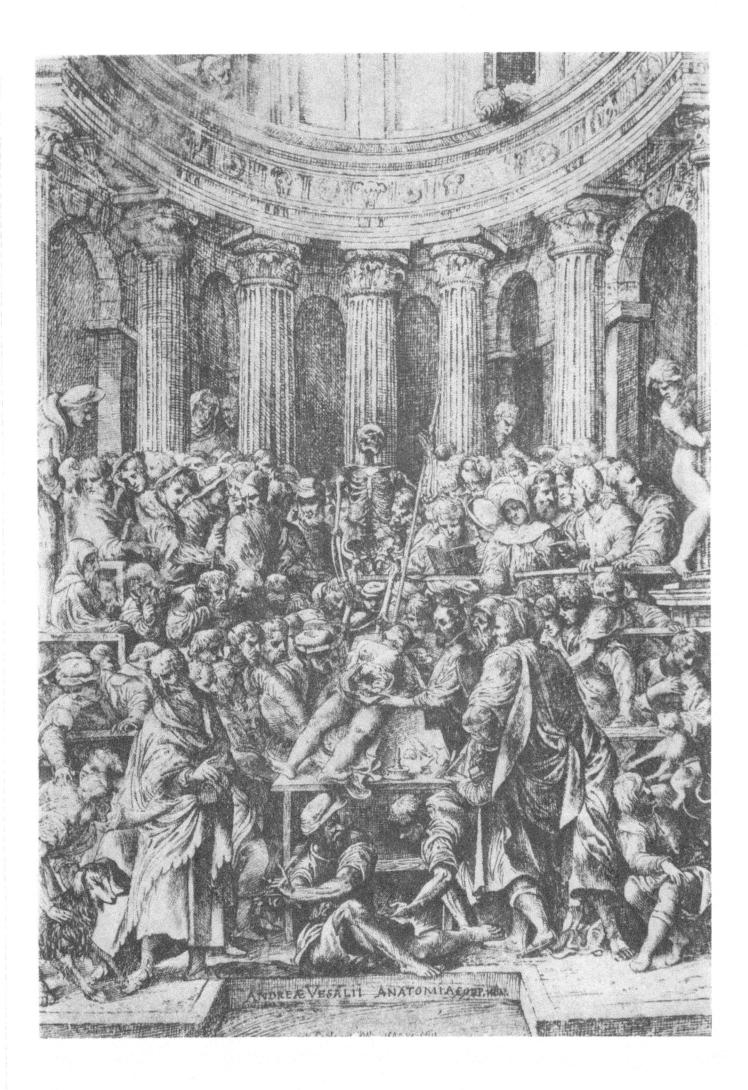

ANDREÆ VESALII ANATOMIA CORP HUM

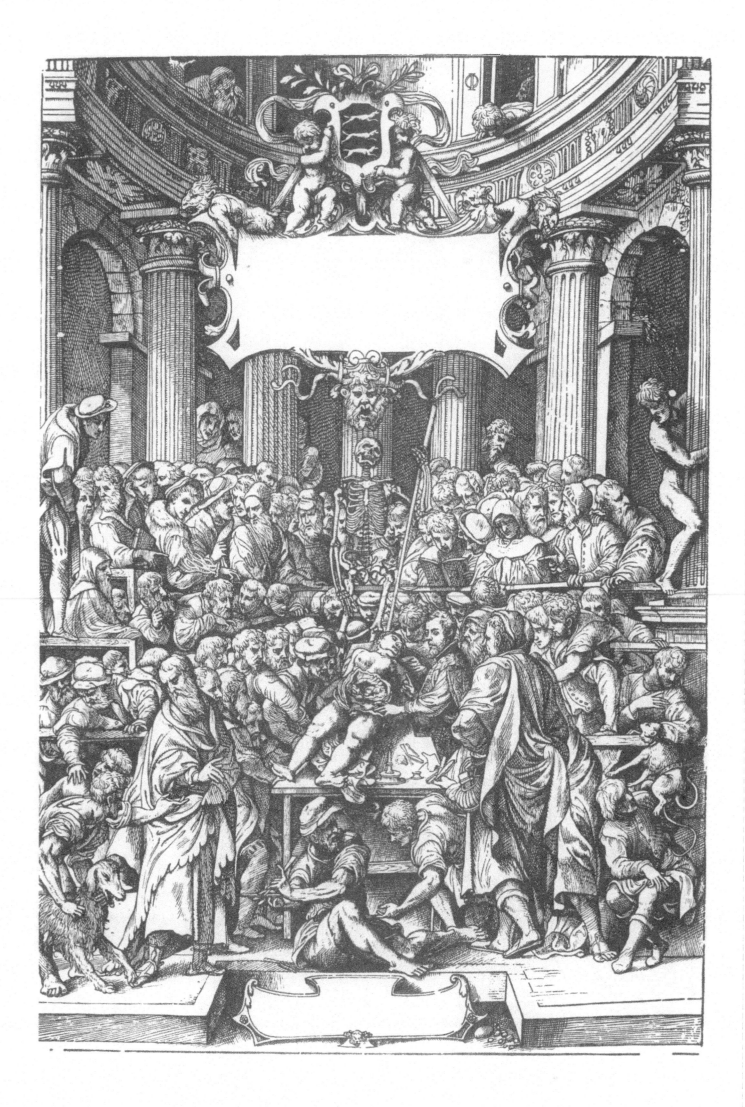